KU-600-537

THE GODFATHER

'A staggering triumph . . . the definitive novel about a sinister fraternity of crime.'

Saturday Review

'A splendid and distinguished blood saga of the Cosa Nostra, the American Mafia, and of the whirl created by five families of *mafiosi* at war in New York. The most influential is led by Don Corleone . . . He will refuse his "god-children" nothing . . . He can, in sudden bloodstreaks, fix anything. One godson is refused a film part. The studio boss wakes up to find in his bedroom the head of his most beautiful racehorse; just the head . . .'

The Sunday Times

'Breakneck drive . . . you can't stop reading it, you'll find it hard to stop dreaming about it.'

New York Magazine

'Plenty of scenes of tough love-making and brutal slaughter.'

Sunday Telegraph

'Big, turbulent, highly entertaining novel that moves at breakneck speed.'

Newsweek

'The plot itself is remarkable. It comes with the force of a mugger in a midnight alley.'

Look

CONDITIONS OF SALE

This book shall not, by way of trade or otherwise, be lent, re-sold, hired out or otherwise circulated without the publisher's prior consent in any form of binding or cover other than that in which it is published and without a similar condition including this condition being imposed on the subsequent purchaser. The book is published at a net price, and is supplied subject to the Publishers Association Standard Conditions of Sale registered under the Restrictive Trade Practices Act, 1956.

MARIO PUZO

THE GODFATHER

UNABRIDGED

PAN BOOKS LTD : LONDON

First published in Great Britain 1969
by William Heinemann Ltd.
This edition published 1970 by Pan Books Ltd.,
33 Tothill Street, London, S.W.1

ISBN 0 330 02457 4

2nd Printing 1970
3rd Printing 1970
4th Printing 1970
5th Printing 1971
6th Printing 1972
7th Printing 1972
8th Printing 1972

© Mario Puzo, 1969

Printed in Great Britain by
Richard Clay (The Chaucer Press) Ltd., Bungay, Suffolk

For Anthony Cleri

Book I

> *Behind every great fortune
> there is a crime.*
>
> —Balzac

CHAPTER ONE

AMERIGO BONASERA sat in New York Criminal Court
Number 3 and waited for justice; vengeance on the men who
had so cruelly hurt his daughter, who had tried to dishonour her.

The judge, a formidably heavy-featured man, rolled up the
sleeves of his black robe as if to physically chastise the two
young men standing before the bench. His face was cold with
majestic contempt. But there was something false in all this
that Amerigo Bonasera sensed but did not yet understand.

'You acted like the worst kind of degenerates,' the judge
said harshly. Yes, yes, thought Amerigo Bonasera. Animals.
Animals. The two young men, glossy hair crew cut, scrubbed
clean-cut faces composed into humble contrition, bowed their
heads in submission.

The judge went on. 'You acted like wild beasts in a jungle
and you are fortunate you did not sexually molest that poor
girl or I'd put you behind bars for twenty years.' The judge
paused, his eyes beneath impressively thick brows flickered
slyly towards the sallow-faced Amerigo Bonasera, then
lowered to a stack of probation reports before him. He
frowned and shrugged as if convinced against his own natural
desire. He spoke again.

'But because of your youth, your clean records, because of
your fine families, and because the law in its majesty does not
seek vengeance, I hereby sentence you to three years' con-
finement to the penitentiary. Sentence to be suspended.'

Only forty years of professional mourning kept the over-
whelming frustration and hatred from showing on Amerigo

Bonasera's face. His beautiful young daughter was still in the hospital with her broken jaw wired together; and now these two *animales* went free? It had all been a farce. He watched the happy parents cluster around their darling sons. Oh, they were all happy now, they were smiling now.

The black bile, sourly bitter, rose in Bonasera's throat, over-flowed through tightly clenched teeth. He used his white linen pocket handkerchief and held it against his lips. He was standing so when the two young men strode freely up the aisle, confident and cool-eyed, smiling, not giving him so much as a glance. He let them pass without saying a word, pressing the fresh linen against his mouth.

The parents of the *animales* were coming by now, two men and two women his age but more American in their dress. They glanced at him, shamefaced, yet in their eyes was an odd, triumphant defiance.

Out of control, Bonasera leaned forward towards the aisle and shouted hoarsely, 'You will weep as I have wept – I will make you weep as your children make me weep' – the linen at his eyes now. The defence attorneys bringing up the rear swept their clients forward in a tight little band, enveloping the two young men, who had started back down the aisle as if to protect their parents. A huge bailiff moved quickly to block the row in which Bonasera stood. But it was not necessary.

All his years in America, Amerigo Bonasera had trusted in law and order. And he had prospered thereby. Now, though his brain smoked with hatred, though wild visions of buying a gun and killing the two young men jangled the very bones of his skull, Bonasera turned to his still uncomprehending wife and explained to her, 'They have made fools of us.' He paused and then made his decision, no longer fearing the cost. 'For justice we must go on our knees to Don Corleone.'

In a garishly decorated Los Angeles hotel suite, Johnny Fontane was as jealously drunk as any ordinary husband. Sprawled on a red couch, he drank straight from the bottle of Scotch in his hand, then washed the taste away by dunking his mouth in a crystal bucket of ice cubes and water. It was four in the morning and he was spinning drunken fantasies of murdering his

trampy wife when she got home. If she ever did come home. It was too late to call his first wife and ask about the kids and he felt funny about calling any of his friends now that his career was plunging downhill. There had been a time when they would have been delighted, flattered by his calling them at four in the morning but now he bored them. He could even smile a little to himself as he thought that on the way up Johnny Fontane's troubles had fascinated some of the greatest female stars in America.

Gulping at his bottle of Scotch, he heard finally his wife's key in the door, but he kept drinking until she walked into the room and stood before him. She was to him so very beautiful, the angelic face, soulful violet eyes, the delicately fragile but perfectly formed body. On the screen her beauty was magnified, spiritualized. A hundred million men all over the world were in love with the face of Margot Ashton. And paid to see it on the screen.

'Where the hell were you?' Johnny Fontane asked.

'Out fucking,' she said.

She had misjudged his drunkenness. He sprang over the cocktail table and grabbed her by the throat. But close up to that magical face, the lovely violet eyes, he lost his anger and became helpless again. She made the mistake of smiling mockingly, saw his fist draw back. She screamed, 'Johnny, not in the face, I'm making a picture.'

She was laughing. He punched her in the stomach and she fell to the floor. He fell on top of her. He could smell her fragrant breath as she gasped for air. He punched her on the arms and on the thigh muscles of her silky tanned legs. He beat her as he had beaten snotty smaller kids long ago when he had been a tough teenager in New York's Hell's Kitchen. A painful punishment that would leave no lasting disfigurement of loosened teeth or broken nose.

But he was not hitting her hard enough. He couldn't. And she was giggling at him. Spread-eagled on the floor, her brocaded gown hitched up above her thighs, she taunted him between giggles. 'Come on, stick it in. Stick it in, Johnny, that's what you really want.'

Johnny Fontane got up. He hated the woman on the floor, but her beauty was a magic shield. Margot rolled away, and in

a dancer's spring was on her feet facing him. She went into a childish mocking dance and chanted, 'Johnny never hurt me, Johnny never hurt me.' Then almost sadly with grave beauty she said, 'You poor silly bastard, giving me cramps like a kid. Ah, Johnny, you always will be a dumb romantic guinea, you even make love like a kid. You still think screwing is really like those dopey songs you used to sing.' She shook her head and said, 'Poor Johnny. Goodbye, Johnny.' She walked into the bedroom and he heard her turn the key in the lock.

Johnny sat on the floor with his face in his hands. The sick, humiliating despair overwhelmed him. And then the gutter toughness that had helped him survive the jungle of Hollywood made him pick up the phone and call for a car to take him to the airport. There was one person who could save him. He would go back to New York. He would go back to the one man with the power, the wisdom, he needed and a love he still trusted. His Godfather Corleone.

The baker, Nazorine, pudgy and crusty as his great Italian loaves, still dusty with flour, scowled at his wife, his nubile daughter, Katherine, and his baker's helper, Enzo. Enzo had changed into his prisoner-of-war uniform with its green-lettered armband and was terrified that this scene would make him late reporting back to Governor's Island. One of the many thousands of Italian Army prisoners paroled daily to work in the American economy, he lived in constant fear of that parole being revoked. And so the little comedy being played now was, for him, a serious business.

Nazorine asked fiercely, 'Have you dishonoured my family? Have you given my daughter a little package to remember you by now that the war is over and you know America will kick your ass back to your village full of shit in Sicily?'

Enzo, a very short, strongly built boy, put his hand over his heart and said almost in tears, yet cleverly, '*Padrone*, I swear by the Holy Virgin I have never taken advantage of your kindness. I love your daughter with all respect. I asked for her hand with all respect. I know I have no right, but if they send me back to Italy I can never come back to America. I will never be able to marry Katherine.'

Nazorine's wife, Filomena, spoke to the point. 'Stop all this foolishness,' she said to her pudgy husband. 'You know what you must do. Keep Enzo here, send him to hide with our cousins in Long Island.'

Katherine was weeping. She was already plump, homely, and sprouting a faint moustache. She would never get a husband as handsome as Enzo, never find another man who touched her body in secret places with such respectful love. 'I'll go and live in Italy,' she screamed at her father. 'I'll run away if you don't keep Enzo here.'

Nazorine glanced at her shrewdly. She was a 'hot number' this daughter of his. He had seen her brush her swelling buttocks against Enzo's front when the baker's helper squeezed behind her to fill the counter baskets with hot loaves from the oven. The young rascal's hot loaf would be in *her* oven, Nazorine thought lewdly, if proper steps were not taken. Enzo must be kept in America and be made an American citizen. And there was only one man who could arrange such an affair. The Godfather. Don Corleone.

All of these people and many others received engraved invitations to the wedding of Miss Constanzia Corleone, to be celebrated on the last Saturday in August 1945. The father of the bride, Don Vito Corleone, never forgot his old friends and neighbours though he himself now lived in a huge house on Long Island. The reception would be held in that house and the festivities would go on all day. There was no doubt it would be a momentous occasion. The war with the Japanese had just ended, so there would not be any nagging fear for their sons fighting in the Army to cloud these festivities. A wedding was just what people needed to show their joy.

And so on that Saturday morning the friends of Don Corleone streamed out of New York City to do him honour. They bore cream-coloured envelopes stuffed with cash as bridal gifts, no cheques. Inside each envelope a card established the identity of the giver and the measure of his respect for the Godfather. A respect truly earned.

Don Vito Corleone was a man to whom everybody came for help, and never were they disappointed. He made no

empty promises, nor the craven excuse that his hands were tied by more powerful forces in the world than himself. It was not necessary that he be your friend, it was not even important that you had no means with which to repay him. Only one thing was required. That you, *you yourself*, proclaim your friendship. And then, no matter how poor or powerless the supplicant, Don Corleone would take that man's troubles to his heart. And he would let nothing stand in the way to a solution of that man's woe. His reward? Friendship, the respectful title of 'Don', and sometimes the more affectionate salutation of 'Godfather'. And perhaps, to show respect only, never for profit, some humble gift – a gallon of homemade wine or a basket of peppered *taralles* specially baked to grace his Christmas table. It was understood, it was mere good manners, to proclaim that you were in his debt and that he had the right to call upon you at any time to redeem your debt by some small service.

Now on this great day, his daughter's wedding day, Don Vito Corleone stood in the doorway of his Long Beach home to greet his guests, all of them known, all of them trusted. Many of them owed their good fortune in life to the Don and on this intimate occasion felt free to call him 'Godfather' to his face. Even the people performing festal services were his friends. The bartender was an old comrade whose gift was all the wedding liqueurs and his own expert skills. The waiters were the friends of Don Corleone's sons. The food on the garden picnic tables had been cooked by the Don's wife and her friends, and the gaily festooned one-acre garden itself had been decorated by the young girl-chums of the bride.

Don Corleone received everyone – rich and poor, powerful and humble – with an equal show of love. He slighted no one. That was his character. And the guests so exclaimed at how well he looked in his tux that an inexperienced observer might easily have thought the Don himself was the lucky groom.

Standing at the door with him were two of his three sons. The eldest, baptized Santino but called Sonny by everyone except his father, was looked at askance by the older Italian men; with admiration by the younger. Sonny Corleone was tall for a first-generation American of Italian parentage,

almost six feet, and his crop of bushy, curly hair made him look even taller. His face was that of a gross Cupid, the features even but the bow-shaped lips thickly sensual, the dimpled cleft chin in some curious way obscene. He was built as powerfully as a bull, and it was common knowledge that he was so generously endowed by nature that his martyred wife feared the marriage bed as unbelievers once feared the rack. It was whispered that when as a youth he had visited houses of ill fame, even the most hardened and fearless *putain*, after an awed inspection of his massive organ, demanded double price.

Here at the wedding feast, some young matrons, wide-hipped, wide-mouthed, measured Sonny Corleone with coolly confident eyes. But on this particular day they were wasting their time. Sonny Corleone, despite the presence of his wife and three small children, had plans for his sister's maid of honour, Lucy Mancini. This young girl, fully aware, sat at a garden table in her pink formal gown, a tiara of flowers in her glossy black hair. She had flirted with Sonny in the past week of rehearsals and squeezed his hand that morning at the altar. A maiden could do no more.

She did not care that he would never be the great man his father had proved to be. Sonny Corleone had strength, he had courage. He was generous and his heart was admitted to be as big as his organ. Yet he did not have his father's humility but instead a quick, hot temper that led him into errors of judgement. Though he was a great help in his father's business, there were many who doubted that he would become the heir to it.

The second son, Frederico, called Fred or Fredo, was a child every Italian prayed to the saints for. Dutiful, loyal, always at the service of his father, living with his parents at age thirty. He was short and burly, not handsome but with the same Cupid head of the family, the curly helmet of hair over the round face and sensual bow-shaped lips. Only, in Fred, these lips were not sensual but granitelike. Inclined to dourness, he was still a crutch to his father, never disputed him, never embarrassed him by scandalous behaviour with women. Despite all these virtues, he did not have that personal

magnetism, that animal force, so necessary for a leader of men, and he, too, was not expected to inherit the family business.

The third son, Michael Corleone, did not stand with his father and his two brothers but sat at a table in the most secluded corner of the garden. But even there he could not escape the attentions of the family friends.

Michael Corleone was the youngest son of the Don and the only child who had refused the great man's direction. He did not have the heavy, Cupid-shaped face of the other children, and his jet black hair was straight rather than curly. His skin was a clear olive-brown that would have been called beautiful in a girl. He was handsome in a delicate way. Indeed there had been a time when the Don had worried about his youngest son's masculinity. A worry that was put to rest when Michael Corleone became seventeen years old.

Now this youngest son sat at a table in the extreme corner of the garden to proclaim his chosen alienation from father and family. Beside him sat the American girl everyone had heard about but whom no one had seen until this day. He had, of course, shown the proper respect and introduced her to everyone at the wedding, including his family. They were not impressed with her. She was too thin, she was too fair, her face was too sharply intelligent for a woman, her manner too free for a maiden. Her name, too, was outlandish to their ears; she called herself Kay Adams. If she had told them that her family had settled in America two hundred years ago and her name was a common one, they would have shrugged.

Every guest noticed that the Don paid no particular attention to this third son. Michael had been his favourite before the war and obviously the chosen heir to run the family business when the proper moment came. He had all the quiet force and intelligence of his great father, the born instinct to act in such a way that men had no recourse but to respect him. But when World War II broke out, Michael Corleone volunteered for the Marine Corps. He defied his father's express command when he did so.

Don Corleone had no desire, no intention, of letting his youngest son be killed in the service of a power foreign to himself. Doctors had been bribed, secret arrangements had

been made. A great deal of money had been spent to take the proper precautions. But Michael was twenty-one years of age and nothing could be done against his own wilfulness. He enlisted and fought over the Pacific Ocean. He became a Captain and won medals. In 1944 his picture was printed in *Life* magazine with a photo layout of his deeds. A friend had shown Don Corleone the magazine (his family did not dare), and the Don had grunted disdainfully and said, 'He performs those miracles for strangers.'

When Michael Corleone was discharged early in 1945 to recover from a disabling wound he had no idea that his father had arranged his release. He stayed home for a few weeks, then, without consulting anyone, entered Dartmouth College in Hanover, New Hampshire, and so he left his father's house. To return for the wedding of his sister and to show his own future wife to them, the washed-out rag of an American girl.

Michael Corleone was amusing Kay Adams by telling her little stories about some of the more colourful wedding guests. He was, in turn, amused by her finding these people exotic, and, as always, charmed by her intense interest in anything new and foreign to her experience. Finally her attention was caught by a small group of men gathered around a wooden barrel of homemade wine. The men were Amerigo Bonasera, Nazorine the baker, Anthony Coppola, and Luca Brasi. With her usual alert intelligence she remarked on the fact that these four men did not seem particularly happy. Michael smiled.

'No, they're not,' he said. 'They're waiting to see my father in private. They have favours to ask.' And indeed it was easy to see that all four men constantly followed the Don with their eyes.

As Don Corleone stood greeting guests, a black Chevrolet sedan came to a stop on the far side of the paved mall. Two men in the front seat pulled notebooks from their jackets and, with no attempt at concealment, jotted down licence numbers of the other cars parked around the mall. Sonny turned to his father and said, 'Those guys over there must be cops.'

Don Corleone shrugged. 'I don't own the street. They can do what they please.'

Sonny's heavy Cupid face grew red with anger. 'Those

lousy bastards, they don't respect anything.' He left the steps of the house and walked across the mall to where the black sedan was parked. He thrust his face angrily close to the face of the driver, who did not flinch but flapped open his wallet to show a green identification card. Sonny stepped back without saying a word. He spat so that the spittle hit the back door of the sedan and walked away. He was hoping the driver would get out of the sedan and come after him, on the mall, but nothing happened. When he reached the steps he said to his father, 'Those guys are FBI men. They're taking down all the licence numbers. Snotty bastards.'

Don Corleone knew who they were. His closest and most intimate friends had been advised to attend the wedding in automobiles not their own. And though he disapproved of his son's foolish display of anger, the tantrum served a purpose. It would convince the interlopers that their presence was unexpected and unprepared for. So Don Corleone himself was not angry. He had long ago learned that society imposes insults that must be borne, comforted by the knowledge that in this world there comes a time when the most humble of men, if he keeps his eyes open, can take his revenge on the most powerful. It was this knowledge that prevented the Don from losing the humility all his friends admired in him.

But now in the garden behind the house, a four-piece band began to play. All the guests had arrived. Don Corleone put the intruders out of his mind and led his two sons to the wedding feast.

There were, now, hundreds of guests in the huge garden, some dancing on the wooden platform bedecked with flowers, others sitting at long tables piled high with spicy food and gallon jugs of black, homemade wine. The bride, Connie Corleone, sat in splendour at a special raised table with her groom, the maid of honour, bridesmaids, and ushers. It was a rustic setting in the old Italian style. Not to the bride's taste, but Connie had consented to a 'guinea' wedding to please her father because she had so displeasured him in her choice of a husband.

The groom, Carlo Rizzi, was a half-breed, born of a Sicilian father and the North Italian mother from whom he had

inherited his blond hair and blue eyes. His parents lived in Nevada and Carlo had left that state because of a little trouble with the law. In New York he met Sonny Corleone and so met the sister. Don Corleone, of course, sent trusted friends to Nevada and they reported that Carlo's police trouble was a youthful indiscretion with a gun, not serious, that could easily be wiped off the books to leave the youth with a clean record. They also came back with detailed information on legal gambling in Nevada which greatly interested the Don and which he had been pondering over since. It was part of the Don's greatness that he profited from everything.

Connie Corleone was a not quite pretty girl, thin and nervous and certain to become shrewish later in life. But today, transformed by her white bridal gown and eager virginity, she was so radiant as to be almost beautiful. Beneath the wooden table her hand rested on the muscular thigh of her groom. Her Cupid-bow mouth pouted to give him an airy kiss.

She thought him incredibly handsome. Carlo Rizzi had worked in the open desert air while very young – heavy labourer's work. Now he had tremendous forearms and his shoulders bulged the jacket of his tux. He basked in the adoring eyes of his bride and filled her glass with wine. He was elaborately courteous to her as if they were both actors in a play. But his eyes kept flickering towards the huge silk purse the bride wore on her right shoulder and which was now stuffed full of money envelopes. How much did it hold? Ten thousand? Twenty thousand? Carlo Rizzi smiled. It was only the beginning. He had, after all, married into a royal family. They would have to take care of him.

In the crowd of guests a dapper young man with the sleek head of a ferret was also studying the silk purse. From sheer habit Paulie Gatto wondered just how he could go about hijacking that fat pocketbook. The idea amused him. But he knew it was idle, innocent dreaming, as small children dream of knocking out tanks with pop-guns. He watched his boss, fat, middle-aged Peter Clemenza whirling young girls around the wooden dance floor in a rustic and lusty *Tarantella*. Clemenza, immensely tall, immensely huge, danced with such skill and

abandon, his hard belly lecherously bumping the breasts of younger, tinier women, that all the guests were applauding him. Older women grabbed his arm to become his next partner. The younger men respectfully cleared off the floor and clapped their hands in time to the mandolin's wild strumming. When Clemenza finally collapsed in a chair, Paulie Gatto brought him a glass of icy black wine and wiped the per-spiring Jovelike brow with his silk handkerchief. Clemenza was blowing like a whale as he gulped down the wine. But instead of thanking Paulie he said curtly, 'Never mind being a dance judge, do your job. Take a walk around the neighbour-hood and see everything is OK.' Paulie slid away into the crowd.

The band took a refreshment break. A young man named Nino Valenti picked up a discarded mandolin, put his left foot up on a chair, and began to sing a coarse Sicilian love song. Nino Valenti's face was handsome though bloated by con-tinual drinking and he was already a little drunk. He rolled his eyes as his tongue caressed the obscene lyrics. The women shrieked with glee and the men shouted the last word of each stanza with the singer.

Don Corleone, notoriously straitlaced in such matters, though his stout wife was screaming joyfully with the others, disappeared tactfully into the house. Seeing this, Sonny Corleone made his way to the bride's table and sat down beside young Lucy Mancini, the maid of honour. They were safe. His wife was in the kitchen putting the last touches on the serving of the wedding cake. Sonny whispered a few words in the young girl's ear and she rose. Sonny waited a few minutes and then casually followed her, stopping to talk with a guest here and there as he worked his way through the crowd.

All eyes followed them. The maid of honour, thoroughly Americanized by three years of college, was a ripe girl who already had a 'reputation'. All through the marriage re-hearsals she had flirted with Sonny Corleone in a teasing, joking way she thought was permitted because he was the best man and her wedding partner. Now holding her pink gown up off the ground, Lucy Mancini went into the house, smiling with false innocence, ran lightly up the stairs to the bath-

room. She stayed there for a few moments. When she came out Sonny Corleone was on the landing above, beckoning her upward.

From behind the closed window of Don Corleone's 'office', a slightly raised corner room, Thomas Hagen watched the wedding party in the festooned garden. The walls behind him were stacked with law books. Hagen was the Don's lawyer and acting *Consigliori*, or counsellor, and as such held the most vital subordinate position in the family business. He and the Don had solved many a knotty problem in this room, and so when he saw the Godfather leave the festivities and enter the house, he knew, wedding or no, there would be a little work this day. The Don would be coming to see him. Then Hagen saw Sonny Corleone whisper in Lucy Mancini's ear and their little comedy as he followed her into the house. Hagen grimaced, debated whether to inform the Don, and decided against it. He went to the desk and picked up a hand-written list of the people who had been granted permission to see Don Corleone privately. When the Don entered the room Hagen handed him the list. Don Corleone nodded and said, 'Leave Bonasera to the end.'

Hagen used the french doors and went directly out into the garden to where the supplicants clustered around the barrel of wine. He pointed to the baker, the pudgy Nazorine.

Don Corleone greeted the baker with an embrace. They had played together as children in Italy and had grown up in friendship. Every Easter freshly baked clotted-cheese and wheat-germ pies, their crusts yolk-gold, big around as truck wheels, arrived at Don Corleone's home. On Christmas, on family birthdays, rich creamy pastries proclaimed the Nazorines' respect. And all through the years, lean and fat, Nazorine cheerfully paid his dues to the bakery union organized by the Don in his salad days. Never asking for a favour in return except for the chance to buy black-market OPA sugar coupons during the war. Now the time had come for the baker to claim his rights as a loyal friend, and Don Corleone looked forward with great pleasure to granting his request.

He gave the baker a Di Nobili cigar and a glass of yellow Strega and put his hand on the man's shoulder to urge him on.

That was the mark of the Don's humanity. He knew from bitter experience what courage it took to ask a favour from a fellow man.

The baker told the story of his daughter and Enzo. A fine Italian lad from Sicily; captured by the American Army; sent to the United States as a prisoner of war; given parole to help our war effort! A pure and honourable love had sprung up between honest Enzo and his sheltered Katherine, but now that the war was ended the poor lad would be repatriated to Italy and Nazorine's daughter would surely die of a broken heart. Only Godfather Corleone could help this afflicted couple. He was their last hope.

The Don walked Nazorine up and down the room, his hand on the baker's shoulder, his head nodding with understanding to keep up the man's courage. When the baker had finished Don Corleone smiled at him and said, 'My dear friend, put all your worries aside.' He went on to explain very carefully what must be done. The Congressman of the district must be petitioned. The Congressman would propose a special bill that would allow Enzo to become a citizen. The bill would surely pass Congress. A privilege all those rascals extended to each other. Don Corleone explained that this would cost money, the going price was now two thousand dollars. He, Don Corleone, would guarantee performance and accept payment. Did his friend agree?

The baker nodded his head vigorously. He did not expect such a great favour for nothing. That was understood. A special Act of Congress does not come cheap. Nazorine was almost tearful in his thanks. Don Corleone walked him to the door, assuring him that competent people would be sent to the bakery to arrange all details, complete all necessary documents. The baker embraced him before disappearing into the garden.

Hagen smiled at the Don. 'That's a good investment for Nazorine. A son-in-law and a cheap lifetime helper in his bakery all for two thousand dollars.' He paused. 'Who do I give this job to?'

Don Corleone frowned in thought. 'Not to our *paisan*. Give it to the Jew in the next district. Have the home addresses

changed. I think there might be many such cases now the war is over; we should have extra people in Washington that can handle the overflow and not raise the price.' Hagen made a note on his pad. 'Not Congressman Luteco. Try Fischer.'

The next man Hagen brought in was a very simple case. His name was Anthony Coppola and he was the son of a man Don Corleone had worked with in the railroad yards in his youth. Coppola needed five hundred dollars to open a pizzeria; for a deposit on fixtures and the special oven. For reasons not gone into, credit was not available. The Don reached into his pocket and took out a roll of bills. It was not quite enough. He grimaced and said to Tom Hagen, 'Loan me a hundred dollars, I'll pay you back Monday when I go to the bank.' The supplicant protested that four hundred dollars would be ample, but Don Corleone patted his shoulder, saying, apologetically, 'This fancy wedding left me a little short of cash.' He took the money Hagen extended to him and gave it to Anthony Coppola with his own roll of bills.

Hagen watched with quiet admiration. The Don always taught that when a man was generous, he must show the generosity as personal. How flattering to Anthony Coppola that a man like the Don would borrow to loan *him* money. Not that Coppola did not know that the Don was a millionaire, but how many millionaires let themselves be put to even a small inconvenience by a poor friend?

The Don raised his head inquiringly. Hagen said, 'He's not on the list but Luca Brasi wants to see you. He understands it can't be public but he wants to congratulate you in person.'

For the first time the Don seemed displeased. The answer was devious. 'Is it necessary?' he asked.

Hagen shrugged. 'You understand him better than I do. But he was very grateful that you invited him to the wedding. He never expected that. I think he wants to show his gratitude.'

Don Corleone nodded and gestured that Luca Brasi should be brought to him.

In the garden Kay Adams was struck by the violet fury imprinted on the face of Luca Brasi. She asked about him. Michael had brought Kay to the wedding so that she would slowly, and perhaps without too much of a shock, absorb the

truth about his father. But so far she seemed to regard the Don as a slightly unethical businessman. Michael decided to tell her part of the truth indirectly. He explained that Luca Brasi was one of the most feared men in the Eastern underworld. His great talent, it was said, was that he could do a job of murder all by himself, without confederates, which automatically made discovery and conviction by the law almost impossible. Michael grimaced and said, 'I don't know whether all that stuff is true. I do know he is sort of a friend to my father.'

For the first time Kay began to understand. She asked a little incredulously, 'You're not hinting that a man like that works for your father?'

The hell with it, he thought. He said, straight out, 'Nearly fifteen years ago some people wanted to take over my father's oil importing business. They tried to kill him and nearly did. Luca Brasi went after them. The story is that he killed six men in two weeks and that ended the famous olive oil war.' He smiled as if it were a joke.

Kay shuddered. 'You mean your father was shot by gangsters?'

'Fifteen years ago,' Michael said. 'Everything's been peaceful since then.' He was afraid he had gone too far.

'You're trying to scare me,' Kay said. 'You just don't want me to marry you.' She smiled at him and poked his ribs with her elbow. 'Very clever.'

Michael smiled back at her. 'I want you to think about it,' he said.

'Did he really kill six men?' Kay asked.

'That's what the newspapers claimed,' Mike said. 'Nobody ever proved it. But there's another story about him that nobody ever tells. It's supposed to be so terrible that even my father won't talk about it. Tom Hagen knows the story and he won't tell me. Once I kidded him, I said, "When will I be old enough to hear that story about Luca?" and Tom said, "When you're a hundred."' Michael sipped his glass of wine. 'That must be some story. That must be some Luca.'

Luca Brasi was indeed a man to frighten the devil in hell himself. Short, squat, massive-skulled, his presence sent out

alarm bells of danger. His face was stamped into a mask of fury. The eyes were brown but with none of the warmth of that colour, more a deadly tan. The mouth was not so much cruel as lifeless; thin, rubbery, and the colour of veal.

Brasi's reputation for violence was awesome and his devotion to Don Corleone legendary. He was, in himself, one of the great blocks that supported the Don's power structure. His kind was a rarity.

Luca Brasi did not fear the police, he did not fear society, he did not fear God, he did not fear hell, he did not fear or love his fellow man. But he had elected, he had *chosen*, to fear and love Don Corleone. Ushered into the presence of the Don, the terrible Brasi held himself stiff with respect. He stuttered over the flowery congratulations he offered and his formal hope that the first grandchild would be masculine. He then handed the Don an envelope stuffed with cash as a gift for the bridal couple.

So that was what he wanted to do. Hagen noticed the change in Don Corleone. The Don received Brasi as a king greets a subject who has done him an enormous service, never familiar but with regal respect. With every gesture, with every word, Don Corleone made it clear to Luca Brasi that he was *valued*. Not for one moment did he show surprise at the wedding gift being presented to him personally. He understood.

The money in the envelope was sure to be more than anyone else had given. Brasi had spent many hours deciding on the sum, comparing it to what the other guests might offer. He wanted to be the most generous to show that he had the most respect, and that was why he had given his envelope to the Don personally, a gaucherie the Don overlooked in his own flowery sentence of thanks. Hagen saw Luca Brasi's face lose its mask of fury, swell with pride and pleasure. Brasi kissed the Don's hand before he went out the door that Hagen held open. Hagen prudently gave Brasi a friendly smile which the squat man acknowledged with a polite stretching of rubbery, veal-coloured lips.

When the door closed Don Corleone gave a small sigh of

relief. Brasi was the only man in the world who could make him nervous. The man was like a natural force, not truly subject to control. He had to be handled as gingerly as dynamite. The Don shrugged. Even dynamite could be exploded harmlessly if the need arose. He looked questioningly at Hagen. 'Is Bonasera the only one left?'

Hagen nodded. Don Corleone frowned in thought, then said, 'Before you bring him in, tell Santino to come here. He should learn some things.'

Out in the garden, Hagen searched anxiously for Sonny Corleone. He told the waiting Bonasera to be patient and went over to Michael Corleone and his girlfriend. 'Did you see Sonny around?' he asked. Michael shook his head. Damn, Hagen thought, if Sonny was screwing the maid of honour all this time there was going to be a mess of trouble. His wife, the young girl's family; it could be a disaster. Anxiously he hurried to the entrance through which he had seen Sonny disappear almost a half hour ago.

Seeing Hagen go into the house, Kay Adams asked Michael Corleone, 'Who is he? You introduced him as your brother, but his name is different and he certainly doesn't look Italian.'

'Tom lived with us since he was twelve years old,' Michael said. 'His parents died and he was roaming around the streets with this bad eye infection. Sonny brought him home one night and he just stayed. He didn't have any place to go. He lived with us until he got married.'

Kay Adams was thrilled. 'That's really romantic,' she said. 'Your father must be a warmhearted person. To adopt somebody just like that when he had so many children of his own.'

Michael didn't bother to point out that immigrant Italians considered four children a small family. He merely said, 'Tom wasn't adopted. He just lived with us.'

'Oh,' Kay said, then asked curiously, 'why didn't you adopt him?'

Michael laughed. 'Because my father said it would be disrespectful for Tom to change his name. Disrespectful to his own parents.'

They saw Hagen shoo Sonny through the french door into the Don's office and then crook a finger at Amerigo Bonasera.

'Why do they bother your father with business on a day like this?' Kay asked.

Michael laughed again. 'Because they know that by tradition no Sicilian can refuse a request on his daughter's wedding day. And no Sicilian ever lets a chance like that go by.'

Lucy Mancini lifted her pink gown off the floor and ran up the steps. Sonny Corleone's heavy Cupid face, redly obscene with winey lust, frightened her, but she had teased him for the past week to just this end. In her two college love affairs she had felt nothing and neither of them lasted more than a week. Quarrelling, her second lover had mumbled something about her being 'too big down there'. Lucy had understood and for the rest of the school term had refused to go out on any dates.

During the summer, preparing for the wedding of her best friend, Connie Corleone, Lucy heard the whispered stories about Sonny. One Sunday afternoon in the Corleone kitchen, Sonny's wife Sandra gossiped freely. Sandra was a coarse, good-natured woman who had been born in Italy but brought to America as a small child. She was strongly built with great breasts and had already borne three children in five years of marriage. Sandra and the other women teased Connie about the terrors of the nuptial bed. 'My God,' Sandra had giggled, 'when I saw that pole of Sonny's for the first time and realized he was going to stick it into *me*, I yelled bloody murder. After the first year my insides felt as mushy as macaroni boiled for an hour. When I heard he was doing the job on other girls I went to church and lit a candle.'

They had all laughed, but Lucy had felt her flesh twitching between her legs.

Now as she ran up the steps towards Sonny a tremendous flash of desire went through her body. On the landing Sonny grabbed her hand and pulled her down the hall into an empty bedroom. Her legs went weak as the door closed behind them. She felt Sonny's mouth on hers, his lips tasting of burnt tobacco, bitter. She opened her mouth. At that moment she felt his hand come up beneath her bridesmaid's gown, heard the rustle of material giving way, felt his large warm hand

25

between her legs, ripping aside the satin panties to caress her vulva. She put her arms around his neck and hung there as he opened his trousers. Then he placed both hands beneath her bare buttocks and lifted her. She gave a little hop in the air so that both her legs were wrapped around his upper thighs. His tongue was in her mouth and she sucked on it. He gave a savage thrust that banged her head against the door. She felt something burning pass between her thighs. She let her right hand drop from his neck and reached down to guide him. Her hand closed around an enormous, blood-gorged pole of muscle. It pulsated in her hand like an animal and almost weeping with grateful ecstasy she pointed it into her own wet, turgid flesh. The thrust of its entering, the unbelievable pleasure made her gasp, brought her legs up almost around his neck, and then like a quiver, her body received the savage arrows of his lightning-like thrusts; innumerable, torturing; arching her pelvis higher and higher until for the first time in her life she reached a shattering climax, felt his hardness break and then the crawly flood of semen over her thighs. Slowly her legs relaxed from around his body, slid down until they reached the floor. They leaned against each other, out of breath.

It might have been going on for some time, but now they could hear the soft knocking on the door. Sonny quickly buttoned his trousers, meanwhile blocking the door so that it could not be opened. Lucy frantically smoothed down her pink gown, her eyes flickering, but the thing that had given her so much pleasure was hidden inside sober black cloth. Then they heard Tom Hagen's voice, very low, 'Sonny, you in there?'

Sonny sighed with relief. He winked at Lucy. 'Yeah, Tom, what is it?'

Hagen's voice, still low, said, 'The Don wants you in his office. Now.' They could hear his footsteps as he walked away. Sonny waited for a few moments, gave Lucy a hard kiss on the lips, and then slipped out the door after Hagen.

Lucy combed her hair. She checked her dress and pulled around her garter straps. Her body felt bruised, her lips pulpy and tender. She went out the door, and though she felt the

sticky wetness between her thighs she did not go to the bathroom to wash but ran straight on down the steps and into the garden. She took her seat at the bridal table next to Connie, who exclaimed petulantly, 'Lucy, where were you? You look drunk. Stay beside me now.'

The blond groom poured Lucy a glass of wine and smiled knowingly. Lucy didn't care. She lifted the grapey, dark red juice to her parched mouth and drank. She felt the sticky wetness between her thighs and pressed her legs together. Her body was trembling. Over the glass rim, as she drank, her eyes searched hungrily to find Sonny Corleone. There was no one else she cared to see. Slyly she whispered in Connie's ear, 'Only a few hours more and you'll know what it's all about.' Connie giggled. Lucy demurely folded her hands on the table, treacherously triumphant, as if she had stolen a treasure from the bride.

Amerigo Bonasera followed Hagen into the corner room of the house and found Don Corleone sitting behind a huge desk. Sonny Corleone was standing by the window, looking out into the garden. For the first time that afternoon the Don behaved coolly. He did not embrace the visitor or shake hands. The sallow-faced undertaker owed his invitation to the fact that his wife and the wife of the Don were the closest of friends. Amerigo Bonasera himself was in severe disfavour with Don Corleone.

Bonasera began his request obliquely and cleverly. 'You must excuse my daughter, your wife's goddaughter, for not doing your family the respect of coming today. She is in the hospital still.' He glanced at Sonny Corleone and Tom Hagen to indicate that he did not wish to speak before them. But the Don was merciless.

'We all know of your daughter's misfortune,' Don Corleone said. 'If I can help her in any way, you have only to speak. My wife is her godmother after all. I have never forgotten that honour.' This was a rebuke. The undertaker never called Don Corleone 'Godfather' as custom dictated.

Bonasera, ashen-faced, asked, directly now, 'May I speak to you alone?'

Don Corleone shook his head, 'I trust these two men with my life. They are my two right arms. I cannot insult them by sending them away.'

The undertaker closed his eyes for a moment and then began to speak. His voice was quiet, the voice he used to console the bereaved. 'I raised my daughter in the American fashion. I believe in America. America has made my fortune. I gave my daughter her freedom and yet taught her never to dishonour her family. She found a "boyfriend", not an Italian. She went to the movies with him. She stayed out late. But he never came to meet her parents. I accepted all this without a protest, the fault is mine. Two months ago he took her for a drive. He had a masculine friend with him. They made her drink whisky and then they tried to take advantage of her. She resisted. She kept her honour. They beat her. Like an animal. When I went to the hospital she had two black eyes. Her nose was broken. Her jaw was shattered. They had to wire it together. She wept through her pain. "Father, Father, why did they do it? Why did they do this to me?" And I wept.' Bonasera could not speak further, he was weeping now though his voice had not betrayed his emotion.

Don Corleone, as if against his will, made a gesture of sympathy and Bonasera went on, his voice human with suffering. 'Why did I weep? She was the light of my life, an affectionate daughter. A beautiful girl. She trusted people and now she will never trust them again. She will never be beautiful again.' He was trembling, his sallow face flushed an ugly dark red.

'I went to the police like a good American. The two boys were arrested. They were brought to trial. The evidence was overwhelming and they pleaded guilty. The judge sentenced them to three years in prison and suspended the sentence. They went free that very day. I stood in the courtroom like a fool and those bastards smiled at me. And then I said to my wife: "We must go to Don Corleone for justice."'

The Don had bowed his head to show respect for the man's grief. But when he spoke, the words were cold with offended dignity. 'Why did you go to the police? Why didn't you come to me at the beginning of this affair?'

Bonasera muttered almost inaudibly, 'What do you want of me? Tell me what you wish. But do what I beg you to do.' There was something almost insolent in his words.

Don Corleone said gravely, 'And what is that?'

Bonasera glanced at Hagen and Sonny Corleone and shook his head. The Don, still sitting at Hagen's desk, inclined his body towards the undertaker. Bonasera hesitated, then bent down and put his lips so close to the Don's hairy ear that they touched. Don Corleone listened like a priest in the confessional, gazing away into the distance, impassive, remote. They stood so for a long moment until Bonasera finished whispering and straightened to his full height. The Don looked up gravely at Bonasera. Bonasera, his face flushed, returned the stare unflinchingly.

Finally the Don spoke. 'That I cannot do. You are being carried away.'

Bonasera said loudly, clearly, 'I will pay you anything you ask.' On hearing this, Hagen flinched, a nervous flick of his head. Sonny Corleone folded his arms, smiled sardonically as he turned from the window to watch the scene in the room for the first time.

Don Corleone rose from behind the desk. His face was still impassive, but his voice rang like cold death. 'We have known each other many years, you and I,' he said to the undertaker, 'but until this day you never came to me for counsel or help. I can't remember the last time you invited me to your house for coffee, though my wife is godmother to your only child. Let us be frank. You spurned my friendship. You feared to be in my debt.'

Bonasera murmured, 'I didn't want to get into trouble.'

The Don held up his hand. 'No. Don't speak. You found America a paradise. You had a good trade, you made a good living, you thought the world a harmless place where you could take your pleasure as you willed. You never armed yourself with true friends. After all, the police guarded you, there were courts of law, you and yours could come to no harm. You did not need Don Corleone. Very well. My feelings were wounded, but I am not that sort of person who thrusts his friendship on those who do not value it – on those who

think me of little account.' The Don paused and gave the undertaker a polite, ironic smile. 'Now you come to me and say, "Don Corleone give me justice." And you do not ask with respect. You do not offer me your friendship. You come into my home on the bridal day of my daughter and you ask me to do murder and you say' – here the Don's voice became a scornful mimicry – '"I will pay you anything." No, no, I am not offended, but what have I ever done to make you treat me so disrespectfully?'

Bonasera cried out in his anguish and his fear, 'America has been good to me. I wanted to be a good citizen. I wanted my child to be American.'

The Don clapped his hands together with decisive approval. 'Well spoken. Very fine. Then you have nothing to complain about. The judge has ruled. America has ruled. Bring your daughter flowers and a box of candy when you go visit her in the hospital. That will comfort her. Be content. After all, this is not a serious affair, the boys were young, high-spirited, and one of them is the son of a powerful politician. No, my dear Amerigo, you have always been honest. I must admit, though you spurned my friendship, that I would trust the given word of Amerigo Bonasera more than I would any other man's. So give me your word that you will put aside this madness. It is not American. Forgive. Forget. Life is full of misfortunes.'

The cruel and contemptuous irony with which all this was said, the controlled anger of the Don, reduced the poor undertaker to a quivering jelly, but he spoke up bravely again. 'I ask you for justice.'

Don Corleone said curtly, 'The court gave you justice.'

Bonasera shook his head stubbornly. 'No. They gave the youths justice. They did not give me justice.'

The Don acknowledged this fine distinction with an approving nod, then asked, 'What is your justice?'

'An eye for an eye,' Bonasera said.

'You asked for more,' the Don said. 'Your daughter is alive.'

Bonasera said reluctantly, 'Let them suffer as she suffers.' The Don waited for him to speak further. Bonasera screwed

up the last of his courage and said, 'How much shall I pay you?' It was a despairing wail.

Don Corleone turned his back. It was a dismissal. Bonasera did not budge.

Finally, sighing, a good-hearted man who cannot remain angry with an erring friend, Don Corleone turned back to the undertaker, who was now as pale as one of his corpses. Don Corleone was gentle, patient. 'Why do you fear to give your first allegiance to me?' he said. 'You go to the law courts and wait for months. You spend money on lawyers who know full well you are to be made a fool of. You accept judgement from a judge who sells himself like the worst whore in the streets. Years gone by, when you needed money, you went to the banks and paid ruinous interest, waited hat in hand like a beggar while they sniffed around, poked their noses up your very asshole to make sure you could pay them back.' The Don paused, his voice became sterner.

'But if you had come to me, my purse would have been yours. If you had come to me for justice those scum who ruined your daughter would be weeping bitter tears this day. If by some misfortune an honest man like yourself made enemies they would become my enemies' – the Don raised his arm, finger pointing at Bonasera – 'and then, believe me, they would fear you.'

Bonasera bowed his head and murmured in a strangled voice, 'Be my friend. I accept.'

Don Corleone put his hand on the man's shoulder. 'Good,' he said, 'you shall have your justice. Some day, and that day may never come, I will call upon you to do me a service in return. Until that day, consider this justice a gift from my wife, your daughter's godmother.'

When the door closed behind the grateful undertaker Don Corleone turned to Hagen and said, 'Give this affair to Clemenza and tell him to be sure to use reliable people, people who will not be carried away by the smell of blood. After all, we're not murderers, no matter what that corpse valet dreams up in his foolish head.' He noted that his first-born, masculine son was gazing through the window at the garden party. It was hopeless, Don Corleone thought. If he refused to be

instructed, Santino could never run the family business, could never become a Don. He would have to find somebody else. And soon. After all, he was not immortal.

From the garden, startling all three men, there came a happy roaring shout. Sonny Corleone pressed close to the window. What he saw made him move quickly towards the door, a delighted smile on his face. 'It's Johnny, he came to the wedding, what did I tell you?' Hagen moved to the window. 'It's really your godson,' he said to Don Corleone. 'Shall I bring him here?'

'No,' the Don said. 'Let the people enjoy him. Let him come to me when he is ready.' He smiled at Hagen. 'You see? He is a good godson.'

Hagen felt a twinge of jealousy. He said dryly, 'It's been two years. He's probably in trouble again and wants you to help.'

'And who should he come to if not his godfather?' asked Don Corleone.

The first one to see Johnny Fontane enter the garden was Connie Corleone. She forgot her bridal dignity and screamed, 'Johneee'. Then she ran into his arms. He hugged her tight and kissed her on the mouth, kept his arm around her as others came up to greet him. They were all his old friends, people he had grown up with on the West Side. Then Connie was dragging him to her new husband. Johnny saw with amusement that the blond young man looked a little sour at no longer being the star of the day. He turned on all his charm, shaking the groom's hand, toasting him with a glass of wine.

A familiar voice called from the bandstand, 'How about giving us a song, Johnny?' He looked up and saw Nino Valenti smiling down at him. Johnny Fontane jumped up on the bandstand and threw his arms around Nino. They had been inseparable, singing together, going out with girls together, until Johnny had started to become famous and sing on the radio. When he had gone to Hollywood to make movies Johnny had phoned Nino a couple of times just to talk and had promised to get him a club singing date. But he had never done so. Seeing Nino now, his cheerful, mocking, drunken grin, all the affection returned.

Nino began strumming on the mandolin. Johnny Fontane put his hand on Nino's shoulder. 'This is for the bride,' he said, and stamping his foot, chanted the words to an obscene Sicilian love song. As he sang, Nino made suggestive motions with his body. The bride blushed proudly, the throng of guests roared its approval. Before the song ended they were all stamping with their feet and roaring out the sly, double-meaning tag line that finished each stanza. At the end they would not stop applauding until Johnny cleared his throat to sing another song.

They were all proud of him. He was of them and he had become a famous singer, a movie star who slept with the most desired women in the world. And yet he had shown proper respect for his Godfather by travelling three thousand miles to attend this wedding. He still loved old friends like Nino Valenti. Many of the people there had seen Johnny and Nino singing together when they were just boys, when no one dreamed that Johnny Fontane would grow up to hold the hearts of fifty million women in his hands.

Johnny Fontane reached down and lifted the bride up on to the bandstand so that Connie stood between him and Nino. Both men crouched down, facing each other, Nino plucking the mandolin for a few harsh chords. It was an old routine of theirs, a mock battle and wooing, using their voices like swords, each shouting a chorus in turn. With the most delicate courtesy, Johnny let Nino's voice overwhelm his own, let Nino take the bride from his arm, let Nino swing into the last victorious stanza while his own voice died away. The whole wedding party broke into shouts of applause, the three of them embraced each other at the end. The guests begged for another song.

Only Don Corleone, standing in the corner entrance of the house, sensed something amiss. Cheerily, with bluff good humour, careful not to give offence to his guests, he called out, 'My godson has come three thousand miles to do us honour and no one thinks to wet his throat?' At once a dozen full wine glasses were thrust at Johnny Fontane. He took a sip from all and rushed to embrace his Godfather. As he did so he whispered something into the older man's ear. Don Corleone led him into the house.

Tom Hagen held out his hand when Johnny came into the room. Johnny shook it and said, 'How are you, Tom?' But without his usual charm that consisted of a genuine warmth for people. Hagen was a little hurt by this coolness, but shrugged it off. It was one of the penalties for being the Don's hatchet man.

Johnny Fontane said to the Don, 'When I got the wedding invitation I said to myself, "My Godfather isn't mad at me any more." I called you five times after my divorce and Tom always told me you were out or busy, so I knew you were sore.'

Don Corleone was filling glasses from the yellow bottle of Strega. 'That's all forgotten. Now. Can I do something for you still? You're not too famous, too rich, that I can't help you?'

Johnny gulped down the yellow fiery liquid and held out his glass to be refilled. He tried to sound jaunty. 'I'm not rich, Godfather. I'm going down. You were right. I should never have left my wife and kids for that tramp I married. I don't blame you for getting sore at me.'

The Don shrugged. 'I worried about you, you're my godson, that's all.'

Johnny paced up and down the room. 'I was crazy about that bitch. The biggest star in Hollywood. She looks like an angel. And you know what she does after a picture? If the make-up man does a good job on her face she lets him bang her. If the cameraman made her look extra good she brings him into her dressing room and gives him a screw. Anybody. She uses her body like I use the loose change in my pocket for a tip. A whore made for the devil.'

Don Corleone curtly broke in. 'How is your family?'

Johnny sighed. 'I took care of them. After the divorce I gave Ginny and the kids more than the courts said I should. I go see them once a week. I miss them. Sometimes I think I'm going crazy.' He took another drink. 'Now my second wife laughs at me. She can't understand my being jealous. She calls me an old-fashioned guinea, she makes fun of my singing. Before I left I gave her a nice beating, but not in the face because she was making a picture. I gave her cramps, I

34

punched her on the arms and legs like a kid and she kept laughing at me.' He lit a cigarette. 'So, Godfather, right now, life doesn't seem worth living.'

Don Corleone said simply, 'These are troubles I can't help you with.' He paused, then asked, 'What's the matter with your voice?'

All the assured charm, the self-mockery, disappeared from Johnny Fontane's face. He said almost brokenly, 'Godfather, I can't sing any more, something happened to my throat, the doctors don't know what.' Hagen and the Don looked at him with surprise, Johnny had always been so tough. Fontane went on. 'My two pictures made a lot of money. I was a big star. Now they throw me out. The head of the studio always hated my guts, and now he's paying me off.'

Don Corleone stood before his godson and asked grimly, 'Why doesn't this man like you?'

'I used to sing those songs for the liberal organizations, you know, all that stuff you never liked me to do. Well, Jack Woltz didn't like it either. He called me a Communist, but he couldn't make it stick. Then I snatched a girl he had saved for himself. It was strictly a one-night stand and she came after me. What the hell could I do? Then my whore second wife throws me out. And Ginny and the kids won't take me back unless I come crawling on my hands and knees, and I can't sing any more. Godfather, what the hell can I do?'

Don Corleone's face had become cold without a hint of sympathy. He said contemptuously, 'You can start by acting like a man.' Suddenly anger contorted his face. He shouted. 'LIKE A MAN!' He reached over the desk and grabbed Johnny Fontane by the hair of his head in a gesture that was savagely affectionate. 'By Christ in heaven, is it possible that you spent so much time in *my* presence and turned out no better than this? A Hollywood *finocchio* who weeps and begs for pity? Who cries out like a woman – "What shall I do? Oh, what shall I do?"'

The mimicry of the Don was so extraordinary, so unexpected, that Hagen and Johnny were startled into laughter. Don Corleone was pleased. For a moment he reflected on how much he loved this godson. How would his own three

sons have reacted to such a tongue-lashing? Santino would have sulked and behaved badly for weeks afterwards. Fredo would have been cowed. Michael would have given him a cold smile and gone out of the house, not to be seen for months. But Johnny, ah, what a fine chap he was, smiling now, gathering strength, knowing already the true purpose of his Godfather.

Don Corleone went on. 'You took the woman of your boss, a man more powerful than yourself, then you complain he won't help you. What nonsense. You left your family, your children without a father, to marry a whore and you weep because they don't welcome you back with open arms. The whore, you don't hit her in the face because she is making a picture, then you are amazed because she laughs at you. You lived like a fool and you have come to a fool's end.'

Don Corleone paused to ask in a patient voice, 'Are you willing to take my advice this time?'

Johnny Fontane shrugged. 'I can't marry Ginny again, not the way she wants. I have to gamble, I have to drink, I have to go out with the boys. Beautiful broads run after me and I never could resist them. Then I used to feel like a heel when I went back to Ginny. Christ, I can't go through all that crap again.'

It was rare that Don Corleone showed exasperation. 'I didn't tell you to get married again. Do what you want. It's good you wish to be a father to your children. A man who is not a father to his children can never be a real man. But then, you must make their mother accept you. Who says you can't see them every day? Who says you can't live in the same house? Who says you can't live your life exactly as you want to live it?'

Johnny Fontane laughed. 'Godfather, not all women are like the old Italian wives. Ginny won't stand for it.'

Now the Don was mocking. 'Because you acted like a *finocchio*. You gave her *more* than the court said. You didn't hit the other in the face because she was making a picture. You let women dictate your actions and they are not competent in this world, though certainly they will be saints in heaven while we men burn in hell. And then I've watched you all these

ears.' The Don's voice became earnest. 'You've been a fine
odson, you've given me all the respect. But what of your
ther old friends? One year you run around with this person,
he next year with another person. That Italian boy who was so
unny in the movies, he had some bad luck and you never saw
im again because you were more famous. And how about
our old, old comrade that you went to school with, who was
our partner singing? Nino. He drinks too much out of dis-
ppointment, but he never complains. He works hard driving
he gravel truck and sings weekends for a few dollars. He
ever says anything against you. You couldn't help him a bit?
Vhy not? He sings well.'

Johnny Fontane said with patient weariness, 'Godfather, he
ast hasn't got enough talent. He's OK, but he's not big
ime.'

Don Corleone lidded his eyes almost closed and then said,
And you, godson, you now, you just don't have talent
nough. Shall I get you a job on the gravel truck with Nino?'
Vhen Johnny didn't answer, the Don went on. 'Friendship is
verything. Friendship is more than talent. It is more than
overnment. It is almost the equal of family. Never forget
hat. If you had built up a wall of friendships you wouldn't
ave to ask me to help. Now tell me, why can't you sing? You
ang well in the garden. As well as Nino.'

Hagen and Johnny smiled at this delicate thrust. It was
ohnny's turn to be patronizingly patient. 'My voice is weak.
sing one or two songs and then I can't sing again for hours or
lays. I can't make it through the rehearsals or the retakes. My
oice is weak, it's got some sort of sickness.'

'So you have woman trouble. Your voice is sick. Now tell
ne the trouble you're having with this Hollywood *pezzonovante*
vho won't let you work.' The Don was getting down to
usiness.

'He's bigger than one of your *pezzonovanti*,' Johnny said.
He owns the studio. He advises the President on movie
ropaganda for the war. Just a month ago he bought the
novie rights to the biggest novel of the year. A bestseller.
And the main character is a guy just like me. I wouldn't even
ave to act, just be myself. I wouldn't even have to sing. I

might even win the Academy Award. Everybody knows it' perfect for me and I'd be big again. As an actor. But tha bastard Jack Woltz is paying me off, he won't give it to me. offered to do it for nothing, for a minimum price and he sti says no. He sent the word that if I come and kiss his ass in th studio commissary, maybe he'll think about it.'

Don Corleone dismissed this emotional nonsense with wave of his hand. Among reasonable men problems business could always be solved. He patted his godson on th shoulder. 'You're discouraged. Nobody cares about you, s you think. And you've lost a lot of weight. You drink a lo eh? You don't sleep and you take pills?' He shook his hea disapprovingly.

'Now I want you to follow my orders,' the Don said. 'I war you to stay in my house for one month. I want you to eat wel to rest and sleep. I want you to be my companion, I enjo your company, and maybe you can learn something about th world from your Godfather that might even help you in th great Hollywood. But no singing, no drinking, and n women. At the end of the month you can go back to Holly wood and this *pezzonovante*, this .90 calibre will give you tha job you want. Done?'

Johnny Fontane could not altogether believe that the Do had such power. But his Godfather had never said such an such a thing could be done without having it done. 'This gu is a personal friend of J. Edgar Hoover,' Johnny said. 'Yo can't even raise your voice to him.'

'He's a businessman,' the Don said blandly. 'I'll make hir an offer he can't refuse.'

'It's too late,' Johnny said. 'All the contracts have bee signed and they start shooting in a week. It's absolutely im possible.'

Don Corleone said, 'Go, go back to the party. Your friend are waiting for you. Leave everything to me.' He pushe Johnny Fontane out of the room.

Hagen sat behind the desk and made notes. The Don heave a sigh and asked, 'Is there anything else?'

'Sollozzo can't be put off any more. You'll have to see hir this week.' Hagen held his pen over the calendar.

The Don shrugged. 'Now that the wedding is over, when-ver you like.'

This answer told Hagen two things. Most important, that he answer to Virgil Sollozzo would be no. The second, that Don Corleone, since he would not give the answer before his daughter's wedding, expected his no to cause trouble.

Hagen said cautiously, 'Shall I tell Clemenza to have some men come live in the house?'

The Don said impatiently, 'For what? I didn't answer before the wedding because on an important day like that there should be no cloud, not even in the distance. Also I wanted to know beforehand what he wanted to talk about. We know now. What he will propose is an *infamita*.'

Hagen asked, 'Then you will refuse?' When the Don nodded, Hagen said, 'I think we should all discuss it – the whole Family – before you give your answer.'

The Don smiled. 'You think so? Good, we will discuss it. When you come back from California. I want you to fly there tomorrow and settle this business for Johnny. See that movie *pezzonovante*. Tell Sollozzo I will see him when you get back from California. Is there anything else?'

Hagen said formally, 'The hospital called. *Consigliori* Abbandando is dying, he won't last out the night. His family was told to come and wait.'

Hagen had filled the *Consigliori*'s post for the past year, ever since the cancer had imprisoned Genco Abbandando in his hospital bed. Now he waited to hear Don Corleone say the post was his permanently. The odds were against it. So high a position was traditionally given only to a man descended from two Italian parents. There had already been trouble about his temporary performance of the duties. Also, he was only thirty-five, not old enough, supposedly, to have acquired the necessary experience and cunning for a successful *Consigliori*.

But the Don gave him no encouragement. He asked, 'When does my daughter leave with her bridegroom?'

Hagen looked at his wristwatch. 'In a few minutes they'll cut the cake and then a half hour after that.' That reminded him of something else. 'Your new son-in-law. Do we give him something important, inside the Family?'

He was surprised at the vehemence of the Don's answer. 'Never.' The Don hit the desk with the flat of his hand. 'Never. Give him something to earn his living, a good living. But never let him know the Family's business. Tell the others, Sonny, Fredo, Clemenza.'

The Don paused. 'Instruct my sons, all three of them, that they will accompany me to the hospital to see poor Genco. I want them to pay their last respects. Tell Freddie to drive the big car and ask Johnny if he will come with us, as a special favour to me.' He saw Hagen look at him questioningly. 'I want you to go to California tonight. You won't have time to go see Genco. But don't leave until I come back from the hospital and speak with you. Understood?'

'Understood,' Hagen said. 'What time should Fred have the car waiting?'

'When the guests have left,' Don Corleone said. 'Genco will wait for me.'

'The Senator called,' Hagen said. 'Apologizing for not coming personally but that you would understand. He probably means those two FBI men across the street taking down licence numbers. But he sent his gift over by special messenger.'

The Don nodded. He did not think it necessary to mention that he himself had warned the Senator not to come. 'Did he send a nice present?'

Hagen made a face of impressed approval that was very strangely Italian on his German-Irish features. 'Antique silver, very valuable. The kids can sell it for a grand at least. The Senator spent a lot of time getting exactly the right thing. For those kind of people that's more important than how much it costs.'

Don Corleone did not hide his pleasure that so great a man as the Senator had shown him such respect. The Senator, like Luca Brasi, was one of the great stones in the Don's power structure, and he too, with this gift, had resworn his loyalty.

When Johnny Fontane appeared in the garden Kay Adams recognized him immediately. She was truly surprised. 'You

ever told me your family knew Johnny Fontane,' she said.
Now I'm sure I'll marry you.'

'Do you want to meet him?' Michael asked.

'Not now,' Kay said. She sighed. 'I was in love with him
or three years. I used to come down to New York whenever
e sang at the Capitol and scream my head off. He was so
onderful.'

'We'll meet him later,' Michael said.

When Johnny finished singing and vanished into the house
vith Don Corleone, Kay said archly to Michael, 'Don't tell
ne a big movie star like Johnny Fontane has to ask your
ather for a favour?'

'He's my father's godson,' Michael said. 'And if it wasn't
or my father he might not be a big movie star today.'

Kay Adams laughed with delight. 'That sounds like another
reat story.'

Michael shook his head. 'I can't tell that one,' he said.

'Trust me,' she said.

He told her. He told her without being funny. He told it
vithout pride. He told it without any sort of explanation
xcept that eight years before his father had been more
npetuous, and because the matter concerned his godson,
he Don considered it an affair of personal honour.

The story was quickly told. Eight years ago Johnny Fontane
ad made an extraordinary success singing with a popular
ance band. He had become a top radio attraction. Unfor-
unately the band leader, a well-known show business per-
onality named Les Halley, had signed Johnny to a five-year
ersonal services contract. It was a common show-business
ractice. Les Halley could now loan Johnny out and pocket
nost of the money.

Don Corleone entered the negotiations personally. He
ffered Les Halley twenty thousand dollars to release Johnny
ontane from the personal services contract. Halley offered to
ake only fifty per cent of Johnny's earnings. Don Corleone
vas amused. He dropped his offer from twenty thousand
ollars to ten thousand dollars. The band leader, obviously
ot a man of the world outside his beloved show business, com-
letely missed the significance of this lower offer. He refused.

41

The next day Don Corleone went to see the band leader personally. He brought with him his two best friends, Genco Abbandando, who was his *Consigliori*, and Luca Brasi. With no other witnesses Don Corleone persuaded Les Halley to sign a document giving up all rights to all services from Johnny Fontane upon payment of a certified cheque to the amount of ten thousand dollars. Don Corleone did this by putting a pistol to the forehead of the band leader and assuring him with the utmost seriousness that either his signature or his brains would rest on that document in exactly one minute. Les Halley signed. Don Corleone pocketed his pistol and handed over the certified cheque.

The rest was history. Johnny Fontane went on to become the greatest singing sensation in the country. He made Hollywood musicals that earned a fortune for his studio. His records made millions of dollars. Then he divorced his childhood-sweetheart wife and left his two children, to marry the most glamorous blonde star in motion pictures. He soon learned that she was a 'whore'. He drank, he gambled, he chased other women. He lost his singing voice. His records stopped selling. The studio did not renew his contract. And so now he had come back to his Godfather.

Kay said thoughtfully, 'Are you sure you're not jealous of your father? Everything you've told me about him shows him doing something for other people. He must be good-hearted. She smiled wryly. 'Of course his methods are not exactly constitutional.'

Michael sighed. 'I guess that's the way it sounds, but let me tell you this. You know those Arctic explorers who leave caches of food scattered on the route to the North Pole? Just in case they may need them some day? That's my father's favours. Some day he'll be at each one of those people's houses and they had better come across.'

It was nearly twilight before the wedding cake was shown, exclaimed over, and eaten. Specially baked by Nazorine, it was cleverly decorated with shells of cream so dizzyingly delicious that the bride greedily plucked them from the corpse of the cake before she whizzed away on her honeymoon with her blond groom. The Don politely sped his guests' departure

noting meanwhile that the black sedan with its FBI men was no longer visible.

Finally, the only car left in the driveway was the long black Cadillac with Freddie at the wheel. The Don got into the front seat, moving with quick coordination for his age and bulk. Sonny, Michael, and Johnny Fontane got into the back seat. Don Corleone said to his son Michael, 'Your girlfriend, she'll get back to the city by herself all right?'

Michael nodded. 'Tom said he'd take care of it.' Don Corleone nodded with satisfaction at Hagen's efficiency.

Because of the gas rationing still in effect, there was little traffic on the Belt Parkway to Manhattan. In less than an hour the Cadillac rolled into the street of French Hospital. During the ride Don Corleone asked his youngest son if he was doing well in school. Michael nodded. Then Sonny in the back seat asked his father, 'Johnny says you're getting him squared away with that Hollywood business. Do you want me to go out there and help?'

Don Corleone was curt. 'Tom is going tonight. He won't need any help, it's a simple affair.'

Sonny Corleone laughed. 'Johnny thinks you can't fix it, that's why I thought you might want me to go out there.'

Don Corleone turned his head. 'Why do you doubt me?' he asked Johnny Fontane. 'Hasn't your Godfather always done what he said he would do? Have I ever been taken for a fool?'

Johnny apologized nervously. 'Godfather, the man who runs it is a real .90 calibre *pezzonovante*. You can't budge him, not even with money. He has big connexions. And he hates me. I just don't know how you can swing it.'

The Don spoke with affectionate amusement. 'I say to you: you shall have it.' He nudged Michael with his elbow. 'We won't disappoint my godson, eh, Michael?'

Michael, who never doubted his father for a moment, shook his head.

As they walked towards the hospital entrance, Don Corleone put his hand on Michael's arm so that the others forged ahead. 'When you get through with college, come and talk to me,' the Don said. 'I have some plans you will like.'

Michael didn't say anything. Don Corleone grunted in

exasperation. 'I know how you are. I won't ask you to do anything you don't approve of. This is something special. Go your own way now, you're a man after all. But come to me as a son should when you have finished with your schooling.'

The family of Genco Abbandando, wife and three daughters dressed in black, clustered like a flock of plump crows on the white tile floor of the hospital corridor. When they saw Don Corleone come out of the elevator they seemed to flutter up off the white tiles in an instinctive surge towards him for protection. The mother was regally stout in black, the daughters fat and plain. Mrs Abbandando pecked at Don Corleone's cheek, sobbing, wailing, 'Oh, what a saint you are, to come here on your daughter's wedding day.'

Don Corleone brushed these thanks aside. 'Don't I owe respect to such a friend, a friend who has been my right arm for twenty years?' He had understood immediately that the soon-to-be widow did not comprehend that her husband would die this night. Genco Abbandando had been in this hospital for nearly a year dying of his cancer and the wife had come to consider his fatal illness almost an ordinary part of life. Tonight was just another crisis. She babbled on. 'Go in and see my poor husband,' she said, 'he asks for you. Poor, man, he wanted to come to the wedding to show his respect, but the doctor would not permit it. Then he said you would come to see him on this great day, but I did not believe it possible. Ah, men understand friendship more than we women. Go inside, you will make him happy.'

A nurse and a doctor came out of Genco Abbandando's private room. The doctor was a young man, serious-faced and with the air of one born to command, that is to say, the air of one who has been immensely rich all his life. One of the daughters asked timidly, 'Dr Kennedy, can we go to see him now?'

Dr Kennedy looked over the large group with exasperation. Didn't these people realize that the man inside was dying and dying in torturous pain? It would be much better if everyone let him die in peace. 'I think just the immediate family,' he said in his exquisitely polite voice. He was surprised

44

when the wife and daughters turned to the short, heavy man dressed in an awkwardly fitted tuxedo, as if to hear his decision.

The heavy man spoke. There was just the slightest trace of an Italian accent in his voice. 'My dear doctor,' said Don Corleone, 'is it true he is dying?'

'Yes,' said Dr Kennedy.

'Then there is nothing more for you to do,' said Don Corleone. 'We will take up the burden. We will comfort him. We will close his eyes. We will bury him and weep at his funeral and afterwards we will watch over his wife and daughters.' At hearing things put so bluntly, forcing her to understand, Mrs Abbandando began to weep.

Dr Kennedy shrugged. It was impossible to explain to these peasants. At the same time he recognized the crude justice in the man's remarks. His role was over. Still exquisitely polite, he said, 'Please wait for the nurse to let you in, she has a few necessary things to do with the patient.' He walked away from them down the corridor, his white coat flapping.

The nurse went back into the room and they waited. Finally she came out again, holding the door for them to enter. She whispered, 'He's delirious with the pain and fever, try not to excite him. And you can stay only a few minutes, except for the wife.' She recognized Johnny Fontane as he went by her and her eyes opened wide. He gave her a faint smile of acknowledgement and she stared at him with frank invitation. He filed her away for future reference, then followed the others into the sick man's room.

Genco Abbandando had run a long race with death, and now, vanquished, he lay exhausted on the raised bed. He was wasted away to no more than a skeleton, and what had once been vigorous black hair had turned into obscene stringy wisps. Don Corleone said cheerily, 'Genco, dear friend, I have brought my sons to pay their respects, and look, even Johnny all the way from Hollywood.'

The dying man raised his fevered eyes gratefully to the Don. He let the young men clasp his bony hand in their fleshy ones. His wife and daughters ranged themselves along his bed, kissing his cheek, taking his other hand in turn.

The Don pressed his old friend's hand. He said comfortingly, 'Hurry up and get better and we'll take a trip to Italy together to our old village. We'll play *boccie* in front of the wineshop like our fathers before us.'

The dying man shook his head. He motioned the young men and his family away from his bedside; with the other bony claw he hung fast to the Don. He tried to speak. The Don put his head down and then sat on the bedside chair. Genco Abbandando was babbling about their childhood. Then his coal-black eyes became sly. He whispered. The Don bent closer. The others in the room were astonished to see tears running down Don Corleone's face as he shook his head. The quavering voice grew louder, filling the room. With a tortured, superhuman effort, Abbandando lifted his head off his pillow, eyes unseeing, and pointed a skeletal forefinger at the Don. 'Godfather, Godfather,' he called out blindly, 'save me from death, I beg of you. My flesh is burning off my bones and I can feel the worms eating away my brain. Godfather, cure me, you have the power, dry the tears of my poor wife. In Corleone we played together as children, and now will you let me die when I fear hell for my sins?'

The Don was silent. Abbandando said, 'It is your daughter's wedding day, you cannot refuse me.'

The Don spoke quietly, gravely, to pierce through the blasphemous delirium. 'Old friend,' he said, 'I have no such powers. If I did I would be more merciful than God, believe me. But don't fear death and don't fear hell. I will have a mass said for your soul every night and every morning. Your wife and your children will pray for you. How can God punish you with so many pleas for mercy?'

The skeleton face took on a cunning expression that was obscene. Abbandando said slyly, 'It's been arranged then?'

When the Don answered, his voice was cold, without comfort. 'You blaspheme. Resign yourself.'

Abbandando fell back on the pillow. His eyes lost their wild gleam of hope. The nurse came back into the room and started shooing them out in a very matter-of-fact way. The Don got up, but Abbandando put out his hand. 'Godfather,' he said, 'stay here with me and help me meet death. Perhaps if He sees

you near me He will be frightened and leave me in peace. Or perhaps you can say a word, pull a few strings, eh?' The dying man winked as if he were mocking the Don, now not really serious. 'You're brothers in blood, after all.' Then, as if fearing the Don would be offended, he clutched at his hand. 'Stay with me, let me hold your hand. We'll outwit that bastard as we've outwitted others. Godfather, don't betray me.'

The Don motioned the other people out of the room. They left. He took the withered claw of Genco Abbandando in his own two broad hands. Softly, reassuringly, he comforted his friend, as they waited for death together. As if the Don could truly snatch the life of Genco Abbandando back from that most foul and criminal traitor to man.

The wedding day of Connie Corleone ended well for her. Carlo Rizzi performed his duties as a bridegroom with skill and vigour, spurred on by the contents of the bride's gift purse which totalled up to over twenty thousand dollars. The bride, however, gave up her virginity with a great deal more willingness than she gave up her purse. For the latter, he had to blacken one of her eyes.

Lucy Mancini waited in her house for a call from Sonny Corleone, sure that he would ask her for a date. Finally she called his house and when she heard a woman's voice answer the phone she hung up. She had no way of knowing that nearly everyone at the wedding had remarked the absence of her and Sonny for that fatal half hour and the gossip was already spreading that Santino Corleone had found another victim. That he had 'done the job' on his own sister's maid of honour.

Amerigo Bonasera had a terrible nightmare. In his dreams he saw Don Corleone, in peaked cap, overalls, and heavy gloves, unloading bullet-riddled corpses in front of his funeral parlour and shouting, 'Remember, Amerigo, not a word to anyone, and bury them quickly.' He groaned so loud and long in his sleep that his wife shook him awake. 'Eh, what a man you are,' she grumbled. 'To have a nightmare only after a wedding.'

Kay Adams was escorted to her New York City hotel by Paulie Gatto and Clemenza. The car was large, luxurious, and driven by Gatto. Clemenza sat in the back seat and Kay was

given the front seat next to the driver. She found both men wildly exotic. Their speech was movie Brooklynese and they treated her with exaggerated courtliness. During the ride she chatted casually with both men and was surprised when they spoke of Michael with unmistakable affection and respect. He had led her to believe that he was an alien in his father's world. Now Clemenza was assuring her in his wheezing guttural voice that the 'old man' thought Mike was the best of his sons, the one who would surely inherit the family business.

'What business is that?' Kay asked in the most natural way.

Paulie Gatto gave her a quick glance as he turned the wheel. Behind her Clemenza said in a surprised voice. 'Didn't Mike tell you? Mr Corleone is the biggest importer of Italian olive oil in the States. Now that the war is over the business could get real rich. He'll need a smart boy like Mike.'

At the hotel Clemenza insisted on coming to the desk with her. When she protested, he said simply, 'The boss said to make sure you got home OK. I gotta do it.'

After she received her room key he walked her to the elevator and waited until she got in. She waved to him, smiling, and was surprised at his genuine smile of pleasure in return. It was just as well she did not see him go back to the hotel clerk and ask, 'What name she registered under?'

The hotel clerk looked at Clemenza coldly. Clemenza rolled the little green spitball he was holding in his hand across to the clerk, who picked it up and immediately said, 'Mr and Mrs Michael Corleone.'

Back in the car, Paulie Gatto said, 'Nice dame.'

Clemenza grunted. 'Mike is doing the job on her.' Unless, he thought, they were really married. 'Pick me up early in the morning,' he told Paulie Gatto. 'Hagen got some deal for us that gotta be done right away.'

It was late Sunday night before Tom Hagen could kiss his wife goodbye and drive out to the airport. With his special number one priority (a grateful gift from a Pentagon staff general officer) he had no trouble getting on a plane to Los Angeles.

It had been a busy but satisfying day for Tom Hagen. Genco

Abbandando had died at three in the morning and when Don Corleone returned from the hospital, he had informed Hagen that he was now officially the new *Consigliori* to the family. This meant that Hagen was sure to become a very rich man, to say nothing of power.

The Don had broken a long-standing tradition. The *Consigliori* was always a full-blooded Sicilian, and the fact that Hagen had been brought up as a member of the Don's family made no difference to that tradition. It was a question of blood. Only a Sicilian born to the ways of *omerta*, the law of silence, could be trusted in the key post of *Consigliori*.

Between the head of the family, Don Corleone, who dictated policy, and the operating level of men who actually carried out the orders of the Don, there were three layers, or buffers. In that way nothing could be traced to the top. Unless the *Consigliori* turned traitor. That Sunday morning Don Corleone gave explicit instructions on what should be done to the two young men who had beaten the daughter of Amerigo Bonasera. But he had given those orders in private to Tom Hagen. Later in the day Hagen had, also in private without witnesses, instructed Clemenza. In turn Clemenza had told Paulie Gatto to execute the commission. Paulie Gatto would now muster the necessary manpower and execute the orders. Paulie Gatto and his men would not know why this particular task was being carried out or who had ordered it originally. Each link of the chain would have to turn traitor for the Don to be involved and though it had never yet happened, there was always the possibility. The cure for that possibility also was known. Only one link in the chain had to disappear.

The *Consigliori* was also what his name implied. He was the counsellor to the Don, his right-hand man, his auxiliary brain. He was also his closest companion and his closest friend. On important trips he would drive the Don's car, at conferences he would go out and get the Don refreshments, coffee and sandwiches, fresh cigars. He would know everything the Don knew or nearly everything, all the cells of power. He was the one man in the world who could bring the Don crashing down to destruction. But no *Consigliori* had ever betrayed a Don, not in the memory of any of the powerful Sicilian families who had

established themselves in America. There was no future in it. And every *Consigliori* knew that if he kept the faith, he would become rich, wield power, and win respect. If misfortune came, his wife and children would be sheltered and cared for as if he were alive or free. *If he kept the faith*.

In some matters the *Consigliori* had to act for his Don in a more open way and yet not involve his principal. Hagen was flying to California on just such a matter. He realized that his career as *Consigliori* would be seriously affected by the success or failure of this mission. By family business standards whether Johnny Fontane got his coveted part in the war movie, or did not, was a minor matter. Far more important was the meeting Hagen had set up with Virgil Sollozzo the following Friday. But Hagen knew that to the Don, both were of equal importance, which settled the matter for any good *Consigliori*.

The piston plane shook Tom Hagen's already nervous insides and he ordered a martini from the hostess to quiet them. Both the Don and Johnny had briefed him on the character of the movie producer, Jack Woltz. From everything that Johnny said, Hagen knew he would never be able to persuade Woltz. But he also had no doubt whatsoever that the Don would keep his promise to Johnny. His own role was that of negotiator and contact.

Lying back in his seat, Hagen went over all the information given to him that day. Jack Woltz was one of the three most important movie producers in Hollywood, owner of his own studio with dozens of stars under contract. He was on the President of the United States' Advisory Council for War Information, Cinematic Division, which meant simply that he helped make propaganda movies. He had had dinner at the White House. He had entertained J. Edgar Hoover in his Hollywood home. But none of this was as impressive as it sounded. They were all official relationships. Woltz didn't have any personal political power, mainly because he was an extreme reactionary, partly because he was a megalomaniac who loved to wield power wildly without regard to the fact that by so doing legions of enemies sprang up out of the ground.

Hagen sighed. There would be no way to 'handle' Jack

Woltz. He opened his briefcase and tried to get some paper work done, but he was too tired. He ordered another martini and reflected on his life. He had no regrets, indeed he felt that he had been extremely lucky. Whatever the reason, the course he had chosen ten years ago had proved to be right for him. He was successful, he was as happy as any grown man could reasonably expect, and he found life interesting.

Tom Hagen was thirty-five years old, a tall crew-cut man, very slender, very ordinary-looking. He was a lawyer but did not do the actual detailed legal work for the Corleone family business though he had practised law for three years after passing the bar exam.

At the age of eleven he had been a playmate of eleven-year-old Sonny Corleone. Hagen's mother had gone blind and then died during his eleventh year. Hagen's father, a heavy drinker, had become a hopeless drunkard. A hard-working carpenter, he had never done a dishonest thing in his life. But his drinking destroyed his family and finally killed him. Tom Hagen was left an orphan who wandered the streets and slept in hallways. His younger sister had been put in a foster home, but in the 1920s the social agencies did not follow up cases of twelve-year-old boys who were so ungrateful as to run from their charity. Hagen, too, had an eye infection. Neighbours whispered that he had caught or inherited it from his mother and so therefore it could be caught from him. He was shunned. Sonny Corleone, a warmhearted and imperious eleven-year-old, had brought his friend home and demanded that he be taken in. Tom Hagen was given a hot dish of spaghetti with oily rich tomato sauce, the taste of which he had never forgotten, and then given a metal folding bed to sleep on.

In the most natural way, without a word being spoken or the matter discussed in any fashion, Don Corleone had permitted the boy to stay in his household. Don Corleone himself took the boy to a special doctor and had his eye infection cured. He sent him to college and law school. In all this the Don acted not as a father but rather as a guardian. There was no show of affection but oddly enough the Don treated Hagen more courteously than his own sons, did not impose a parental will upon him. It was the boy's decision to go to law school

after college. He had heard Don Corleone say once, 'A lawyer with his briefcase can steal more than a hundred men with guns.' Meanwhile, much to the annoyance of their father, Sonny and Freddie insisted on going into the family business after graduation from high school. Only Michael had gone on to college, and he had enlisted in the Marines the day after Pearl Harbor.

After he passed the bar exam, Hagen married to start his own family. The bride was a young Italian girl from New Jersey, rare at that time for being a college graduate. After the wedding, which was of course held in the home of Don Corleone, the Don offered to support Hagen in any undertaking he desired, to send him law clients, furnish his office, start him in real estate.

Tom Hagen had bowed his head and said to the Don, 'I would like to work for you.'

The Don was surprised, yet pleased. 'You know who I am?' he asked.

Hagen nodded. He hadn't really known the extent of the Don's power, not then. He did not really know in the ten years that followed until he was made the acting *Consigliori* after Genco Abbandando became ill. But he nodded and met the Don's eyes with his own. 'I would work for you like your sons,' Hagen said, meaning with complete loyalty, with complete acceptance of the Don's parental divinity. The Don, with that understanding which was even then building the legend of his greatness, showed the young man the first mark of fatherly affection since he had come into his household. He took Hagen into his arms for a quick embrace and afterwards treated him more like a true son, though he would sometimes say, 'Tom, never forget your parents,' as if he were reminding himself as well as Hagen.

There was no chance that Hagen would forget. His mother had been near moronic and slovenly, so ridden by anaemia she could not feel affection for her children or make a pretence of it. His father Hagen had hated. His mother's blindness before she died had terrified him and his own eye infection had been a stroke of doom. He had been sure he would go blind. When his father died, Tom Hagen's eleven-year-old mind had

snapped in a curious way. He had roamed the streets like an animal waiting for death until the fateful day Sonny found him sleeping in the back of a hallway and brought him to his home. What had happened afterwards was a miracle. But for years Hagen had had nightmares, dreaming he had grown to manhood blind, tapping a white cane, his blind children behind him tap-tapping with their little white canes as they begged in the streets. Some mornings when he woke the face of Don Corleone was imprinted on his brain in that first conscious moment and he would feel safe.

But the Don had insisted that he put in three years of general law practice in addition to his duties for the family business. This experience had proved invaluable later on, and also removed any doubts in Hagen's mind about working for Don Corleone. He had then spent two years of training in the offices of a top firm of criminal lawyers in which the Don had some influence. It was apparent to everyone that he had a flair for this branch of the law. He did well and when he went into the full-time service of the family business, Don Corleone had not been able to reproach him once in the six years that followed.

When he had been made the acting *Consigliori*, the other powerful Sicilian families referred contemptuously to the Corleone family as the 'Irish gang'. This had amused Hagen. It had also taught him that he could never hope to succeed the Don as the head of the family business. But he was content. That had never been his goal, such an ambition would have been a 'disrespect' to his benefactor and his benefactor's blood family.

It was still dark when the plane landed in Los Angeles. Hagen checked into his hotel, showered and shaved, and watched dawn come over the city. He ordered breakfast and newspapers to be sent up to his room and relaxed until it was time for his ten AM appointment with Jack Woltz. The appointment had been surprisingly easy to make.

The day before, Hagen had called the most powerful man in the movie labour unions, a man named Billy Goff. Acting on instructions from Don Corleone, Hagen had told Goff to arrange an appointment on the next day for Hagen to call on

Jack Woltz, that he should hint to Woltz that if Hagen was not made happy by the results of the interview, there could be a labour strike at the movie studio. An hour later Hagen received a call from Goff. The appointment would be at ten AM. Woltz had got the message about the possible labour strike but hadn't seemed too impressed, Goff said. He added, 'If it really comes down to that, I gotta talk to the Don myself.'

'If it comes to that he'll talk to you,' Hagen said. By saying this he avoided making any promises. He was not surprised that Goff was so agreeable to the Don's wishes. The family empire, technically, did not extend beyond the New York area but Don Corleone had first become strong by helping labour leaders. Many of them still owed him debts of friendship.

But the ten AM appointment was a bad sign. It meant that he would be first on the appointment list, that he would not be invited to lunch. It meant that Woltz held him in small worth. Goff had not been threatening enough, probably because Woltz had him on his graft payroll. And sometimes the Don's success in keeping himself out of the limelight worked to the disadvantage of the family business, in that his name did not mean anything to outside circles.

His analysis proved correct. Woltz kept him waiting for a half hour past the appointed time. Hagen didn't mind. The reception room was very plush, very comfortable, and on a plum-coloured couch opposite him sat the most beautiful child Hagen had ever seen. She was no more than eleven or twelve, dressed in a very expensive but simple way as a grown woman. She had incredibly golden hair, huge deep sea-blue eyes and a fresh raspberry-red mouth. She was guarded by a woman obviously her mother, who tried to stare Hagen down with a cold arrogance that made him want to punch her in the face. The angel child and the dragon mother, Hagen thought, returning the mother's cold stare.

Finally an exquisitely dressed but stout middle-aged woman came to lead him through a string of offices to the office-apartment of the movie producer. Hagen was impressed by the beauty of the offices and the people working in them. He smiled. They were all shrewdies, trying to get their foot in the

movie door by taking office jobs, and most of them would work in these offices for the rest of their lives or until they accepted defeat and returned to their home towns.

Jack Woltz was a tall, powerfully built man with a heavy paunch almost concealed by his perfectly tailored suit. Hagen knew his history. At ten years of age Woltz had hustled empty beer kegs and pushcarts on the East Side. At twenty he helped his father sweat garment workers. At thirty he had left New York and moved West, invested in the nickelodeon, and pioneered motion pictures. At forty-eight he had been the most powerful movie magnate in Hollywood, still rough-spoken, rapaciously amorous, a raging wolf ravaging helpless flocks of young starlets. At fifty he transformed himself. He took speech lessons, learned how to dress from an English valet, and how to behave socially from an English butler. When his first wife died he married a world-famous and beautiful actress who didn't like acting. Now at the age of sixty he collected old master paintings, was a member of the President's Advisory Committee, and had set up a multimillion-dollar foundation in his name to promote art in motion pictures. His daughter had married an English lord, his son an Italian princess.

His latest passion, as reported dutifully by every movie columnist in America, was his own racing stables on which he had spent ten million dollars in the past year. He had made headlines by purchasing the famed English racing horse Khartoum for the incredible price of six hundred thousand dollars and then announcing that the undefeated racer would be retired and put to stud exclusively for the Woltz stables.

He received Hagen courteously, his beautifully, evenly tanned, meticulously barbered face contorted with a grimace meant to be a smile. Despite all the money spent, despite the ministrations of the most knowledgeable technicians, his age showed; the flesh of his face looked as if it had been seamed together. But there was an enormous vitality in his movements and he had what Don Corleone had, the air of a man who commanded absolutely the world in which he lived.

Hagen came directly to the point. That he was an emissary from a friend of Johnny Fontane. That this friend was a very

powerful man who would pledge his gratitude and undying friendship to Mr Woltz if Mr Woltz would grant a small favour. The small favour would be the casting of Johnny Fontane in the new war movie the studio planned to start next week.

The seamed face was impassive, polite. 'What favours can your friend do me?' Woltz asked. There was just a trace of condescension in his voice.

Hagen ignored the condescension. He explained. 'You've got some labour trouble coming up. My friend can absolutely guarantee to make that trouble disappear. You have a top male star who makes a lot of money for your studio but he just graduated from marijuana to heroin. My friend will guarantee that your male star won't be able to get any more heroin. And if some other little things come up over the years a phone call to me can solve your problems.'

Jack Woltz listened to this as if he were hearing the boasting of a child. Then he said harshly, his voice deliberately all East Side, 'You trying to put muscle on me?'

Hagen said coolly, 'Absolutely not. I've come to ask a service for a friend. I've tried to explain that you won't lose anything by it.'

Almost as if he willed it, Woltz made his face a mask of anger. The mouth curled, his heavy brows, dyed black, contracted to form a thick line over his glinting eyes. He leaned over the desk towards Hagen. 'All right, you smooth son of a bitch, let me lay it on the line for you and your boss, whoever he is. Johnny Fontane never gets that movie. I don't care how many guinea Mafia goombahs come out of the woodwork.' He leaned back. 'A word of advice to you, my friend. J. Edgar Hoover, I assume you've heard of him' – Woltz smiled sardonically – 'is a personal friend of mine. If I let him know I'm being pressured, you guys will never know what hit you.'

Hagen listened patiently. He had expected better from a man of Woltz's stature. Was it possible that a man who acted this stupidly could rise to the head of a company worth hundreds of millions? That was something to think about since the Don was looking for new things to put money into, and if the top brains of this industry were so dumb, movies might be the

thing. The abuse itself bothered him not at all. Hagen had learned the art of negotiation from the Don himself. 'Never get angry,' the Don had instructed. 'Never make a threat. Reason with people.' The word 'reason' sounded so much better in Italian, *rajunah*, to rejoin. The art of this was to ignore all insults, all threats; to turn the other cheek. Hagen had seen the Don sit at a negotiating table for eight hours, swallowing insults, trying to persuade a notorious and megalomaniac strong-arm man to mend his ways. At the end of the eight hours Don Corleone had thrown up his hands in a helpless gesture and said to the other men at the table, 'But no one can reason with this fellow,' and had stalked out of the meeting room. The strong-arm man had turned white with fear. Emissaries were sent to bring the Don back into the room. An agreement was reached but two months later the strong-arm man was shot to death in his favourite barbershop.

So Hagen started again, speaking in the most ordinary voice. 'Look at my card,' he said. 'I'm a lawyer. Would I stick my neck out? Have I uttered one threatening word? Let me just say that I am prepared to meet any condition you name to get Johnny Fontane that movie. I think I've already offered a great deal for such a small favour. A favour that I understand it would be in your interest to grant. Johnny tells me that you admit he would be perfect for that part. And let me say that this favour would never be asked if that were not so. In fact, if you're worried about your investment, my client would finance the picture. But please let me make myself absolutely clear. We understand your no is no. Nobody can force you or is trying to. We know about your friendship with Mr Hoover, I may add, and my boss respects you for it. He respects that relationship very much.'

Woltz had been doodling with a huge, red-feathered pen. At the mention of money his interest was aroused and he stopped doodling. He said patronizingly, 'This picture is budgeted at five million.'

Hagen whistled softly to show that he was impressed. Then he said very casually, 'My boss has a lot of friends who back his judgement.'

For the first time Woltz seemed to take the whole thing

seriously. He studied Hagen's card. 'I never heard of you,' he said. 'I know most of the big lawyers in New York, but just who the hell are you?'

'I have one of those dignified corporate practices,' Hagen said dryly. 'I just handle this one account.' He rose. 'I won't take up any more of your time.' He held out his hand, Woltz shook it. Hagen took a few steps towards the door and turned to face Woltz again. 'I understand you have to deal with a lot of people who try to seem more important than they are. In my case the reverse is true. Why don't you check me out with our mutual friend? If you reconsider, call me at my hotel.' He paused. 'This may be sacrilege to you, but my client can do things for you that even Mr Hoover might find out of his range.' He saw the movie producer's eyes narrowing. Woltz was finally getting the message. 'By the way, I admire your pictures very much,' Hagen said in the most fawning voice he could manage. 'I hope you can keep up the good work. Our country needs it.'

Late that afternoon Hagen received a call from the producer's secretary that a car would pick him up within the hour to take him out to Mr Woltz's country home for dinner. She told him it would be about a three-hour drive but that the car was equipped with a bar and some hors d'oeuvres. Hagen knew that Woltz made the trip in his private plane and wondered why he hadn't been invited to make the trip by air. The secretary's voice was adding politely, 'Mr Woltz suggested you bring an overnight bag and he'll get you to the airport in the morning.'

'I'll do that,' Hagen said. That was another thing to wonder about. How did Woltz know he was taking the morning plane back to New York? He thought about it for a moment. The most likely explanation was that Woltz had set private detectives on his trail to get all possible information. Then Woltz certainly knew he represented the Don, which meant that he knew something about the Don, which in turn meant that he was now ready to take the whole matter seriously. Something might be done after all, Hagen thought. And maybe Woltz was smarter than he had appeared this morning.

* * * * *

The home of Jack Woltz looked like an implausible movie set. There was a plantation-type mansion, huge grounds girdled by a rich black dirt bridle path, stables and pasture for a herd of horses. The hedges, flower beds, and grasses were as carefully manicured as a movie star's nails.

Woltz greeted Hagen on a glass-panel air-conditioned porch. The producer was informally dressed in blue silk shirt open at the neck, mustard-coloured slacks, soft leather sandals. Framed in all this colour and rich fabric his seamed, tough face was startling. He handed Hagen an outsized martini glass and took one for himself from the prepared tray. He seemed more friendly than he had been earlier in the day. He put his arm over Hagen's shoulder and said, 'We have a little time before dinner, let's go look at my horses.' As they walked towards the stables he said, 'I checked you out, Tom; you should have told me your boss is Corleone. I thought you were just some third-rate hustler Johnny was running in to bluff me. And I don't bluff. Not that I want to make enemies, I never believed in that. But let's just enjoy ourselves now. We can talk business after dinner.'

Surprisingly Woltz proved to be a truly considerate host. He explained his new methods, innovations that he hoped would make his stable the most successful in America. The stables were all fire-proofed, sanitized to the highest degree, and guarded by a special security detail of private detectives. Finally Woltz led him to a stall which had a huge bronze plaque attached to its outside wall. On the plaque was the name 'Khartoum'.

The horse inside the stall was, even to Hagen's inexperienced eyes, a beautiful animal. Khartoum's skin was jet black except for a diamond-shaped white patch on his huge forehead. The great brown eyes glinted like golden apples, the black skin over the taut body was silk. Woltz said with childish pride, 'The greatest racehorse in the world. I bought him in England last year for six hundred grand. I bet even the Russian Czars never paid that much for a single horse. But I'm not going to race him, I'm going to put him to stud. I'm going to build the greatest racing stable this country has ever known.' He stroked the horse's mane and called out softly,

'Khartoum, Khartoum.' There was real love in his voice and the animal responded. Woltz said to Hagen, 'I'm a good horseman, you know, and the first time I ever rode I was fifty years old.' He laughed. 'Maybe one of my grandmothers in Russia got raped by a Cossack and I got his blood.' He tickled Khartoum's belly and said with sincere admiration, 'Look at that cock on him. I should have such a cock.'

They went back to the mansion to have dinner. It was served by three waiters under the command of a butler, the table linen and ware were all gold thread and silver, but Hagen found the food mediocre. Woltz obviously lived alone, and just as obviously was not a man who cared about food. Hagen waited until they had both lit up huge Havana cigars before he asked Woltz, 'Does Johnny get it or not?'

'I can't,' Woltz said. 'I can't put Johnny into that picture even if I wanted to. The contracts are all signed for all the performers and the cameras roll next week. There's no way I can swing it.'

Hagen said impatiently, 'Mr Woltz, the big advantage of dealing with a man at the top is that such an excuse is not valid. You can do anything you want to do.' He puffed on his cigar. 'Don't you believe my client can keep his promises?'

Woltz said dryly, 'I believe that I'm going to have labour trouble. Goff called me up on that, the son of a bitch, and the way he talked to me you'd never guess I pay him a hundred grand a year under the table. And I believe you can get that fag he-man star of mine off heroin. But I don't care about that and I can finance my own pictures. Because I hate that bastard Fontane. Tell your boss this is one favour I can't give but that he should try me again on anything else. Anything at all.'

Hagen thought, you sneaky bastard, then why the hell did you bring me all the way out here? The producer had something on his mind. Hagen said coldly, 'I don't think you understand the situation. Mr Corleone is Johnny Fontane's godfather. That is a very close, a very sacred religious relationship.' Woltz bowed his head in respect at this reference to religion. Hagen went on. 'Italians have a little joke, that the world is so hard a man must have two fathers to look after him, and that's why they have godfathers. Since Johnny's

father died, Mr Corleone feels his responsibility even more deeply. As for trying you again, Mr Corleone is much too sensitive. He never asks a second favour where he has been refused the first.'

Woltz shrugged. 'I'm sorry. The answer is still no. But since you're here, what will it cost me to have that labour trouble cleared up? In cash. Right now.'

That solved one puzzle for Hagen. Why Woltz was putting in so much time on him when he had already decided not to give Johnny the part. And that could not be changed at this meeting. Woltz felt secure; he was not afraid of the power of Don Corleone. And certainly Woltz with his national political connexions, his acquaintanceship with the FBI chief, his huge personal fortune, and his absolute power in the film industry, could not feel threatened by Don Corleone. To any intelligent man, even to Hagen, it seemed that Woltz had correctly assessed his position. He was impregnable to the Don if he was willing to take the losses the labour struggle would cost. There was only one thing wrong with the whole equation. Don Corleone had promised his godson he would get the part and Don Corleone had never, to Hagen's knowledge, broken his word in such matters.

Hagen said quietly, 'You are deliberately misunderstanding me. You are trying to make me an accomplice to extortion. Mr Corleone promises only to speak in your favour on this labour trouble as a matter of friendship in return for your speaking in behalf of his client. A friendly exchange of influence, nothing more. But I can see you don't take me seriously. Personally, I think that is a mistake.'

Woltz, as if he had been waiting for such a moment, let himself get angry. 'I understood perfectly,' he said. 'That's the Mafia style, isn't it? All olive oil and sweet talk when what you're really doing is making threats. So let me lay it on the line. Johnny Fontane will never get that part and he's perfect for it. It would make him a great star. But he never will be because I hate that pinko punk and I'm going to run him out of the movies. And I'll tell you why. He ruined one of my most valuable protégées. For five years I had this girl under training, singing, dancing, acting lessons, I spent hundreds of

thousands of dollars. I was going to make her a star. I'll be even more frank, just to show you that I'm not a hard-hearted man, that it wasn't all dollars and cents. That girl was beautiful and she was the greatest piece of ass I've ever had and I've had them all over the world. She could suck you out like a water pump. Then Johnny comes along with that olive-oil voice and guinea charm and she runs off. She threw it all away just to make me ridiculous. A man in my position, Mr Hagen, can't afford to look ridiculous. I have to pay Johnny off.'

For the first time, Woltz succeeded in astounding Hagen. He found it inconceivable that a grown man of substance would let such trivialities affect his judgement in an affair of business, and one of such importance. In Hagen's world, the Corleones' world, the physical beauty, the sexual power of women, carried not the slightest weight in worldly matters. It was a private affair, except, of course, in matters of marriage and family disgrace. Hagen decided to make one last try.

'You are absolutely right, Mr Woltz,' Hagen said. 'But are your grievances that major? I don't think you've understood how important this very small favour is to my client. Mr Corleone held the infant Johnny in his arms when he was baptized. When Johnny's father died, Mr Corleone assumed the duties of parenthood, indeed he is called "Godfather" by many people who wish to show their respect and gratitude for the help he has given them. Mr Corleone never lets his friends down.'

Woltz stood up abruptly. 'I've listened to about enough. Thugs don't give me orders, I give them orders. If I pick up this phone, you'll spend the night in jail. And if that Mafia goombah tries any rough stuff, he'll find out I'm not a band leader. Yeah, I heard that story too. Listen, your Mr Corleone will never know what hit him. Even if I have to use my influence at the White House.'

The stupid, stupid son of a bitch. How the hell did he get to be a *pezzonovante*, Hagen wondered. Advisor to the President, head of the biggest movie studio in the world. Definitely the Don should get into the movie business. And the guy was taking his words at their sentimental face value. He was not getting the message.

'Thank you for the dinner and a pleasant evening,' Hagen said. 'Could you give me transportation to the airport? I don't think I'll spend the night.' He smiled coldly at Woltz. 'Mr Corleone is a man who insists on hearing bad news at once.'

While waiting in the floodlit colonnade of the mansion for his car, Hagen saw two women about to enter a long limousine already parked in the driveway. They were the beautiful twelve-year-old blonde girl and her mother he had seen in Woltz's office that morning. But now the girl's exquisitely cut mouth seemed to have smeared into a thick, pink mass. Her sea-blue eyes were filmed over and when she walked down the steps towards the open car her long legs tottered like a crippled foal's. Her mother supported the child, helping her into the car, hissing commands into her ear. The mother's head turned for a quick furtive look at Hagen and he saw in her eyes a burning, hawklike triumph. Then she too disappeared into the limousine.

So that was why he hadn't got the plane ride from Los Angeles, Hagen thought. The girl and her mother had made the trip with the movie producer. That had given Woltz enough time to relax before dinner and do the job on the little kid. And Johnny wanted to live in this world? Good luck to him, and good luck to Woltz.

Paulie Gatto hated quickie jobs, especially when they involved violence. He liked to plan things ahead. And something like tonight, even though it was punk stuff, could turn into serious business if somebody made a mistake. Now, sipping his beer, he glanced around, checking how the two young punks were making out with the two little tramps at the bar.

Paulie Gatto knew everything there was to know about those two punks. Their names were Jerry Wagner and Kevin Moonan. They were both about twenty years old, good-looking, brown-haired, tall, well-built. Both were due to go back to college out of town in two weeks, both had fathers with political influence and this, with their college student classification, had so far kept them out of the draft. They were both also under suspended sentences for assaulting the daughter of

Amerigo Bonasera. The lousy bastards, Paulie Gatto thought. Draft dodging, violating their probation by drinking in a bar after midnight, chasing floozies. Young punks. Paulie Gatto had been deferred from the draft himself because his doctor had furnished the draft board with documents showing that this patient, male, white, aged twenty-six, unmarried, had received electrical shock treatments for a mental condition. All false of course, but Paulie Gatto felt that he had earned his draft exemption. It had been arranged by Clemenza after Gatto had 'made his bones' in the family business.

It was Clemenza who had told him that this job must be rushed through, before the boys went to college. Why the hell did it have to be done in New York, Gatto wondered. Clemenza was always giving extra orders instead of just giving out the job. Now if those two little tramps walked out with the punks it would be another night wasted.

He could hear one of the girls laughing and saying, 'Are you crazy, Jerry? I'm not going in any car with you. I don't want to wind up in the hospital like that other poor girl.' Her voice was spitefully rich with satisfaction. That was enough for Gatto. He finished up his beer and walked out into the dark street. Perfect. It was after midnight. There was only one other bar that showed light. The rest of the stores were closed. The precinct patrol car had been taken care of by Clemenza. They wouldn't be around that way until they got a radio call and then they'd come slow.

He leaned against the four-door Chevy sedan. In the back seat two men were sitting, almost invisible, although they were very big men. Paulie said, 'Take them when they come out.'

He still thought it had all been set up too fast. Clemenza had given him copies of the police mug shots of the two punks, the dope on where the punks went drinking every night to pick up bar girls. Paulie had recruited two of the strong-arms in the family and fingered the punks for them. He had also given them their instructions. No blows on the top or the back of the head, there was to be no accidental fatality. Other than that they could go as far as they liked. He had given them only one

64

warning: 'If those punks get out of the hospital in less than a month, you guys go back to driving trucks.'

The two big men were getting out of the car. They were both ex-boxers who had never made it past the small clubs and had been fixed up by Sonny Corleone with a little loan-shark action so that they could make a decent living. They were, naturally, anxious to show their gratitude.

When Jerry Wagner and Kevin Moonan came out of the bar they were perfect setups. The bar girl's taunts had left their adolescent vanity prickly. Paulie Gatto, leaning against the fender of his car, called out to them with a teasing laugh, 'Hey, Casanova, those broads really brushed you off.'

The two young men turned on him with delight. Paulie Gatto looked like a perfect outlet for their humiliation. Ferret-faced, short, slightly built, and a wise guy in the bargain. They pounced on him eagerly and immediately found their arms pinned by two men grabbing them from behind. At the same moment Paulie Gatto had slipped onto his right hand a specially made set of brass knuckles studded with one-sixteenth-inch iron spikes. His timing was good, he worked out in the gym three times a week. He smashed the punk named Wagner right on the nose. The man holding Wagner lifted him up off the ground and Paulie swung his arm, uppercutting into the perfectly positioned groin. Wagner went limp and the big man dropped him. This had taken no more than six seconds.

Now both of them turned their attention to Kevin Moonan, who was trying to shout. The man holding him from behind did so easily with one huge muscled arm. The other hand he put around Moonan's throat to cut off any sound.

Paulie Gatto jumped into the car and started the motor. The two big men were beating Moonan to jelly. They did so with frightening deliberation, as if they had all the time in the world. They did not throw punches in flurries but in timed, slow-motion sequences that carried the full weight of their massive bodies. Each blow landed with a *splat* of flesh splitting open. Gatto got a glimpse of Moonan's face. It was unrecognizable. The two men left Moonan lying on the side-walk and turned their attention to Wagner. Wagner was trying

to get to his feet and he started to scream for help. Someone came out of the bar and the two men had to work faster now. They clubbed Wagner to his knees. One of the men took his arm and twisted it, then kicked him in the spine. There was a cracking sound and Wagner's scream of agony brought windows open all along the street. The two men worked very quickly. One of them held Wagner up by using his two hands around Wagner's head like a vice. The other man smashed his huge fist into the fixed target. There were more people coming out of the bar but none tried to interfere. Paulie Gatto yelled, 'Come on, enough.' The two big men jumped into the car and Paulie gunned it away. Somebody would describe the car and read the licence plates but it didn't matter. It was a stolen California plate and there were one hundred thousand black Chevy sedans in New York City.

CHAPTER TWO

TOM HAGEN went to his law office in the city on Thursday morning. He planned to catch up on his paper work so as to have everything cleared away for the meeting with Virgil Sollozzo on Friday. A meeting of such importance that he had asked the Don for a full evening of talk to prepare for the proposition they knew Sollozzo would offer the family business. Hagen wanted to have all little details cleared away so that he could go to that preparatory meeting with an unencumbered mind.

The Don had not seemed surprised when Hagen returned from California late Tuesday evening and told him the results of the negotiations with Woltz. He had made Hagen go over every detail and grimaced with distaste when Hagen told about the beautiful little girl and her mother. He had murmured 'infamita', his strongest disapproval. He had asked Hagen one final question. 'Does this man have real balls?'

Hagen considered exactly what the Don meant by this question. Over the years he had learned that the Don's values

were so different from those of most people that his words also could have a different meaning. Did Woltz have character? Did he have a strong will? He most certainly did, but that was not what the Don was asking. Did the movie producer have the courage not to be bluffed? Did he have the willingness to suffer heavy financial loss delay on his movies would mean, the scandal of his big star exposed as a user of heroin? Again the answer was yes. But again this was not what the Don meant. Finally Hagen translated the question properly in his mind. Did Jack Woltz have the balls to risk everything, to run the chance of losing *all* on a matter of principle, on a matter of honour; for revenge?

Hagen smiled. He did it rarely but now he could not resist jesting with the Don. 'You're asking if he is a Sicilian.' The Don nodded his head pleasantly, acknowledging the flattering witticism and its truth. 'No,' Hagen said.

That had been all. The Don had pondered the question until the next day. On Wednesday afternoon he had called Hagen to his home and given him his instructions. The instructions had consumed the rest of Hagen's working day and left him dazed with admiration. There was no question in his mind that the Don had solved the problem, that Woltz would call him this morning with the news that Johnny Fontane had the starring part in his new war movie.

At that moment the phone did ring but it was Amerigo Bonasera. The undertaker's voice was trembling with gratitude. He wanted Hagen to convey to the Don his undying friendship. The Don had only to call on him. He, Amerigo Bonasera, would lay down his life for the blessed Godfather. Hagen assured him that the Don would be told.

The *Daily News* had carried a middle-page spread of Jerry Wagner and Kevin Moonan lying in the street. The photos were expertly gruesome, they seemed to be pulps of human beings. Miraculously, said the *News*, they were both still alive though they would both be in the hospital for months and would require plastic surgery. Hagen made a note to tell Clemenza that something should be done for Paulie Gatto. He seemed to know his job.

Hagen worked quickly and efficiently for the next three

hours consolidating earning reports from the Don's real estate company, his olive oil importing business, and his construction firm. None of them were doing well but with the war over they should all become rich producers. He had almost forgotten the Johnny Fontane problem when his secretary told him California was calling. He felt a little thrill of anticipation as he picked up the phone and said, 'Hagen here.'

The voice that came over the phone was unrecognizable with hate and passion. 'You fucking bastard,' Woltz screamed. 'I'll have you all in jail for a hundred years. I'll spend every penny I have to get you. I'll get that Johnny Fontane's balls cut off, do you hear me, you guinea fuck?'

Hagen said kindly, 'I'm German-Irish.' There was a long pause and then a click of the phone being hung up. Hagen smiled. Not once had Woltz uttered a threat against Don Corleone himself. Genius had its rewards.

Jack Woltz always slept alone. He had a bed big enough for ten people and a bedroom large enough for a movie ballroom scene, but he had slept alone since the death of his first wife ten years before. This did not mean he no longer used women. He was physically a vigorous man despite his age, but he could be aroused now only by very young girls and had learned that a few hours in the evening were all the youth of his body and his patience could tolerate.

On this Thursday morning, for some reason, he awoke early. The light of dawn made his huge bedroom as misty as a foggy meadow-land. Far down at the foot of his bed was a familiar shape and Woltz struggled up on his elbows to get a clearer look. It had the shape of a horse's head. Still groggy, Woltz reached and flicked on the night table lamp.

The shock of what he saw made him physically ill. It seemed as if a great sledgehammer had struck him on the chest, his heartbeat jumped erratically and he became nauseous. His vomit spluttered on the thick flair rug.

Severed from its body, the black silky head of the great horse Khartoum was stuck fast in a thick cake of blood. White reedy tendons showed. Froth covered the muzzle and those apple-sized eyes that had glinted like gold were mottled the

colour of rotting fruit with dead, haemorrhaged blood. Woltz was struck by a purely animal terror and out of that terror he screamed for his servants and out of that terror he called Hagen to make his uncontrolled threats. His maniacal raving alarmed the butler, who called Woltz's personal physician and his second in command at the studio. But Woltz regained his senses before they arrived.

He had been profoundly shocked. What kind of man could destroy an animal worth six hundred thousand dollars? Without a word of warning. Without any negotiation to have the act, its order, countermanded. The ruthlessness, the sheer disregard for any values, implied a man who considered himself completely his own law, even his own God. And a man who backed up this kind of will with the power and cunning that held his own stable security force of no account. For by this time Woltz had learned that the horse's body had obviously been heavily drugged before someone leisurely hacked the huge triangular head off with an axe. The men on night duty claimed that they had heard nothing. To Woltz this seemed impossible. They could be made to talk. They had been bought off and they could be made to tell who had done the buying.

Woltz was not a stupid man, he was merely a supremely egotistical one. He had mistaken the power he wielded in his world to be more potent than the power of Don Corleone. He had merely needed some proof that this was not true. He understood this message. That despite all his wealth, despite all his contacts with the President of the United States, despite all his claims of friendship with the director of the FBI, an obscure importer of Italian olive oil would have him killed. Would actually have him killed! Because he wouldn't give Johnny Fontane a movie part he wanted. It was incredible. People didn't have any right to act that way. There couldn't be any kind of world if people acted that way. It was insane. It meant you couldn't do what you wanted with your own money, with the companies you owned, the power you had to give orders. It was ten times worse than communism. It had to be smashed. It must never be allowed.

Woltz let the doctor give him a very mild sedation. It helped

him calm down again and to think sensibly. What really shocked him was the casualness with which this man Corleone had ordered the destruction of a world-famous horse worth six hundred thousand dollars. Six hundred thousand dollars! And that was just for openers. Woltz shuddered. He thought of this life he had built up. He was rich. He could have the most beautiful women in the world by crooking his finger and promising a contract. He was received by kings and queens. He lived a life as perfect as money and power could make it. It was crazy to risk all this because of a whim. Maybe he could get to Corleone. What was the legal penalty for killing a race-horse? He laughed wildly and his doctor and servants watched him with nervous anxiety. Another thought occurred to him. He would be the laughingstock of California merely because someone had contemptuously defied his power in such arrogant fashion. That decided him. That and the thought that maybe, maybe they wouldn't kill him. That they had something much more clever and painful in reserve.

Woltz gave the necessary orders. His personal confidential staff swung into action. The servants and the doctor were sworn to secrecy on pain of incurring the studio and Woltz's undying enmity. Word was given to the press that the race-horse Khartoum had died of an illness contracted during his shipment from England. Orders were given to bury the remains in a secret place on the estate.

Six hours later Johnny Fontane received a phone call from the executive producer of the film telling him to report for work the following Monday.

That evening, Hagen went to the Don's house to prepare him for the important meeting the next day with Virgil Sollozzo. The Don had summoned his eldest son to attend, and Sonny Corleone, his heavy Cupid-shaped face drawn with fatigue, was sipping at a glass of water. He must still be humping that maid of honour, Hagen thought. Another worry.

Don Corleone settled into an armchair puffing his Di Nobili cigar. Hagen kept a box of them in his room. He had tried to get the Don to switch to Havanas but the Don claimed they hurt his throat.

'Do we know everything necessary for us to know?' the Don asked.

Hagen opened the folder that held his notes. The notes were in no way incriminating, merely cryptic reminders to make sure he touched on every important detail. 'Sollozzo is coming to us for help,' Hagen said. 'He will ask the family to put up at least a million dollars and to promise some sort of immunity from the law. For that we get a piece of the action, nobody knows how much. Sollozzo is vouched for by the Tattaglia family and they may have a piece of the action. The action is narcotics. Sollozzo has the contacts in Turkey, where they grow the poppy. From there he ships to Sicily. No trouble. In Sicily he has the plant to process into heroin. He has safety-valve operations to bring it down to morphine and bring it up to heroin if necessary. But it would seem that the processing plant in Sicily is protected in every way. The only hitch is bringing it into this country, and then distribution. Also initial capital. A million dollars cash doesn't grow on trees.' Hagen saw Don Corleone grimace. The old man hated unnecessary flourishes in business matters. He went on hastily.

'They call Sollozzo the Turk. Two reasons. He's spent a lot of time in Turkey and is supposed to have a Turkish wife and kids. Second. He's supposed to be very quick with the knife, or was, when he was young. Only in matters of business, though, and with some sort of reasonable complaint. A very competent man and his own boss. He has a record, he's done two terms in prison, one in Italy, one in the United States, and he's known to the authorities as a narcotics man. This could be a plus for us. It means that he'll never get immunity to testify, since he's considered the top and, of course, because of his record. Also he has an American wife and three children and he is a good family man. He'll stand still for any rap as long as he knows that they will be well taken care of for living money.'

The Don puffed on his cigar and said, 'Santino, what do you think?'

Hagen knew what Sonny would say. Sonny was chafing at being under the Don's thumb. He wanted a big operation of his own. Something like this would be perfect.

Sonny took a long slug of Scotch. 'There's a lot of money in that white powder,' he said. 'But it could be dangerous. Some people could wind up in jail for twenty years. I'd say that if we kept out of the operations end, just stuck to protection and financing, it might be a good idea.'

Hagen looked at Sonny approvingly. He had played his cards well. He had stuck to the obvious, much the best course for him.

The Don puffed on his cigar. 'And you, Tom, what do you think?'

Hagen composed himself to be absolutely honest. He had already come to the conclusion that the Don would refuse Sollozzo's proposition. But what was worse, Hagen was convinced that for one of the few times in his experience, the Don had not thought things through. He was not looking far enough ahead.

'Go ahead, Tom,' the Don said encouragingly. 'Not even a Sicilian *Consigliori* always agrees with the boss.' They all laughed.

'I think you should say yes,' Hagen said. 'You know all the obvious reasons. But the most important one is this. There is more money potential in narcotics than in any other business. If we don't get into it, somebody else will, maybe the Tattaglia family. With the revenue they earn they can amass more and more police and political power. Their family will become stronger than ours. Eventually they will come after us to take away what we have. It's just like countries. If they arm, we have to arm. If they become stronger economically, they become a threat to us. Now we have the gambling and we have the unions and right now they are the best things to have. But I think narcotics is the coming thing. I think we have to have a piece of that action or we risk everything we have. Not now, but maybe ten years from now.'

The Don seemed enormously impressed. He puffed on his cigar and murmured, 'That's the most important thing of course.' He sighed and got to his feet. 'What time do I have to meet this infidel tomorrow?'

Hagen said hopefully, 'He'll be here at ten in the morning.' Maybe the Don would go for it.

'I'll want you both here with me,' the Don said. He rose, stretching, and took his son by the arm. 'Santino, get some sleep tonight, you look like the devil himself. Take care of yourself, you won't be young forever.'

Sonny, encouraged by this sign of fatherly concern, asked the question Hagen did not dare to ask. 'Pop, what's your answer going to be?'

Don Corleone smiled. 'How do I know until I hear the percentages and other details? Besides I have to have time to think over the advice given here tonight. After all, I'm not a man who does things rashly.' As he went out the door he said casually to Hagen, 'Do you have in your notes that the Turk made his living from prostitution before the war? As the Tattaglia family does now. Write that down before you forget.' There was just a touch of derision in the Don's voice and Hagen flushed. He had deliberately not mentioned it, legitimately so since it really had no bearing, but he had feared it might prejudice the Don's decision. He was notoriously straitlaced in matters of sex.

Virgil 'the Turk' Sollozzo was a powerfully built, medium-sized man of dark complexion who could have been taken for a true Turk. He had a scimitar of a nose and cruel black eyes. He also had an impressive dignity.

Sonny Corleone met him at the door and brought him into the office where Hagen and the Don waited. Hagen thought he had never seen a more dangerous-looking man except for Luca Brasi.

There were polite handshakings all around. If the Don ever asks me if this man has balls, I would have to answer yes, Hagen thought. He had never seen such force in one man, not even the Don. In fact the Don appeared at his worst. He was being a little too simple, a little too peasantlike in his greeting.

Sollozzo came to the point immediately. The business was narcotics. Everything was set up. Certain poppy fields in Turkey had pledged him certain amounts every year. He had a protected plant in France to convert into morphine. He had an absolutely secure plant in Sicily to process into heroin. Smuggling into both countries was as positively safe as such

73

matters could be. Entry into the United States would entail about five per cent losses since the FBI itself was incorruptible, as they both knew. But the profits would be enormous, the risk nonexistent.

'Then why do you come to me?' the Don asked politely. 'How have I deserved your generosity?'

Sollozzo's dark face remained impassive. 'I need two million dollars cash,' he said. 'Equally important, I need a man who has powerful friends in the important places. Some of my couriers will be caught over the years. That is inevitable. They will all have clean records, that I promise. So it will be logical for judges to give light sentences. I need a friend who can guarantee that when my people get in trouble they won't spend more than a year or two in jail. Then they won't talk. But if they get ten and twenty years, who knows? In this world there are many weak individuals. They may talk, they may jeopardize more important people. Legal protection is a must. I hear, Don Corleone, that you have as many judges in your pocket as a bootblack has pieces of silver.'

Don Corleone didn't bother to acknowledge the compliment. 'What percentage for my family?' he asked.

Sollozzo's eyes gleamed. 'Fifty per cent.' He paused and then said in a voice that was almost a caress, 'In the first year your share would be three or four million dollars. Then it would go up.'

Don Corleone said, 'And what is the percentage of the Tattaglia family?'

For the first time Sollozzo seemed to be nervous. 'They will receive something from my share. I need some help in the operations.'

'So,' Don Corleone said, 'I receive fifty per cent merely for finance and legal protection. I have no worries about operations, is that what you tell me?'

Sollozzo nodded. 'If you think two million dollars in cash is "merely finance", I congratulate you, Don Corleone.'

The Don said quietly, 'I consented to see you out of my respect for the Tattaglias and because I've heard you are a serious man to be treated also with respect. I must say no to you but I must give you my reasons. The profits in your

business are huge but so are the risks. Your operation, if I were part of it, could damage my other interests. It's true I have many, many friends in politics, but they would not be so friendly if my business were narcotics instead of gambling. They think gambling is something like liquor, a harmless vice, and they think narcotics a dirty business. No, don't protest. I'm telling you their thoughts, not mine. How a man makes his living is not my concern. And what I am telling you is that this business of yours is too risky. All the members of my family have lived well the last ten years, without danger, without harm. I can't endanger them or their livelihoods out of greed.'

The only sign of Sollozzo's disappointment was a quick flickering of his eyes around the room, as if he hoped Hagen or Sonny would speak in his support. Then he said, 'Are you worried about security for your two million?'

The Don smiled coldly. 'No,' he said.

Sollozzo tried again. 'The Tattaglia family will guarantee your investment also.'

It was then that Sonny Corleone made an unforgivable error in judgement and procedure. He said eagerly, 'The Tattaglia family guarantees the return of our investment without any percentage from us?'

Hagen was horrified at this break. He saw the Don turn cold, malevolent eyes on his eldest son, who froze in uncomprehending dismay. Sollozzo's eyes flickered again but this time with satisfaction. He had discovered a chink in the Don's fortress. When the Don spoke his voice held a dismissal. 'Young people are greedy,' he said. 'And today they have no manners. They interrupt their elders. They meddle. But I have a sentimental weakness for my children and I have spoiled them. As you see. Signor Sollozzo, my no is final. Let me say that I myself wish you good fortune in your business. It has no conflict with my own. I'm sorry that I had to disappoint you.'

Sollozzo bowed, shook the Don's hand and let Hagen take him to his car outside. There was no expression on his face when he said goodbye to Hagen.

Back in the room, Don Corleone asked Hagen, 'What did you think of that man?'

'He's a Sicilian,' Hagen said dryly.

The Don nodded his head thoughtfully. Then he turned to his son and said gently, 'Santino, never let anyone outside the family know what you are thinking. Never let them know what you have under your fingernails. I think your brain is going soft from all that comedy you play with that young girl. Stop it and pay attention to business. Now get out of my sight.'

Hagen saw the surprise on Sonny's face, then anger at his father's reproach. Did he really think the Don would be ignorant of his conquest, Hagen wondered. And did he really not know what a dangerous mistake he had made this morning? If that were true, Hagen would never wish to be the *Consigliori* to the Don of Santino Corleone.

Don Corleone waited until Sonny had left the room. Then he sank back into his leather armchair and motioned brusquely for a drink. Hagen poured him a glass of anisette. The Don looked up at him. 'Send Luca Brasi to see me,' he said.

Three months later, Hagen hurried through the paper work in his city office hoping to leave early enough for some Christmas shopping for his wife and children. He was interrupted by a phone call from a Johnny Fontane bubbling with high spirits. The picture had been shot, the rushes, whatever the hell they were, Hagen thought, were fabulous. He was sending the Don a present for Christmas that would knock his eyes out, he'd bring it himself but there were some little things to be done in the movie. He would have to stay out on the Coast. Hagen tried to conceal his impatience. Johnny Fontane's charm had always been lost on him. But his interest was aroused. 'What is it?' he asked. Johnny Fontane chuckled and said, 'I can't tell, that's the best part of a Christmas present.' Hagen immediately lost all interest and finally managed, politely, to hang up.

Ten minutes later his secretary told him that Connie Corleone was on the phone and wanted to speak to him. Hagen sighed. As a young girl Connie had been nice, as a married woman she was a nuisance. She made complaints about her husband. She kept going home to visit her mother

76

for two or three days. And Carlo Rizzi was turning out to be a real loser. He had been fixed up with a nice little business and was running it into the ground. He was also drinking, whoring around, gambling, and beating his wife up occasionally. Connie hadn't told her family about that but she had told Hagen. He wondered what new tale of woe she had for him now.

But the Christmas spirit seemed to have cheered her up. She just wanted to ask Hagen what her father would really like for Christmas. And Sonny and Fred and Mike. She already knew what she would get her mother. Hagen made some suggestions, all of which she rejected as silly. Finally she let him go.

When the phone rang again, Hagen threw his papers back into the basket. The hell with it. He'd leave. It never occurred to him to refuse to take the call, however. When his secretary told him it was Michael Corleone he picked up the phone with pleasure. He had always liked Mike.

'Tom,' Michael Corleone said, 'I'm driving down to the city with Kay tomorrow. There's something important I want to tell the old man before Christmas. Will he be home tomorrow night?'

'Sure,' Hagen said. 'He's not going out of town until after Christmas. Anything I can do for you?'

Michael was as closemouthed as his father. 'No,' he said. 'I guess I'll see you Christmas, everybody is going to be out at Long Beach, right?'

'Right,' Hagen said. He was amused when Mike hung up on him without any small talk.

He told his secretary to call his wife and tell her he would be home a little late but to have some supper for him. Outside the building he walked briskly downtown towards Macy's. Someone stepped in his way. To his surprise he saw it was Sollozzo.

Sollozzo took him by the arm and said quietly, 'Don't be frightened, I just want to talk to you.' A car parked at the kerb suddenly had its door open. Sollozzo said urgently, 'Get in, I want to talk to you.'

Hagen pulled his arm loose. He was still not alarmed, just irritated. 'I haven't got time,' he said. At that moment two men came up behind him. Hagen felt a sudden weakness in his

legs. Sollozzo said softly, 'Get in the car. If I wanted to kill you you'd be dead now. Trust me.'

Without a shred of trust Hagen got into the car.

Michael Corleone had lied to Hagen. He was already in New York, and he had called from a room in the Hotel Pennsylvania less than ten blocks away. When he hung up the phone, Kay Adams put out her cigarette and said, 'Mike, what a good fibber you are.'

Michael sat down beside her on the bed. 'All for you, honey; if I told my family we were in town we'd have to go there right away. Then we couldn't go out to dinner, we couldn't go to the theatre, and we couldn't sleep together tonight. Not in my father's house, not when we're not married.' He put his arms around her and kissed her gently on the lips. Her mouth was sweet and he gently pulled her down on the bed. She closed her eyes, waiting for him to make love to her and Michael felt an enormous happiness. He had spent the war years fighting in the Pacific, and on those bloody islands he had dreamed of a girl like Kay Adams. Of a beauty like hers. A fair and fragile body, milky-skinned and electrified by passion. She opened her eyes and then pulled his head down to kiss him. They made love until it was time for dinner and the theatre.

After dinner they walked past the brightly-lit department stores full of holiday shoppers and Michael said to her, 'What shall I get you for Christmas?'

She pressed against him. 'Just you,' she said. 'Do you think your father will approve of me?'

Michael said gently, 'That's not really the question. Will your parents approve of me?'

Kay shrugged. 'I don't care,' she said.

Michael said, 'I even thought of changing my name, legally, but if something happened, that wouldn't really help. You sure you want to be a Corleone?' He said it only half-jokingly.

'Yes,' she said without smiling. They pressed against each other. They had decided to get married during Christmas week, a quiet civil ceremony at City Hall with just two friends

as witnesses. But Michael had insisted he must tell his father. He had explained that his father would not object in any way as long as it was not done in secrecy. Kay was doubtful. She said she could not tell her parents until after the marriage. 'Of course they'll think I'm pregnant,' she said. Michael grinned. 'So will my parents,' he said.

What neither of them mentioned was the fact that Michael would have to cut his close ties with his family. They both understood that Michael had already done so to some extent and yet they both felt guilty about this fact. They planned to finish college, seeing each other weekends and living together during summer vacations. It seemed like a happy life.

The play was a musical called *Carousel* and its sentimental story of a braggart thief made them smile at each other with amusement. When they came out of the theatre it had turned cold. Kay snuggled up to him and said, 'After we're married, will you beat me and then steal a star for a present?'

Michael laughed. 'I'm going to be a mathematics professor,' he said. Then he asked, 'Do you want something to eat before we go to the hotel?'

Kay shook her head. She looked up at him meaningfully. As always he was touched by her eagerness to make love. He smiled down at her, and they kissed in the cold street. Michael felt hungry, and he decided to order sandwiches sent up to the room.

In the hotel lobby Michael pushed Kay towards the news-stand and said, 'Get the papers while I get the key.' He had to wait in a small line; the hotel was still short of help despite the end of the war. Michael got his room key and looked around impatiently for Kay. She was standing by the news-stand, staring down at a newspaper she held in her hand. He walked towards her. She looked up at him. Her eyes were filled with tears. 'Oh, Mike,' she said, 'oh, Mike.' He took the paper from her hands. The first thing he saw was a photo of his father lying in the street, his head in a pool of blood. A man was sitting on the kerb weeping like a child. It was his brother Freddie. Michael Corleone felt his body turning to ice. There was no grief, no fear, just cold rage. He said to Kay, 'Go up to the room.' But he had to take her by the arm and

lead her into the elevator. They rode up together in silence. In their room, Michael sat down on the bed and opened the paper. The headlines said, VITO CORLEONE SHOT. ALLEGED RACKET CHIEF CRITICALLY WOUNDED. OPERATED ON UNDER HEAVY POLICE GUARD. BLOODY MOB WAR FEARED.

Michael felt the weakness in his legs. He said to Kay, 'He's not dead, the bastards didn't kill him.' He read the story again. His father had been shot at five in the afternoon. That meant that while he had been making love to Kay, having dinner, enjoying the theatre, his father was near death. Michael felt sick with guilt.

Kay said, 'Shall we go down to the hospital now?'

Michael shook his head. 'Let me call the house first. The people who did this are crazy and now that the old man's still alive they'll be desperate. Who the hell knows what they'll pull next.'

Both phones in the Long Beach house were busy and it was almost twenty minutes before Michael could get through. He heard Sonny's voice saying, 'Yeah.'

'Sonny, it's me,' Michael said.

He could hear the relief in Sonny's voice. 'Jesus, kid, you had us worried. Where the hell are you? I've sent people to that hick town of yours to see what happened.'

'How's the old man?' Michael said. 'How bad is he hurt?'

'Pretty bad,' Sonny said. 'They shot him five times. But he's tough.' Sonny's voice was proud. 'The doctors said he'll pull through. Listen, kid, I'm busy, I can't talk, where are you?'

'In New York,' Michael said. 'Didn't Tom tell you I was coming down?'

Sonny's voice dropped a little. 'They've snatched Tom. That's why I was worried about you. His wife is here. She don't know and neither do the cops. I don't want them to know. The bastards who pulled this must be crazy. I want you to get out here right away and keep your mouth shut. OK?'

'OK,' Mike said, 'do you know who did it?'

'Sure,' Sonny said. 'And as soon as Luca Brasi checks in they're gonna be dead meat. We still have all the horses.'

'I'll be out in an hour,' Mike said. 'In a cab.' He hung up.

The papers had been on the streets for over three hours. There must have been radio news reports. It was almost impossible that Luca hadn't heard the news. Thoughtfully Michael pondered the question. Where was Luca Brasi? It was the same question that Hagen was asking himself at that moment. It was the same question that was worrying Sonny Corleone out in Long Beach.

At a quarter to five that afternoon, Don Corleone had finished checking the papers the office manager of his olive oil company had prepared for him. He put on his jacket and rapped his knuckles on his son Freddie's head to make him take his nose out of the afternoon newspaper. 'Tell Gatto to get the car from the lot,' he said. 'I'll be ready to go home in a few minutes.'

Freddie grunted. 'I'll have to get it myself. Paulie called in sick this morning. Got a cold again.'

Don Corleone looked thoughtful for a moment. 'That's the third time this month. I think maybe you'd better get a healthier fellow for this job. Tell Tom.'

Fred protested. 'Paulie's a good kid. If he says he's sick, he's sick. I don't mind getting the car.' He left the office. Don Corleone watched out the window as his son crossed Ninth Avenue to the parking lot. He stopped to call Hagen's office but there was no answer. He called the house at Long Beach but again there was no answer. Irritated, he looked out the window. His car was parked at the kerb in front of his building. Freddie was leaning against the fender, arms folded, watching the throng of Christmas shoppers. Don Corleone put on his jacket. The office manager helped him with his overcoat. Don Corleone grunted his thanks and went out the door and started down the two flights of steps.

Out in the street the early winter light was failing. Freddie leaned casually against the fender of the heavy Buick. When he saw his father come out of the building Freddie went out into the street to the driver's side of the car and got in. Don Corleone was about to get in on the sidewalk side of the car when he hesitated and then turned back to the long open fruit stand near the corner. This had been his habit lately, he loved

the big out-of-season fruits, yellow peaches and oranges, that glowed in their green boxes. The proprietor sprang to serve him. Don Corleone did not handle the fruit. He pointed. The fruit man disputed his decisions only once, to show him that one of his choices had a rotten underside. Don Corleone took the paper bag in his left hand and paid the man with a five-dollar bill. He took his change and, as he turned to go back to the waiting car, two men stepped from around the corner. Don Corleone knew immediately what was to happen.

The two men wore black overcoats and black hats pulled low to prevent identification by witnesses. They had not expected Don Corleone's alert reaction. He dropped the bag of fruit and darted towards the parked car with startling quickness for a man of his bulk. At the same time he shouted, 'Fredo, Fredo.' It was only then that the two men drew their guns and fired.

The first bullet caught Don Corleone in the back. He felt the hammer shock of its impact but made his body move towards the car. The next two bullets hit him in the buttocks and sent him sprawling in the middle of the street. Meanwhile the two gunmen, careful not to slip on the rolling fruit, started to follow in order to finish him off. At that moment, perhaps no more than five seconds after the Don's call to his son, Frederico Corleone appeared out of his car, looming over it. The gunmen fired two more hasty shots at the Don lying in the gutter. One hit him in the fleshy part of his arm and the second hit him in the calf of his right leg. Though these wounds were the least serious they bled profusely, forming small pools of blood beside his body. But by this time Don Corleone had lost consciousness.

Freddie had heard his father shout, calling him by his childhood name, and then he had heard the first two loud reports. By the time he got out of the car he was in shock, he had not even drawn his gun. The two assassins could easily have shot him down. But they too panicked. They must have known the son was armed, and besides too much time had passed. They disappeared around the corner, leaving Freddie alone in the street with his father's bleeding body. Many of the people thronging the avenue had flung themselves into doorways

or on the ground, others had huddled together in small groups.

Freddie still had not drawn his weapon. He seemed stunned. He stared down at his father's body lying face down on the tarred street, lying now in what seemed to him a blackish lake of blood. Freddie went into physical shock. People eddied out again and someone, seeing him start to sag, led him to the kerbstone and made him sit down on it. A crowd gathered around Don Corleone's body, a circle that shattered when the first police car sirened a path through them. Directly behind the police was the *Daily News* radio car and even before it stopped a photographer jumped out to snap pictures of the bleeding Don Corleone. A few moments later an ambulance arrived. The photographer turned his attention to Freddie Corleone, who was now weeping openly, and this was a curiously comical sight, because of his tough, Cupid-featured face, heavy nose and thick mouth smeared with snot. Detectives were spreading through the crowd and more police cars were coming up. One detective knelt beside Freddie, questioning him, but Freddie was too deep in shock to answer. The detective reached inside Freddie's coat and lifted his wallet. He looked at the identification inside and whistled to his partner. In just a few seconds Freddie had been cut off from the crowd by a flock of plainclothesmen. The first detective found Freddie's gun in its shoulder holster and took it. Then they lifted Freddie off his feet and shoved him into an un-marked car. As that car pulled away it was followed by the *Daily News* radio car. The photographer was still snapping pictures of everybody and everything.

In the half hour after the shooting of his father, Sonny Corleone received five phone calls in rapid succession. The first was from Detective John Phillips, who was on the family payroll and had been in the lead car of plainclothesmen at the scene of the shooting. The first thing he said to Sonny over the phone was, 'Do you recognize my voice?'

'Yeah,' Sonny said. He was fresh from a nap, called to the phone by his wife.

Phillips said quickly without preamble, 'Somebody shot

your father outside his place. Fifteen minutes ago. He's alive but hurt bad. They've taken him to French Hospital. They got your brother Freddie down at the Chelsea precinct. You better get him a doctor when they turn him loose. I'm going down to the hospital now to help question your old man, if he can talk. I'll keep you posted.'

Across the table, Sonny's wife Sandra noticed that her husband's face had gone red with flushing blood. His eyes were glazed over. She whispered, 'What's the matter?' He waved at her impatiently to shut up, swung his body away so that his back was towards her and said into the phone, 'You sure he's alive?'

'Yeah, I'm sure,' the detective said. 'A lot of blood but I think maybe he's not as bad as he looks.'

'Thanks,' Sonny said. 'Be home tomorrow morning eight sharp. You got a grand coming.'

Sonny cradled the phone. He forced himself to sit still. He knew that his greatest weakness was his anger and this was one time when anger could be fatal. The first thing to do was get Tom Hagen. But before he could pick up the phone, it rang. The call was from the bookmaker licensed by the Family to operate in the district of the Don's office. The bookmaker had called to tell him that the Don had been killed, shot dead in the street. After a few questions to make sure that the bookmaker's informant had not been close to the body, Sonny dismissed the information as incorrect. Phillips' dope would be more accurate. The phone rang almost immediately a third time. It was a reporter from the *Daily News*. As soon as he identified himself, Sonny Corleone hung up.

He dialled Hagen's house and asked Hagen's wife, 'Did Tom come home yet?' She said, 'No,' that he was not due for another twenty minutes but she expected him home for supper. 'Have him call me,' Sonny said.

He tried to think things out. He tried to imagine how his father would react in a like situation. He had known immediately that this was an attack by Sollozzo, but Sollozzo would never have dared to eliminate so high-ranking a leader as the Don unless he was backed by other powerful people. The phone, ringing for the fourth time, interrupted his thoughts.

The voice on the other end was very soft, very gentle. 'Santino Corleone?' it asked.

'Yeah,' Sonny said.

'We have Tom Hagen,' the voice said. 'In about three hours he'll be released with our proposition. Don't do anything rash until you've heard what he has to say. You can only cause a lot of trouble. What's done is done. Everybody has to be sensible now. Don't lose that famous temper of yours.' The voice was slightly mocking. Sonny couldn't be sure, but it sounded like Sollozzo. He made his voice sound muted, depressed. 'I'll wait,' he said. He heard the receiver on the other end click. He looked at his heavy gold-banded wristwatch and noted the exact time of the call and jotted it down on the table-cloth.

He sat at the kitchen table, frowning. His wife asked, 'Sonny, what is it?' He told her calmly. 'They shot the old man.' When he saw the shock on her face he said roughly, 'Don't worry, he's not dead. And nothing else is going to happen.' He did not tell her about Hagen. And then the phone rang for the fifth time.

It was Clemenza. The fat man's voice came wheezing over the phone in gruntlike gasps. 'You hear about your father?' he asked.

'Yeah,' Sonny said. 'But he's not dead.' There was a long pause over the phone and then Clemenza's voice came packed with emotion, 'Thank God, thank God.' Then anxiously, 'You sure? I got word he was dead in the street.'

'He's alive,' Sonny said. He was listening intently to every intonation in Clemenza's voice. The emotion had seemed genuine but it was part of the fat man's profession to be a good actor.

'You'll have to carry the ball, Sonny,' Clemenza said. 'What do you want me to do?'

'Get over to my father's house,' Sonny said. 'Bring Paulie Gatto.'

'That's all?' Clemenza asked. 'Don't you want me to send some people to the hospital and your place?'

'No, I just want you and Paulie Gatto,' Sonny said. There was a long pause. Clemenza was getting the message. To make

it a little more natural, Sonny asked, 'Where the hell was Paulie anyway? What the hell was he doing?'

There was no longer any wheezing on the other end of the line. Clemenza's voice was guarded. 'Paulie was sick, he had a cold, so he stayed home. He's been a little sick all winter.'

Sonny was instantly alert. 'How many times did he stay home the last couple of months?'

'Maybe three or four times,' Clemenza said. 'I always asked Freddie if he wanted another guy but he said no. There's been no cause, the last ten years things been smooth, you know.'

'Yeah,' Sonny said. 'I'll see you at my father's house. Be sure you bring Paulie. Pick him up on your way over. I don't care how sick he is. You got that?' He slammed down the phone without waiting for an answer.

His wife was weeping silently. He stared at her for a moment, then said in a harsh voice, 'Any of our people call, tell them to get me in my father's house on his special phone. Anybody else call, you don't know nothing. If Tom's wife calls, tell her that Tom won't be home for a while, he's on business.'

He pondered for a moment. 'A couple of our people will come to stay here.' He saw her look of fright and said impatiently, 'You don't have to be scared, I just want them here. Do whatever they tell you to do. If you wanta talk to me, get me on Pop's special phone but don't call me unless it's really important. And don't worry.' He went out of the house.

Darkness had fallen and the December wind whipped through the mall. Sonny had no fear about stepping out into the night. All eight houses were owned by Don Corleone. At the mouth of the mall the two houses on either side were rented by family retainers with their own families and star boarders, single men who lived in the basement apartments. Of the remaining six houses that formed the rest of the half circle, one was inhabited by Tom Hagen and his family, his own, and the smallest and least ostentatious by the Don himself. The other three houses were given rent-free to retired friends of the Don with the understanding that they would be

vacated whenever he requested. The harmless-looking mall was an impregnable fortress.

All eight houses were equipped with floodlights which bathed the grounds around them and made the mall impossible to lurk in. Sonny went across the street to his father's house and let himself inside with his own key. He yelled out, 'Ma, where are you?' and his mother came out of the kitchen. Behind her rose the smell of frying peppers. Before she could say anything, Sonny took her by the arm and made her sit down. 'I just got a call,' he said. 'Now don't get worried. Pop's in the hospital, he's hurt. Get dressed and get ready to get down there. I'll have a car and a driver for you in a little while. OK?'

His mother looked at him steadily for a moment and then asked in Italian, 'Have they shot him?'

Sonny nodded. His mother bowed her head for a moment. Then she went back into the kitchen. Sonny followed her. He watched her turn off the gas under the panful of peppers and then go out and up to the bedroom. He took peppers from the pan and bread from the basket on the table and made a sloppy sandwich with hot olive oil dripping from his fingers. He went into the huge corner room that was his father's office and took the special phone from a locked cabinet box. The phone had been especially installed and was listed under a phony name and a phony address. The first person he called was Luca Brasi. There was no answer. Then he called the safety-valve *caporegime* in Brooklyn, a man of unquestioned loyalty to the Don. This man's name was Tessio. Sonny told him what had happened and what he wanted. Tessio was to recruit fifty absolutely reliable men. He was to send guards to the hospital, he was to send men out to Long Beach to work there. Tessio asked, 'Did they get Clemenza too?' Sonny said, 'I don't want to use Clemenza's people right now.' Tessio understood immediately, there was a pause, and then he said, 'Excuse me, Sonny, I say this as your father would say it. Don't move too fast. I can't believe Clemenza would betray us.'

'Thanks,' Sonny said. 'I don't think so but I have to be careful. Right?'

'Right,' Tessio said.

'Another thing,' Sonny said. 'My kid brother Mike goes to college in Hanover, New Hampshire. Get some people we know in Boston to go up and get him and bring him down here to the house until this blows over. I'll call him up so he'll expect them. Again I'm just playing the percentages, just to make sure.'

'OK,' Tessio said, 'I'll be over your father's house as soon as I get things rolling. OK? You know my boys, right?'

'Yeah,' Sonny said. He hung up. He went over to a small wall safe and unlocked it. From it he took an indexed book bound in blue leather. He opened it to the T's until he found the entry he was looking for. It read, 'Ray Farrell $5,000 Christmas Eve.' This was followed by a telephone number. Sonny dialled the number and said, 'Farrell?' The man on the other end answered, 'Yes.' Sonny said, 'This is Santino Corleone. I want you to do me a favour and I want you to do it right away. I want you to check two phone numbers and give me all the calls they got and all the calls they made for the last three months.' He gave Farrell the number of Paulie Gatto's home and Clemenza's home. Then he said, 'This is important. Get it to me before midnight and you'll have an extra very Merry Christmas.'

Before he settled back to think things out he gave Luca Brasi's number one more call. Again there was no answer. This worried him but he put it out of his mind. Luca would come to the house as soon as he heard the news. Sonny leaned back in the swivel chair. In an hour the house would be swarming with Family people and he would have to tell them all what to do, and now that he finally had time to think he realized how serious the situation was. It was the first challenge to the Corleone Family and their power in ten years. There was no doubt that Sollozzo was behind it, but he would never have dared attempt such a stroke unless he had support from at least one of the five great New York families. And that support must have come from the Tattaglias. Which meant a full-scale war or an immediate settlement on Sollozzo's terms. Sonny smiled grimly. The wily Turk had planned well but he had been unlucky. The old man was alive and so it was war. With Luca Brasi and the resources of the Corleone Family there

could be but one outcome. But again the nagging worry.
Where was Luca Brasi?

CHAPTER THREE

COUNTING the driver, there were four men in the car with
Hagen. They put him in the back seat, in the middle of the two
men who had come up behind him in the street. Sollozzo sat
up front. The man on Hagen's right reached over across his
body and tilted Hagen's hat over his eyes so that he could not
see. 'Don't even move your pinkie,' he said.

It was a short ride, not more than twenty minutes and when
they got out of the car Hagen could not recognize the neigh-
bourhood because darkness had fallen. They led him into a
basement apartment and made him sit on a straight-backed
kitchen chair. Sollozzo sat across the kitchen table from him.
His dark face had a peculiarly vulterine look.

'I don't want you to be afraid,' he said. 'I know you're not
in the muscle end of the Family. I want you to help the
Corleones and I want you to help me.'

Hagen's hands were shaking as he put a cigarette in his
mouth. One of the men brought a bottle of rye to the table and
gave him a slug of it in a china coffee cup. Hagen drank the
fiery liquid gratefully. It steadied his hands and took the
weakness out of his legs.

'Your boss is dead,' Sollozzo said. He paused, surprised at
the tears that sprang to Hagen's eyes. Then he went on. 'We
got him outside his office, in the street. As soon as I got the
word, I picked you up. You have to make the peace between
me and Sonny.'

Hagen didn't answer. He was surprised at his own grief.
And the feeling of desolation mixed with his fear of
death. Sollozzo was speaking again. 'Sonny was hot for my deal.
Right? You know it's the smart thing to do too. Narcotics is
the coming thing. There's so much money in it that everybody
can get rich just in a couple of years. The Don was an old

"Moustache Pete", his day was over but he didn't know it. Now he's dead, nothing can bring him back. I'm ready to make a new deal, I want you to talk Sonny into taking it.'

Hagen said, 'You haven't got a chance. Sonny will come after you with everything he's got.'

Sollozzo said impatiently, 'That's gonna be his first reaction. You have to talk some sense to him. The Tattaglia Family stand behind me with all their people. The other New York Families will go along with anything that will stop a full-scale war between us. Our war has to hurt them and their businesses. If Sonny goes along with the deal, the other Families in the country will consider it none of their affair, even the Don's oldest friends.'

Hagen stared down at his hands, not answering. Sollozzo went on persuasively, 'The Don was slipping. In the old days I could never have got to him. The other Families distrust him because he made you his *Consigliori* and you're not even Italian, much less Sicilian. If it goes to all-out war the Corleone Family will be smashed and everybody loses, me included. I need the Family political contacts more than I need the money even. So talk to Sonny, talk to the *caporegimes*; you'll save a lot of bloodshed.'

Hagen held out his china cup for more whisky. 'I'll try,' he said. 'But Sonny is strong-headed. And even Sonny won't be able to call off Luca. You have to worry about Luca. *I'll* have to worry about Luca if I go for your deal.'

Sollozzo said quietly, 'I'll take care of Luca. You take care of Sonny and the other two kids. Listen, you can tell them that Freddie would have got it today with his old man but my people had strict orders not to gun him. I didn't want any more hard feelings than necessary. You can tell them that, Freddie is alive because of me.'

Finally Hagen's mind was working. For the first time he really believed that Sollozzo did not mean to kill him or hold him as a hostage. The sudden relief from fear that flooded his body made him flush with shame. Sollozzo watched him with a quiet understanding smile. Hagen began to think things out. If he did not agree to argue Sollozzo's case, he might be killed. But then he realized that Sollozzo expected him only to

present it and present it properly, as he was bound to do as a responsible *Consigliori*. And now, thinking about it, he also realized that Sollozzo was right. An unlimited war between the Tattaglias and the Corleones must be avoided at all costs. The Corleones must bury their dead and forget, make a deal. And then when the time was right they could move against Sollozzo.

But glancing up, he realized that Sollozzo knew exactly what he was thinking. The Turk was smiling. And then it struck Hagen. What had happened to Luca Brasi that Sollozzo was so unconcerned? Had Luca made a deal? He remembered that on the night Don Corleone had refused Sollozzo, Luca had been summoned into the office for a private conference with the Don. But now was not the time to worry about such details. He had to get back to the safety of the Corleone Family fortress in Long Beach. 'I'll do my best,' he said to Sollozzo. 'I believe you're right, it's even what the Don would want us to do.'

Sollozzo nodded gravely. 'Fine,' he said. 'I don't like bloodshed, I'm a businessman and blood costs too much money.' At that moment the phone rang and one of the men sitting behind Hagen went to answer it. He listened and then said curtly, 'OK, I'll tell him.' He hung up the phone, went to Sollozzo's side and whispered in the Turk's ear. Hagen saw Sollozzo's face go pale, his eyes glitter with rage. He himself felt a thrill of fear. Sollozzo was looking at him speculatively and suddenly Hagen knew that he was no longer going to be set free. That something had happened that might mean his death. Sollozzo said, 'The old man is still alive. Five bullets in his Sicilian hide and he's still alive.' He gave a fatalistic shrug. 'Bad luck,' he said to Hagen. 'Bad luck for me. Bad luck for you.'

CHAPTER FOUR

WHEN Michael Corleone arrived at his father's house in Long Beach he found the narrow entrance mouth of the mall blocked off with a link chain. The mall itself was bright with

the floodlights of all eight houses, outlining at least ten cars parked along the curving cement walk.

Two men he didn't know were leaning against the chain. One of them asked in a Brooklyn accent, 'Who're you?'

He told them. Another man came out of the nearest house and peered at his face. 'That's the Don's kid,' he said. 'I'll bring him inside.' Mike followed this man to his father's house, where two men at the door let him and his escort pass inside.

The house seemed to be full of men he didn't know, until he went into the living room. There Michael saw Tom Hagen's wife, Theresa, sitting stiffly on the sofa, smoking a cigarette. On the coffee table in front of her was a glass of whisky. On the other side of the sofa sat the bulky Clemenza. The *caporegime*'s face was impassive, but he was sweating and the cigar in his hand glistened slickly black with his saliva.

Clemenza came to wring his hand in a consoling way, muttering, 'Your mother is at the hospital with your father, he's going to be all right.' Paulie Gatto stood up to shake hands. Michael looked at him curiously. He knew Paulie was his father's bodyguard but did not know that Paulie had stayed home sick that day. But he sensed tension in the thin dark face. He knew Gatto's reputation as an up-and-coming man, a very quick man who knew how to get delicate jobs done without complications, and today he had failed in his duty. He noticed several other men in the corners of the room but he did not recognize them. They were not of Clemenza's people. Michael put these facts together and understood. Clemenza and Gatto were suspect. Thinking that Paulie had been at the scene, he asked the ferret-faced young man, 'How is Freddie? He OK?'

'The doctor gave him a shot,' Clemenza said. 'He's sleeping.'

Michael went to Hagen's wife and bent down to kiss her cheek. They had always liked each other. He whispered, 'Don't worry, Tom will be OK. Have you talked to Sonny yet?'

Theresa clung to him for a moment and shook her head. She was a delicate, very pretty woman, more American than

Italian, and very scared. He took her hand and lifted her off the sofa. Then he led her into his father's corner room office.

Sonny was sprawled out in his chair behind the desk holding a yellow pad in one hand and a pencil in the other. The only other man in the room with him was the *caporegime* Tessio, whom Michael recognized and immediately realized that it must be his men who were in the house and forming the new palace guard. He too had a pencil and pad in his hands.

When Sonny saw them he came from behind his desk and took Hagen's wife in his arms. 'Don't worry, Theresa,' he said. 'Tom's OK. They just wanta give him the proposition, they said they'd turn him loose. He's not on the operating end, he's just our lawyer. There's no reason for anybody to do him harm.'

He released Theresa and then to Michael's surprise he, too, got a hug and a kiss on the cheek. He pushed Sonny away and said grinning, 'After I get used to you beating me up I gotta put up with this?' They had often fought when they were younger.

Sonny shrugged. 'Listen, kid, I was worried when I couldn't get ahold of you in that hick town. Not that I gave a crap if they knocked you off, but I didn't like the idea of bringing the news to the old lady. I had to tell her about Pop.'

'How'd she take it?' Michael asked.

'Good,' Sonny said. 'She's been through it before. Me too. You were too young to know about it and then things got pretty smooth while you were growing up.' He paused and then said, 'She's down at the hospital with the old man. He's gonna pull through.'

'How about us going down?' Michael asked.

Sonny shook his head and said dryly, 'I can't leave this house until it's all over.' The phone rang. Sonny picked it up and listened intently. While he was listening Michael sauntered over to the desk and glanced down at the yellow pad Sonny had been writing on. There was a list of seven names. The first three were Sollozzo, Phillip Tattaglia, and John Tattaglia. It struck Michael with full force that he had interrupted Sonny and Tessio as they were making up a list of men to be killed.

When Sonny hung up the phone he said to Theresa Hagen

and Michael, 'Can you two wait outside? I got some business with Tessio we have to finish.'

Hagen's wife said, 'Was that call about Tom?' She said it almost truculently but she was weeping with fright. Sonny put his arm around her and led her to the door. 'I swear he's going to be OK,' he said. 'Wait in the living room. I'll come out as soon as I hear something.' He shut the door behind her. Michael had sat down in one of the big leather armchairs. Sonny gave him a quick sharp look and then went to sit down behind the desk.

'You hang around me, Mike,' he said, 'you're gonna hear things you don't wanta hear.'

Michael lit a cigarette. 'I can help out,' he said.

'No, you can't,' Sonny said. 'The old man would be sore as hell if I let you get mixed up in this.'

Michael stood up and yelled. 'You lousy bastard, he's my father. I'm not supposed to help him? I can help. I don't have to go out and kill people but I can help. Stop treating me like a kid brother. I was in the war. I got shot, remember? I killed some Japs. What the hell do you think I'll do when you knock somebody off? Faint?'

Sonny grinned at him. 'Pretty soon you'll want me to put up my dukes. OK, stick around, you can handle the phone.' He turned to Tessio. 'That call I just got gave me dope we needed.' He turned to Michael. 'Somebody had to finger the old man. It could have been Clemenza, it could have been Paulie Gatto, who was very conveniently sick today. I know the answer now, let's see how smart you are, Mike, you're the college boy. Who sold out to Sollozzo?'

Michael sat down again and relaxed back into the leather armchair. He thought everything over very carefully. Clemenza was a *caporegime* in the Corleone Family structure. Don Corleone had made him a millionaire and they had been intimate friends for over twenty years. He held one of the most powerful posts in the organization. What could Clemenza gain for betraying his Don? More money? He was rich enough but then men are always greedy. More power? Revenge for some fancied insult or slight? That Hagen had been made the *Consigliori*? Or perhaps a businessman's conviction that

94

Sollozzo would win out? No, it was impossible for Clemenza to be a traitor, and then Michael thought sadly it was only impossible because he didn't want Clemenza to die. The fat man had always brought him gifts when he was growing up, had sometimes taken him on outings when the Don had been too busy. He could not believe that Clemenza was guilty of treachery.

But, on the other hand, Sollozzo would want Clemenza in his pocket more than any other man in the Corleone Family.

Michael thought about Paulie Gatto. Paulie as yet had not become rich. He was well thought of, his rise in the organization was certain but he would have to put in his time like everybody else. Also he would have wilder dreams of power, as the young always do. It had to be Paulie. And then Michael remembered that in the sixth grade he and Paulie had been in the same class in school and he didn't want it to be Paulie either.

He shook his head. 'Neither one of them,' he said. But he said it only because Sonny had said he had the answer. If it had been a vote, he would have voted Paulie guilty.

Sonny was smiling at him. 'Don't worry,' he said. 'Clemenza is OK. It's Paulie.'

Michael could see that Tessio was relieved. As a fellow *caporegime* his sympathy would be with Clemenza. Also the present situation was not so serious if treachery did not reach so high. Tessio said cautiously, 'Then I can send my people home tomorrow?'

Sonny said, 'The day after tomorrow. I don't want anybody to know about this until then. Listen, I want to talk some family business with my brother, personal. Wait out in the living room, eh? We can finish our list later. You and Clemenza will work together on it.'

'Sure,' Tessio said. He went out.

'How do you know for sure it's Paulie?' Michael asked.

Sonny said, 'We have people in the telephone company and they tracked down all of Paulie's phone calls in and out. Clemenza's too. On the three days Paulie was sick this month he got a call from a street booth across from the old man's building. Today too. They were checking to see if

Paulie was coming down or somebody was being sent down to take his place. Or for some other reason. It doesn't matter.' Sonny shrugged. 'Thank God it was Paulie. We'll need Clemenza bad.'

Michael asked hesitantly, 'Is it going to be an all-out war?'

Sonny's eyes were hard. 'That's how I'm going to play it as soon as Tom checks in. Until the old man tells me different.'

Michael asked, 'So why don't you wait until the old man can tell you?'

Sonny looked at him curiously. 'How the hell did you win those combat medals? We are under the gun, man, we gotta fight. I'm just afraid they won't let Tom go.'

Michael was surprised at this. 'Why not?'

Again Sonny's voice was patient. 'They snatched Tom because they figured the old man was finished and they could make a deal with me and Tom would be the sit-down guy in the preliminary stages, carry the proposition. Now with the old man alive they know I can't make a deal so Tom's no good to them. They can turn him loose or dump him, depending how Sollozzo feels. If they dump him, it would be just to show us they really mean business, trying to bulldoze us.'

Michael said quietly, 'What made Sollozzo think he could get a deal with you?'

Sonny flushed and he didn't answer for a moment. Then he said, 'We had a meeting a few months ago, Sollozzo came to us with a proposition on drugs. The old man turned him down. But during the meeting I shot off my mouth a little, I showed I wanted the deal. Which is absolutely the wrong thing to do; if there's one thing the old man hammered into me it's never to do a thing like that, to let other people know there's a split of opinion in the Family. So Sollozzo figures he gets rid of the old man, I have to go in with him on the drugs. With the old man gone, the Family power is cut at least in half. I would be fighting for my life anyway to keep all the businesses the old man got together. Drugs are the coming thing, we should get into it. And his knocking off the old man is purely business, nothing personal. As a matter of business I would go in with him. Of course he would never let me get too close, he'd make sure I'd never get a clean shot at him, just

in case. But he also knows that once I accepted the deal the other Families would never let me start a war a couple of years later just for revenge. Also, the Tattaglia Family is behind him.'

'If they had got the old man, what would you have done?' Michael asked.

Sonny said very simply, 'Sollozzo is dead meat. I don't care what it costs. I don't care if we have to fight all the five Families in New York. The Tattaglia Family is going to be wiped out. I don't care if we all go down together.'

Michael said softly, 'That's not how Pop would have played it.'

Sonny made a violent gesture. 'I know I'm not the man he was. But I'll tell you this and he'll tell you too. When it comes to real action I can operate as good as anybody, short-range. Sollozzo knows that and so do Clemenza and Tessio. I "made my bones" when I was nineteen, the last time the Family had a war, and I was a big help to the old man. So I'm not worried now. And our Family has all the horses in a deal like this. I just wish we could get contact with Luca.'

Michael asked curiously, 'Is Luca that tough, like they say? Is he that good?'

Sonny nodded. 'He's in a class by himself. I'm going to send him after the three Tattaglias. I'll get Sollozzo myself.'

Michael shifted uneasily in his chair. He looked at his older brother. He remembered Sonny as being sometimes casually brutal but essentially warmhearted. A nice guy. It seemed unnatural to hear him talking this way, it was chilling to see the list of names he had scribbled down, men to be executed, as if he were some newly crowned Roman Emperor. He was glad that he was not truly part of all this, that now his father lived he did not have to involve himself in vengeance. He'd help out, answering the phone, running errands and messages. Sonny and the old man could take care of themselves, especially with Luca behind them.

At that moment they heard a woman scream in the living room. Oh, Christ, Michael thought, it sounded like Tom's wife. He rushed to the door and opened it. Everybody in the living room was standing. And by the sofa Tom Hagen was

holding Theresa close to him, his face embarrassed. Theresa was weeping and sobbing, and Michael realized that the scream he had heard had been her calling out her husband's name with joy. As he watched, Tom Hagen disentangled himself from his wife's arms and lowered her back onto the sofa. He smiled at Michael grimly. 'Glad to see you, Mike, really glad.' He strode into the office without another look at his still-sobbing wife. He hadn't lived with the Corleone Family ten years for nothing, Michael thought with a queer flush of pride. Some of the old man had rubbed off on him, as it had on Sonny, and he thought, with surprise, even on himself.

CHAPTER FIVE

IT WAS nearly four o'clock in the morning as they all sat in the corner room office – Sonny, Michael, Tom Hagen, Clemenza, and Tessio. Theresa Hagen had been persuaded to go to her own home next door. Paulie Gatto was still waiting in the living room, not knowing that Tessio's men had been instructed not to let him leave or let him out of their sight.

Tom Hagen relayed the deal Sollozzo offered: He told how after Sollozzo had learned the Don still lived, it was obvious that he meant to kill Hagen. Hagen grinned. 'If I ever plead before the Supreme Court, I'll never plead better than I did with that goddamn Turk tonight. I told him I'd talk the Family into the deal even though the Don was alive. I told him I could wrap you around my finger, Sonny. How we were buddies as kids; and don't get sore, but I let him get the idea that maybe you weren't too sorry about getting the old man's job, God forgive me.' He smiled apologetically at Sonny, who made a gesture signifying that he understood, that it was of no consequence.

Michael, leaning back in his armchair with the phone at his right hand, studied both men. When Hagen had entered the

room Sonny had come rushing to embrace him. Michael realized with a faint twinge of jealousy that in many ways Sonny and Tom Hagen were closer than he himself could ever be to his own brother.

'Let's get down to business,' Sonny said. 'We have to make plans. Take a look at this list me and Tessio made up. Tessio, give Clemenza your copy.'

'If we make plans,' Michael said, 'Freddie should be here.'

Sonny said grimly, 'Freddie is no use to us. The doctor says he's in shock so bad he has to have complete rest. I don't understand that. Freddie was always a pretty tough guy. I guess seeing the old man gunned down was hard on him, he always thought the Don was God. He wasn't like you and me, Mike.'

Hagen said quickly, 'OK, leave Freddie out. Leave him out of everything, absolutely everything. Now, Sonny, until this is all over I think you should stay in the house. I mean never leave it. You're safe here. Don't underrate Sollozzo, he's got to be a *pezzonovante*, a real .90 calibre. Is the hospital covered?'

Sonny nodded. 'The cops have it locked in and I got my people there visiting Pop all the time. What do you think of that list, Tom?'

Hagen frowned down at the list of names. 'Jesus Christ, Sonny, you're really taking this personal. The Don would consider it a purely business dispute. Sollozzo is the key. Get rid of Sollozzo and everything falls in line. You don't have to go after the Tattaglias.'

Sonny looked at his two *caporegimes*. Tessio shrugged. 'It's tricky,' he said. Clemenza didn't answer at all.

Sonny said to Clemenza, 'One thing we can take care of without discussion. I don't want Paulie around here any more. Make that first on your list.' The fat *caporegime* nodded.

Hagen said, 'What about Luca? Sollozzo didn't seem worried about Luca. That *worries me*. If Luca sold us out, we're in real trouble. That's the first thing we have to know. Has anybody been able to get in touch with him?'

'No,' Sonny said. 'I've been calling him all night. Maybe he's shacked up.'

'No,' Hagen said. 'He never sleeps over with a broad. He

99

always goes home when he's through. Mike, keep ringing his number until you get an answer.' Michael dutifully picked up the phone and dialled. He could hear the phone ringing on the other end but no one answered. Finally he hung up. 'Keep trying every fifteen minutes,' Hagen said.

Sonny said impatiently, 'OK, Tom you're the *Consigliori*, how about some advice? What the hell do you think we should do?'

Hagen helped himself to the whisky bottle on the desk. 'We negotiate with Sollozzo until your father is in shape to take charge. We might even make a deal if we have to. When your father gets out of bed he can settle the whole business without a fuss and all the Families will go along with him.'

Sonny said angrily, 'You think I can't handle this guy Sollozzo?'

Tom Hagen looked him directly in the eye. 'Sonny, sure you can outfight him. The Corleone Family has the power. You have Clemenza and Tessio here and they can muster a thousand men if it comes to an all-out war. But at the end there will be a shambles over the whole East Coast and all the other Families will blame the Corleones. We'll make a lot of enemies. And that's something your father never believed in.'

Michael, watching Sonny, thought he took this well. But then Sonny said to Hagen, 'What if the old man dies, what do you advise then, *Consigliori*?'

Hagen said quietly, 'I know you won't do it, but I would advise you to make a real deal with Sollozzo on the drugs. Without your father's political contacts and personal influence the Corleone Family loses half its strength. Without your father, the other New York Families might wind up supporting the Tattaglias and Sollozzo just to make sure there isn't a long destructive war. If your father dies, make the deal. Then wait and see.'

Sonny was white-faced with anger. 'That's easy for you to say, it's not your father they killed.'

Hagen said quickly and proudly, 'I was as good a son to him as you or Mike, maybe better. I'm giving you a professional opinion. Personally I want to kill all those bastards.' The emotion in his voice shamed Sonny, who said, 'Oh,

Christ, Tom, I didn't mean it that way.' But he had, really. Blood was blood and nothing else was its equal.

Sonny brooded for a moment as the others waited in embarrassed silence. Then he sighed and spoke quietly. 'OK, we'll sit tight until the old man can give us the lead. But, Tom, I want you to stay inside the mall, too. Don't take any chances. Mike, you be careful, though I don't think even Sollozzo would bring personal family into the war. Everybody would be against him then. But be careful. Tessio, you hold your people in reserve but have them nosing around the city. Clemenza, after you settle the Paulie Gatto thing, you move your men into the house and the mall to replace Tessio's people. Tessio, you keep your men at the hospital, though. Tom, start negotiation over the phone or by messenger with Sollozzo and the Tattaglias the first thing in the morning. Mike, tomorrow you take a couple of Clemenza's people and go to Luca's house and wait for him to show up or find out where the hell he is. That crazy bastard might be going after Sollozzo right now if he's heard the news. I can't believe he'd ever go against his Don, no matter what the Turk offered him.'

Hagen said reluctantly, 'Maybe Mike shouldn't get mixed up in this so directly.'

'Right,' Sonny said. 'Forget that, Mike. Anyway I need you on the phone here in the house, that's more important.'

Michael didn't say anything. He felt awkward, almost ashamed, and he noticed Clemenza and Tessio with faces so carefully impassive that he was sure that they were hiding their contempt. He picked up the phone and dialled Luca Brasi's number and kept the receiver to his ear as it rang and rang.

CHAPTER SIX

PETER CLEMENZA slept badly that night. In the morning he got up early and made his own breakfast of a glass of *grappa*, a thick slice of Genoa salami with a chunk of fresh Italian bread

that was still delivered to his door as in the old days. Then he drank a great, plain china mug filled with hot coffee that had been laced with anisette. But as he padded about the house in his old bathrobe and red felt slippers he pondered on the day's work that lay ahead of him. Last night Sonny Corleone had made it very clear that Paulie Gatto was to be taken care of immediately. It had to be today.

Clemenza was troubled. Not because Gatto had been his protégé and had turned traitor. This did not reflect on the *caporegime*'s judgement. After all, Paulie's background had been perfect. He came from a Sicilian family, he had grown up in the same neighbourhood as the Corleone children, had indeed even gone to school with one of the sons. He had been brought up through each level in the proper manner. He had been tested and not found wanting. And then after he had 'made his bones' he had received a good living from the Family, a percentage of an East Side 'book' and a union payroll slot. Clemenza had not been unaware that Paulie Gatto supplemented his income with freelance stick ups, strictly against the Family rules, but even this was a sign of the man's worth. The breaking of such regulations was considered a sign of high-spiritedness, like that shown by a fine racing horse fighting the reins.

And Paulie had never caused trouble with his stick ups. They had always been meticulously planned and carried out with the minimum of fuss and trouble, with no one ever getting hurt: a three-thousand-dollar Manhattan garment centre payroll, a small chinaware factory payroll in the slums of Brooklyn. After all, a young man could always use some extra pocket money. It was all in the pattern. Who could ever foretell that Paulie Gatto would turn traitor?

What was troubling Peter Clemenza this morning was an administrative problem. The actual execution of Gatto was a cut-and-dried chore. The problem was, who should the *caporegime* bring up from the ranks to replace Gatto in the Family? It was an important promotion, that to 'button' man, one not to be handed out lightly. The man had to be tough and he had to be smart. He had to be safe, not a person that would talk to the police if he got in trouble, one well saturated in the

Sicilians' law of *omerta*, the law of silence. And then, what kind of a living would he receive for his new duties? Clemenza had several times spoken to the Don about better rewards for the all-important button man who was first in the front line when trouble arose, but the Don had put him off. If Paulie had been making more money, he might have been able to resist the blandishments of the wily Turk, Sollozzo.

Clemenza finally narrowed down the list of candidates to three men. The first was an enforcer who worked with the coloured policy bankers in Harlem, a big brawny brute of a man of great physical strength, a man with a great deal of personal charm who could get along with people and yet when necessary make them go in fear of him. But Clemenza scratched him off the list after considering his name for a half hour. This man got along too well with the black people, which hinted at some flaw of character. Also he would be too hard to replace in the position he now held.

The second name Clemenza considered and almost settled on was a hard-working chap who served faithfully and well in the organization. This man was the collector of delinquent accounts for Family-licensed shylocks in Manhattan. He had started off as a bookmaker's runner. But he was not quite yet ready for such an important promotion.

Finally he settled on Rocco Lampone. Lampone had served a short but impressive apprenticeship in the Family. During the war he had been wounded in Africa and been discharged in 1943. Because of the shortage of young men, Clemenza had taken him on even though Lampone was partially incapacitated by his injuries and walked with a pronounced limp. Clemenza had used him as a black-market contact in the garment centre and with government employees controlling OPA food stamps. From that, Lampone had graduated to troubleshooter for the whole operation. What Clemenza liked about him was his good judgement. He knew that there was no percentage in being tough about something that would only cost a heavy fine or six months in jail, small prices to pay for the enormous profits earned. He had the good sense to know that it was not an area for heavy threats but light ones. He kept the whole operation in a minor key, which was exactly what was needed.

Clemenza felt the relief of a conscientious administrator who has solved a knotty personnel problem. Yes, it would be Rocco Lampone who would assist. For Clemenza planned to handle this job himself, not only to help a new, inexperienced man 'make his bones', but to settle a personal score with Paulie Gatto. Paulie had been his protégé, he had advanced Paulie over the heads of more deserving and more loyal people, he had helped Paulie 'make his bones' and furthered his career in every way. Paulie had not only betrayed the Family, he had betrayed his *padrone*, Peter Clemenza. This lack of respect had to be repaid.

Everything else was arranged. Paulie Gatto had been instructed to pick him up at three in the afternoon, and to pick him up with his own car, nothing hot. Now Clemenza took up the telephone and dialled Rocco Lampone's number. He did not identify himself. He simply said, 'Come to my house, I have an errand for you.' He was pleased to note that despite the early hour, Lampone's voice was not surprised or dazed with sleep and he simply said, 'OK.' Good man. Clemenza added, 'No rush, have your breakfast and lunch first before you come see me. But not later than two in the afternoon.'

There was another laconic OK on the other end and Clemenza hung up the phone. He had already alerted his people about replacing *caporegime* Tessio's people in the Corleone mall so that was done. He had capable subordinates and never interfered in a mechanical operation of that kind.

He decided to wash his Cadillac. He loved the car. It gave him such a quiet peaceful ride, and its upholstery was so rich that he sometimes sat in it for an hour when the weather was good because it was more pleasant than sitting in the house. And it always helped him think when he was grooming the car. He remembered his father in Italy doing the same thing with donkeys.

Clemenza worked inside the heated garage, he hated cold. He ran over his plans. You had to be careful with Paulie, the man was like a rat, he could smell danger. And now of course despite being so tough he must be shitting in his pants because the old man was still alive. He'd be as skittish as a donkey with

ants up his ass. But Clemenza was accustomed to these cir-cumstances, usual in his work. First, he had to have a good excuse for Rocco to accompany them. Second, he had to have a plausible mission for the three of them to go on.

Of course, strictly speaking, this was not necessary. Paulie Gatto could be killed without any of these frills. He was locked in, he could not run away. But Clemenza felt strongly that it was important to keep good working habits and never give away a fraction of a percentage point. You never could tell what might happen and these matters were, after all, questions of life and death.

As he washed his baby-blue Cadillac, Peter Clemenza pon-dered and rehearsed his lines, the expressions of his face. He would be curt with Paulie, as if displeased with him. With a man so sensitive and suspicious as Gatto this would throw him off the track or at least leave him uncertain. Undue friendliness would make him wary. But of course the curtness must not be too angry. It had to be rather an absentminded sort of irritation. And why Lampone? Paulie would find that most alarming, especially since Lampone had to be in the rear seat. Paulie wouldn't like being helpless at the wheel with Lampone behind his head. Clemenza rubbed and polished the metal of his Cadillac furiously. It was going to be tricky. Very tricky. For a moment he debated whether to recruit another man but decided against it. Here he followed basic reasoning. In years to come a situation might arise where it might be profitable for one of his partners to testify against him. If there were just one accomplice it was one's word against the other. But the word of a second accomplice could swing the balance. No, they would stick to procedure.

What annoyed Clemenza was that the execution had to be 'public'. That is, the body was to be found. He would have much preferred having it disappear. (Usual burying grounds were the nearby ocean or the swamplands of New Jersey on land owned by friends of the Family or by other more complic-ated methods.) But it had to be public so that embryo traitors would be frightened and the enemy warned that the Corleone Family had by no means gone stupid or soft. Sollozzo would be made wary by this quick discovery of his spy. The Corleone

Family would win back some of its prestige. It had been made to look foolish by the shooting of the old man.

Clemenza sighed. The Cadillac gleamed like a huge blue steel egg, and he was nowhere near the solving of his problem. Then the solution hit him, logical and to the point. It would explain Rocco Lampone, himself, and Paulie being together and give them a mission of sufficient secrecy and importance.

He would tell Paulie that their job today was to find an apartment in case the Family decided to 'go to the mattresses'.

Whenever a war between the Families became bitterly intense, the opponents would set up headquarters in secret apartments where the 'soldiers' could sleep on mattresses scattered through the rooms. This was not so much to keep their families out of danger, their wives and little children, since any attack on noncombatants was undreamed of. All parties were too vulnerable to similar retaliation. But it was always smarter to live in some secret place where your everyday movements could not be charted either by your opponents or by some police who might arbitrarily decide to meddle.

And so usually a trusted *caporegime* would be sent out to rent a secret apartment and fill it with mattresses. That apartment would be used as a sally port into the city when an offensive was mounted. It was natural for Clemenza to be sent on such an errand. It was natural for him to take Gatto and Lampone with him to arrange all the details, including the furnishing of the apartment. Also, Clemenza thought with a grin, Paulie Gatto had proved he was greedy and the first thought that would pop into his head was how much he could get from Sollozzo for this valuable intelligence.

Rocco Lampone arrived early and Clemenza explained what had to be done and what their roles would be. Lampone's face lit up with surprised gratitude and he thanked Clemenza respectfully for the promotion allowing him to serve the Family. Clemenza was sure he had done well. He clapped Lampone on the shoulder and said, 'You'll get something better for your living after today. We'll talk about that later. You understand the Family now is occupied with more critical matters, more important things to do.' Lampone made a

gesture that said he would be patient, knowing his reward was certain.

Clemenza went to his den's safe and opened it. He took out a gun and gave it to Lampone. 'Use this one,' he said. 'They can never trace it. Leave it in the car with Paulie. When this job is finished I want you to take your wife and children on a vacation to Florida. Use your own money now and I'll pay you back later. Relax, get the sun. Use the Family hotel in Miami Beach so I'll know where I can get you when I want.'

Clemenza's wife knocked on the door of the den to tell them that Paulie Gatto had arrived. He was parked in the driveway. Clemenza led the way through the garage and Lampone followed him. When Clemenza got into the front seat with Gatto he merely grunted in greeting, an exasperated look on his face. He looked at the wrist watch as if he expected to find that Gatto was late.

The ferret-faced button man was watching him intently, looking for a clue. He flinched a little when Lampone got into the rear seat behind him and said, 'Rocco, sit on the other side. A big guy like you blocks up my rear-view mirror.' Lampone shifted dutifully so that he was sitting behind Clemenza, as if such a request was the most natural thing in the world.

Clemenza said sourly to Gatto, 'Damn that Sonny, he's running scared. He's already thinking of going to the mattresses. We have to find a place on the West Side. Paulie, you and Rocco gotta staff and supply it until the word comes down for the rest of the soldiers to use it. You know a good location?'

As he had expected, Gatto's eyes became greedily interested. Paulie had swallowed the bait and because he was thinking how much the information was worth to Sollozzo, he was forgetting to think about whether he was in danger. Also, Lampone was acting his part perfectly, staring out the window in a disinterested, relaxed way. Clemenza congratulated himself on his choice.

Gatto shrugged. 'I'd have to think about it,' he said.

Clemenza grunted. 'Drive while you think, I want to get to New York today.'

Paulie was an expert driver and traffic going into the city

was light at this time in the afternoon, so the early winter darkness was just beginning to fall when they arrived. There was no small talk in the car. Clemenza directed Paulie to drive up to the Washington Heights section. He checked a few apartment buildings and told him to park near Arthur Avenue and wait. He also left Rocco Lampone in the car. He went into the Vera Mario Restaurant and had a light dinner of veal and salad, nodding his hello's to some acquaintances. After an hour had gone by he walked the several blocks to where the car was parked and entered it. Gatto and Lampone were still waiting. 'Shit,' Clemenza said, 'they want us back in Long Beach. They got some other job for us now. Sonny says we can let this one go until later. Rocco, you live in the city, can we drop you off?'

Rocco said quietly, 'I have my car out at your place and my old lady needs it first thing in the morning.'

'That's right,' Clemenza said. 'Then you have to come back with us, after all.'

Again on the ride back to Long Beach nothing was said. On the stretch of road that led into the city, Clemenza said suddenly, 'Paulie, pull over, I gotta take a leak.' From working together so long, Gatto knew the fat *caporegime* had a weak bladder. He had often made such a request. Gatto pulled the car off the highway into the soft earth that led to the swamp. Clemenza climbed out of the car and took a few steps into the bushes. He actually relieved himself. Then as he opened the door to get back into the car he took a quick look up and down the highway. There were no lights, the road was completely dark. 'Go ahead,' Clemenza said. A second later the interior of the car reverberated with the report of a gun. Paulie Gatto seemed to jump forward, his body flinging against the steering wheel and then slumping over to the seat. Clemenza had stepped back hastily to avoid being hit with fragments of skull bone and blood.

Rocco Lampone scrambled out of the back seat. He still held the gun and he threw it into the swamp. He and Clemenza walked hastily to a car parked nearby and got in. Lampone reached underneath the seat and found the key that had been left for them. He started the car and drove Clemenza to his

home. Then instead of going back by the same route, he took the Jones Beach Causeway right on through to the town of Merrick and onto the Meadowbrook Parkway until he reached the Northern State Parkway. He rode that to the Long Island Expressway and then continued on to the Whitestone Bridge and through the Bronx to his home in Manhattan.

CHAPTER SEVEN

ON THE night before the shooting of Don Corleone, his strongest and most loyal and most feared retainer prepared to meet with the enemy. Luca Brasi had made contact with the forces of Sollozzo several months before. He had done so on the orders of Don Corleone himself. He had done so by frequenting the nightclubs controlled by the Tattaglia Family and by taking up with one of their top call girls. In bed with this call girl he grumbled about how he was held down in the Corleone Family, how his worth was not recognized. After a week of this affair with the call girl, Luca was approached by Bruno Tattaglia, manager of the nightclub. Bruno was the youngest son, and ostensibly not connected with the Family business of prostitution. But his famous nightclub with its dancing line of long-stemmed beauties was the finishing school for many of the city hookers.

The first meeting was all above-board, Tattaglia offering him a job to work in the Family business as enforcer. The flirtation went on for nearly a month. Luca played his role of man infatuated with a young beautiful girl, Bruno Tattaglia the role of a businessman trying to recruit an able executive from a rival. At one such meeting, Luca pretended to be swayed, then said, 'But one thing must be understood. I will never go against the Godfather. Don Corleone is a man I respect. I understand that he must put his sons before me in the Family business.'

Bruno Tattaglia was one of the new generation with a barely hidden contempt for the old Moustache Petes like Luca Brasi,

Don Corleone, and even his own father. He was just a little too respectful. Now he said, 'My father wouldn't expect you to do anything against the Corleones. Why should he? Everybody gets along with everybody else now, it's not like the old days. It's just that if you're looking for a new job, I can pass along the word to my father. There's always need for a man like you in our business. It's a hard business and it needs hard men to keep it running smooth. Let me know if you ever make up your mind.'

Luca shrugged. 'It's not so bad where I'm at.' And so they left it.

The general idea had been to lead the Tattaglias to believe that he knew about the lucrative narcotics operation and that he wanted a piece of it freelance. In that fashion he might hear something about Sollozzo's plans if the Turk had any, or whether he was getting ready to step on the toes of Don Corleone. After waiting for two months with nothing else happening, Luca reported to the Don that obviously Sollozzo was taking his defeat graciously. The Don had told him to keep trying but merely as a sideline, not to press it.

Luca had dropped into the nightclub the evening before Don Corleone's being shot. Almost immediately Bruno Tattaglia had come to his table and sat down.

'I have a friend who wants to talk to you,' he said.

'Bring him over,' Luca said. 'I'll talk to any friend of yours.'

'No,' Bruno said. 'He wants to see you in private.'

'Who is he?' Luca asked.

'Just a friend of mine,' Bruno Tattaglia said. 'He wants to put a proposition to you. Can you meet him later on tonight?'

'Sure,' Luca said. 'What time and where?'

Tattaglia said softly, 'The club closes at four in the morning. Why don't you meet in here while the waiters are cleaning up?'

They knew his habits, Luca thought, they must have been checking him out. He usually got up about three or four in the afternoon and had breakfast, then amused himself by gambling with cronies in the Family or had a girl. Sometimes he saw one of the midnight movies and then would drop in for a drink at one of the clubs. He never went to bed before dawn. So the

suggestion of a four A M meeting was not as outlandish as it seemed.

'Sure, sure,' he said. 'I'll be back at four.' He left the club and caught a cab to his furnished room on Tenth Avenue. He boarded with an Italian family to which he was distantly related. His two rooms were separated from the rest of their railroad flat by a special door. He liked the arrangement because it gave him some family life and also protection against surprise where he was most vulnerable.

The sly Turkish fox was going to show his bushy tail, Luca thought. If things went far enough, if Sollozzo committed himself tonight, maybe the whole thing could be wound up as a Christmas present for the Don. In his room, Luca unlocked the trunk beneath the bed and took out a bulletproof vest. It was heavy. He undressed and put it on over his woollen under-wear, then put his shirt and jacket over it. He thought for a moment of calling the Don's house at Long Beach to tell him of this new development but he knew the Don never talked over the phone, to anyone, and the Don had given him this assignment in secret and so did not want anyone, not even Hagen or his eldest son, to know about it.

Luca always carried a gun. He had a licence to carry a gun, probably the most expensive gun licence ever issued any place, any time. It had cost a total of ten thousand dollars but it would keep him out of jail if he was frisked by the cops. As a top executive operating official of the Family he rated the licence. But tonight, just in case he could finish off the job, he wanted a 'safe' gun. One that could not possibly be traced. But then thinking the matter over, he decided that he would just listen to the proposition tonight and report back to the Godfather, Don Corleone.

He made his way back to the club but he did not drink any more. Instead he wandered out to 48th Street, where he had a leisurely late supper at Patsy's, his favourite Italian restaurant. When it was time for his appointment he drifted uptown to the club entrance. The doorman was no longer there when he went in. The hat-check girl was gone. Only Bruno Tattaglia waited to greet him and lead him to the deserted bar at the side of the room. Before him he could see the desert of small tables

with the polished yellow wood dance floor gleaming like a small diamond in the middle of them. In the shadows was the empty bandstand, out of it grew the skeleton metal stalk of a microphone.

Luca sat at the bar and Bruno Tattaglia went behind it. Luca refused the drink offered to him and lit a cigarette. It was possible that this would turn out to be something else, not the Turk. But then he saw Sollozzo emerge out of the shadows at the far end of the room.

Sollozzo shook his hand and sat at the bar next to him. Tattaglia put a glass in front of the Turk, who nodded his thanks. 'Do you know who I am?' asked Sollozzo.

Luca nodded. He smiled grimly. The rats were being flushed out of their holes. It would be his pleasure to take care of this renegade Sicilian.

'Do you know what I am going to ask of you?' Sollozzo asked.

Luca shook his head.

'There's big business to be made,' Sollozzo said. 'I mean millions for everybody at the top level. On the first shipment I can guarantee you fifty thousand dollars. I'm talking about drugs. It's the coming thing.'

Luca said, 'Why come to me? You want me to talk to my Don?'

Sollozzo grimaced. 'I've already talked to the Don. He wants no part of it. All right, I can do without him. But I need somebody strong to protect the operation physically. I understand you're not happy with your Family, you might make a switch.'

Luca shrugged. 'If the offer is good enough.'

Sollozzo had been watching him intently and seemed to have come to a decision. 'Think about my offer for a few days and then we'll talk again,' he said. He put out his hand but Luca pretended not to see it and busied himself putting a cigarette in his mouth. Behind the bar, Bruno Tattaglia made a lighter appear magically and held it to Luca's cigarette. And then he did a strange thing. He dropped the lighter on the bar and grabbed Luca's right hand, holding it tight.

Luca reacted instantly, his body slipping off the bar stool

and trying to twist away. But Sollozzo had grabbed his other hand at the wrist. Still, Luca was too strong for both of them and would have broken free except that a man stepped out of the shadows behind him and threw a thin silken cord around his neck. The cord pulled tight, choking off Luca's breath. His face became purple, the strength in his arms drained away. Tattaglia and Sollozzo held his hands easily now, and they stood there curiously childlike as the man behind Luca pulled the cord around Luca's neck tighter and tighter. Suddenly the floor was wet and slippery. Luca's sphincter, no longer under control, opened, the waste of his body spilled out. There was no strength in him any more and his legs folded, his body sagged. Sollozzo and Tattaglia let his hands go and only the strangler stayed with the victim, sinking to his knees to follow Luca's falling body, drawing the cord so tight that it cut into the flesh of the neck and disappeared. Luca's eyes were bulging out of his head as if in the utmost surprise and this surprise was the only humanity remaining to him. He was dead.

'I don't want him found,' Sollozzo said. 'It's important that he not be found right now.' He turned on his heel and left, disappearing back into the shadows.

CHAPTER EIGHT

THE DAY after the shooting of Don Corleone was a busy time for the Family. Michael stayed by the phone relaying messages to Sonny. Tom Hagen was busy trying to find a mediator satisfactory to both parties so that a conference could be arranged with Sollozzo. The Turk had suddenly become cagey, perhaps he knew that the Family button men of Clemenza and Tessio were ranging far and wide over the city in an attempt to pick up his trail. But Sollozzo was sticking close to his hideout, as were all top members of the Tattaglia Family. This was expected by Sonny, an elementary precaution he knew the enemy was bound to take.

Clemenza was tied up with Paulie Gatto. Tessio had been given the assignment of trying to track down the whereabouts of Luca Brasi. Luca had not been home since the night before the shooting, a bad sign. But Sonny could not believe that Brasi had either turned traitor or had been taken by surprise.

Mama Corleone was staying in the city with friends of the Family so that she could be near the hospital. Carlo Rizzi, the son-in-law, had offered his services but had been told to take care of his own business that Don Corleone had set him up in, a lucrative bookmaking territory in the Italian section of Manhattan. Connie was staying with her mother in town so that she too could visit her father in the hospital.

Freddie was still under sedation in his own room of his parents' house. Sonny and Michael had paid him a visit and had been astonished at his paleness, his obvious illness. 'Christ,' Sonny said to Michael when they left Freddie's room, 'he looks like he got plugged worse than the old man.'

Michael shrugged. He had seen soldiers in the same condition on the battlefield. But he had never expected it to happen to Freddie. He remembered the middle brother as being physically the toughest one in the family when all of them were kids. But he had also been the most obedient son to his father. And yet everyone knew that the Don had given up on this middle son ever being important to the business. He wasn't quite smart enough, and failing that, not quite ruthless enough. He was too retiring a person, did not have enough force.

Late in the afternoon, Michael got a call from Johnny Fontane in Hollywood. Sonny took the phone. 'Nah, Johnny, no use coming back here to see the old man. He's too sick and it would give you a lot of bad publicity, and I know the old man wouldn't like that. Wait until he's better and we can move him home, then come see him. OK, I'll give him your regards.' Sonny hung up the phone. He turned to Michael and said, 'That'll make Pop happy, that Johnny wanted to fly from California to see how he was.'

Late that afternoon, Michael was called to the listed phone in the kitchen by one of Clemenza's men. It was Kay.

'Is your father all right?' she asked. Her voice was a little

strained, a little unnatural. Michael knew that she couldn't quite believe what had happened, that his father really was what the newspapers called a gangster.

'He'll be OK,' Michael said.

'Can I come with you when you visit him in the hospital?' Kay asked.

Michael laughed. She had remembered him telling her how important it was to do such things if you wanted to get along with the old Italians. 'This is a special case,' he said. 'If the newspaper guys get a hold of your name and background you'll be on page three of the *Daily News*. Girl from old Yankee family mixed up with son of big Mafia chief. How would your parents like that?'

Kay said dryly, 'My parents never read the *Daily News*.' Again there was an awkward pause and then she said, 'You're OK, aren't you, Mike, you're not in any danger?'

Mike laughed again. 'I'm known as the sissy of the Corleone family. No threat. So they don't have to bother coming after me. No, it's all over, Kay, there won't be any more trouble. It was all sort of an accident anyway. I'll explain when I see you.'

'When will that be?' she asked.

Michael pondered. 'How about late tonight? We'll have a drink and supper in your hotel and then I'll go to the hospital and see my old man. I'm getting tired of hanging around here answering phones. OK? But don't tell anybody. I don't want newspaper photographers snapping pictures of us together. No kidding, Kay, it's damned embarrassing, especially for your parents.'

'All right,' Kay said. 'I'll be waiting. Can I do any Christmas shopping for you? Or anything else?'

'No,' Michael said. 'Just be ready.'

She gave a little excited laugh. 'I'll be ready,' she said. 'Aren't I always?'

'Yes, you are,' he said. 'That's why you're my best girl.'

'I love you,' she said. 'Can you say it?'

Michael looked at the four hoods sitting in the kitchen. 'No,' he said. 'Tonight, OK?'

'OK,' she said. He hung up.

Clemenza had finally come back from his day's work and was bustling around the kitchen cooking up a huge pot of tomato sauce. Michael nodded to him and went to the corner office where he found Hagen and Sonny waiting for him impatiently. 'Is Clemenza out there?' Sonny asked.

Michael grinned. 'He's cooking up spaghetti for the troops, just like the army.'

Sonny said impatiently, 'Tell him to cut out that crap and come on in here. I have more important things for him to do. Get Tessio in here with him.'

In a few minutes they were all gathered in the office. Sonny said curtly to Clemenza, 'You take care of him?'

Clemenza nodded. 'You won't see him any more.'

With a slight electric shock, Michael realized they were talking about Paulie Gatto and that little Paulie was dead, murdered by that jolly wedding dancer, Clemenza.

Sonny asked Hagen, 'You have any luck with Sollozzo?'

Hagen shook his head. 'He seems to have cooled off on the negotiation idea. Anyway he doesn't seem to be too anxious. Or maybe he's just being very careful so that our button men won't nail him. Anyway I haven't been able to set up a top-notch go-between he'll trust. But he must know he has to negotiate now. He missed his chance when he let the old man get away from him.'

Sonny said, 'He's a smart guy, the smartest our Family ever came up against. Maybe he figured we're just stalling until the old man gets better or we can get a line on him.'

Hagen shrugged. 'Sure, he figures that. But he still has to negotiate. He has no choice. I'll get it set up tomorrow. That's certain.'

One of Clemenza's men knocked on the office door and then came in. He said to Clemenza, 'It just came over the radio, the cops found Paulie Gatto. Dead in his car.'

Clemenza nodded and said to the man, 'Don't worry about it.' The button man gave his *caporegime* an astonished look, which was followed by a look of comprehension, before he went back to the kitchen.

The conference went on as if there had been no interruption. Sonny asked Hagen, 'Any change in the Don's condition?'

Hagen shook his head. 'He's OK but he won't be able to talk for another couple of days. He's all knocked out. Still recovering from the operation. Your mother spends most of the day with him, Connie too. There's cops all over the hospital and Tessio's men hang around too, just in case. In a couple of days he'll be all right and then we can see what he wants us to do. Meanwhile we have to keep Sollozzo from doing anything rash. That's why I want to start you talking deals with him.'

Sonny grunted. 'Until he does, I've got Clemenza and Tessio looking for him. Maybe we'll get lucky and solve the whole business.'

'You won't get lucky,' Hagen said. 'Sollozzo is too smart.' Hagen paused. 'He knows once he comes to the table he'll have to go our way mostly. That's why he's stalling. I'm guessing he's trying to line up support from the other New York Families so that we won't go after him when the old man gives us the word.'

Sonny frowned. 'Why the hell should they do that?'

Hagen said patiently, 'To avert a big war which hurts everybody and brings the papers and government into the act. Also, Sollozzo will give them a piece of the action. And you know how much dough there is in drugs. The Corleone Family doesn't need it, we have the gambling, which is the best business to have. But the other Families are hungry. Sollozzo is a proven man, they know he can make the operation go on a big scale. Alive he's money in their pockets, dead he's trouble.'

Sonny's face was as Michael had never seen it. The heavy Cupid mouth and bronzed skin seemed grey. 'I don't give a fuck what they want. They better not mess in this fight.'

Clemenza and Tessio shifted uneasily in their chairs, infantry leaders who hear their general rave about storming an impregnable hill no matter what the cost. Hagen said a little impatiently, 'Come on, Sonny, your father wouldn't like you thinking that way. You know what he always says, "That's a waste." Sure, we're not going to let anybody stop us if the old man says we go after Sollozzo. But this is not a personal thing, this is business. If we go after the Turk and the Families interfere, we'll negotiate the issue. If the Families see that we're

determined to have Sollozzo, they'll let us. The Don will make concessions in other areas to square things. But don't go blood crazy on a thing like this. It's business. Even the shooting of your father was business, not personal. You should know that by now.'

Sonny's eyes were still hard. 'OK, I understand all that. Just so long as you understand that nobody stands in our way when we want Sollozzo.'

Sonny turned to Tessio. 'Any leads on Luca?'

Tessio shook his head. 'None at all. Sollozzo must have snatched him.'

Hagen said quietly, 'Sollozzo wasn't worried about Luca, which struck me as funny. He's too smart not to worry about a guy like Luca. I think he maybe got him out of the picture, one way or the other.'

Sonny muttered, 'Christ, I hope Luca isn't fighting against us. That's the one thing I'd be afraid of. Clemenza, Tessio, how do you two guys figure it?'

Clemenza said slowly, 'Anybody could go wrong, look at Paulie. But with Luca, he was a man who could only go one way. The Godfather was the only thing he believed in, the only man he feared. But not only that, Sonny, he respected your father as no one else respected him and the Godfather has earned respect from everyone. No, Luca would never betray us. And I find it hard to believe that a man like Sollozzo, no matter how cunning, could surprise Luca. He was a man who suspected everyone and everything. He was always ready for the worst. I think maybe he just went off some place for a few days. We'll be hearing from him any time now.'

Sonny turned to Tessio. The Brooklyn *caporegime* shrugged. 'Any man can turn traitor. Luca was very touchy. Maybe the Don offended him some way. That could be. I think though that Sollozzo gave him a little surprise. That fits in with what the *Consigliori* says. We should expect the worst.'

Sonny said to all of them, 'Sollozzo should get the word soon about Paulie Gatto. How will that affect him?'

Clemenza said grimly, 'It will make him think. He will know the Corleone Family are not fools. He will realize that he was very lucky yesterday.'

Sonny said sharply, 'That wasn't luck. Sollozzo was planning that for weeks. They must have tailed the old man to his office every day and watched his routine. Then they bought Paulie off and maybe Luca. They snatched Tom right on the button. They did everything they wanted to do. They were unlucky, not lucky. Those button men they hired weren't good enough and the old man moved too quick. If they had killed him, I would have had to make a deal and Sollozzo would have won. For now. I would have waited maybe and got him five, ten years from now. But don't call him lucky, Pete, that's underrating him. And we've done that too much lately.'

One of the button men brought a bowl of spaghetti in from the kitchen and then some plates, forks and wine. They ate as they talked. Michael watched in amazement. He didn't eat and neither did Tom, but Sonny, Clemenza and Tessio dug in, mopping up sauce with crusts of bread. It was almost comical. They continued their discussion.

Tessio didn't think that the loss of Paulie Gatto would upset Sollozzo, in fact he thought that the Turk might have anticipated it, indeed might have welcomed it. A useless mouth off the payroll. And he would not be frightened by it; after all, would they be in such a situation?

Michael spoke up diffidently. 'I know I'm an amateur in this, but from everything you guys have said about Sollozzo, plus the fact that all of a sudden he's out of touch with Tom, I'd guess he has an ace up his sleeve. He might be ready to pull off something real tricky that would put him back on top. If we could figure out what that would be, we'd be in the driver's seat.'

Sonny said reluctantly, 'Yeah, I thought of that and the only thing I can figure is Luca. The word is already out that he's to be brought here before he's allowed any of his old rights in the Family. The only other thing I can think of is that Sollozzo has made his deal with the Families in New York and we'll get the word tomorrow that they will be against us in a war. That we'll have to give the Turk his deal. Right, Tom?'

Hagen nodded. 'That's what it looks like to me. And we can't move against that kind of opposition without your father. He's the only one who can stand against the Families.

He has the political connexions they always need and he can use them for trading. If he wants to badly enough.'

Clemenza said a little arrogantly for a man whose top button man had recently betrayed him, 'Sollozzo will never get near this house, Boss, you don't have to worry about that.'

Sonny looked at him thoughtfully for a moment. Then he said to Tessio, 'How about the hospital, your men got it covered?'

For the first time during the conference Tessio seemed to be absolutely sure of his ground. 'Outside and inside,' he said. 'Right around the clock. The cops have it covered pretty good too. Detectives at the bedroom door waiting to question the old man. That's a laugh. The Don is still getting that stuff in the tubes, no food, so we don't have to worry about the kitchen, which would be something to worry about with those Turks, they believe in poison. They can't get at the Don, not in any way.'

Sonny tilted back in his chair. 'It wouldn't be me, they have to do business with me, they need the Family machine.' He grinned at Michael. 'I wonder if it's you? Maybe Sollozzo figures to snatch you and hold you for a hostage to make a deal.'

Michael thought ruefully, there goes my date with Kay. Sonny wouldn't let him out of the house. But Hagen said impatiently, 'No, he could have snatched Mike any time if he wanted insurance. But everybody knows that Mike is not in the Family business. He's a civilian and if Sollozzo snatches him, then he loses all the other New York Families. Even the Tattaglias would have to help hunt him down. No, it's simple enough. Tomorrow we'll get a representative from all the Families who'll tell us we have to do business with the Turk. That's what he's waiting for. That's his ace in the hole.'

Michael heaved a sigh of relief. 'Good,' he said. 'I have to go into town tonight.'

'Why?' Sonny asked sharply.

Michael grinned. 'I figure I'll drop in to the hospital and visit the old man, see Mom and Connie. And I got some other things to do.' Like the Don, Michael never told his real

business and now he didn't want to tell Sonny he was seeing Kay Adams. There was no reason not to tell him, it was just habit.

There was a loud murmur of voices in the kitchen. Clemenza went out to see what was happening. When he came back he was holding Luca Brasi's bulletproof vest in his hands. Wrapped in the vest was a huge dead fish.

Clemenza said dryly, 'The Turk has heard about his spy Paulie Gatto.'

Tessio said just as dryly, 'And now we know about Luca Brasi.'

Sonny lit a cigar and took a shot of whisky. Michael, bewildered, said, 'What the hell does that fish mean?' It was Hagen the Irisher, the *Consigliori*, who answered him. 'The fish means that Luca Brasi is sleeping on the bottom of the ocean,' he said. 'It's an old Sicilian message.'

CHAPTER NINE

WHEN Michael Corleone went into the city that night it was with a depressed spirit. He felt that he was being enmeshed in the Family business against his will and he resented Sonny using him even to answer the phone. He felt uncomfortable being on the inside of the Family councils as if he could be absolutely trusted with such secrets as murder. And now, going to see Kay, he felt guilty about her also. He had never been completely honest with her about his family. He had told her about them but always with little jokes and colourful anecdotes that made them seem more like adventurers in a Technicolour movie than what they really were. And now his father had been shot down in the street and his eldest brother was making plans for murder. That was putting it plainly and simply but that was never how he would tell it to Kay. He had already said his father being shot was more like an 'accident' and that all the trouble was over. Hell, it looked like it was just beginning. Sonny and Tom were off-centre on this guy Sollozzo,

they were still underrating him, even though Sonny was smart enough to see the danger. Michael tried to think what the Turk might have up his sleeve. He was obviously a bold man, a clever man, a man of extraordinary force. You had to figure him to come up with a real surprise. But then Sonny and Tom and Clemenza and Tessio were all agreed that everything was under control and they all had more experience than he did. He was the 'civilian' in this war, Michael thought wryly. And they'd have to give him a hell of a lot better medals than he'd got in World War II to make him join this one.

Thinking this made him feel guilty about not feeling more sympathy for his father. His own father shot full of holes and yet in a curious way Michael, better than anyone else, understood when Tom had said it was just business, not personal. That his father had paid for the power he had wielded all his life, the respect he had extorted from all those around him.

What Michael wanted was out, out of all this, to lead his own life. But he couldn't cut loose from the family until the crisis was over. He had to help in a civilian capacity. With sudden clarity he realized that he was annoyed with the role assigned to him, that of the privileged noncombatant, the excused conscientious objector. That was why the word 'civilian' kept popping into his skull in such an irritating way.

When he got to the hotel, Kay was waiting for him in the lobby. (A couple of Clemenza's people had driven him into town and dropped him off on a nearby corner after making sure they were not followed.)

They had dinner together and some drinks. 'What time are you going to visit your father?' Kay asked.

Michael looked at his watch. 'Visiting hours end at eight-thirty. I think I'll go after everybody has left. They'll let me up. He has a private room and his own nurses so I can just sit with him for a while. I don't think he can talk yet or even know if I'm there. But I have to show respect.'

Kay said quietly, 'I feel so sorry for your father, he seemed like such a nice man at the wedding. I can't believe the things the papers are printing about him. I'm sure most of it's not true.'

Michael said politely, 'I don't think so either.' He was surprised to find himself so secretive with Kay. He loved her, he trusted her, but he would never tell her anything about his father or the Family. She was an outsider.

'What about you?' Kay asked. 'Are you going to get mixed up in this gang war the papers are talking about so gleefully?'

Michael grinned, unbuttoned his jacket and held it wide open. 'Look, no guns,' he said. Kay laughed.

It was getting late and they went up to their room. She mixed a drink for both of them and sat on his lap as they drank. Beneath her dress she was all silk until his hand touched the glowing skin of her thigh. They fell back on the bed together and made love with all their clothes on, their mouths glued together. When they were finished they lay very still, feeling the heat of their bodies burning through their garments. Kay murmured, 'Is that what you soldiers call a quickie?'

'Yeah,' Michael said.

'It's not bad,' Kay said in a judicious voice.

They dozed off until Michael suddenly started up anxiously and looked at his watch. 'Damn,' he said. 'It's nearly ten. I have to get down to the hospital.' He went to the bathroom to wash up and comb his hair. Kay came in after him and put her arms around his waist from behind. 'When are we going to get married?' she asked.

'Whenever you say,' Michael said. 'As soon as this family thing quiets down and my old man gets better. I think you'd better explain things to your parents though.'

'What should I explain?' Kay said quietly.

Michael ran the comb through his hair. 'Just say that you've met a brave, handsome guy of Italian descent. Top marks at Dartmouth. Distinguished Service Cross during the war plus the Purple Heart. Honest. Hard-working. But his father is a Mafia chief who has to kill bad people, sometimes bribe high government officials and in his line of work gets shot full of holes himself. But that has nothing to do with his honest hard-working son. Do you think you can remember all that?'

Kay let go his body and leaned against the door of the bathroom. 'Is he really?' she said. 'Does he really?' She paused. 'Kill people?'

Michael finished combing his hair. 'I don't really know,' he said. 'Nobody really knows. But I wouldn't be surprised.'

Before he went out the door she asked, 'When will I see you again?'

Michael kissed her. 'I want you to go home and think things over in that little hick town of yours,' he said. 'I don't want you to get mixed up in this business in any way. After the Christmas holidays I'll be back at school and we'll get together up in Hanover. OK?'

'OK,' she said. She watched him go out the door, saw him wave before he stepped into the elevator. She had never felt so close to him, never so much in love and if someone had told her she would not see Michael again until two years passed, she would not have been able to bear the anguish of it.

When Michael got out of the cab in front of the French Hospital he was surprised to see that the street was completely deserted. When he entered the hospital he was even more surprised to find the lobby empty. Damn it, what the hell were Clemenza and Tessio doing? Sure, they never went to West Point but they knew enough about tactics to have outposts. A couple of their men should have been in the lobby at least.

Even the latest visitors had departed, it was almost ten-thirty at night. Michael was tense and alert now. He didn't bother to stop at the information desk, he already knew his father's room number up on the fourth floor. He took the self-service elevator. Oddly enough nobody stopped him until he reached the nurses' station on the fourth floor. But he strode right past her query and on to his father's room. There was no one outside the door. Where the hell were the two detectives who were supposed to be waiting around to guard and question the old man? Where the hell were Tessio and Clemenza's people? Could there be someone inside the room? But the door was open. Michael went in. There was a figure in the bed and by the December moonlight straining through the window Michael could see his father's face. Even now it was impassive, the chest heaved shallowly with his uneven breath.

Tubes hung from steel gallows beside the bed and ran into his nose. On the floor was a glass jar receiving the poisons emptied from his stomach by other tubes. Michael stayed there for a few moments to make sure his father was all right, then backed out of the room.

He told the nurse, 'My name is Michael Corleone, I just want to sit with my father. What happened to the detectives who were supposed to be guarding him?'

The nurse was a pretty young thing with a great deal of confidence in the power of her office. 'Oh, your father just had too many visitors, it interfered with the hospital service,' she said. 'The police came and made them all leave about ten minutes ago. And then just five minutes ago I had to call the detectives to the phone for an emergency alarm from their headquarters, and then they left too. But don't worry, I look in on your father often and I can hear any sound from his room. That's why we leave the doors open.'

'Thank you,' Michael said. 'I'll sit with him for a little while. OK?'

She smiled at him. 'Just for a little bit and then I'm afraid you'll have to leave. It's the rules, you know.'

Michael went back into his father's room. He took the phone from its cradle and got the hospital operator to give him the house in Long Beach, the phone in the corner office room. Sonny answered. Michael whispered, 'Sonny, I'm down at the hospital, I came down late. Sonny, there's nobody here. None of Tessio's people. No detectives at the door. The old man was completely unprotected.' His voice was trembling.

There was a long silence and then Sonny's voice came, low and impressed, 'This is Sollozzo's move you were talking about.'

Michael said, 'That's what I figured too. But how did he get the cops to clear everybody out and where did they go? What happened to Tessio's men? Jesus Christ, has that bastard Sollozzo got the New York Police Department in his pocket too?'

'Take it easy, kid.' Sonny's voice was soothing. 'We got lucky again with you going to visit the hospital so late. Stay in

the old man's room. Lock the door from the inside. I'll have some men there inside of fifteen minutes, soon as I make some calls. Just sit tight and don't panic. OK, kid?'

'I won't panic,' Michael said. For the first time since it had all started he felt a furious anger rising in him, a cold hatred for his father's enemies.

He hung up the phone and rang the buzzer for the nurse. He decided to use his own judgement and disregard Sonny's orders. When the nurse came in he said, 'I don't want you to get frightened, but we have to move my father right away. To another room or another floor. Can you disconnect all these tubes so we can wheel the bed out?'

The nurse said, 'That's ridiculous. We have to get permission from the doctor.'

Michael spoke very quickly. 'You've read about my father in the papers. You've seen that there's no one here tonight to guard him. Now I've just got word some men will come into the hospital to kill him. Please believe me and help me.' He could be extraordinarily persuasive when he wanted to be.

The nurse said, 'We don't have to disconnect the tubes. We can wheel the stand with the bed.'

'Do you have an empty room?' Michael whispered.

'At the end of the hall,' the nurse said.

It was done in a matter of moments, very quickly and very efficiently. Then Michael said to the nurse, 'Stay here with him until help comes. If you're outside at your station you might get hurt.'

At that moment he heard his father's voice from the bed, hoarse but full of strength, 'Michael, is it you? What happened, what is it?'

Michael leaned over the bed. He took his father's hand in his. 'It's Mike,' he said. 'Don't be afraid. Now listen, don't make any noise at all, especially if somebody calls out your name. Some people want to kill you, understand? But I'm here so don't be afraid.'

Don Corleone, still not fully conscious of what had happened to him the day before, in terrible pain, yet smiled benevolently on his youngest son, wanting to tell him, but it was

too much effort, 'Why should I be afraid now? Strange men have come to kill me ever since I was twelve years old.'

CHAPTER TEN

THE HOSPITAL was small and private with just one entrance. Michael looked through the window down into the street. There was a curved courtyard that had steps leading down into the street and the street was empty of cars. But whoever came into the hospital would have to come through that entrance. He knew he didn't have much time so he ran out of the room and down the four flights and through the wide doors of the ground floor entrance. Off to the side he saw the ambulance yard and there was no car there, no ambulances either.

Michael stood on the sidewalk outside the hospital and lit a cigarette. He unbuttoned his coat and stood in the light of a lamp-post so that his features could be seen. A young man was walking swiftly down from Ninth Avenue, a package under his arm. The young man wore a combat jacket and had a heavy shock of black hair. His face was familiar when he came under the lamplight but Michael could not place it. But the young man stopped in front of him and put out his hand, saying in a heavy Italian accent, 'Don Michael, do you remember me? Enzo, the baker's helper to Nazorine the Paniterra; his son-in-law. Your father saved my life by getting the government to let me stay in America.'

Michael shook his hand. He remembered him now.

Enzo went on, 'I've come to pay my respects to your father. Will they let me into the hospital so late?'

Michael smiled and shook his head. 'No, but thanks anyway. I'll tell the Don you came.' A car came roaring down the street and Michael was instantly alert. He said to Enzo, 'Leave here quickly. There may be trouble. You don't want to get involved with the police.'

He saw the look of fear on the young Italian's face. Trouble

127

with the police might mean being deported or refusal of citizenship. But the young man stood fast. He whispered in Italian, 'If there's trouble I'll stay to help. I owe it to the Godfather.'

Michael was touched. He was about to tell the young man to go away again, but then he thought, why not let him stay? Two men in front of the hospital might scare off any of Sollozzo's crew sent to do a job. One man almost certainly would not. He gave Enzo a cigarette and lit it for him. They both stood under the lamp-post in the cold December night. The yellow panes of the hospital, bisected by the greens of Christmas decorations, twinkled down on them. They had almost finished their cigarettes when a long low black car turned into 30th Street from Ninth Avenue and cruised towards them, very close to the kerb. It almost stopped. Michael peered to see the faces inside, his body flinching involuntarily. The car seemed about to stop, then speeded forward. Somebody had recognized him. Michael gave Enzo another cigarette and noticed that the baker's hands were shaking. To his surprise his own hands were steady.

They stayed in the street smoking for what was no more than ten minutes when suddenly the night air was split by a police siren. A patrol car made a screaming turn from Ninth Avenue and pulled up in front of the hospital. Two more squad cars followed right behind it. Suddenly the hospital entrance-way was flooded with uniformed police and detectives. Michael heaved a sigh of relief. Good old Sonny must have got through right away. He moved forward to meet them.

Two huge, burly policemen grabbed his arms. Another frisked him. A massive police captain, gold braid on his cap, came up the steps, his men parting respectfully to leave a path. He was a vigorous man for his girth and despite the white hair that peeked out of his cap. His face was beefy red. He came up to Michael and said harshly, 'I thought I got all you guinea hoods locked up. Who the hell are you and what are you doing here?'

One of the cops standing beside Michael said, 'He's clean, Captain.'

Michael didn't answer. He was studying this police captain, coldly searching his face, the metallic blue eyes. A detective in plain clothes said, 'That's Michael Corleone, the Don's son.' Michael said quietly, 'What happened to the detectives who were supposed to be guarding my father? Who pulled them off that detail?'

The police captain was choleric with rage. 'You fucking hood, who the hell are you to tell me my business? I pulled them off. I don't give a shit how many dago gangsters kill each other. If it was up to me, I wouldn't lift a finger to keep your old man from getting knocked off. Now get the hell out of here. Get out of this street, you punk, and stay out of this hospital when it's not visiting hours.'

Michael was still studying him intently. He was not angry at what this police captain was saying. His mind was racing furiously. Was it possible that Sollozzo had been in that first car and had seen him standing in front of the hospital? Was it possible that Sollozzo had then called this captain and said, 'How come the Corleones' men are still around the hospital when I paid you to lock them up?' Was it possible that all had been carefully planned as Sonny had said? Everything fitted in. Still cool, he said to the captain, 'I'm not leaving this hospital until you put guards around my father's room.'

The captain didn't bother answering. He said to the detective standing beside him, 'Phil, lock this punk up.'

The detective said hesitantly, 'The kid is clean, Captain. He's a war hero and he's never been mixed up in the rackets. The papers could make a stink.'

The captain started to turn on the detective, his face red with fury. He roared out, 'Goddamn it, I said lock him up.'

Michael, still thinking clearly, not angry, said with deliberate malice, 'How much is the Turk paying you to set my father up, Captain?'

The police captain turned to him. He said to the two burly patrolmen, 'Hold him.' Michael felt his arms pinned to his sides. He saw the captain's massive fist arching towards his face. He tried to weave away but the fist caught him high on the cheekbone. A grenade exploded in his skull. His mouth filled with blood and small hard bones that he realized were his

teeth. He could feel the side of his head puff up as if it were filling with air. His legs were weightless and he would have fallen if the two policemen had not held him up. But he was still conscious. The plainclothes detective had stepped in front of him to keep the captain from hitting him again and was saying, 'Jesus Christ, Captain, you really hurt him.'

The captain said loudly, 'I didn't touch him. He attacked me and he fell. Do you understand that? He resisted arrest.'

Through a red haze Michael could see more cars pulling up to the kerb. Men were getting out. One of them he recognized as Clemenza's lawyer, who was now speaking to the police captain, suavely and surely. 'The Corleone Family has hired a firm of private detectives to guard Mr Corleone. These men with me are licensed to carry firearms, Captain. If you arrest them, you'll have to appear before a judge in the morning and tell him why.'

The lawyer glanced at Michael. 'Do you want to prefer charges against whoever did this to you?' he asked.

Michael had trouble talking. His jaws wouldn't come together but he managed to mumble. 'I slipped,' he said. 'I slipped and fell.' He saw the captain give him a triumphant glance and he tried to answer that glance with a smile. At all costs he wanted to hide the delicious icy chilliness that controlled his brain, the surge of wintry cold hatred that pervaded his body. He wanted to give no warning to anyone in this world as to how he felt at this moment. As the Don would not. Then he felt himself carried into the hospital and he lost consciousness.

When he woke up in the morning he found that his jaw had been wired together and that four of his teeth along the left side of his mouth were missing. Hagen was sitting beside his bed.

'Did they drug me up?' Michael asked.

'Yeah,' Hagen said. 'They had to dig some bone fragments out of your gums and they figured it would be too painful. Besides you were practically out anyway.'

'Is there anything else wrong with me?' Michael asked.

'No,' Hagen said. 'Sonny wants you out at the Long Beach house. Think you can make it?'

'Sure,' Michael said. 'Is the Don all right?'

Hagen flushed. 'I think we've solved the problem now. We have a firm of private detectives and we have the whole area loaded. I'll tell you more when we get in the car.'

Clemenza was driving, Michael and Hagen sat in the back. Michael's head throbbed. 'So what the hell really happened last night, did you guys ever find out?'

Hagen spoke quietly. 'Sonny has an inside man, that Detective Phillips who tried to protect you. He gave us the scoop. The police captain, McCluskey, is a guy who's been on the take very heavy ever since he's been a patrolman. Our Family has paid him quite a bit. And he's greedy and untrustworthy to do business with. But Sollozzo must have paid him a big price. McCluskey had all Tessio's men around and in the hospital arrested right after visiting hours. It didn't help that some of them were carrying guns. Then McCluskey pulled the official guard detectives off the Don's door. Claimed he needed them and that some other cops were supposed to go over and take their place but they got their assignments bollixed. Baloney. He was paid off to set the Don up. And Phillips said he's the kind of guy who'll try it again. Sollozzo must have given him a fortune for openers and promised him the moon to come.'

'Was my getting hurt in the papers?'

'No,' Hagen said. 'We kept that quiet. Nobody wants that known. Not the cops. Not us.'

'Good,' Michael said. 'Did that boy Enzo get away?'

'Yeah,' Hagen said. 'He was smarter than you. When the cops came he disappeared. He claims he stuck with you while Sollozzo's car went by. Is that true?'

'Yeah,' Michael said. 'He's a good kid.'

'He'll be taken care of,' Hagen said. 'You feeling OK?' His face was concerned. 'You look lousy.'

'I'm OK,' Michael said. 'What was that police captain's name?'

'McCluskey,' Hagen said. 'By the way, it might make you feel better to know that the Corleone Family finally got up

on the scoreboard. Bruno Tattaglia, four o'clock this morning.'

Michael sat up. 'How come? I thought we were supposed to sit tight.'

Hagen shrugged. 'After what happened at the hospital Sonny got hard. The button men are out all over New York and New Jersey. We made the list last night. I'm trying to hold Sonny in, Mike. Maybe you can talk to him. This whole business can still be settled without a major war.'

'I'll talk to him,' Michael said. 'Is there a conference this morning?'

'Yeah,' Hagen said. 'Sollozzo finally got in touch and wants to sit down with us. A negotiator is arranging the details. That means we win. Sollozzo knows he's lost and he wants to get out with his life.' Hagen paused. 'Maybe he thought we were soft, ready to be taken, because we didn't strike back. Now with one of the Tattaglia sons dead he knows we mean business. He really took an awful gamble bucking the Don. By the way, we got the confirmation on Luca. They killed him the night before they shot your father. In Bruno's nightclub. Imagine that?'

Michael said, 'No wonder they caught him off guard.'

At the houses in Long Beach the entrance to the mall was blocked by a long black car parked across its mouth. Two men leaned against the hood of the car. The two houses on each side, Michael noticed, had opened windows on their upper floors. Christ, Sonny must really mean business.

Clemenza parked the car outside the mall and they walked inside it. The two guards were Clemenza's men and he gave them a frown of greeting that served as a salute. The men nodded their heads in acknowledgement. There were no smiles, no greetings. Clemenza led Hagen and Michael Corleone into the house.

The door was opened by another guard before they rang. He had obviously been watching from a window. They went to the corner office and found Sonny and Tessio waiting for them. Sonny came to Michael, took his younger brother's head in his hands and said kiddingly, 'Beautiful. Beautiful.' Michael

knocked his hands away, and went to the desk and poured himself some Scotch, hoping it would dull the ache in his wired jaw.

The five of them sat around the room but the atmosphere was different than their earlier meetings. Sonny was gayer, more cheerful, and Michael realized what that gaiety meant. There were no longer any doubts in his older brother's mind. He was committed and nothing would sway him. The attempt by Sollozzo the night before was the final straw. There could no longer be any question of a truce.

'We got a call from the negotiator while you were gone,' Sonny said to Hagen. 'The Turk wants a meeting now.' Sonny laughed. 'The balls on that son of a bitch,' he said admiringly. 'After he craps out last night he wants a meeting today or the next day. Meanwhile we're supposed just to lay back and take everything he dishes out. What fucking nerve.'

Tom asked cautiously, 'What did you answer?'

Sonny grinned. 'I said sure, why not? Any time he says, I'm in no hurry. I've got a hundred button men out on the street twenty-four hours a day. If Sollozzo shows one hair on his asshole he's dead. Let them take all the time they want.'

Hagen said, 'Was there a definite proposal?'

'Yeah,' Sonny said. 'He wants us to send Mike to meet him to hear his proposition. The negotiator guarantees Mike's safety. Sollozzo doesn't ask us to guarantee his safety, he knows he can't ask that. No point. So the meeting will be arranged on his side. His people will pick Mike up and take Mike to the meeting place. Mike will listen to Sollozzo and then they'll turn him loose. But the meeting place is secret. The promise is the deal will be so good we can't turn it down.'

Hagen asked, 'What about the Tattaglias? What will they do about Bruno?'

'That's part of the deal. The negotiator says the Tattaglia Family has agreed to go along with Sollozzo. They'll forget about Bruno Tattaglia. He pays for what they did to my father. One cancels out the other.' Sonny laughed again. 'The nervy bastards.'

Hagen said cautiously, 'We should hear what they have to say.'

Sonny shook his head from side to side. 'No, no, *Consigliori*, not this time.' His voice held a faint trace of Italian accent. He was consciously mocking his father just to kid around. 'No more meetings. No more discussions. No more Sollozzo tricks. When the negotiator gets in touch with us again for our answer I want you to give him one message. I want Sollozzo. If not, it's all-out war. We'll go to the mattresses and we'll put all the button men out on the street. Business will just have to suffer.'

'The other Families won't stand for an all-out war,' Hagen said. 'It puts too much heat on everybody.'

Sonny shrugged. 'They have a simple solution. Give me Sollozzo. Or fight the Corleone Family.' Sonny paused, then said roughly, 'No more advice on how to patch it up, Tom. The decision is made. Your job is to help me win. Understand?'

Hagen bowed his head. He was deep in thought for a moment. Then he said, 'I spoke to your contact in the police station. He says that Captain McCluskey is definitely on Sollozzo's payroll and for big money. Not only that, but McCluskey is going to get a piece of the drug operation. McCluskey has agreed to be Sollozzo's bodyguard. The Turk doesn't poke his nose out of his hole without McCluskey. When he meets Mike for the conference, McCluskey will be sitting beside him. In civilian clothes but carrying his gun. Now what you have to understand, Sonny, is that while Sollozzo is guarded like this, he's invulnerable. Nobody has ever gunned down a New York police captain and got away with it. The heat in this town would be unbearable what with the newspapers, the whole police department, the churches, everything. That would be disastrous. The Families would be after you. The Corleone Family would become outcasts. Even the old man's political protection would run for cover. So take that into consideration.'

Sonny shrugged. 'McCluskey can't stay with the Turk for ever. We'll wait.'

Tessio and Clemenza were puffing on their cigars uneasily, not daring to speak, but sweating. It would be their skins that would go on the line if the wrong decision was made.

Michael spoke for the first time. He asked Hagen, 'Can the old man be moved out of the hospital on to the mall here?'

Hagen shook his head. 'That's the first thing I asked. Impossible. He's in very bad shape. He'll pull through but he needs all kinds of attention, maybe some more surgery. Impossible.'

'Then you have to get Sollozzo right away,' Michael said. 'We can't wait. The guy is too dangerous. He'll come up with some new idea. Remember, the key is still that he gets rid of the old man. He knows that. OK, he knows that now it's very tough so he's willing to take defeat for his life. But if he's going to get killed anyway, he'll have another crack at the Don. And with that police captain helping him who knows what the hell might happen. We can't take that chance. We have to get Sollozzo right away.'

Sonny was scratching his chin thoughtfully. 'You're right, kid,' he said. 'You got right to the old nuts. We can't let Sollozzo get another crack at the old man.'

Hagen said quietly, 'What about Captain McCluskey?'

Sonny turned to Michael with an odd little smile. 'Yeah, kid, what about that tough police captain?'

Michael said slowly, 'OK, it's an extreme. But there are times when the most extreme measures are justified. Let's think now that we have to kill McCluskey. The way to do it would be to have him heavily implicated so that it's not an honest police captain doing his duty but a crooked police official mixed up in the rackets who got what was coming to him, like any crook. We have newspaper people on our payroll we can give that story to with enough proof so that they can back it up. That should take some of the heat off. How does that sound?' Michael looked around deferentially to the others. Tessio and Clemenza had gloomy faces and refused to speak. Sonny said with the same odd smile, 'Go on, kid, you're doing great. Out of the mouths of infants, as the Don always used to say. Go ahead, Mike, tell us more.'

Hagen was smiling too a little and averting his head. Michael flushed. 'Well, they want me to go to a conference with Sollozzo. It will be me, Sollozzo and McCluskey all on our own. Set up the meeting for two days from now, then get

our informers to find out where the meeting will be held. Insist that it has to be a public place, that I'm not going to let them take me into any apartments or houses. Let it be a restaurant or a bar at the height of the dinner hour, something like that, so that I'll feel safe. They'll feel safe too. Even Sollozzo won't figure that we'll dare to gun the captain. They'll frisk me when I meet them so I'll have to be clean then, but figure out a way you can get a weapon to me while I'm meeting them. Then I'll take both of them.'

All four heads turned and stared at him. Clemenza and Tessio were gravely astonished. Hagen looked a little sad but not surprised. He started to speak and thought better of it. But Sonny, his heavy Cupid's face twitching with mirth, suddenly broke out in loud roars of laughter. It was deep belly laughter, not faking. He was really breaking up. He pointed a finger at Michael, trying to speak through gasps of mirth. 'You, the high-class college kid, you never wanted to get mixed up in the Family business. Now you wanta kill a police captain and the Turk just because you got your face smashed by Mc-Cluskey. You're taking it personal, it's just business and you're taking it personal. You wanta kill these two guys just because you got slapped in the face. It was all a lot of crap. All these years it was just a lot of crap.'

Clemenza and Tessio, completely misunderstanding, thinking that Sonny was laughing at his young brother's bravado for making such an offer, were also smiling broadly and a little patronizingly at Michael. Only Hagen warily kept his face impassive.

Michael looked around at all of them, then stared at Sonny, who still couldn't stop laughing. '*You'll* take both of them?' Sonny said. 'Hey, kid, they won't give you medals, they put you in the electric chair. You know that? This is no hero business, kid, you don't shoot people from a mile away. You shoot when you see the whites of their eyes like we got taught in school, remember? You gotta stand right next to them and blow their heads off and their brains get all over your nice Ivy League suit. How about that, kid, you wanta do that just because some dumb cop slapped you around?' He was still laughing.

Michael stood up. 'You'd better stop laughing,' he said. The change in him was so extraordinary that the smiles vanished from the faces of Clemenza and Tessio. Michael was not tall or heavily built but his presence seemed to radiate danger. In that moment he was a reincarnation of Don Corleone himself. His eyes had gone a pale tan and his face was bleached of colour. He seemed at any moment about to fling himself on his older and stronger brother. There was no doubt that if he had had a weapon in his hands Sonny would have been in danger. Sonny stopped laughing, and Michael said to him in a cold deadly voice, 'Don't you think I can do it, you son of a bitch?'

Sonny had got over his laughing fit. 'I know you can do it,' he said. 'I wasn't laughing at what you said. I was just laughing at how funny things turn out. I always said you were the toughest one in the Family, tougher than the Don himself. You were the only one who could stand off the old man. I remember you when you were a kid. What a temper you had then. Hell, you even used to fight me and I was a lot older than you. And Freddie had to beat the shit out of you at least once a week. And now Sollozzo has you figured for the soft touch in the Family because you let McCluskey hit you without fighting back and you wouldn't get mixed up in the Family fights. He figures he got nothing to worry about if he meets you head to head. And McCluskey too, he's got you figured for a yellow guinea.' Sonny paused and then said softly, 'But you're a Corleone after all, you son of a bitch. And I was the only one who knew it. I've been sitting here waiting for the last three days, ever since the old man got shot, waiting for you to crack out of that Ivy League, war hero bullshit character you've been wearing. I've been waiting for you to become my right arm so we can kill those fucks that are trying to destroy our father and our Family. And all it took was a sock on the jaw. How do you like that?' Sonny made a comical gesture, a punch, and repeated, 'How do you like that?'

The tension had relaxed in the room. Mike shook his head. 'Sonny, I'm doing it because it's the only thing to do. I can't give Sollozzo another crack at the old man. I seem to be the only one who can get close enough to him. And I figured it out. I don't think you can get anybody else to knock off a

police captain. Maybe you would do it, Sonny, but you have a wife and kids and you have to run the Family business until the old man is in shape. So that leaves me and Freddie. Freddie is in shock and out of action. Finally that leaves just me. It's all logic. The sock on the jaw had nothing to do with it.'

Sonny came over and embraced him. 'I don't give a damn what your reasons are, just so long as you're with us now. And I'll tell you another thing, you're right all the way. Tom, what's your say?'

Hagen shrugged. 'The reasoning is solid. What makes it so is that I don't think the Turk is sincere about a deal. I think he'll still try to get at the Don. Anyway on his past performance that's how we have to figure him. So we try to get Sollozzo. We get him even if we have to get the police captain. But whoever does the job is going to get an awful lot of heat. Does it have to be Mike?'

Sonny said softly, 'I could do it.'

Hagen shook his head impatiently. 'Sollozzo wouldn't let you get within a mile of him if he had ten police captains. And besides you're the acting head of the Family. You can't be risked.' Hagen paused and said to Clemenza and Tessio, 'Do either one of you have a top button man, someone really special, who would take on this job? He wouldn't have to worry about money for the rest of his life.'

Clemenza spoke first. 'Nobody that Sollozzo wouldn't know, he'd catch on right away. He'd catch on if me or Tessio went too.'

Hagen said, 'What about somebody really tough who hasn't made his rep yet, a good rookie?'

Both *caporegimes* shook their heads. Tessio smiled to take the sting out of his words and said, 'That's like bringing a guy up from the minors to pitch the World Series.'

Sonny broke in curtly, 'It has to be Mike. For a million different reasons. Most important they got him down as faggy. And he can do the job, I guarantee that, and that's important because this is the only shot we'll get at that sneaky bastard Turk. So now we have to figure out the best way to back him up. Tom, Clemenza, Tessio, find out where Sollozzo will take him for the conference, I don't care how much it costs. When

we find that out we can figure out how we can get a weapon into his hands. Clemenza, I want you to get him a really "safe" gun out of your collection, the "coldest" one you got. Impossible to trace. Try to make it short barrel with a lot of blasting power. It doesn't have to be accurate. He'll be right on top of them when he uses it. Mike, as soon as you've used the gun, drop it on the floor. Don't be caught with it on you. Clemenza, tape the barrel and the trigger with that special stuff you got so he won't leave prints. Remember, Mike, we can square everything, witnesses, and so forth, but if they catch you with the gun on you we can't square that. We'll have transportation and protection and then we'll make you disappear for a nice long vacation until the heat wears off. You'll be gone a long time, Mike, but I don't want you saying goodbye to your girlfriend or even calling her. After it's all over and you're out of the country I'll send her word that you're OK. Those are orders.' Sonny smiled at his brother. 'Now stick with Clemenza and get used to handling the gun he picks out for you. Maybe even practise a little. We'll take care of everything else. Everything. OK, kid?'

Again Michael Corleone felt that delicious refreshing chilliness all over his body. He said to his brother, 'You didn't have to give me that crap about not talking to my girlfriend about something like this. What the hell did you think I was going to do, call her up to say goodbye?'

Sonny said hastily, 'OK, but you're still a rookie so I spell things out. Forget it.'

Michael said with a grin, 'What the hell do you mean, a rookie? I listened to the old man just as hard as you did. How do you think I got so smart?' They both laughed.

Hagen poured drinks for everyone. He looked a little glum. The statesman forced to go to war, the lawyer forced to go to law. 'Well, anyway now we know what we're going to do,' he said.

CHAPTER ELEVEN

CAPTAIN MARK MCCLUSKEY sat in his office fingering three envelopes bulging with betting slips. He was frowning and wishing he could decode the notations on the slips. It was very important that he do so. The envelopes were the betting slips that his raiding parties had picked up when they had hit one of the Corleone Family bookmakers the night before. Now the bookmaker would have to buy back the slips so that players couldn't claim winners and wipe him out.

It was very important for Captain McCluskey to decode the slips because he didn't want to get cheated when he sold the slips back to the bookmaker. If there was fifty grand worth of action, then maybe he could sell it back for five grand. But if there were a lot of heavy bets and the slips represented a hundred grand or maybe even two hundred grand, then the price should be considerably higher. McCluskey fiddled with the envelopes and then decided to let the bookie sweat a little bit and make the first offer. That might tip off what the real price should be.

McCluskey looked at the station house clock on the wall of his office. It was time for him to pick up that greasy Turk, Sollozzo, and take him to wherever he was going to meet the Corleone Family. McCluskey went over to his wall locker and started to change into his civilian clothes. When he was finished he called his wife and told her he would not be home for supper that night, that he would be out on the job. He never confided in his wife on anything. She thought they lived the way they did on his policeman's salary. McCluskey grunted with amusement. His mother had thought the same thing but he had learned early. His father had shown him the ropes.

His father had been a police sergeant, and every week father and son had walked through the precinct and McCluskey Senior had introduced his six-year-old son to the storekeepers, saying, 'And this is my little boy.'

The storekeepers would shake his hand and compliment

him extravagantly and ring open their cash registers to give the little boy a gift of five or ten dollars. At the end of the day, little Mark McCluskey would have all the pockets of his suit stuffed with paper money, would feel so proud that his father's friends liked him well enough to give him a present every month they saw him. Of course his father put the money in the bank for him, for his college education, and little Mark got at most a fifty-cent piece for himself.

Then when Mark got home and his policemen uncles asked him what he wanted to be when he grew up and he would lisp childishly, 'A policeman,' they would all laugh uproariously. And of course later on, though his father wanted him to go to college first, he went right from high school to studying for the police force.

He had been a good cop, a brave cop. The tough young punks terrorizing street corners fled when he approached and finally vanished from his beat altogether. He was a very tough cop and a very fair one. He never took his son around to the storekeepers to collect his money presents for ignoring garbage violations and parking violations; he took the money directly into his own hand, direct because he felt he earned it. He never ducked into a movie house or goofed off into restaurants when he was on foot patrol as some of the other cops did, especially on winter nights. He always made his rounds. He gave his stores a lot of protection, a lot of service. When winos and drunks filtered up from the Bowery to panhandle on his beat he got rid of them so roughly that they never came back. The tradespeople in his precinct appreciated it. And they showed their appreciation.

He also obeyed the system. The bookies in his precinct knew he would never make trouble to get an extra payoff for himself, that he was content for his share of the station house bag. His name was on the list with the others and he never tried to make extras. He was a fair cop who took only clean graft and his rise in the police department was steady if not spectacular.

During this time he was raising a large family of four sons, none of whom became policemen. They all went to Fordham University and since by that time Mark McCluskey was rising

from sergeant to lieutenant and finally to captain, they lacked for nothing. It was at this time that McCluskey got the reputation for being a hard bargainer. The bookmakers in his district paid more protection money than the bookmakers in any other part of the city, but maybe that was because of the expense of putting four boys through college.

McCluskey himself felt there was nothing wrong with clean graft. Why the hell should his kids go to CCNY or a cheap Southern college just because the Police Department didn't pay its people enough money to live on and take care of their families properly with? He protected all these people with his life and his record showed his citations for gun duels with stick-up men on his beat, strong-arm protection guys, would-be pimps. He had hammered them into the ground. He had kept his little corner of the city safe for ordinary people and he sure as hell was entitled to more than his lousy one C note a week. But he wasn't indignant about his low pay, he understood that everybody had to take care of themselves.

Bruno Tattaglia was an old friend of his. Bruno had gone to Fordham with one of his sons and then Bruno had opened his nightclub and whenever the McCluskey family spent an infrequent night on the town, they could enjoy the cabaret with liquor and dinner – on the house. On New Year's Eve they received engraved invitations to be guests of the management and always received one of the best tables. Bruno always made sure they were introduced to the celebrities who performed in his club, some of them famous singers and Hollywood stars. Of course sometimes he asked a little favour, like getting an employee with a record cleared for a cabaret work licence, usually a pretty girl with a police dossier as a hustler or roller. McCluskey would be glad to oblige.

McCluskey made it a policy never to show that he understood what other people were up to. When Sollozzo had approached him with the proposition to leave old man Corleone uncovered in the hospital, McCluskey didn't ask why. He asked price. When Sollozzo said ten grand, McCluskey knew why. He did not hesitate. Corleone was one of the biggest Mafia men in the country with more political connexions than Capone had ever had. Whoever knocked him off

would be doing the country a big favour. McCluskey took the money in advance and did the job. When he received a call from Sollozzo that there were still two of Corleone's men in front of the hospital he had flown into a rage. He had locked up all of Tessio's men, he had pulled the detective guards off the door of Corleone's hospital room. And now, being a man of principle, he would have to give back the ten grand, money he had already earmarked to insure the education of his grand-children. It was in that rage that he had gone to the hospital and struck Michael Corleone.

But it had all worked out for the best. He had met with Sollozzo in the Tattaglia nightclub and they had made an even better deal. Again McCluskey didn't ask questions, since he knew all the answers. He just made sure of his price. It never occurred to him that he himself could be in any danger. That anyone would consider even for a moment killing a New York City police captain was too fantastic. The toughest hood in the Mafia had to stand still if the lowliest patrolman decided to slap him around. There was absolutely no percentage in killing cops. Because then all of a sudden a lot of hoods were killed resisting arrest or escaping the scene of a crime, and who the hell was going to do anything about that?

McCluskey sighed and got ready to leave the station house. Problems, always problems. His wife's sister in Ireland had just died after many years of fighting cancer and that cancer had cost him a pretty penny. Now the funeral would cost him more. His own uncles and aunts in the old country needed a little help now and then to keep their potato farms and he sent the money to do the trick. He didn't begrudge it. And when he and his wife visited the old country they were treated like a king and queen. Maybe they would go again this summer now that the war was over and with all this extra money coming in. McCluskey told his patrolman clerk where he would be if he was needed. He did not feel it necessary to take any precautions. He could always claim Sollozzo was an informer he was meeting. Outside the station house he walked a few blocks and then caught a cab to the house where he would meet with Sollozzo.

It was Tom Hagen who had to make all the arrangements

for Michael's leaving the country, his false passport, his seaman's card, his berth on an Italian freighter that would dock in a Sicilian port. Emissaries were sent that very day by plane to Sicily to prepare a hiding place with the Mafia chief in the hill country.

Sonny arranged for a car and an absolutely trustworthy driver to be waiting for Michael when he stepped out of the restaurant where the meeting would be held with Sollozzo. The driver would be Tessio himself, who had volunteered for the job. It would be a beat-up-looking car but with a fine motor. It would have phony licence plates and the car itself would be untraceable. It had been saved for a special job requiring the best.

Michael spent the day with Clemenza, practising with the small gun that would be got to him. It was a .22 filled with soft-nosed bullets that made pinpricks going in and left insulting gaping holes when they exited from the human body. He found that it was accurate up to five of his steps away from a target. After that the bullets might go anywhere. The trigger was tight but Clemenza worked on this with some tools so that it pulled easier. They decided to leave it noisy. They didn't want an innocent bystander misunderstanding the situation and interfering out of ignorant courage. The report of the gun would keep them away from Michael.

Clemenza kept instructing him during the training session. 'Drop the gun as soon as you've finished using it. Just let your hand drop to your side and the gun slip out. Nobody will notice. Everybody will think you're still armed. They'll be staring at your face. Walk out of the place very quickly but don't run. Don't look anybody directly in the eye but don't look away from them either. Remember, they'll be scared of you, believe me, they'll be scared of you. Nobody will interfere. As soon as you're outside Tessio will be in the car waiting for you. Get in and leave the rest to him. Don't be worried about accidents. You'd be surprised how well these affairs go. Now put this hat on and let's see how you look.' He clapped a grey fedora on Michael's head. Michael, who never wore a hat, grimaced. Clemenza reassured him. 'It helps against identification, just in case. Mostly it gives witnesses an excuse to

144

change their identification when we make them see the light. Remember, Mike, don't worry about prints. The butt and trigger are fixed with special tape. Don't touch any other part of the gun, remember that.'

Michael said, 'Has Sonny found out where Sollozzo is taking me?'

Clemenza shrugged. 'Not yet. Sollozzo is being very careful. But don't worry about him harming you. The negotiator stays in our hands until you come back safe. If anything happens to you, the negotiator pays.'

'Why the hell should he stick his neck out?' Michael asked.

'He gets a big fee,' Clemenza said. 'A small fortune. Also he is an important man in the Families. He knows Sollozzo can't let anything happen to him. Your life is not worth the negotiator's life to Sollozzo. Very simple. You'll be safe all right. We're the ones who catch hell afterwards.'

'How bad will it be?' Michael asked.

'Very bad,' Clemenza said. 'It means an all-out war with the Tattaglia Family against the Corleone Family. Most of the others will line up with the Tattaglias. The Sanitation Department will be sweeping up a lot of dead bodies this winter.' He shrugged. 'These things have to happen once every ten years or so. It gets rid of the bad blood. And then if we let them push us around on the little things they wanta take over everything. You gotta stop them at the beginning. Like they shoulda stopped Hitler at Munich, they should never let him get away with that, they were just asking for big trouble when they let him get away with that.'

Michael had heard his father say this same thing before, only in 1939 before the war actually started. If the Families had been running the State Department there would never have been World War II, he thought with a grin.

They drove back to the mall and to the Don's house, where Sonny still made his headquarters. Michael wondered how long Sonny could stay cooped up in the safe territory of the mall. Eventually he would have to venture out. They found Sonny taking a nap on the couch. On the coffee table were the remains of his late lunch, scraps of steak and breadcrumbs and a half-empty bottle of whisky.

His father's usually neat office was taking on the look of a badly kept furnished room. Michael shook his brother awake and said, 'Why don't you stop living like a bum and get this place cleaned up.'

Sonny yawned. 'What the hell are you, inspecting the barracks? Mike, we haven't got the word yet where they plan to take you, those bastards Sollozzo and McCluskey. If we don't find that out, how the hell are we going to get the gun to you?'

'Can't I carry it on me?' Michael asked. 'Maybe they won't frisk me and even if they do maybe they'll miss it if we're smart enough. And even if they find it – so what. They'll just take it off me and no harm done.'

Sonny shook his head. 'Nah,' he said. 'We have to make this a sure hit on that bastard Sollozzo. Remember, get him first if you possibly can. McCluskey is slower and dumber. You should have plenty of time to take him. Did Clemenza tell you to be sure to drop the gun?'

'A million times,' Michael said.

Sonny got up from the sofa and stretched. 'How does your jaw feel, kid?'

'Lousy,' Michael said. The left side of his face ached except those parts that felt numb because of the drugged wire holding it together. He took the bottle of whisky from the table and swigged directly from it. The pain eased.

Sonny said, 'Easy, Mike, now is no time to get slowed up by booze.'

Michael said, 'Oh, Christ, Sonny, stop playing the big brother. I've been in combat against tougher guys than Sollozzo and under worse conditions. Where the hell are his mortars? Has he got air cover? Heavy artillery? Land mines? He's just a wise son of a bitch with a big-wheel cop sidekick. Once anybody makes up their mind to kill them there's no other problem. That's the hard part, making up your mind. They'll never know what hit them.'

Tom Hagen came into the room. He greeted them with a nod and went directly to the falsely-listed telephone. He called a few times and then shook his head at Sonny. 'Not a whisper,' he said. 'Sollozzo is keeping it to himself as long as he can.'

The phone rang. Sonny answered it and he held up a hand as if to signal for quiet though no one had spoken. He jotted some notes down on a pad, then said, 'OK, he'll be there,' and hung up the phone.

Sonny was laughing. 'That son of a bitch Sollozzo, he really is something. Here's the deal. At eight tonight he and Captain McCluskey pick up Mike in front of Jack Dempsey's bar on Broadway. They go some place to talk, and get this. Mike and Sollozzo talk in Italian so that the Irish cop don't know what the hell they are talking about. He even tells me, don't worry, he knows McCluskey doesn't know one word in Italian unless it's "*soldi*" and he's checked you out, Mike, and knows you can understand Sicilian dialect.'

Michael said dryly, 'I'm pretty rusty but we won't talk long.'

Tom Hagen said, 'We don't let Mike go until we have the negotiator. Is that arranged?'

Clemenza nodded. 'The negotiator is at my house playing pinochle with three of my men. They wait for a call from me before they let him go.'

Sonny sank back in the leather armchair. 'Now how the hell do we find out the meeting place? Tom, we've got informers with the Tattaglia Family, how come they haven't given us the word?'

Hagen shrugged. 'Sollozzo is really damn smart. He's playing this close to the vest, so close that he's not using any men as a cover. He figures the captain will be enough and that security is more important than guns. He's right too. We'll have to put a tail on Mike and hope for the best.'

Sonny shook his head. 'Nah, anybody can lose a tail when they really want to. That's the first thing they'll check out.'

By this time it was five in the afternoon. Sonny, with a worried look on his face, said, 'Maybe we should just let Mike blast whoever is in the car when it tries to pick him up.'

Hagen shook his head. 'What if Sollozzo is not in the car? We've tipped our hand for nothing. Damn it, we have to find out where Sollozzo is taking him.'

Clemenza put in, 'Maybe we should start trying to figure why he's making it such a big secret.'

Michael said impatiently, 'Because it's the percentage. Why should he let us know anything if he can prevent it? Besides, he smells danger. He must be leery as hell even with that police captain for his shadow.'

Hagen snapped his fingers. 'That detective, that guy Phillips. Why don't you give him a ring, Sonny? Maybe he can find out where the hell the captain can be reached. It's worth a try. McCluskey won't give a damn who knows where he's going.'

Sonny picked up the phone and dialled a number. He spoke softly into the phone, then hung up. 'He'll call us back,' Sonny said.

They waited for nearly another thirty minutes and then the phone rang. It was Phillips. Sonny jotted something down on his pad and then hung up. His face was taut. 'I think we've got it,' he said. 'Captain McCluskey always has to leave word on where he can be reached. From eight to ten tonight he'll be at the Luna Azure up in the Bronx. Anybody know it?'

Tessio spoke confidently. 'I do. It's perfect for us. A small family place with big booths where people can talk in private. Good food. Everybody minds their own business. Perfect.' He leaned over Sonny's desk and arranged stubbed-out cigarettes into map figures. 'This is the entrance. Mike, when you finish just walk out and turn left, then turn the corner. I'll spot you and put on my headlights and catch you on the fly. If you have any trouble, yell and I'll try to come in and get you out. Clemenza, you gotta work fast. Send somebody up there to plant the gun. They got an old-fashioned toilet with a space between the water container and the wall. Have your man tape the gun behind there. Mike, after they frisk you in the car and find you're clean, they won't be too worried about you. In the restaurant, wait a bit before you excuse yourself. No, better still, ask permission to go. Act a little in trouble first, very natural. They can't figure anything. But when you come out again, don't waste any time. Don't sit down again at the table, start blasting. And don't take chances. In the head, two shots apiece, and out as fast as your legs can travel.'

Sonny had been listening judiciously. 'I want somebody very good, very safe, to plant that gun,' he told Clemenza. 'I

148

don't want my brother coming out of that toilet with just his dick in his hand.'

Clemenza said emphatically, 'The gun will be there.'

'OK,' Sonny said. 'Everybody get rolling.'

Tessio and Clemenza left. Tom Hagen said, 'Sonny, should I drive Mike down to New York?'

'No,' Sonny said. 'I want you here. When Mike finishes, then our work begins and I'll need you. Have you got those newspaper guys lined up?'

Hagen nodded. 'I'll be feeding them info as soon as things break.'

Sonny got up and came to stand in front of Michael. He shook his hand. 'OK, kid,' he said, 'you're on. I'll square it with Mom your not seeing her before you left. And I'll get a message to your girlfriend when I think the time is right. OK?'

'OK,' Mike said. 'How long do you think before I can come back?'

'At least a year,' Sonny said.

Tom Hagen put in, 'The Don might be able to work faster than that, Mike, but don't count on it. The time element hinges on a lot of factors. How well we can plant stories with the newsmen. How much the Police Department wants to cover up. How violently the other Families react. There's going to be a hell of a lot of heat and trouble. That's the only thing we can be sure of.'

Michael shook Hagen's hand. 'Do your best,' he said. 'I don't want to do another three-year stretch away from home.'

Hagen said gently, 'It's not too late to back out, Mike, we can get somebody else, we can go back over our alternatives. Maybe it's not necessary to get rid of Sollozzo.'

Michael laughed. 'We can talk ourselves into any viewpoint,' he said. 'But we figured it right the first time. I've been riding the gravy train all my life, it's about time I paid my dues.'

'You shouldn't let that broken jaw influence you,' Hagen said. 'McCluskey is a stupid man and it was business, not personal.'

For the second time he saw Michael Corleone's face freeze

into a mask that resembled uncannily the Don's. 'Tom, don't let anybody kid you. It's all personal, every bit of business. Every piece of shit every man has to eat every day of his life is personal. They call it business. OK. But it's personal as hell. You know where I learned that from? The Don. My old man. The Godfather. If a bolt of lightning hit a friend of his the old man would take it personal. He took my going into the Marines personal. That's what makes him great. The Great Don. He takes everything personal. Like God. He knows every feather that falls from the tail of a sparrow or however the hell it goes. Right? And you know something? Accidents don't happen to people who take accidents as a personal insult. So I came late, OK, but I'm coming all the way. Damn right, I take that broken jaw personal; damn right, I take Sollozzo trying to kill my father personal.' He laughed. 'Tell the old man I learned it all from him and that I'm glad I had this chance to pay him back for all he did for me. He was a good father.' He paused and then he said thoughtfully to Hagen, 'You know, I can never remember him hitting me. Or Sonny. Or Freddie. And of course Connie, he wouldn't even yell at her. And tell me the truth, Tom, how many men do you figure the Don killed or had killed.'

Tom Hagen turned away. 'I'll tell you one thing you didn't learn from him: talking the way you're talking now. There are things that have to be done and you do them and you never talk about them. You don't try to justify them. They can't be justified. You just do them. Then you forget it.'

Michael Corleone frowned. He said quietly, 'As the *Consigliori*, you agree that it's dangerous to the Don and our Family to let Sollozzo live?'

'Yes,' Hagen said.

'OK,' Michael said. 'Then I have to kill him.'

Michael Corleone stood in front of Jack Dempsey's restaurant on Broadway and waited for his pickup. He looked at his watch. It said five minutes to eight. Sollozzo was going to be punctual. Michael had made sure he was there in plenty of time. He had been waiting fifteen minutes.

All during the ride from Long Beach into the city he had

been trying to forget what he had said to Hagen. For if he believed what he said, then his life was set on an irrevocable course. And yet, could it be otherwise after tonight? He might be dead after tonight if he didn't stop all this crap, Michael thought grimly. He had to keep his mind on the business at hand. Sollozzo was no dummy and McCluskey was a very tough egg. He felt the ache in his wired jaw and welcomed the pain, it would keep him alert.

Broadway wasn't that crowded on this cold winter night, even though it was near theatre time. Michael flinched as a long black car pulled up to the kerb and the driver, leaning over, opened the front door and said, 'Get in, Mike.' He didn't know the driver, a young punk with slick black hair and an open shirt, but he got in. In the back seat were Captain McCluskey and Sollozzo.

Sollozzo reached a hand over the back of the seat and Michael shook it. The hand was firm, warm and dry. Sollozzo said, 'I'm glad you came, Mike. I hope we can straighten everything out. All this is terrible, it's not the way I wanted things to happen at all. It should never have happened.'

Michael Corleone said quietly, 'I hope we can settle things tonight, I don't want my father bothered any more.'

'He won't be,' Sollozzo said sincerely. 'I swear to you by my children he won't be. Just keep an open mind when we talk. I hope you're not a hothead like your brother Sonny. It's impossible to talk business with him.'

Captain McCluskey grunted. 'He's a good kid, he's all right.' He leaned over to give Michael an affectionate pat on the shoulder. 'I'm sorry about the other night, Mike. I'm getting too old for my job, too grouchy. I guess I'll have to retire pretty soon. Can't stand the aggravation, all day I get aggravation. You know how it is.' Then with a doleful sigh, he gave Michael a thorough frisk for a weapon.

Michael saw a slight smile on the driver's lips. The car was going west with no apparent attempt to elude any trailers. It went up on to the West Side Highway, speeding in and out of traffic. Anyone following would have had to do the same. Then to Michael's dismay it took the exit for the George Washington Bridge, they were going over to New Jersey.

Whoever had given Sonny the info on where the meeting was to be held had given him the wrong dope.

The car threaded through the bridge approaches and then was on it, leaving the blazing city behind. Michael kept his face impassive. Were they going to dump him into the swamps or was it just a last-minute change in meeting place by the wily Sollozzo? But when they were nearly all the way across, the driver gave the wheel a violent twist. The heavy automobile jumped into the air when it hit the divider and bounced over into the lanes going back to New York City. Both McCluskey and Sollozzo were looking back to see if anyone had tried doing the same thing. The driver was really hitting it back to New York and then they were off the bridge and going towards the East Bronx. They went through side streets with no cars behind them. By this time it was nearly nine o'clock. They had made sure there was no one on their tail. Sollozzo lit up a cigarette after offering his pack to McCluskey and Michael, both of whom refused. Sollozzo said to the driver, 'Nice work. I'll remember it.'

Ten minutes later the car pulled up in front of a restaurant in a small Italian neighbourhood. There was no one on the streets and because of the lateness of the hour only a few people were still at dinner. Michael had been worried that the driver would come in with them, but he stayed outside with his car. The negotiator had not mentioned a driver, nobody had. Technically Sollozzo had broken the agreement by bringing him along. But Michael decided not to mention it, knowing they would think he would be afraid to mention it, afraid of ruining the chances for the success of the parley.

The three of them sat at the only round table, Sollozzo refusing a booth. There were only two other people in the restaurant. Michael wondered whether they were Sollozzo plants. But it didn't matter. Before they could interfere it would be all over.

McCluskey asked with real interest, 'Is the Italian food good here?'

Sollozzo reassured him. 'Try the veal, it's the finest in New York.' The solitary waiter had brought a bottle of wine to the table and uncorked it. He poured three glasses full. Sur-

prisingly McCluskey did not drink. 'I must be the only Irish-man who don't take the booze,' he said. 'I seen too many good people get in trouble because of the booze.'

Sollozzo said placatingly to the captain, 'I am going to talk Italian to Mike, not because I don't trust you but because I can't explain myself properly in English and I want to convince Mike that I mean well, that it's to everybody's advantage for us to come to an agreement tonight. Don't be insulted by this, it's not that I don't trust you.'

Captain McCluskey gave them both an ironic grin. 'Sure, you two go right ahead,' he said. 'I'll concentrate on my veal and spaghetti.'

Sollozzo began speaking to Michael in rapid Sicilian. He said, 'You must understand that what happened between me and your father was strictly a business matter. I have a great respect for Don Corleone and would beg for the opportunity to enter his service. But you must understand that your father is an old-fashioned man. He stands in the way of progress. The business I am in is the coming thing, the wave of the future, there are untold millions of dollars for everyone to make. But your father stands in the way because of certain unrealistic scruples. By doing this he imposes his will on men like myself. Yes, yes, I know, he says to me, "Go ahead, it's your business," but we both know that is unrealistic. We must tread on each other's corns. What he is really telling me is that I cannot operate my business. I am a man who respects himself and cannot let another man impose his will on me so what had to happen did happen. Let me say that I had the support, the silent support of all the New York Families. And the Tattaglia Family became my partners. If this quarrel continues, then the Corleone Family will stand alone against everyone. Perhaps if your father were well, it could be done. But the eldest son is not the man the Godfather is, no disrespect intended. And the Irish *Consigliori*, Hagen, is not the man Genco Abbandando was, God rest his soul. So I propose a peace, a truce. Let us cease all hostilities until your father is well again and can take part in these bargainings. The Tattaglia Family agrees, upon my persuasions and my indemnities, to forgo justice for their son Bruno. We will have peace. Meanwhile, I have to make a

living and will do a little trading in my business. I do not ask your cooperation but I ask you, the Corleone Family, not to interfere. These are my proposals. I assume you have the authority to agree, to make a deal.'

Michael said in Sicilian, 'Tell me more about how you propose to start your business, exactly what part my Family has to play in it and what profit we can take from this business.'

'You want the whole proposition in detail then?' Sollozzo asked.

Michael said gravely, 'Most important of all I must have sure guarantees that no more attempts will be made on my father's life.'

Sollozzo raised his hand expressively. 'What guarantees can I give you? I'm the hunted one. I've missed my chance. You think too highly of me, my friend. I am not that clever.'

Michael was sure now that the conference was only to gain a few days' time. That Sollozzo would make another attempt to kill the Don. What was beautiful was that the Turk was under-rating him as a punk kid. Michael felt that strange delicious chill filling his body. He made his face look distressed. Sollozzo asked sharply, 'What is it?'

Michael said with an embarrassed air, 'The wine went right to my bladder. I've been holding it in. Is it all right if I go to the bathroom.'

Sollozzo was searching his face intently with his dark eyes. He reached over and roughly thrust his hand in Michael's crotch, under it and around, searching for a weapon. Michael looked offended. McCluskey said curtly, 'I frisked him. I've frisked thousands of young punks. He's clean.'

Sollozzo didn't like it. For no reason at all he didn't like it. He glanced at the man sitting at a table opposite them and raised his eyebrows towards the door of the bathroom. The man gave a slight nod that he had checked it, that there was nobody inside. Sollozzo said reluctantly, 'Don't take too long.' He had marvellous antennae, he was nervous.

Michael got up and went into the bathroom. The urinal had a pink bar of soap in it secured by a wire net. He went into the

booth. He really had to go, his bowels were loose. He did it very quickly, then reached behind the enamel water cabinet until his hand touched the small, blunt-nose gun fastened with tape. He ripped the gun loose, remembering that Clemenza had said not to worry about leaving prints on the tape. He shoved the gun into his waistband and buttoned his jacket over it. He washed his hands and wet his hair. He wiped his prints off the faucet with his handkerchief. Then he left the toilet.

Sollozzo was sitting directly facing the door of the toilet, his dark eyes blazing with alertness. Michael gave a smile. 'Now I can talk,' he said with a sigh of relief.

Captain McCluskey was eating the plate of veal and spaghetti that had arrived. The man on the far wall had been stiff with attention, now he too relaxed visibly.

Michael sat down again. He remembered Clemenza had told him not to do this, to come out of the toilet and blaze away. But either out of some warning instinct or sheer funk he had not done so. He had felt that if he had made one swift move he would have been cut down. Now he felt safe and he must have been scared because he was glad he was no longer standing on his legs. They had gone weak with trembling.

Sollozzo was leaning towards him. Michael, his belly covered by the table, unbuttoned his jacket and listened intently. He could not understand a word the man was saying. It was literally gibberish to him. His mind was so filled with pounding blood that no word registered. Underneath the table his right hand moved to the gun tucked into his waistband and he drew it free. At that moment the waiter came to take their order and Sollozzo turned his head to speak to the waiter. Michael thrust the table away from him with his left hand and his right hand shoved the gun almost against Sollozzo's head. The man's coordination was so acute that he had already begun to fling himself away at Michael's motion. But Michael, younger, his reflexes sharper, pulled the trigger. The bullet caught Sollozzo squarely between his eye and his ear and when it exited on the other side blasted out a huge gout of blood and skull fragments on to the petrified waiter's jacket. Instinctively Michael knew that one bullet was enough.

Sollozzo had turned his head in that last moment and he had seen the light of life die in the man's eyes as clearly as a candle goes out.

Only one second had gone by as Michael pivoted to bring the gun to bear on McCluskey. The police captain was staring at Sollozzo with phlegmatic surprise, as if this had nothing to do with him. He did not seem to be aware of his own danger. His veal-covered fork was suspended in his hand and his eyes were just turning on Michael. And the expression on his face, in his eyes, held such confident outrage, as if now he expected Michael to surrender or to run away, that Michael smiled at him as he pulled the trigger. This shot was bad, not mortal. It caught McCluskey in his thick bull-like throat and he started to choke loudly as if he had swallowed too large a bite of the veal. Then the air seemed to fill with a fine mist of sprayed blood as he coughed it out of his shattered lungs. Very coolly, very deliberately, Michael fired the next shot through the top of his white-haired skull.

The air seemed to be full of pink mist. Michael swung towards the man sitting against the wall. This man had not made a move. He seemed paralysed. Now he carefully showed his hands on top of the table and looked away. The waiter was staggering back towards the kitchen, an expression of horror on his face, staring at Michael in disbelief. Sollozzo was still in his chair, the side of his body propped up by the table. McCluskey, his heavy body pulling downward, had fallen off his chair on to the floor. Michael let the gun slip out of his hand so that it bounced off his body and made no noise. He saw that neither the man against the wall nor the waiter had noticed him dropping the gun. He strode the few steps towards the door and opened it. Sollozzo's car was parked at the kerb still, but there was no sign of the driver. Michael turned left and around the corner. Headlights flashed on and a battered sedan pulled up to him, the door swinging open. He jumped in and the car roared away. He saw that it was Tessio at the wheel, his trim features hard as marble.

'Did you do the job on Sollozzo?' Tessio asked.

For that moment Michael was struck by the idiom Tessio had used. It was always used in a sexual sense, to do the job on

a woman meant seducing her. It was curious that Tessio used it now. 'Both of them,' Michael said.

'Sure?' Tessio asked.

'I saw their brains,' Michael said.

There was a change of clothes for Michael in the car. Twenty minutes later he was on an Italian freighter slated for Sicily. Two hours later the freighter put out to sea and from his cabin Michael could see the lights of New York City burning like the fires of hell. He felt an enormous sense of relief. He was out of it now. The feeling was familiar and he remembered being taken off the beach of an island his Marine division had invaded. The battle had been still going on but he had received a slight wound and was being ferried back to a hospital ship. He had felt the same overpowering relief then that he felt now. All hell would break loose but he wouldn't be there.

On the day after the murder of Sollozzo and Captain Mc-Cluskey, the police captains and lieutenants in every station house in New York City sent out the word: there would be no more gambling, no more prostitution, no more deals of any kind until the murderer of Captain McCluskey was caught. Massive raids began all over the city. All unlawful business activities came to a standstill.

Later that day an emissary from the Families asked the Corleone Family if they were prepared to give up the murderer. They were told that the affair did not concern them. That night a bomb exploded in the Corleone Family mall in Long Beach, thrown from a car that pulled up to the chain, then roared away. That night also two button men of the Corleone Family were killed as they peaceably ate their dinner in a small Italian restaurant in Greenwich Village. The Five Families War of 1946 had begun.

Book II

CHAPTER TWELVE

JOHNNY FONTANE waved a casual dismissal to the manservant and said, 'See you in the morning, Billy.' The coloured butler bowed his way out of the huge dining room-living room with its view of the Pacific Ocean. It was a friendly-goodbye sort of bow, not a servant's bow, and given only because Johnny Fontane had company for dinner.

Johnny's company was a girl named Sharon Moore, a New York City Greenwich Village girl in Hollywood to try for a small part in a movie being produced by an old flame who had made the big time. She had visited the set while Johnny was acting in the Woltz movie. Johnny had found her young and fresh and charming and witty, and had asked her to come to his place for dinner that evening. His invitations to dinner were already famous and had the force of royalty and of course she said yes.

Sharon Moore obviously expected him to come on very strong because of his reputation, but Johnny hated the Hollywood 'piece of meat' approach. He never slept with any girl unless there was something about her he really liked. Except, of course, sometimes when he was very drunk and found himself in bed with a girl he didn't even remember meeting or seeing before. And now that he was thirty-five years old, divorced once, estranged from his second wife, with maybe a thousand pubic scalps dangling from his belt, he simply wasn't that eager. But there was something about Sharon Moore that aroused affection in him and so he had invited her to dinner.

He never ate much but he knew young pretty girls ambitiously starved themselves for pretty clothes and were usually big eaters on a date so there was plenty of food on the table. There was also plenty of liquor: champagne in a bucket,

Scotch, rye, brandy, and liqueurs on the sideboard. Johnny served the drinks and the plates of food already prepared. When they had finished eating he led her into the huge living room with its glass wall that looked out on to the Pacific. He put a stack of Ella Fitzgerald records on the hi-fi and settled on the couch with Sharon. He made a little small talk with her, found out about what she had been like as a kid, whether she had been a tomboy or boy crazy, whether she had been homely or pretty, lonely or gay. He always found these details touching, it always evoked the tenderness he needed to make love.

They nestled together on the sofa, very friendly, very comfortable. He kissed her on the lips, a cool friendly kiss, and when she kept it that way he left it that way. Outside the huge picture window he could see the dark blue sheet of the Pacific lying flat beneath the moonlight.

'How come you're not playing any of your records?' Sharon asked him. Her voice was teasing. Johnny smiled at her. He was amused by her teasing him. 'I'm not that Hollywood,' he said.

'Play some for me,' she said. 'Or sing for me. You know, like the movies. I'll bubble up and melt all over you just like those girls do on the screen.'

Johnny laughed outright. When he had been younger, he had done just such things and the result had always been stagy, the girls trying to look sexy and melting, making their eyes swim with desire for an imagined fantasy camera. He would never dream of singing to a girl now; for one thing, he hadn't sung for months, he didn't trust his voice. For another thing, amateurs didn't realize how much professionals depended on technical help to sound as good as they did. He could have played his records but he felt the same shyness about hearing his youthful passionate voice as an ageing, balding man running to fat feels about showing pictures of himself as a youth in the full bloom of manhood.

'My voice is out of shape,' he said. 'And honestly, I'm sick of hearing myself sing.'

They both sipped their drinks. 'I hear you're great in this picture,' she said. 'Is it true you did it for nothing?'

'Just a token payment,' Johnny said.

He got up to give her a refill on her brandy glass, gave her a gold-monogrammed cigarette and flashed his lighter out to hold the light for her. She puffed on the cigarette and sipped her drink and he sat down beside her again. His glass had considerably more brandy in it than hers, he needed it to warm himself, to cheer himself, to charge himself up. His situation was the reverse of the lover's usual one. He had to get himself drunk instead of the girl. The girl was usually too willing where he was not. The last two years had been hell on his ego, and he used this simple way to restore it, sleeping with a young fresh girl for one night, taking her to dinner a few times, giving her an expensive present, and then brushing her off in the nicest way possible so that her feelings wouldn't be hurt. And then they could always say they had had a thing with the great Johnny Fontane. It wasn't true love, but you couldn't knock it if the girl was beautiful and genuinely nice. He hated the hard, bitchy ones, the ones who screwed for him and then rushed off to tell their friends that they'd screwed the great Johnny Fontane, always adding that they'd had better. What amazed him more than anything else in his career were the complaisant husbands who almost told him to his face that they forgave their wives since it was allowed for even the most virtuous matron to be unfaithful with a great singing and movie star like Johnny Fontane. That really floored him.

He loved Ella Fitzgerald on records. He loved that kind of clean singing, that kind of clean phrasing. It was the only thing in life he really understood and he knew he understood it better than anyone else on earth. Now lying back on the couch, the brandy warming his throat, he felt a desire to sing, not music, but to phrase with the records, yet it was something impossible to do in front of a stranger. He put his free hand in Sharon's lap, sipping his drink from his other hand. Without any slyness but with the sensualness of a child seeking warmth, his hand in her lap pulled up the silk of her dress to show milky white thigh above the sheer netted gold of her stockings and as always, despite all the women, all the years, all the familiarity, Johnny felt the fluid sticky warmness flooding through his body at that sight. The miracle still happened, and what would he do when that failed him as his voice had?

He was ready now. He put his drink down on the long in-laid cocktail table and turned his body towards her. He was very sure, very deliberate, and yet tender. There was nothing sly or lecherously lascivious in his caresses. He kissed her on the lips while his hands rose to her breasts. His hand fell to her warm thighs, the skin so silky to his touch. Her returning kiss was warm but not passionate and he preferred it that way right now. He hated girls who turned on all of a sudden as if their bodies were motors galvanized into erotic pumpings by the touching of a hairy switch.

Then he did something he always did, something that had never yet failed to arouse him. Delicately and as lightly as it was possible to do so and still feel something, he brushed the tip of his middle finger deep down between her thighs. Some girls never even felt that initial move towards lovemaking. Some were distracted by it, not sure it was a physical touch because at the same time he always kissed them deeply on the mouth. Still others seemed to suck in his finger or gobble it up with a pelvic thrust. And of course before he became famous, some girls had slapped his face. It was his whole technique and usually it served him well enough.

Sharon's reaction was unusual. She accepted it all, the touch, the kiss, then shifted her mouth off his, shifted her body ever so slightly back along the couch and picked up her drink. It was a cool but definite refusal. It happened sometimes. Rarely; but it happened. Johnny picked up his drink and lit a cigarette.

She was saying something very sweetly, very lightly. 'It's not that I don't like you, Johnny, you're much nicer than I thought you'd be. And it's not because I'm not that kind of a girl. It's just that I have to be turned on to do it with a guy, you know what I mean?'

Johnny Fontane smiled at her. He still liked her. 'And I don't turn you on?'

She was a little embarrassed. 'Well, you know, when you were so great singing and all, I was still a little kid. I sort of just missed you, I was the next generation. Honest, it's not that I'm goody-goody. If you were James Dean or somebody I grew up on, I'd have my panties off in a second.'

He didn't like her quite so much now. She was sweet, she was witty, she was intelligent. She hadn't fallen all over herself to screw for him or try to hustle him because his connexions would help her in show biz. She was really a straight kid. But there was something else he recognized. It had happened a few times before. The girl who went on a date with her mind all made up not to go to bed with him, no matter how much she liked him, just so that she could tell her friends, and even more, herself, that she had turned down a chance to screw for the great Johnny Fontane. It was something he understood now that he was older and he wasn't angry. He just didn't like her quite that much and he had really liked her a lot.

And now that he didn't like her quite so much, he relaxed more. He sipped his drink and watched the Pacific Ocean. She said, 'I hope you're not sore, Johnny. I guess I'm being square, I guess in Hollywood a girl's supposed to put out just as casually as kissing a beau goodnight. I just haven't been around long enough.'

Johnny smiled at her and patted her cheek. His hand fell down to pull her skirt discreetly over her rounded silken knees. 'I'm not sore,' he said. 'It's nice having an old-fashioned date.' Not telling what he felt: the relief at not having to prove himself a great lover, not having to live up to his screened, godlike image. Not having to listen to the girl trying to react as if he really had lived up to that image, making more out of a very simple, routine piece of ass than it really was.

They had another drink, shared a few more cool kisses and then she decided to go. Johnny said politely, 'Can I call you for dinner some night?'

She played it frank and honest to the end. 'I know you don't want to waste your time and then get disappointed,' she said. 'Thanks for a wonderful evening. Some day I'll tell my children I had supper with the great Johnny Fontane all alone in his apartment.'

He smiled at her. 'And that you didn't give in,' he said. They both laughed. 'They'll never believe that,' she said. And then Johnny, being a little phony in his turn, said, 'I'll give it to you in writing, want me to?' She shook her head. He con-

tinued on. 'Anybody doubts you, give me a buzz on the phone, I'll straighten them right out. I'll tell them how I chased you all around the apartment but you kept your honour. OK?'

He had, finally, been a little too cruel and he felt stricken at the hurt on her young face. She understood that he was telling her that he hadn't tried too hard. He had taken the sweetness of her victory away from her. Now she would feel that it had been her lack of charm or attractiveness that had made her the victor this night. And being the girl she was, when she told the story of how she resisted the great Johnny Fontane, she would always have to add with a wry little smile, 'Of course, he didn't try very hard.' So now taking pity on her, he said, 'If you ever feel real down, give me a ring. OK? I don't have to shack up every girl I know.'

'I will,' she said. She went out the door.

He was left with a long evening before him. He could have used what Jack Woltz called the 'meat factory', the stable of willing starlets, but he wanted human companionship. He wanted to talk like a human being. He thought of his first wife, Virginia. Now that the work on the picture was finished he would have more time for the kids. He wanted to become part of their life again. And he worried about Virginia too. She wasn't equipped to handle the Hollywood sharpies who might come after her just so that they could brag about having screwed Johnny Fontane's first wife. As far as he knew, nobody could say that yet. Everybody could say it about his second wife though, he thought wryly. He picked up the phone.

He recognized her voice immediately and that was not surprising. He had heard it the first time when he was ten years old and they had been in 4B together. 'Hi, Ginny,' he said, 'you busy tonight? Can I come over for a little while?'

'All right,' she said. 'The kids are sleeping though; I don't want to wake them up.'

'That's OK,' he said. 'I just wanted to talk to you.'

Her voice hesitated slightly, then carefully controlled not to show any concern, she asked, 'Is it anything serious, anything important?'

'No,' Johnny said. 'I finished the picture today and I

thought maybe I could just see you and talk to you. Maybe I could take a look at the kids if you're sure they won't wake up.'

'OK,' she said. 'I'm glad you got that part you wanted.'

'Thanks,' he said. 'I'll see you in about a half hour.'

When he got to what had been his home in Beverly Hills, Johnny Fontane sat in the car for a moment staring at the house. He remembered what his Godfather had said, that he could make his own life what he wanted. Great chance if you knew what you wanted. But what did he want?

His first wife was waiting for him at the door. She was pretty, petite and brunette, a nice Italian girl, the girl next door who would never fool around with another man and that had been important to him. Did he still want her, he asked himself, and the answer was no. For one thing, he could no longer make love to her, their affection had grown too old. And there were some things, nothing to do with sex, she could never forgive him. But they were no longer enemies.

She made him coffee and served him homemade cookies in the living room. 'Stretch out on the sofa,' she said, 'you look tired.' He took off his jacket and his shoes and loosened his tie while she sat in the chair opposite him with a grave little smile on her face. 'It's funny,' she said.

'What's funny?' he asked her, sipping coffee and spilling some of it on his shirt.

'The great Johnny Fontane stuck without a date,' she said.

'The great Johnny Fontane is lucky if he can even get it up any more,' he said.

It was unusual for him to be so direct. Ginny asked, 'Is there something really the matter?'

Johnny grinned at her. 'I had a date with a girl in my apartment and she brushed me off. And you know, I was relieved.'

To his surprise he saw a look of anger pass over Ginny's face. 'Don't worry about those little tramps,' she said. 'She must have thought that was the way to get you interested in her.' And Johnny realized with amusement that Ginny was actually angry with the girl who had turned him down.

'Ah, what the hell,' he said. 'I'm tired of that stuff. I have to grow up sometime. And now that I can't sing any more I guess

I'll have a tough time with dames. I never got in on my looks, you know.'

She said loyally, 'You were always better looking than you photographed.'

Johnny shook his head. 'I'm getting fat and I'm getting bald. Hell, if this picture doesn't make me big again I better learn how to bake pizzas. Or maybe we'll put you in the movies, you look great.'

She looked thirty-five. A good thirty-five, but thirty-five. And out here in Hollywood that might as well be a hundred. The young beautiful girls thronged through the city like lemmings, lasting one year, some two. Some of them so beautiful they could make a man's heart almost stop beating until they opened their mouths, until the greedy hopes for success clouded the loveliness of their eyes. Ordinary women could never hope to compete with them on a physical level. And you could talk all you wanted to about charm, about intelligence, about chic, about poise, the raw beauty of these girls overpowered everything else. Perhaps if there were not so many of them there might be a chance for an ordinary, nice-looking woman. And since Johnny Fontane could have all of them, or nearly all of them, Ginny knew that he was saying all this just to flatter her. He had always been nice that way. He had always been polite to women even at the height of his fame, paying them compliments, holding lights for their cigarettes, opening doors. And since all this was usually done for *him*, it made it even more impressive to the girls he went out with. And he did it with all girls, even the one-night stands, I-don't-know-your-name girls.

She smiled at him, a friendly smile. 'You already made me, Johnny, remember? For twelve years. You don't have to give me your line.'

He sighed and stretched out on the sofa. 'No kidding, Ginny, you look good. I wish I looked that good.'

She didn't answer him. She could see he was depressed. 'Do you think the picture is OK? Will it do you some good?' she asked.

Johnny nodded. 'Yeah. It could bring me all the way back. If I get the Academy thing and play my cards right, I can make

it big again even without the singing. Then maybe I can give you and the kids more dough.'

'We have more than enough,' Ginny said.

'I wanta see more of the kids too,' Johnny said. 'I want to settle down a little bit. Why can't I come every Friday night for dinner here? I swear I'll never miss one Friday, I don't care how far away I am or how busy I am. And then whenever I can I'll spend weekends or maybe the kids can spend some part of their vacations with me.'

Ginny put an ashtray on his chest. 'It's OK with me,' she said. 'I never got married because I wanted you to keep being their father.' She said this without any kind of emotion, but Johnny Fontane, staring up at the ceiling, knew she said it as an atonement for those other things, the cruel things she had once said to him when their marriage had broken up, when his career had started going down the drain.

'By the way, guess who called me,' she said.

Johnny wouldn't play that game, he never did. 'Who?' he asked.

Ginny said, 'You could take at least one lousy guess.' Johnny didn't answer. 'Your Godfather,' she said.

Johnny was really surprised. 'He never talks to anybody on the phone. What did he say to you?'

'He told me to help you,' Ginny said. 'He said you could be as big as you ever were, that you were on your way back, but that you needed people to believe in you. I asked him why should I? And he said because you're the father of my children. He's such a sweet old guy and they tell such horrible stories about him.'

Virginia hated phones and she had had all the extensions taken out except for the one in her bedroom and one in the kitchen. Now they could hear the kitchen phone ringing. She went to answer it. When she came back into the living room there was a look of surprise on her face. 'It's for you, Johnny,' she said. 'It's Tom Hagen. He says it's important.'

Johnny went into the kitchen and picked up the phone. 'Yeah, Tom,' he said.

Tom Hagen's voice was cool. 'Johnny, the Godfather wants me to come out and see you and set some things up that can

help you out now that the picture is finished. He wants me to catch the morning plane. Can you meet it in Los Angeles? I have to fly back to New York the same night so you won't have to worry about keeping your night free for me.'

'Sure, Tom,' Johnny said. 'And don't worry about me losing a night. Stay over and relax a bit. I'll throw a party and you can meet some movie people.' He always made that offer, he didn't want the folks from his old neighbourhood to think he was ashamed of them.

'Thanks,' Hagen said, 'but I really have to catch the early morning plane back. OK, you'll meet the eleven-thirty AM out of New York?'

'Sure,' Johnny said.

'Stay in your car,' Hagen said. 'Send one of your people to meet me when I get off the plane and bring me to you.'

'Right,' Johnny said.

He went back to the living room and Ginny looked at him inquiringly. 'My Godfather has some plans for me, to help me out,' Johnny said. 'He got me the part in the movie, I don't know how. But I wish he'd stay out of the rest of it.'

He went back on to the sofa. He felt very tired. Ginny said, 'Why don't you sleep in the guest bedroom tonight instead of going home. You can have breakfast with the kids and you won't have to drive home so late. I hate to think of you all alone in that house of yours anyway. Don't you get lonely?'

'I don't stay home much,' Johnny said.

She laughed and said, 'Then you haven't changed much.' She paused and then said, 'Shall I fix up the other bedroom?'

Johnny said, 'Why can't I sleep in your bedroom?'

She flushed. 'No,' she said. She smiled at him and he smiled back. They were still friends.

When Johnny woke up the next morning it was late, he could tell by the sun coming in through the drawn blinds. It never came in that way unless it was in the afternoon. He yelled, 'Hey, Ginny, do I still rate breakfast?' And far away he heard her voice call, 'Just a second.'

And it was just a second. She must have had everything ready, hot in the oven, the tray waiting to be loaded, because as Johnny lit his first cigarette of the day, the door of the

bedroom opened and his two small daughters came in wheeling the breakfast cart.

They were so beautiful it broke his heart. Their faces were shining and clear, their eyes alive with curiosity and the eager desire to run to him. They wore their hair braided old-fashioned in long pigtails and they wore old-fashioned frocks and white patent-leather shoes. They stood by the breakfast cart watching him as he stubbed out his cigarette and waited for him to call and hold his arms wide. Then they came running to him. He pressed his face between their two fresh fragrant cheeks and scraped them with his beard so that they shrieked. Ginny appeared in the bedroom door and wheeled the breakfast cart the rest of the way so that he could eat in bed. She sat beside him on the edge of the bed, pouring his coffee, buttering his toast. The two young daughters sat on the bedroom couch watching him. They were too old now for pillow fights or to be tossed around. They were already smoothing their mussed hair. Oh, Christ, he thought, pretty soon they'll be all grown up, Hollywood punks will be out after them.

He shared his toast and bacon with them as he ate, gave them sips of coffee. It was a habit left over from when he had been singing with the band and rarely ate with them so they liked to share his food when he had his odd-hour meals like afternoon breakfasts or morning suppers. The change-around in food delighted them – to eat steak and french fries at seven in the morning, bacon and eggs in the afternoon.

Only Ginny and a few of his close friends knew how much he idolized his daughters. That had been the worst thing about the divorce and leaving home. The one thing he had fought about, and for, was his position as a father to them. In a very sly way he had made Ginny understand he would not be pleased by her remarrying, not because he was jealous of her, but because he was jealous of his position as a father. He had arranged the money to be paid to her so it would be enormously to her advantage financially not to remarry. It was understood that she could have lovers as long as they were not introduced into her home life. But on this score he had absolute faith in her. She had always been amazingly shy and

old-fashioned in sex. The Hollywood gigolos had batted zero when they started swarming around her, sniffing for the financial settlement and the favours they could get from her famous husband.

He had no fear that she expected a reconciliation because he had wanted to sleep with her the night before. Neither one of them wanted to renew their old marriage. She understood his hunger for beauty, his irresistible impulse towards young women far more beautiful than she. It was known that he always slept with his movie co-stars at least once. His boyish charm was irresistible to them, as their beauty was to him.

'You'll have to start getting dressed pretty soon,' Ginny said. 'Tom's plane will be getting in.' She shooed the daughters out of the room.

'Yeah,' Johnny said. 'By the way, Ginny, you know I'm getting divorced? I'm gonna be a free man again.'

She watched him getting dressed. He always kept fresh clothes at her house ever since they had come to their new arrangement after the wedding of Don Corleone's daughter. 'Christmas is only two weeks away,' she said. 'Shall I plan on you being here?'

It was the first time he had even thought about the holidays. When his voice was in shape, holidays were lucrative singing dates but even then Christmas was sacred. If he missed this one, it would be the second one. Last year he had been courting his second wife in Spain, trying to get her to marry him.

'Yeah,' he said. 'Christmas Eve and Christmas.' He didn't mention New Year's Eve. That would be one of the wild nights he needed every once in a while, to get drunk with his friends, and he didn't want a wife along then. He didn't feel guilty about it.

She helped him put on his jacket and brushed it off. He was always fastidiously neat. She could see him frowning because the shirt he had put on was not laundered to his taste, the cuff links, a pair he had not worn for some time, were a little too loud for the way he liked to dress now. She laughed softly and said, 'Tom won't notice the difference.'

The three women of the family walked him to the door and out on the driveway to his car. The two little girls held his

hands, one on each side. His wife walked a little behind him. She was getting pleasure out of how happy he looked. When he reached his car he turned around and swung each girl in turn high up in the air and kissed her on the way down. Then he kissed his wife and got into the car. He never liked drawn-out goodbyes.

Arrangements had been made by his PR man and aide. At his house a chauffeured car was waiting, a rented car. In it were the PR man and another member of his entourage. Johnny parked his car and hopped in and they were on their way to the airport. He waited inside the car while the PR man went out to meet Tom Hagen's plane. When Tom got into the car they shook hands and drove back to his house.

Finally he and Tom were alone in the living room. There was a coolness between them. Johnny had never forgiven Hagen for acting as a barrier to his getting in touch with the Don when the Don was angry with him, in those bad days before Connie's wedding. Hagen never made excuses for his actions. He could not. It was part of his job to act as a lightning rod for resentments which people were too awed to feel towards the Don himself though he had earned them.

'Your Godfather sent me out here to give you a hand on some things,' Hagen said. 'I wanted to get it out of the way before Christmas.'

Johnny Fontane shrugged. 'The picture is finished. The director was a square guy and treated me right. My scenes are too important to be left on the cutting-room floor just for Woltz to pay me off. He can't ruin a ten-million-dollar picture. So now everything depends on how good people think I am in the movie.'

Hagen said cautiously, 'Is winning this Academy Award so terribly important to an actor's career, or is it just the usual publicity crap that really doesn't mean anything one way or the other?' He paused and added hastily, 'Except of course the glory, everybody likes glory.'

Johnny Fontane grinned at him. 'Except my Godfather. And you. No, Tom, it's not a lot of crap. An Academy Award can make an actor for ten years. He can get his pick of roles.

The public goes to see him. It's not everything, but for an actor it's the most important thing in the business. I'm counting on winning it. Not because I'm such a great actor but because I'm known primarily as a singer and the part is foolproof. And I'm pretty good too, no kidding.'

Tom Hagen shrugged and said, 'Your Godfather tells me that the way things stand now, you don't have a chance of winning the award.'

Johnny Fontane was angry. 'What the hell are you talking about? The picture hasn't even been cut yet, much less shown. And the Don isn't even in the movie business. Why the hell did you fly the three thousand miles just to tell me that shit?' He was so shaken he was almost in tears.

Hagen said worriedly, 'Johnny, I don't know a damn thing about all this movie stuff. Remember, I'm just a messenger boy for the Don. But we have discussed this whole business of yours many times. He worries about you, about your future. He feels you still need his help and he wants to settle your problem once and for all. That's why I'm here now, to get things rolling. But you have to start growing up, Johnny. You have to stop thinking about yourself as a singer or an actor. You've got to start thinking about yourself as a prime mover, as a guy with muscle.'

Johnny Fontane laughed and filled his glass. 'If I don't win that Oscar I'll have as much muscle as one of my daughters. My voice is gone; if I had that back I could make some moves. Oh, hell. How does my Godfather know I won't win it? OK. I believe he knows. He's never been wrong.'

Hagen lit a thin cigar. 'We got the word that Jack Woltz won't spend studio money to support your candidacy. In fact he's sent the word out to everybody who votes that he does not want you to win. But holding back the money for ads and all that may do it. He's also arranging to have one other guy get as much of the opposition votes as he can swing. He's using all sorts of bribes – jobs, money, broads, everything. And he's trying to do it without hurting the picture or hurting it as little as possible.'

Johnny Fontane shrugged. He filled his glass with whisky and downed it. 'Then I'm dead.'

Hagen was watching him with his mouth curled up with distaste. 'Drinking won't help your voice,' he said.

'Fuck you,' Johnny said.

Hagen's face suddenly became smoothly impassive. Then he said, 'OK, I'll keep this purely business.'

Johnny Fontane put his drink down and went over to stand in front of Hagen. 'I'm sorry I said that, Tom,' he said. 'Christ, I'm sorry. I'm taking it out on you because I wanta kill that bastard Jack Woltz and I'm afraid to tell off my God-father. So I get sore at you.' There were tears in his eyes. He threw the empty whisky glass against the wall but so weakly that the heavy shot glass did not even shatter and rolled along the floor back to him so that he looked down at it in baffled fury. Then he laughed. 'Jesus Christ,' he said.

He walked over to the other side of the room and sat opposite Hagen. 'You know, I had everything my own way for a long time. Then I divorced Ginny and everything started going sour. I lost my voice. My records stopped selling. I didn't get any more movie work. And then my Godfather got sore at me and wouldn't talk to me on the phone or see me when I came into New York. You were always the guy barring the path and I blamed you, but I knew you wouldn't do it without orders from the Don. But you can't get sore at him. It's like getting sore at God. So I curse you. But you've been right all along the line. And to show you I mean my apology I'm taking your advice. No more booze until I get my voice back. OK?'

The apology was sincere. Hagen forgot his anger. There must be something to this thirty-five-year-old boy or the Don would not be so fond of him. He said, 'Forget it, Johnny.' He was embarrassed at the depth of Johnny's feeling and embarrassed by the suspicion that it might have been inspired by fear, fear that he might turn the Don against him. And of course the Don could never be turned by anyone for any reason. His affection was mutable only by himself.

'Things aren't so bad,' he told Johnny. 'The Don says he can cancel out everything Woltz does against you. That you will almost certainly win the Award. But he feels that won't

solve your problem. He wants to know if you have the brains and balls to become a producer on your own, make your own movies from top to bottom.'

'How the hell is he going to get me the Award?' Johnny asked incredulously.

Hagen said sharply, 'How do you find it so easy to believe that Woltz can finagle it and your Godfather can't? Now since it's necessary to get your faith for the other part of our deal I must tell you this. Just keep it to yourself. Your Godfather is a much more powerful man than Jack Woltz. And he is much more powerful in areas far more critical. How can he swing the Award? He controls, or controls the people who control, all the labour unions in the industry, all the people or nearly all the people who vote. Of course you have to be good, you have to be in contention on your own merits. And your Godfather has more brains than Jack Woltz. He doesn't go up to these people and put a gun to their heads and say, '"Vote for Johnny Fontane or you are out of a job." He doesn't strong-arm where strong-arm doesn't work or leaves too many hard feelings. He'll make those people vote for you because they want to. But they won't want to unless he takes an interest. Now just take my word for it that he can get you the Award. And that if he doesn't do it, you won't get it.'

'OK,' Johnny said. 'I believe you. And I have the balls and brains to be a producer but I don't have the money. No bank would finance me. It takes millions to support a movie.'

Hagen said dryly, 'When you get the Award, start making plans to produce three of your own movies. Hire the best people in the business, the best technicians, the best stars, whoever you need. Plan on three to five movies.'

'You're crazy,' Johnny said. 'That many movies could mean twenty million bucks.'

'When you need the money,' Hagen said, 'get in touch with me. I'll give you the name of the bank out here in California to ask for financing. Don't worry, they finance movies all the time. Just ask them for the money in the ordinary way, with the proper justifications, like a regular business deal. They will approve. But first you have to see me and tell me the figures and the plans. OK?'

Johnny was silent for a long time. Then he said quietly, 'Is there anything else?'

Hagen smiled. 'You mean, do you have to do any favours in return for a loan of twenty million dollars? Sure you will.' He waited for Johnny to say something. 'Nothing you wouldn't do anyway if the Don asked you to do it for him.'

Johnny said, 'The Don has to ask me himself if it's something serious, you know what I mean? I won't take your word or Sonny's for it.'

Hagen was surprised by this good sense. Fontane had some brains after all. He had sense to know that the Don was too fond of him, and too smart, to ask him to do something foolishly dangerous, whereas Sonny might. He said to Johnny, 'Let me reassure you on one thing. Your Godfather has given me and Sonny strict instructions not to involve you in any way in anything that might get you bad publicity through our fault. And he will never do that himself. I guarantee you that any favour he asks of you, you will offer to do before he requests it. OK?'

Johnny smiled. 'OK,' he said.

Hagen said, 'Also he has faith in you. He thinks you have brains and so he figures the bank will make money on the investment, which means he will make money on it. So it's really a business deal, never forget that. Don't go screwing around with the money. You may be his favourite godson but twenty million bucks is a lot of dough. He has to stick his neck out to make sure you get it.'

'Tell him not to worry,' Johnny said. 'If a guy like Jack Woltz can be a big movie genius, anybody can.'

'That's what your Godfather figures,' Hagen said. 'Can you have me driven back to the airport? I've said all I have to say. When you do start signing contracts for everything, hire your own lawyers, I won't be in on it. But I'd like to see everything before you sign, if that's OK with you. Also, you'll never have any labour troubles. That will cut costs on your pictures to some extent, so when the accountants lump some of that in, disregard those figures.'

Johnny said cautiously, 'Do I have to get your OK on anything else, scripts, stars, any of that?'

Hagen shook his head. 'No,' he said. 'It may happen that the Don would object to something but he'll object to you direct if he does. But I can't imagine what that would be. Movies don't affect him at all, in any way, so he has no interest. And he doesn't believe in meddling, that I can tell you from experience.'

'Good,' Johnny said, 'I'll drive you to the airport myself. And thank the Godfather for me. I'd call him up and thank him but he never comes to the phone. Why is that, by the way?'

Hagen shrugged. 'He hardly ever talks on the phone. He doesn't want his voice recorded, even saying something perfectly innocent. He's afraid that they can splice the words together so that it sounds as if he says something else. I think that's what it is. Anyway his only worry is that someday he'll be framed by the authorities. So he doesn't want to give them an edge.'

They got into Johnny's car and drove to the airport. Hagen was thinking that Johnny was a better guy than he figured. He'd already learned something, just his driving him personally to the airport proved that. The personal courtesy, something the Don himself always believed in. And the apology. That had been sincere. He had known Johnny a long time and he knew the apology would never be made out of fear. Johnny had always had guts. That's why he had always been in trouble, with his movie bosses and with his women. He was also one of the few people who was not afraid of the Don. Fontane and Michael were maybe the only two men Hagen knew of whom this could be said. So the apology was sincere, he would accept it as such. He and Johnny would have to see a lot of each other in the next few years. And Johnny would have to pass the next test, which would prove how smart he was. He would have to do something for the Don that the Don would never ask him to do or insist that he do as part of the agreement. Hagen wondered if Johnny Fontane was smart enough to figure out that part of the bargain.

After Johnny dropped Hagen off at the airport (Hagen insisted that Johnny not hang around for his plane with him)

he drove back to Ginny's house. She was surprised to see him. But he wanted to stay at her place so that he would have time to think things out, to make his plans. He knew that what Hagen had told him was extremely important, that his whole life was being changed. He had once been a big star but now at the young age of thirty-five he was washed up. He didn't kid himself about that. Even if he won the Award as best actor, what the hell could it mean at the most? Nothing, if his voice didn't come back. He'd be just second-rate, with no real power, no real juice. Even that girl turning him down, she had been nice and smart and acting sort of hip, but would she have been so cool if he had really been at the top? Now with the Don backing him with dough he could be as big as anybody in Hollywood. He could be a king. Johnny smiled. Hell. He could even be a Don.

It would be nice living with Ginny again for a few weeks, maybe longer. He'd take the kids out every day, maybe have a few friends over. He'd stop drinking and smoking, really take care of himself. Maybe his voice would get strong again. If that happened and with the Don's money, he'd be unbeatable. He'd really be as close to an old-time king or emperor as it was possible to be in America. And it wouldn't depend on his voice holding up or how long the public cared about him as an actor. It would be an empire rooted in money and the most special, the most coveted kind of power.

Ginny had the guest bedroom made up for him. It was understood that he would not share her room, that they would not live as man and wife. They could never have that relationship again. And though the outside world of gossip columnists and movie fans gave the blame for the failure of their marriage solely to him, yet in a curious way, between the two of them, they both knew that she was even more to blame for their divorce.

When Johnny Fontane became the most popular singer and movie musical comedy star in motion pictures, it had never occurred to him to desert his wife and children. He was too Italian, still too old-style. Naturally he had been unfaithful. That had been impossible to avoid in his business and the temptations to which he was continually exposed. And despite

being a skinny, delicate-looking guy, he had the wiry horniness of many small-boned Latin types. And women delighted him in their surprises. He loved going out with a demure sweet-faced virginal-looking girl and then uncapping her breasts to find them so unexpectedly slopingly full and rich, lewdly heavy in contrast to the cameo face. He loved to find sexual shyness and timidity in the sexy-looking girls who were all fake motion like a shifty basketball player, vamping as if they had slept with a hundred guys, and then when he got them alone having to battle for hours to get in and do the job and finding out they were virgins.

And all these Hollywood guys laughed at his fondness for virgins. They called it an old guinea taste, square, and look how long it took to make a virgin give you a blow job with all the aggravation and then they usually turned out to be a lousy piece of ass. But Johnny knew that it was how you handled a young girl. You had to come on to her the right way and then what could be greater than a girl who was tasting her first dick and loving it? Ah, it was so great breaking them in. It was so great having them wrap their legs around you. Their thighs were all different shapes, their asses were different, their skins were all different colours and shades of white and brown and tan and when he had slept with that young coloured girl in Detroit, a good girl, not a hustler, the young daughter of a jazz singer on the same nightclub bill with him, she had been one of the sweetest things he had ever had. Her lips had really tasted like warm honey with pepper mixed in it, her dark brown skin was rich, creamy, and she had been as sweet as God had ever made any woman and she had been a virgin.

And the other guys were always talking about blow jobs this and other variations and he really didn't enjoy that stuff so much. He never liked a girl that much after they tried it that way, it just didn't satisfy him right. He and his second wife had finally not got along because she preferred the old sixty-nine too much to a point where she didn't want anything else and he had to fight to stick it in. She began making fun of him and calling him a square and the word got around that he made love like a kid. Maybe that was why that girl last night had turned him down. Well, the hell with it, she wouldn't be

too great in the sack anyway. You could tell a girl who really liked to fuck and they were always the best. Especially the ones who hadn't been at it too long. What he really hated were the ones who had started screwing at twelve and were all fucked out by the time they were twenty and just going through the motions and some of them were the prettiest of all and could fake you out.

Ginny brought coffee and cake into his bedroom and put it on the long table in the sitting room part. He told her simply that Hagen was helping him put together the money credit for a producing package and she was excited about that. He would be important again. But she had no idea of how powerful Don Corleone really was so she didn't understand the significance of Hagen coming from New York. He told her Hagen was also helping with legal details.

When they had finished the coffee he told her he was going to work that night, and make phone calls and plans for the future. 'Half of all this will be in the kids' names,' he told her. She gave him a grateful smile and kissed him goodnight before she left his room.

There was a glass dish full of his favourite monogrammed cigarettes, a humidor with pencil-thin black Cuban cigars on his writing desk. Johnny tilted back and started making calls. His brain was really whirring along. He called the author of the book, the best-selling novel, on which his new film was based. The author was a guy his own age who had come up the hard way and was now a celebrity in the literary world. He had come out to Hollywood expecting to be treated like a wheel and, like most authors, had been treated like shit. Johnny had seen the humiliation of the author one night at the Brown Derby. The writer had been fixed up with a well-known bosomy starlet for a date on the town and a sure shack-up later. But while they were at dinner the starlet had deserted the famous author because a ratty-looking movie comic had waggled his finger at her. That had given the writer the right slant on just who was who in the Hollywood pecking order. It didn't matter that his book had made him world famous. A starlet would prefer the crummiest, the rattiest, the phoniest movie wheel.

Now Johnny called the author at his New York home to

thank him for the great part he had written in his book for him. He flattered the shit out of the guy. Then casually he asked him how he was doing on his next novel and what it was all about. He lit a cigar while the author told him about a specially interesting chapter and then finally said, 'Gee, I'd like to read it when you're finished. How about sending me a copy? Maybe I can get you a good deal for it, better than you got with Woltz.'

The eagerness in the author's voice told him that he had guessed right. Woltz had chiselled the guy, given him peanuts for the book. Johnny mentioned that he might be in New York right after the holidays and would the author want to come and have dinner with some of his friends. 'I know a few good-looking broads,' Johnny said jokingly. The author laughed and said OK.

Next Johnny called up the director and cameraman on the film he had just finished to thank them for having helped him in the film. He told them confidentially that he knew Woltz had been against him and he doubly appreciated their help and that if there was ever anything he could do for them they should just call.

Then he made the hardest call of all, the one to Jack Woltz. He thanked him for the part in the picture and told him how happy he would be to work for him any time. He did this merely to throw Woltz off the track. He had always been very square, very straight. In a few days Woltz would find out about this manoeuvring and be astounded by the treachery of this call, which was exactly what Johnny Fontane wanted him to feel.

After that he sat at the desk and puffed at his cigar. There was whisky on a side table but he had made some sort of promise to himself and Hagen that he wouldn't drink. He shouldn't even be smoking. It was foolish; whatever was wrong with his voice probably wouldn't be helped by knocking off drinking and smoking. Not too much, but what the hell, it might help and he wanted all the percentages with him, now that he had a fighting chance.

Now with the house quiet, his divorced wife sleeping, his beloved daughters sleeping, he could think back to that

terrible time in his life when he had deserted them. Deserted them for a whore tramp of a bitch who was his second wife. But even now he smiled at the thought of her, she was such a lovely broad in so many ways and, besides, the only thing that saved his life was the day that he had made up his mind never to hate a woman or, more specifically, the day he had decided he could not afford to hate his first wife and his daughters, his girlfriends, his second wife, and the girlfriends after that right up to Sharon Moore brushing him off so that she could brag about refusing to screw for the great Johnny Fontane.

He had travelled with the band singing and then he had become a radio star and a star of the movie stage shows and then he had finally made it in the movies. And in all that time he had lived the way he wanted to, screwed the women he wanted to, but he had never let it affect his personal life. Then he had fallen for his soon-to-be second wife, Margot Ashton, he had gone absolutely crazy for her. His career had gone to hell, his voice had gone to hell, his family life had gone to hell. And there had come the day when he was left without anything.

The thing was, he had always been generous and fair. He had given his first wife everything he owned when he divorced her. He had made sure his two daughters would get a piece of everything he made, every record, every movie, every club date. And when he had been rich and famous he had refused his first wife nothing. He had helped out all her brothers and sisters, her father and mother, the girlfriends she had gone to school with and their families. He had never been a stuck-up celebrity. He had sung at the weddings of his wife's two younger sisters, something he hated to do. He had never refused her anything except the complete surrender of his own personality.

And then when he had touched bottom, when he could no longer get movie work, when he could no longer sing, when his second wife had betrayed him, he had gone to spend a few days with Ginny and his daughters. He had more or less flung himself on her mercy one night because he felt so lousy. That day he had heard one of his recordings and he had sounded so

terrible that he accused the sound technicians of sabotaging the record. Until finally he had become convinced that that was what his voice really sounded like. He had smashed the master record and refused to sing any more. He was so ashamed that he had not sung a note except with Nino at Connie Corleone's wedding.

He had never forgotten the look on Ginny's face when she found out about all his misfortunes. It had passed over her face only for a second but that was enough for him never to forget it. It was a look of savage and joyful satisfaction. It was a look that could only make him believe that she had contemptuously hated him all these years. She quickly recovered and offered him cool but polite sympathy. He had pretended to accept it. During the next few days he had gone to see three of the girls he had liked the most over the years, girls he had remained friends with and sometimes still slept with in a comradely way, girls that he had done everything in his power to help, girls to whom he had given the equivalent of hundreds of thousands of dollars in gifts or job opportunities. On their faces he had caught that same fleeting look of savage satisfaction.

It was during that time that he knew he had to make a decision. He could become like a great many other men in Hollywood, successful producers, writers, directors, actors, who preyed on beautiful women with lustful hatred. He could use power and monetary favours grudgingly, always alert for treason, always believing that women would betray and desert him, adversaries to be bested. Or he could refuse to hate women and continue to believe in them.

He knew he could not afford *not* to love them, that something of his spirit would die if he did not continue to love women no matter how treacherous and unfaithful they were. It didn't matter that the women he loved most in the world were secretly glad to see him crushed, humiliated, by a wayward fortune; it did not matter that in the most awful way, not sexually, they had been unfaithful to him. He had no choice. He had to accept them. And so he made love to all of them, gave them presents, hid the hurt their enjoyment of his misfortunes gave him. He forgave them knowing he was being

paid back for having lived in the utmost freedom from women and in the fullest flush of their flavour. But now he never felt guilty about being untrue to them. He never felt guilty about how he treated Ginny, insisting on remaining the sole father of his children, yet never even considering remarrying her, and letting her know that too. That was one thing he had salvaged out of his fall from the top. He had grown a thick skin about the hurts he gave women.

He was tired and ready for bed but one note of memory stuck with him: singing with Nino Valenti. And suddenly he knew what would please Don Corleone more than anything else. He picked up the phone and told the operator to get him New York. He called Sonny Corleone and asked him for Nino Valenti's number. Then he called Nino. Nino sounded a little drunk as usual.

'Hey, Nino, how'd you like to come out here and work for me,' Johnny said. 'I need a guy I can trust.'

Nino, kidding around, said, 'Gee, I don't know, Johnny, I got a good job on the truck, boffing housewives along my route, picking up a clear hundred-fifty every week. What you got to offer?'

'I can start you at five hundred and get you blind dates with movie stars, how's that?' Johnny said. 'And maybe I'll let you sing at my parties.'

'Yeah, OK, let me think about it,' Nino said. 'Let me talk it over with my lawyer and my accountant and my helper on the truck.'

'Hey, no kidding around, Nino,' Johnny said. 'I need you out here. I want you to fly out tomorrow morning and sign a personal contract for five hundred a week for a year. Then if you steal one of my broads and I fire you, you pick up at least a year's salary. OK?'

There was a long pause. Nino's voice was sober. 'Hey, Johnny, you kidding?'

Johnny said, 'I'm serious, kid. Go to my agent's office in New York. They'll have your plane ticket and some cash. I'm gonna call them first thing in the morning. So you go up there in the afternoon. OK? Then I'll have somebody meet you at the plane and bring you out to the house.'

Again there was a long pause and then Nino's voice, very subdued, uncertain, said, 'OK, Johnny.' He didn't sound drunk any more.

Johnny hung up the phone and got ready for bed. He felt better than any time since he had smashed that master record.

CHAPTER THIRTEEN

JOHNNY FONTANE sat in the huge recording studio and figured costs on a yellow pad. Musicians were filing in, all of them friends he had known since he was a kid singer with the bands. The conductor, top man in the business of pop accompaniment and a man who had been kind to him when things went sour, was giving each musician bundles of music and verbal instructions. His name was Eddie Neils. He had taken on this recording as a favour to Johnny, though his schedule was crowded.

Nino Valenti was sitting at a piano fooling around nervously with the keys. He was also sipping from a huge glass of rye. Johnny didn't mind that. He knew Nino sang just as well drunk as sober and what they were doing today wouldn't require any real musicianship on Nino's part.

Eddie Neils had made special arrangements of some old Italian and Sicilian songs, and a special job on the duel-duet song that Nino and Johnny had sung at Connie Corleone's wedding. Johnny was making the record primarily because he knew that the Don loved such songs and it would be a perfect Christmas gift for him. He also had a hunch that the record would sell in the high numbers, not a million, of course. And he had figured out that helping Nino was how the Don wanted his payoff. Nino was, after all, another one of the Don's godchildren.

Johnny put his clipboard and yellow pad on the folding chair beside him and got up to stand beside the piano. He said, 'Hey, *paisan*,' and Nino glanced up and tried to smile. He looked a little sick. Johnny leaned over and rubbed his

shoulder blades. 'Relax, kid,' he said. 'Do a good job today and I'll fix you up with the best and most famous piece of ass in Hollywood.'

Nino took a gulp of whisky. 'Who's that, Lassie?'

Johnny laughed. 'No, Deanna Dunn. I guarantee the goods.'

Nino was impressed but couldn't help saying with pseudo-hopefulness, 'You can't get me Lassie?'

The orchestra swung into the opening song of the medley. Johnny Fontane listened intently. Eddie Neils would play all the songs through in their special arrangements. Then would come the first take for the record. As Johnny listened he made mental notes on exactly how he would handle each phrase, how he would come into each song. He knew his voice wouldn't last long, but Nino would be doing most of the singing, Johnny would be singing under him. Except of course in the duet-duel song. He would have to save himself for that.

He pulled Nino to his feet and they both stood by their microphones. Nino flubbed the opening, flubbed it again. His face was beginning to get red with embarrassment. Johnny kidded him, 'Hey, you stalling for overtime?'

'I don't feel natural without my mandolin,' Nino said.

Johnny thought that over for a moment. 'Hold that glass of booze in your hand,' he said.

It seemed to do the trick. Nino kept drinking from the glass as he sang but he was doing fine. Johnny sang easily, not straining, his voice merely dancing around Nino's main melody. There was no emotional satisfaction in this kind of singing but he was amazed at his own technical skill. Ten years of vocalizing had taught him something.

When they came to the duet-duel song that ended the record, Johnny let his voice go and when they finished his vocal chords ached. The musicians had been carried away by the last song, a rare thing for these calloused veterans. They hammered down their instruments and stamped their feet in approval as applause. The drummer gave them a ruffle of drums.

With stops and conferences they worked nearly four hours

before they quit. Eddie Neils came over to Johnny and said quietly, 'You sounded pretty good, kid. Maybe you're ready to do a record. I have a new song that's perfect for you.'

Johnny shook his head. 'Come on, Eddie, don't kid me. Besides in a couple of hours I'll be too hoarse to even talk. Do you think we'll have to fix up much of the stuff we did today?'

Eddie said thoughtfully, 'Nino will have to come into the studio tomorrow. He made some mistakes. But he's much better than I thought he would be. As for your stuff, I'll have the sound engineers fix anything I don't like. OK?'

'OK,' Johnny said. 'When can I hear the pressing?'

'Tomorrow night,' Eddie Neils said. 'Your place?'

'Yeah,' Johnny said. 'Thanks, Eddie. See you tomorrow.' He took Nino by the arm and walked out of the studio. They went to his house instead of Ginny's.

By this time it was late afternoon. Nino was still more than half-drunk. Johnny told him to get under the shower and then take a snooze. They had to be at a big party at eleven that night.

When Nino woke up, Johnny briefed him. 'This party is a movie star Lonely Hearts Club,' he said. 'These broads tonight are dames you've seen in the movies as glamour queens millions of guys would give their right arms to screw. And the only reason they'll be at the party tonight is to find somebody to shack them up. Do you know why? Because they are hungry for it, they are just a little old. And just like every dame, they want it with a little bit of class.'

'What's the matter with your voice?' Nino asked.

Johnny had been speaking almost in a whisper. 'Every time after I sing a little bit that happens. I won't be able to sing for a month now. But I'll get over the hoarseness in a couple of days.'

Nino said thoughtfully, 'Tough, huh?'

Johnny shrugged. 'Listen, Nino, don't get too drunk tonight. You have to show these Hollywood broads that my *paisan* buddy ain't weak in the poop. You gotta come across. Remember, some of these dames are very powerful in movies, they can get you work. It doesn't hurt to be charming after you knock off a piece.'

Nino was already pouring himself a drink. 'I'm always charming,' he said. He drained the glass. Grinning, he asked, 'No kidding, can you really get me close to Deanna Dunn?'

'Don't be so anxious,' Johnny said. 'It's not going to be like you think.'

The Hollywood Movie Star Lonely Hearts Club (so called by the young juvenile leads whose attendance was mandatory) met every Friday night at the palatial, studio-owned home of Roy McElroy, press agent or rather public relations counsel for the Woltz International Film Corporation. Actually, though it was McElroy's open house party, the idea had come from the practical brain of Jack Woltz himself. Some of his money-making movie stars were getting older now. Without the help of special lights and genius makeup men they looked their age. They were having problems. They had also become, to some extent, desensitized physically and mentally. They could no longer 'fall in love'. They could no longer assume the role of hunted women. They had been made too imperious; by money, by fame, by their former beauty. Woltz gave his parties so that it would be easier for them to pick up lovers, one-night stands, who, if they had the stuff, could graduate into full-time bed partners and so work their way upward. Since the action sometimes degenerated into brawls or sexual excess that led to trouble with the police, Woltz decided to hold the parties in the house of the public relations counsellor, who would be right there to fix things up, pay off newsmen and police officers and keep everything quiet.

For certain virile young male actors on the studio payroll who had not yet achieved stardom or featured roles, attendance at the Friday night parties was a not always pleasant duty. This was explained by the fact that a new film yet to be released by the studio would be shown at the party. In fact that was the excuse for the party itself. People would say, 'Let's go over to see what the new picture so and so made is like.' And so it was put in a professional context.

Young female starlets were forbidden to attend the Friday night parties. Or rather discouraged. Most of them took the hint.

Screenings of the new movies took place at midnight and Johnny and Nino arrived at eleven. Roy McElroy proved to be, at first sight, an enormously likeable man, well-groomed, beautifully dressed. He greeted Johnny Fontane with a surprised cry of delight. 'What the hell are you doing here?' he said with genuine astonishment.

Johnny shook his hand. 'I'm showing my country cousin the sights. Meet Nino.'

McElroy shook hands with Nino and gazed at him appraisingly. 'They'll eat him up alive,' he said to Johnny. He led them to the rear patio.

The rear patio was really a series of huge rooms whose glass doors had been opened to a garden and pool. There were almost a hundred people milling around, all with drinks in their hands. The patio lighting was artfully arranged to flatter feminine faces and skin. These were women Nino had seen on the darkened movie screens when he had been a teenager. They had played their part in his erotic dreams of adolescence. But seeing them now in the flesh was like seeing them in some horrible makeup. Nothing could hide the tiredness of their spirit and their flesh; time had eroded their godhead. They posed and moved as charmingly as he remembered but they were like wax fruit, they could not lubricate his glands. Nino took two drinks, wandered to a table where he could stand next to a nest of bottles. Johnny moved with him. They drank together until behind them came the magic voice of Deanna Dunn.

Nino, like millions of other men, had that voice imprinted on his brain forever. Deanna Dunn had won two Academy Awards, had been in the biggest movie grosser made in Hollywood. On the screen she had a feline feminine charm that made her irresistible to all men. But the words she was saying had never been heard on the silver screen. 'Johnny, you bastard, I had to go to my psychiatrist again because you gave me a one-night stand. How come you never came back for seconds?'

Johnny kissed her on her proffered cheek. 'You wore me out for a month,' he said. 'I want you to meet my cousin Nino. A nice strong Italian boy. Maybe he can keep up with you.'

Deanna Dunn turned to give Nino a cool look. 'Does he like to watch previews?'

Johnny laughed. 'I don't think he's ever had the chance. Why don't you break him in?'

Nino had to take a big drink when he was alone with Deanna Dunn. He was trying to be nonchalant but it was hard. Deanna Dunn had the upturned nose, the clean-cut classical features of the Anglo-Saxon beauty. And he knew her so well. He had seen her alone in a bedroom, heartbroken, weeping over her dead flier husband who had left her with fatherless children. He had seen her angry, hurt, humiliated, yet with a shining dignity when a caddish Clark Gable had taken advantage of her, then left her for a sexpot. (Deanna Dunn never played sexpots in the movies.) He had seen her flushed with requited love, writhing in the embrace of the man she adored and he had seen her die beautifully at least a half dozen times. He had seen her and heard her and dreamed about her and yet he was not prepared for the first thing she said to him alone.

'Johnny is one of the few men with balls in this town,' she said. 'The rest are all fags and sick morons who couldn't get it up with a broad if you pumped a truckload of Spanish fly into their scrotums.' She took Nino by the hand and led him into a corner of the room, out of traffic and out of competition.

Then still coolly charming, she asked him about himself. He saw through her. He saw that she was playing the role of the rich society girl who is being kind to the stableboy or the chauffeur, but who in the movie would either discourage his amatory interest (if the part were played by Spencer Tracy), or throw up everything in her mad desire for him (if the part were played by Clark Gable). But it didn't matter. He found himself telling her about how he and Johnny had grown up together in New York, about how he and Johnny had sung together on little club dates. He found her marvellously sympathetic and interested. Once she asked casually, 'Do you know how Johnny made that bastard Jack Woltz give him the part?' Nino froze and shook his head. She didn't pursue it.

The time had come to see the preview of a new Woltz movie. Deanna Dunn led Nino, her warm hand imprisoning his, to an interior room of the mansion that had no windows

but was furnished with about fifty small two-person couches scattered around in such a way as to give each one a little island of semiprivacy.

Nino saw there was a small table beside the couch and on the table were an ice bowl, glasses, and bottles of liquor plus a tray of cigarettes. He gave Deanna Dunn a cigarette, lit it and then mixed them both drinks. They didn't speak to each other. After a few minutes the lights went out.

He had been expecting something outrageous. After all, he had heard the legends of Hollywood depravity. But he was not quite prepared for Deanna Dunn's voracious plummet on his sexual organ without even a courteous and friendly word of preparation. He kept sipping his drink and watching the movie, but not tasting, not seeing. He was excited in a way he had never been before but part of it was because this woman servicing him in the dark had been the object of his adolescent dreams.

Yet in a way his masculinity was insulted. So when the world-famous Deanna Dunn was sated and had tidied him up, he very coolly fixed her a fresh drink in the darkness and lit her a fresh cigarette and said in the most relaxed voice imaginable, 'This looks like a pretty good movie.'

He felt her stiffen beside him on the couch. Could it be she was waiting for some sort of compliment? Nino poured his glass full from the nearest bottle his hand touched in the darkness. The hell with that. She'd treated him like a goddamn male whore. For some reason now he felt a cold anger at all these women. They watched the picture for another fifteen minutes. He leaned away from her so their bodies did not touch.

Finally she said in a low harsh whisper, 'Don't be such a snotty punk, you liked it. You were as big as a house.'

Nino sipped his drink and said in his natural off-hand manner, 'That's the way it *always* is. You should see it when I get excited.'

She laughed a little and kept quiet for the rest of the picture. Finally it was over and the lights went on. Nino took a look around. He could see there had been a ball here in the darkness though oddly enough he hadn't heard a thing. But some of the

dames had that hard, shiny, bright-eyed look of women who had just been worked over real good. They sauntered out of the projection room. Deanna Dunn left him immediately to go over and talk to an older man Nino recognized as a famous featured player, only now, seeing the guy in person, he realized that he was a fag. He sipped his drink thoughtfully.

Johnny Fontane came up beside him and said, 'Hi, old buddy, having a good time?'

Nino grinned. 'I don't know. It's different. Now when I go back to the old neighbourhood I can say Deanna Dunn had me.'

Johnny laughed. 'She can be better than that if she invites you home with her. Did she?'

Nino shook his head. 'I got too interested in the movie,' he said. But this time Johnny didn't laugh.

'Get serious, kid,' he said. 'A dame like that can do you a lot of good. And you used to boff anything. Man, sometimes I still get nightmares when I remember those ugly broads you used to bang.'

Nino waved his glass drunkenly and said very loud, 'Yeah, they were ugly but they were *women*.' Deanna Dunn, in the corner, turned her head to look at them. Nino waved his glass at her in greeting.

Johnny Fontane sighed. 'OK, you're just a guinea peasant.'

'And I ain't gonna change,' Nino said with his charmingly drunken smile.

Johnny understood him perfectly. He knew Nino was not as drunk as he pretended. He knew that Nino was only pretending so that he could say things which he felt were too rude to say to his new Hollywood *padrone* when sober. He put his arm around Nino's neck and said affectionately, 'You wise guy bum, you know you got an ironclad contract for a year and you can say and do anything you want and I can't fire you.'

'You can't fire me?' Nino said with drunken cunning.

'No,' Johnny said.

'Then fuck you,' Nino said.

For a moment Johnny was surprised into anger. He saw the careless grin on Nino's face. But in the past few years he must have got smarter, or his own descent from stardom had

made him more sensitive. In that moment he understood Nino, why his boyhood singing partner had never become successful, why he was trying to destroy any chance of success now. That Nino was reacting away from all the prices of success, that in some way he felt insulted by everything that was being done for him.

Johnny took Nino by the arm and led him out of the house. Nino could barely walk now. Johnny was talking to him soothingly. 'OK, kid, you just sing for me, I wanta make dough on you. I won't try to run your life. You do whatever you wanta do. OK, *paisan*? All you gotta do is sing for me and earn me money now that I can't sing any more. You got that, old buddy?'

Nino straightened up. 'I'll sing for you, Johnny,' he said, his voice slurring so that he could barely be understood. 'I'm a better singer than you now. I was always a better singer than you, you know that?'

Johnny stood there thinking; so that was it. He knew that when his voice was healthy Nino simply wasn't in the same league with him, never had been in those years they had sung together as kids. He saw Nino was waiting for an answer, weaving drunkenly in the California moonlight. 'Fuck you,' he said gently, and they both laughed together like the old days when they had both been equally young.

When Johnny Fontane got word about the shooting of Don Corleone he not only worried about his Godfather, but also wondered whether the financing for his movie was still alive. He had wanted to go to New York to pay his respects to his Godfather in the hospital but he had been told not to get any bad publicity, that was the last thing Don Corleone would want. So he waited. A week later a messenger came from Tom Hagen. The financing was still on but for only one picture at a time.

Meanwhile Johnny let Nino go his own way in Hollywood and California, and Nino was doing all right with the young starlets. Sometimes Johnny called him up for a night out together but never leaned on him. When they talked about the Don getting shot, Nino said to Johnny, 'You know, once I

asked the Don for a job in his organization and he wouldn't give it to me. I was tired of driving a truck and I wanted to make a lot of dough. You know what he told me? He says every man has only one destiny and that my destiny was to be an artist. Meaning that I couldn't be a racket guy.'

Johnny thought that one over. The Godfather must be just about the smartest guy in the world. He'd known immediately that Nino could never make a racket guy, would only get himself in trouble or get killed. Get killed with just one of his wisecracks. But how did the Don know that he would be an artist? Because, goddamn it, he figured that someday I'd help Nino. And how did he figure that? Because he would drop the word to me and I would try to show my gratitude. Of course he never asked me to do it. He just let me know it would make him happy if I did it. Johnny Fontane sighed. Now the Godfather was hurt, in trouble, and he could kiss the Academy Award goodbye with Woltz working against him and no help on his side. Only the Don had the personal contacts that could apply pressure and the Corleone Family had other things to think about. Johnny had offered to help, Hagen had given him a curt no.

Johnny was busy getting his own picture going. The author of the book he had starred in had finished his new novel and came west on Johnny's invitation, to talk it over without agents or studios getting into the act. The second book was perfect for what Johnny wanted. He wouldn't have to sing, it had a good gutsy story with plenty of dames and sex and it had a part that Johnny instantly recognized as tailor-made for Nino. The character talked like Nino, acted like him, even looked like him. It was uncanny. All Nino would have to do would be to get up on the screen and be himself.

Johnny worked fast. He found that he knew a lot more about production than he thought he did, but he hired an executive producer, a man who knew his stuff but had trouble finding work because of the blacklist. Johnny didn't take advantage but gave the man a fair contract. 'I expect you to save me more dough this way,' he told the man frankly.

So he was surprised when the executive producer came to him and told him the union rep had to be taken care of to the

tune of fifty thousand dollars. There were a lot of problems dealing with overtime and hiring and the fifty thousand dollars would be well spent. Johnny debated whether the executive producer was hustling him and then said, 'Send the union guy to me.'

The union guy was Billy Goff. Johnny said to him, 'I thought the union stuff was fixed by my friends. I was told not to worry about it. At all.'

Goff said, 'Who told you that?'

Johnny said, 'You know goddamn well who told me. I won't say his name but if he tells me something that's it.'

Goff said, 'Things have changed. Your friend is in trouble and his word don't go this far west any more.'

Johnny shrugged. 'See me in a couple of days. OK?'

Goff smiled. 'Sure, Johnny,' he said. 'But calling in New York ain't going to help you.'

But calling New York did help. Johnny spoke to Hagen at his office. Hagen told him bluntly not to pay. 'Your Godfather will be sore as hell if you pay that bastard a dime,' he told Johnny. 'It will make the Don lose respect and right now he can't afford that.'

'Can I talk to the Don?' Johnny asked. 'Will you talk to him? I gotta get the picture rolling.'

'Nobody can talk to the Don right now,' Hagen said. 'He's too sick. I'll talk to Sonny about fixing things up. But I'll make the decision on this. Don't pay that smart bastard a dime. If anything changes, I'll let you know.'

Annoyed, Johnny hung up. Union trouble could add a fortune to making the film and screw up the works generally. For a moment he debated slipping Goff the fifty grand on the quiet. After all, the Don telling him something and Hagen telling him something and giving him orders were two different things. But he decided to wait for a few days.

By waiting he saved fifty thousand dollars. Two nights later, Goff was found shot to death in his home in Glendale. There was no more talk of union trouble. Johnny was a little shaken by the killing. It was the first time the long arm of the Don had struck such a lethal blow so close to him.

As the weeks went by and he became busier and busier with

getting the script ready, casting the movie, and working out production details, Johnny Fontane forgot about his voice, his not being able to sing. Yet when the Academy Award nominations came out and he found himself one of the candidates, he was depressed because he was not asked to sing one of the songs nominated for the Oscar at the ceremony that would be televised nationally. But he shrugged it off and kept working. He had no hope of winning the Academy Award now that his Godfather was no longer able to put pressure on, but getting the nomination had some value.

The record he and Nino had cut, the one of Italian songs, was selling much better than anything he had cut lately, but he knew that it was Nino's success more than his. He resigned himself to never being able to again sing professionally.

Once a week he had dinner with Ginny and the kids. No matter how hectic things got he never skipped that duty. But he didn't sleep with Ginny. Meanwhile his second wife had finagled a Mexican divorce and so he was a bachelor again. Oddly enough he was not that frantic to bang starlets who would have been easy meat. He was too snobbish really. He was hurt that none of the young stars, the actresses who were still on top, ever gave him a tumble. But it was good to work hard. Most nights he would go home alone, put his old records on the player, have a drink, and hum along with them for a few bars. He had been good, damn good. He hadn't realized how good he was. Even aside from the special voice, which could have happened to anybody, he was good. He had been a real artist and never knew how much he loved it. He'd ruined his voice with booze and tobacco and broads just when he really knew what it was all about.

Sometimes Nino came over for a drink and listened with him and Johnny would say to him scornfully, 'You guinea bastard, you never sang like that in your life.' And Nino would give him that curiously charming smile and shake his head and say, 'No, and I never will,' in a sympathetic voice, as if he knew what Johnny was thinking.

Finally, a week before shooting the new picture, the Academy Award night rolled around. Johnny invited Nino to come along but Nino refused. Johnny said, 'Buddy, I never

asked you a favour, right? Do me a favour tonight and come with me. You're the only guy who'll really feel sorry for me if I don't win.'

For one moment Nino looked startled. Then he said, 'Sure, old buddy, I can make it.' He paused for a moment and said, 'If you don't win, forget it. Just get as drunk as you can get and I'll take care of you. Hell, I won't even drink myself tonight. How about that for being a buddy?'

'Man,' Johnny Fontane said, 'that's some buddy.'

The Academy Award night came and Nino kept his promise. He came to Johnny's house dead sober and they left for the presentation theatre together. Nino wondered why Johnny hadn't invited any of his girls or his ex-wives to the Award dinner. Especially Ginny. Didn't he think Ginny would root for him? Nino wished he could have just one drink, it looked like a long bad night.

Nino Valenti found the whole Academy Award affair a bore until the winner of the best male actor was announced. When he heard the words 'Johnny Fontane', he found himself jumping into the air and applauding. Johnny reached out a hand for him to shake and Nino shook it. He knew his buddy needed human contact with someone he trusted and Nino felt an enormous sadness that Johnny didn't have anyone better than himself to touch in his moment of glory.

What followed was an absolute nightmare. Jack Woltz's picture had swept all the major awards and so the studio's party was swamped with newspaper people and all the on-the-make hustlers, male and female. Nino kept his promise to remain sober, and he tried to watch over Johnny. But the women of the party kept pulling Johnny Fontane into bedrooms for a little chat and Johnny kept getting drunker and drunker.

Meanwhile the woman who had won the award for the best actress was suffering the same fate but loving it more and handling it better. Nino turned her down, the only man at the party to do so.

Finally somebody had a great idea. The public mating of the two winners, everybody else at the party to be spectators in the stands. The actress was stripped down and the other

women started to undress Johnny Fontane. It was then that Nino, the only sober person there, grabbed the half-clothed Johnny and slung him over his shoulder and fought his way out of the house and to their car. As he drove Johnny home, Nino thought that if that was success, he didn't want it.

Book III

CHAPTER FOURTEEN

THE DON was a real man at the age of twelve. Short, dark, slender, living in the strange Moorish-looking village of Corleone in Sicily, he had been born Vito Andolini, but when strange men came to kill the son of the man they had murdered, his mother sent the young boy to America to stay with friends. And in the new land he changed his name to Corleone to preserve some tie with his native village. It was one of the few gestures of sentiment he was ever to make.

In Sicily at the turn of the century the Mafia was the second government, far more powerful than the official one in Rome. Vito Corleone's father became involved in a feud with another villager who took his case to the Mafia. The father refused to knuckle under and in a public quarrel killed the local Mafia chief. A week later he himself was found dead, his body torn apart by *lupara* blasts. A month after the funeral Mafia gunmen came inquiring after the young boy, Vito. They had decided that he was too close to manhood, that he might try to avenge the death of his father in the years to come. The twelve-year-old Vito was hidden by relatives and shipped to America. There he was boarded with the Abbandandos, whose son Genco was later to become *Consigliori* to his Don.

Young Vito went to work in the Abbandando grocery store on Ninth Avenue in New York's Hell's Kitchen. At the age of eighteen Vito married an Italian girl freshly arrived from Sicily, a girl of only sixteen but a skilled cook, a good housewife. They settled down in a tenement on Tenth Avenue, near 35th Street, only a few blocks from where Vito worked, and two years later were blessed with their first child, Santino, called by all his friends Sonny because of his devotion to his father.

In the neighbourhood lived a man called Fanucci. He was a

heavy-set, fierce-looking Italian who wore expensive light-coloured suits and a cream-coloured fedora. This man was reputed to be of the 'Black Hand', an offshoot of the Mafia which extorted money from families and storekeepers by threat of physical violence. However, since most of the inhabitants of the neighbourhood were violent themselves, Fanucci's threats of bodily harm were effective only with elderly couples without male children to defend them. Some of the storekeepers paid him trifling sums as a matter of convenience. However, Fanucci was also a scavenger on fellow criminals, people who illegally sold Italian lottery or ran gambling games in their homes. The Abbandando grocery gave him a small tribute, this despite the protests of young Genco, who told his father he would settle the Fanucci hash. His father forbade him. Vito Corleone observed all this without feeling in any way involved.

One day Fanucci was set upon by three young men who cut his throat from ear to ear, not deeply enough to kill him, but enough to frighten him and make him bleed a great deal. Vito saw Fanucci fleeing from his punishers, the circular slash flowing red. What he never forgot was Fanucci holding the cream-coloured fedora under his chin to catch the dripping blood as he ran. As if he did not want his suit soiled or did not want to leave a shameful trail of carmine.

But this attack proved a blessing in disguise for Fanucci. The three young men were not murderers, merely tough young boys determined to teach him a lesson and stop him from scavenging. Fanucci proved himself a murderer. A few weeks later the knife-wielder was shot to death and the families of the other two young men paid an indemnity to Fanucci to make him forswear his vengeance. After that the tributes became higher and Fanucci became a partner in the neighbourhood gambling games. As for Vito Corleone, it was none of his affair. He forgot about it immediately.

During World War I, when imported olive oil became scarce, Fanucci acquired a part-interest in the Abbandando grocery store by supplying it not only with oil, but imported Italian salami, hams, and cheeses. He then moved a nephew into the store and Vito Corleone found himself out of a job.

By this time, the second child, Frederico, had arrived and Vito Corleone had four mouths to feed. Up to this time he had been a quiet, very contained young man who kept his thoughts to himself. The son of the grocery store owner, young Genco Abbandando, was his closest friend, and to the surprise of both of them, Vito reproached his friend for his father's deed. Genco, flushed with shame, vowed to Vito that he would not have to worry about food. That he, Genco, would steal food from the grocery to supply his friend's needs. This offer though was sternly refused by Vito as too shameful, a son stealing from his father.

The young Vito, however, felt a cold anger for the dreaded Fanucci. He never showed this anger in any way but bided his time. He worked in the railroad for a few months and then, when the war ended, work became slow and he could earn only a few days' pay a month. Also, most of the foremen were Irish and American and abused the workmen in the foulest language, which Vito always bore stone-faced as if he did not comprehend, though he understood English very well despite his accent.

One evening as Vito was having supper with his family there was a knock on the window that led to the open air shaft that separated them from the next building. When Vito pulled aside the curtain he saw to his astonishment one of the young men in the neighbourhood, Peter Clemenza, leaning out from a window on the other side of the air shaft. He was extending a white sheeted bundle.

'Hey, *paisan*,' Clemenza said. 'Hold these for me until I ask for them. Hurry up.' Automatically Vito reached over the empty space of the air shaft and took the bundle. Clemenza's face was strained and urgent. He was in some sort of trouble and Vito's helping action was instinctive. But when he untied the bundle in his kitchen, there were five oily guns staining the white cloth. He put them in his bedroom closet and waited. He learned that Clemenza had been taken away by the police. They must have been knocking on his door when he handed the guns over the air shaft.

Vito never said a word to anyone and of course his terrified wife dared not open her lips even in gossip for fear her own

husband would be sent to prison. Two days later Peter Clemenza reappeared in the neighbourhood and asked Vito casually, 'Do you have my goods still?'

Vito nodded. He was in the habit of talking little. Clemenza came up to his tenement flat and was given a glass of wine while Vito dug the bundle out of his bedroom closet.

Clemenza drank his wine, his heavy good-natured face alertly watching Vito. 'Did you look inside?'

Vito, his face impassive, shook his head. 'I'm not interested in things that don't concern me,' he said.

They drank wine together the rest of the evening. They found each other congenial. Clemenza was a storyteller; Vito Corleone was a listener to storytellers. They became casual friends.

A few days later Clemenza asked the wife of Vito Corleone if she would like a fine rug for her living room floor. He took Vito with him to help carry the rug.

Clemenza led Vito to an apartment house with two marble pillars and a white marble stoop. He used a key to open the door and they were inside a plush apartment. Clemenza grunted, 'Go on the other side of the room and help me roll it up.'

The rug was a rich red wool. Vito Corleone was astonished by Clemenza's generosity. Together they rolled the rug into a pile and Clemenza took one end while Vito took the other. They lifted it and started carrying it towards the door.

At that moment the apartment bell rang. Clemenza immediately dropped the rug and strode to the window. He pulled the drape aside slightly and what he saw made him draw a gun from inside his jacket. It was only at that moment the astonished Vito Corleone realized that they were stealing the rug from some stranger's apartment.

The apartment bell rang again. Vito went up alongside Clemenza so that he too could see what was happening. At the door was a uniformed policeman. As they watched, the policeman gave the doorbell a final push, then shrugged and walked away down the marble steps and down the street.

Clemenza grunted in a satisfied way and said, 'Come on, let's go.' He picked up his end of the rug and Vito picked up the

other end. The policeman had barely turned the corner before they were edging out the heavy oaken door and into the street with the rug between them. Thirty minutes later they were cutting the rug to fit the living room of Vito Corleone's apartment. They had enough left over for the bedroom. Clemenza was an expert workman and from the pockets of his wide, ill-fitting jacket (even then he liked to wear loose clothes though he was not so fat), he had the necessary carpet-cutting tools.

Time went on, things did not improve. The Corleone family could not eat the beautiful rug. Very well, there was no work, his wife and children must starve. Vito took some parcels of food from his friend Genco while he thought things out. Finally he was approached by Clemenza and Tessio, another young tough of the neighbourhood. They were men who thought well of him, the way he carried himself, and they knew he was desperate. They proposed to him that he become one of their gang which specialized in hijacking trucks of silk dresses after those trucks were loaded up at the factory on 31st Street. There was no risk. The truck drivers were sensible working-men who at the sight of a gun flopped on the sidewalk like angels while the hijackers drove the truck away to be unloaded at a friend's warehouse. Some of the merchandise would be sold to an Italian wholesaler, part of the loot would be sold door-to-door in the Italian neighbourhoods – Arthur Avenue in the Bronx, Mulberry Street, and the Chelsea district in Manhattan – all to poor Italian families looking for a bargain, whose daughters could never be able to afford such fine apparel. Clemenza and Tessio needed Vito to drive since they knew he chauffeured the Abbandando grocery store delivery truck. In 1919, skilled automobile drivers were at a premium.

Against his better judgement, Vito Corleone accepted their offer. The clinching argument was that he would clear at least a thousand dollars for his share of the job. But his young companions struck him as rash, the planning of the job haphazard, the distribution of the loot foolhardy. Their whole approach was too careless for his taste. But he thought them of good, sound character. Peter Clemenza, already burly, inspired a certain trust, and the lean saturnine Tessio inspired confidence.

The job itself went off without a hitch. Vito Corleone felt no fear, much to his astonishment, when his two comrades flashed guns and made the driver get out of the silk truck. He was also impressed with the coolness of Clemenza and Tessio. They didn't get excited but joked with the driver, told him if he was a good lad they'd send his wife a few dresses. Because Vito thought it stupid to peddle dresses himself and so gave his whole share of stock to the fence, he made only seven hundred dollars. But this was a considerable sum of money in 1919.

The next day on the street, Vito Corleone was stopped by the cream-suited, white-fedoraed Fanucci. Fanucci was a brutal-looking man and he had done nothing to disguise the circular scar that stretched in a white semicircle from ear to ear, looping under his chin. He had heavy black brows and coarse features which, when he smiled, were in some odd way amiable.

He spoke with a very thick Sicilian accent. 'Ah, young fellow,' he said to Vito. 'People tell me you're rich. You and your two friends. But don't you think you've treated me a little shabbily? After all, this is my neighbourhood and you should let me wet my beak.' He used the Sicilian phrase of the Mafia, '*Fari vagnari a pizzu.*' *Pizzu* means the beak of any small bird such as a canary. The phrase itself was a demand for part of the loot.

As was his habit, Vito Corleone did not answer. He understood the implication immediately and was waiting for a definite demand.

Fanucci smiled at him, showing gold teeth and stretching his noose-like scar tight around his face. He mopped his face with a handkerchief and unbuttoned his jacket for a moment as if to cool himself but really to show the gun he carried stuck in the waistband of his comfortably wide trousers. Then he sighed and said, 'Give me five hundred dollars and I'll forget the insult. After all, young people don't know the courtesies due a man like myself.'

Vito Corleone smiled at him and even as a young man still unblooded, there was something so chilling in his smile that Fanucci hesitated a moment before going on. 'Otherwise the police will come to see you, your wife and children will be

shamed and destitute. Of course if my information as to your gains is incorrect I'll dip my beak just a little. But no less than three hundred dollars. And don't try to deceive me.'

For the first time Vito Corleone spoke. His voice was reasonable, showed no anger. It was courteous, as befitted a young man speaking to an older man of Fanucci's eminence. He said softly, 'My two friends have my share of the money, I'll have to speak to them.'

Fanucci was reassured. 'You can tell your two friends that I expect them to let me wet my beak in the same manner. Don't be afraid to tell them,' he added reassuringly. 'Clemenza and I know each other well, he understands these things. Let yourself be guided by him. He has more experience in these matters.'

Vito Corleone shrugged. He tried to look a little embarrassed. 'Of course,' he said. 'You understand this is all new to me. Thank you for speaking to me as a godfather.'

Fanucci was impressed. 'You're a good fellow,' he said. He took Vito's hand and clasped it in both of his hairy ones. 'You have respect,' he said. 'A fine thing in the young. Next time speak to me first, eh? Perhaps I can help you in your plans.'

In later years Vito Corleone understood that what had made him act in such a perfect, tactical way with Fanucci was the death of his own hot-tempered father who had been killed by the Mafia in Sicily. But at that time all he felt was an icy rage that this man planned to rob him of the money he had risked his life and freedom to earn. He had not been afraid. Indeed he thought, at that moment, that Fanucci was a crazy fool. From what he had seen of Clemenza, that burly Sicilian would sooner give up his life than a penny of his loot. After all, Clemenza had been ready to kill a policeman merely to steal a rug. And the slender Tessio had the deadly air of a viper.

But later that night, in Clemenza's tenement apartment across the air shaft, Vito Corleone received another lesson in the education he had just begun. Clemenza cursed, Tessio scowled, but then both men started talking about whether Fanucci would be satisfied with two hundred dollars. Tessio thought he might.

Clemenza was positive. 'No, that scarface bastard must have found out what we made from the wholesaler who bought the dresses. Fanucci won't take a dime less than three hundred dollars. We'll have to pay.'

Vito was astonished but was careful not to show his astonishment. 'Why do we have to pay him? What can he do to the three of us? We're stronger than him. We have guns. Why do we have to hand over the money we earned?'

Clemenza explained patiently. 'Fanucci has friends, real brutes. He has connexions with the police. He'd like us to tell him our plans because he could set us up for the cops and earn their gratitude. Then they would owe him a favour. That's how he operates. And he has a licence from Maranzalla himself to work this neighbourhood.' Maranzalla was a gangster often in the newspapers, reputed to be the leader of a criminal ring specializing in extortion, gambling, and armed robbery.

Clemenza served wine that he had made himself. His wife, after putting a plate of salami, olives, and a loaf of Italian bread on the table, went down to sit with her women cronies in front of the building, carrying her chair with her. She was a young Italian girl only a few years in the country and did not yet understand English.

Vito Corleone sat with his two friends and drank wine. He had never used his intelligence before as he was using it now. He was surprised at how clearly he could think. He recalled everything he knew about Fanucci. He remembered the day the man had had his throat cut and had run down the street holding his fedora under his chin to catch the dripping blood. He remembered the murder of the man who had wielded the knife and the other two having their sentences removed by paying an indemnity. And suddenly he was sure that Fanucci had no great connexions, could not possibly have. Not a man who informed to the police. Not a man who allowed his vengeance to be bought off. A real *mafioso* chief would have had the other two men killed also. No, Fanucci had got lucky and killed one man but had known he could not kill the other two after they were alerted. And so he had allowed himself to be paid. It was the personal brutal force of the man that allowed him to levy tribute on the shopkeepers, the gambling games

that ran in the tenement apartments. But Vito Corleone knew of at least one gambling game that had never paid Fanucci tributes and nothing had ever happened to the man running it.

And so it was Fanucci alone. Or Fanucci with some gunmen hired for special jobs on a strictly cash basis. Which left Vito Corleone with another decision. The course his own life must take.

It was from this experience came his oft-repeated belief that every man has but one destiny. On that night he could have paid Fanucci the tribute and have become again a grocery clerk with perhaps his own grocery store in the years to come. But destiny had decided that he was to become a Don and had brought Fanucci to him to set him on his destined path.

When they finished the bottle of wine, Vito said cautiously to Clemenza and Tessio, 'If you like, why not give me two hundred dollars each to pay to Fanucci? I guarantee he will accept that amount from me. Then leave everything in my hands. I'll settle this problem to your satisfaction.'

At once Clemenza's eyes gleamed with suspicion. Vito said to him coldly, 'I never lie to people I have accepted as my friends. Speak to Fanucci yourself tomorrow. Let him ask you for the money. But don't pay him. And don't in any way quarrel with him. Tell him you have to get the money and will give it to me to give him. Let him understand that you are willing to pay what he asks. Don't bargain. I'll quarrel over the price with him. There's no point making him angry with us if he's as dangerous a man as you say he is.'

They left it at that. The next day Clemenza spoke with Fanucci to make sure that Vito was not making up the story. Then Clemenza came to Vito's apartment and gave him the two hundred dollars. He peered at Vito Corleone and said, 'Fanucci told me nothing below three hundred dollars, how will you make him take less?'

Vito Corleone said reasonably, 'Surely that's no concern of yours. Just remember that I've done you a service.'

Tessio came later. Tessio was more reserved than Clemenza, sharper, more clever but with less force. He sensed something amiss, something not quite right. He was a little worried. He said to Vito Corleone, 'Watch yourself with that bastard of a

Black Hand, he's tricky as a priest. Do you want me to be here when you hand him the money, as a witness?'

Vito Corleone shook his head. He didn't even bother to answer. He merely said to Tessio, 'Tell Fanucci I'll pay him the money here in my house at nine o'clock tonight. I'll have to give him a glass of wine and talk, reason with him to take the lesser sum.'

Tessio shook his head. 'You won't have much luck. Fanucci never retreats.'

'I'll reason with him,' Vito Corleone said. It was to become a famous phrase in the years to come. It was to become the warning rattle before a deadly strike. When he became a Don and asked opponents to sit down and reason with him, they understood it was the last chance to resolve an affair without bloodshed and murder.

Vito Corleone told his wife to take the two children, Sonny and Fredo, down into the street after supper and on no account to let them come up to the house until he gave her permission. She was to sit on guard at the tenement door. He had some private business with Fanucci that could not be interrupted. He saw the look of fear on her face and was angry. He said to her quietly, 'Do you think you've married a fool?' She didn't answer. She did not answer because she was frightened, not of Fanucci now, but of her husband. He was changing visibly before her eyes, hour by hour, into a man who radiated some dangerous force. He had always been quiet, speaking little, but always gentle, always reasonable, which was extraordinary in a young Sicilian male. What she was seeing was the shedding of his protective coloration of a harmless nobody now that he was ready to start on his destiny. He had started late, he was twenty-five years old, but he was to start with a flourish.

Vito Corleone had decided to murder Fanucci. By doing so he would have an extra seven hundred dollars in his bankroll. The three hundred dollars he himself would have to pay the Black Hand terrorist and the two hundred dollars from Tessio and the two hundred dollars from Clemenza. If he did not kill Fanucci, he would have to pay the man seven hundred dollars cold cash. Fanucci alive was not worth seven hundred dollars

to him. He would not pay seven hundred dollars to keep Fanucci alive. If Fanucci needed seven hundred dollars for an operation to save his life, he would not give Fanucci seven hundred dollars for the surgeon. He owed Fanucci no personal debt of gratitude, they were not blood relatives, he did not love Fanucci. Whyfore, then, should he give Fanucci seven hundred dollars?

And it followed inevitably, that since Fanucci wished to take seven hundred dollars from him by force, why should he not kill Fanucci? Surely the world could do without such a person.

There were of course some practical reasons. Fanucci might indeed have powerful friends who would seek vengeance. Fanucci himself was a dangerous man, not so easily killed. There were the police and the electric chair. But Vito Corleone had lived under a sentence of death since the murder of his father. As a boy of twelve he had fled his executioners and crossed the ocean into a strange land, taking a strange name. And years of quiet observation had convinced him that he had more intelligence and more courage than other men, though he had never had the opportunity to use that intelligence and courage.

And yet he hesitated before taking that first step towards his destiny. He even packed the seven hundred dollars in a single fold of bills and put the money in a convenient side pocket of his trousers. But he put the money in the left side of his trousers. In the right-hand pocket he put the gun Clemenza had given him to use in the hijacking of the silk truck.

Fanucci came promptly at nine in the evening. Vito Corleone set out a jug of homemade wine that Clemenza had given him.

Fanucci put his white fedora on the table beside the jug of wine. He unloosened his broad multiflowered tie, its tomato stains camouflaged by the bright patterns. The summer night was hot, the gaslight feeble. It was very quiet in the apartment. But Vito Corleone was icy. To show his good faith he handed over the roll of bills and watched carefully as Fanucci, after counting it, took out a wide leather wallet and stuffed the money inside. Fanucci sipped his glass of wine and said, 'You still owe me two hundred dollars.' His heavy-browed face was expressionless.

Vito Corleone said in his cool reasonable voice, 'I'm a little short, I've been out of work. Let me owe you the money for a few weeks.'

This was a permissible gambit. Fanucci had the bulk of the money and would wait. He might even be persuaded to take nothing more or to wait a little longer. He chuckled over his wine and said, 'Ah, you're a sharp young fellow. How is it I've never noticed you before? You're too quiet a chap for your own interest. I could find some work for you to do that would be very profitable.'

Vito Corleone showed his interest with a polite nod and filled up the man's glass from the purple jug. But Fanucci thought better of what he was going to say and rose from his chair and shook Vito's hand. 'Goodnight, young fellow,' he said. 'No hard feelings, eh? If I can ever do you a service let me know. You've done a good job for yourself tonight.'

Vito let Fanucci go down the stairs and out the building. The street was thronged with witnesses to show that he had left the Corleone home safely. Vito watched from the window. He saw Fanucci turn the corner towards Eleventh Avenue and knew he was headed towards his apartment, probably to put away his loot before coming out on the streets again. Perhaps to put away his gun. Vito Corleone left his apartment and ran up the stairs to the roof. He travelled over the square block of roofs and descended down the steps of an empty loft building fire escape that left him in the back yard. He kicked the back door open and went through the front door. Across the street was Fanucci's tenement apartment house.

The village of tenements extended only as far west as Tenth Avenue. Eleventh Avenue was mostly warehouses and lofts rented by firms who shipped by New York Central Railroad and wanted access to the freight yards that honeycombed the area from Eleventh Avenue to the Hudson River. Fanucci's apartment house was one of the few left standing in this wilderness and was occupied mostly by bachelor trainmen, yard workers, and the cheapest prostitutes. These people did not sit in the street and gossip like honest Italians, they sat in beer taverns guzzling their pay. So Vito Corleone found it an easy matter to slip across the deserted Eleventh Avenue and

into the vestibule of Fanucci's apartment house. There he drew the gun he had never fired and waited for Fanucci.

He watched through the glass door of the vestibule, knowing Fanucci would come down from Tenth Avenue. Clemenza had showed him the safety on the gun and he had triggered it empty. But as a young boy in Sicily at the early age of nine, he had often gone hunting with his father, had often fired the heavy shotgun called the *lupara*. It was his skill with the *lupara* even as a small boy that had brought the sentence of death upon him by his father's murderers.

Now waiting in the darkened hallway, he saw the white blob of Fanucci crossing the street towards the doorway. Vito stepped back, shoulders pressed against the inner door that led to the stairs. He held his gun out to fire. His extended hand was only two paces from the outside door. The door swung in. Fanucci, white, broad, smelly, filled the square of light. Vito Corleone fired.

The opened door let some of the sound escape into the street, the rest of the gun's explosion shook the building. Fanucci was holding on to the sides of the door, trying to stand erect, trying to reach for his gun. The force of his struggle had torn the buttons off his jacket and made it swing loose. His gun was exposed but so was a spidery vein of red on the white shirtfront of his stomach. Very carefully, as if he were plunging a needle into a vein, Vito Corleone fired his second bullet into that red web.

Fanucci fell to his knees, propping the door open. He let out a terrible groan, the groan of a man in great physical distress that was almost comical. He kept giving these groans; Vito remembered hearing at least three of them before he put the gun against Fanucci's sweaty, suety cheek and fired into his brain. No more than five seconds had passed when Fanucci slumped into death, jamming the door open with his body.

Very carefully Vito took the wide wallet out of the dead man's jacket pocket and put it inside his shirt. Then he walked across the street into the loft building, through that into the yard and climbed the fire escape to the roof. From there he surveyed the street. Fanucci's body was still lying in the doorway but there was no sign of any other person. Two windows

had gone up in the tenement and he could see dark heads poked out but since he could not see their features they had certainly not seen his. And such men would not give information to the police. Fanucci might lie there until dawn or until a patrolman making the rounds stumbled on his body. No person in that house would deliberately expose himself to police suspicion or questioning. They would lock their doors and pretend they had heard nothing.

He could take his time. He travelled over the rooftops to his own roof door and down to his own flat. He unlocked the door, went inside and then locked the door behind him. He rifled the dead man's wallet. Besides the seven hundred dollars he had given Fanucci there were only some singles and a five-dollar note.

Tucked inside the flap was an old five-dollar gold piece, probably a luck token. If Fanucci was a rich gangster, he certainly did not carry his wealth with him. This confirmed some of Vito's suspicions.

He knew he had to get rid of the wallet and the gun (knowing enough even then that he must leave the gold piece in the wallet). He went up on the roof again and travelled over a few ledges. He threw the wallet down one air shaft and then he emptied the gun of bullets and smashed its barrel against the roof ledge. The barrel wouldn't break. He reversed it in his hand and smashed the butt against the side of a chimney. The butt split into two halves. He smashed it again and the pistol broke into barrel and handle, two separate pieces. He used a separate air shaft for each. They made no sound when they struck the earth five storeys below, but sank into the soft hill of garbage that had accumulated there. In the morning more garbage would be thrown out of the windows and, with luck, would cover everything. Vito returned to his apartment.

He was trembling a little but was absolutely under control. He changed his clothes and fearful that some blood might have splattered on them, he threw them into a metal tub his wife used for washing. He took lye and heavy brown laundry soap to soak the clothes and scrubbed them with the metal wash board beneath the sink. Then he scoured tub and sink with lye

and soap. He found a bundle of newly-washed clothes in the corner of the bedroom and mingled his own clothes with these. Then he put on a fresh shirt and trousers and went down to join his wife and children and neighbours in front of the tenement.

All these precautions proved to be unnecessary. The police, after discovering the dead body at dawn, never questioned Vito Corleone. Indeed he was astonished that they never learned about Fanucci's visit to his home on the night he was shot to death. He had counted on that for an alibi, Fanucci leaving the tenement alive. He only learned later that the police had been delighted with the murder of Fanucci and not too anxious to pursue his killers. They had assumed it was another gang execution, and had questioned hoodlums with records in the rackets and a history of strong-arm. Since Vito had never been in trouble he never came into the picture.

But if he had outwitted the police, his partners were another matter. Pete Clemenza and Tessio avoided him for the next week, for the next two weeks, then they came to call on him one evening. They came with obvious respect. Vito Corleone greeted them with impassive courtesy and served them wine.

Clemenza spoke first. He said softly, 'Nobody is collecting from the store owners on Ninth Avenue. Nobody is collecting from the card games and gambling in the neighbourhood.'

Vito Corleone gazed at both men steadily but did not reply. Tessio spoke. 'We could take over Fanucci's customers. They would pay us.'

Vito Corleone shrugged. 'Why come to me? I have no interest in such things.'

Clemenza laughed. Even in his youth, before growing his enormous belly, he had a fat man's laugh. He said now to Vito Corleone, 'How about that gun I gave you for the truck job? Since you won't need it any more you can give it back to me.'

Very slowly and deliberately Vito Corleone took a wad of bills out of his side pocket and peeled off five tens. 'Here, I'll pay you. I threw the gun away after the truck job.' He smiled at the two men.

At that time Vito Corleone did not know the effect of this smile. It was chilling because it attempted no menace. He

smiled as if it was some private joke only he himself could appreciate. But since he smiled in that fashion only in affairs that were lethal, and since the joke was not really private, and since his eyes did not smile, and since his outward character was usually so reasonable and quiet, the sudden unmasking of his true self was frightening.

Clemenza shook his head. 'I don't want the money,' he said. Vito pocketed the bills. He waited. They all understood each other. They knew he had killed Fanucci and though they never spoke about it to anyone the whole neighbourhood, within a few weeks, also knew. Vito Corleone was treated as a 'man of respect' by everyone. But he made no attempt to take over the Fanucci rackets and tributes.

What followed then was inevitable. One night Vito's wife brought a neighbour, a widow, to the flat. The woman was Italian and of unimpeacheable character. She worked hard to keep a home for her fatherless children. Her sixteen-year-old son brought home his pay envelope sealed, to hand over to her in the old-country style; her seventeen-year-old daughter, a dressmaker, did the same. The whole family sewed buttons on cards at night at slave labour piece rates. The woman's name was Signora Colombo.

Vito Corleone's wife said, 'The Signora has a favour to ask of you. She is having some trouble.'

Vito Corleone expected to be asked for money, which he was ready to give. But it seemed that Mrs Colombo owned a dog which her youngest son adored. The landlord had received complaints on the dog barking at night and had told Mrs Colombo to get rid of it. She had pretended to do so. The landlord had found out that she had deceived him and had ordered her to vacate her apartment. She had promised this time to truly get rid of the dog and she had done so. But the landlord was so angry that he would not revoke his order. She had to get out or the police would be summoned to put her out. And her poor little boy had cried so when they had given the dog away to relatives who lived in Long Island. All for nothing, they would lose their home.

Vito Corleone asked her gently, 'Why do you ask me to help you?'

Mrs Colombo nodded towards his wife. 'She told me to ask you.'

He was surprised. His wife had never questioned him about the clothes he had washed the night he had murdered Fanucci. Had never asked him where all the money came from when he was not working. Even now her face was impassive. Vito said to Mrs Colombo, 'I can give you some money to help you move, is that what you want?'

The woman shook her head, she was in tears. 'All my friends are here, all the girls I grew up with in Italy. How can I move to another neighbourhood with strangers? I want you to speak to the landlord to let me stay.'

Vito nodded. 'It's done then. You won't have to move. I'll speak to him tomorrow morning.'

His wife gave him a smile which he did not acknowledge, but he felt pleased. Mrs Colombo looked a little uncertain. 'You're sure he'll say yes, the landlord?' she asked.

'Signor Roberto?' Vito said in a surprised voice. 'Of course he will. He's a good-hearted fellow. Once I explain how things are with you he'll take pity on your misfortunes. Now don't let it trouble you any more. Don't get so upset. Guard your health, for the sake of your children.'

The landlord, Mr Roberto, came to the neighbourhood every day to check on the row of five tenements that he owned. He was a *padrone*, a man who sold Italian labourers just off the boat to the big corporations. With his profits he had bought the tenements one by one. An educated man from the North of Italy, he felt only contempt for these illiterate Southerners from Sicily and Naples who swarmed like vermin through his buildings, who threw garbage down the air shafts, who let cockroaches and rats eat away his walls without lifting a hand to preserve his property. He was not a bad man, he was a good husband and father, but constant worry about his investments, about the money he earned, about the inevitable expenses that came with being a man of property had worn his nerves to a frazzle so that he was in a constant state of irritation. When Vito Corleone stopped him on the street to ask for a word, Mr Roberto was brusque. Not rude, since any one of these

Southerners might stick a knife into you if rubbed the wrong way, though this young man looked like a quiet fellow.

'Signor Roberto,' said Vito Corleone, 'the friend of my wife, a poor widow with no man to protect her, tells me that for some reason she has been ordered to move from her apartment in your building. She is in despair. She has no money, she has no friends except those that live here. I told her that I would speak to you, that you are a reasonable man who acted out of some misunderstanding. She has got rid of the animal that caused all the trouble and so why shouldn't she stay? As one Italian to another, I ask you the favour.'

Signor Roberto studied the young man in front of him. He saw a man of medium stature but strongly built, a peasant but not a bandit, though he so laughably dared to call himself an Italian. Roberto shrugged. 'I have already rented the apartment to another family for higher rent,' he said. 'I cannot disappoint them for the sake of your friend.'

Vito Corleone nodded in agreeable understanding. 'How much more a month?' he asked.

'Five dollars,' Mr Roberto said. This was a lie. The railway flat, four dark rooms, rented for twelve dollars a month to the widow and he had not been able to get more than that from the new tenant.

Vito Corleone took a roll of bills out of his pocket and peeled off three tens. 'Here is the six months' increase in advance. You needn't speak to her about it, she's a proud woman. See me again in another six months. But of course you'll let her keep her dog.'

'Like hell,' Mr Roberto said. 'And who the hell are you to give me orders. Watch your manners or you'll be out on your Sicilian ass in the street there.'

Vito Corleone raised his hands in surprise. 'I'm asking you a favour, only that. One never knows when one might need a friend, isn't that true? Here, take this money as a sign of my goodwill and make your own decision. I wouldn't dare to quarrel with it.' He thrust the money into Mr Roberto's hand. 'Do me this little favour, just take the money and think things over. Tomorrow morning if you want to give me the money back by all means do so. If you want the woman out of your

house, how can I stop you? It's your property, after all. If you don't want the dog in there, I can understand. I dislike animals myself.' He patted Mr Roberto on the shoulder. 'Do me this service, eh? I won't forget it. Ask your friends in the neighbourhood about me, they'll tell you I'm a man who believes in showing his gratitude.'

But of course Mr Roberto had already begun to understand. That evening he made inquiries about Vito Corleone. He did not wait until the next morning. He knocked on the Corleone door that very night, apologizing for the lateness of the hour and accepted a glass of wine from Signora Corleone. He assured Vito Corleone that it had all been a dreadful misunderstanding, that of course Signora Colombo could remain in the flat, of course she could keep her dog. Who were those miserable tenants to complain about noise from a poor animal when they paid such a low rent? At the finish he threw the thirty dollars Vito Corleone had given him on the table and said in the most sincere fashion, 'Your good heart in helping this poor widow has shamed me and I wish to show that I, too, have some Christian charity. Her rent will remain what it was.'

All concerned played this comedy prettily. Vito poured wine, called for cakes, wrung Mr Roberto's hand and praised his warm heart. Mr Roberto sighed and said that having made the acquaintance of such a man as Vito Corleone restored his faith in human nature. Finally they tore themselves away from each other. Mr Roberto, his bones turned to jelly with fear at his narrow escape, caught the streetcar to his home in the Bronx and took to his bed. He did not reappear in his tenements for three days.

Vito Corleone was now a 'man of respect' in the neighbourhood. He was reputed to be a member of the Mafia of Sicily. One day a man who ran card games in a furnished room came to him and voluntarily paid him twenty dollars each week for his 'friendship'. He had only to visit the game once or twice a week to let the players understand they were under his protection.

Store owners who had problems with young hoodlums

asked him to intercede. He did so and was properlyre warded. Soon he had the enormous income for that time and place of one hundred dollars a week. Since Clemenza and Tessio were his friends, his allies, he had to give them each part of the money, but this he did without being asked. Finally he decided to go into the olive oil importing business with his boyhood chum, Genco Abbandando. Genco would handle the business, the importing of the olive oil from Italy, the buying at the proper price, the storing in his father's warehouse. Genco had the experience for this part of the business. Clemenza and Tessio would be the salesmen. They would go to every Italian grocery store in Manhattan, then Brooklyn, then the Bronx, to persuade store owners to stock *Genco Pura* olive oil. (With typical modesty, Vito Corleone refused to name the brand after himself.) Vito of course would be the head of the firm since he was supplying most of the capital. He also would be called in on special cases, where store owners resisted the sales talks of Clemenza and Tessio. Then Vito Corleone would use his own formidable powers of persuasion.

For the next few years Vito Corleone lived that completely satisfying life of a small businessman wholly devoted to building up his commercial enterprise in a dynamic, expanding economy. He was a devoted father and husband but so busy he could spare his family little of his time. As *Genco Pura* olive oil grew to become the best-selling imported Italian oil in America, his organization mushroomed. Like any good businessman he came to understand the benefits of under-cutting his rivals in price, barring them from distribution out-lets by persuading store owners to stock less of their brands. Like any good businessman he aimed at holding a monopoly by forcing his rivals to abandon the field or by merging with his own company. However, since he had started off relatively helpless, economically, since he did not believe in advertising, relying on word of mouth, and since if truth be told, his olive oil was no better than his competitors', he could not use the common strangleholds of legitimate businessmen. He had to rely on the force of his own personality and his reputation as a 'man of respect'.

Even as a young man, Vito Corleone became known as a

'man of reasonableness'. He never uttered a threat. He always used logic that proved to be irresistible. He always made certain that the other fellow got his share of profit. Nobody lost. He did this, of course, by obvious means. Like many businessmen of genius he learned that free competition was wasteful, monopoly efficient. And so he simply set about achieving that efficient monopoly. There were some oil wholesalers in Brooklyn, men of fiery temper, headstrong, not amenable to reason, who refused to see, to recognize, the vision of Vito Corleone, even after he had explained everything to them with the utmost patience and detail. With these men Vito Corleone threw up his hands in despair and sent Tessio to Brooklyn to set up a headquarters and solve the problem. Warehouses were burned, truckloads of olive-green oil were dumped to form lakes in the cobbled waterfront streets. One rash man, an arrogant Milanese with more faith in the police than a saint has in Christ, actually went to the authorities with a complaint against his fellow Italians, breaking the ten-century-old law of *omerta*. But before the matter could progress any further the wholesaler disappeared, never to be seen again, leaving behind, deserted, his devoted wife and three children, who, God be thanked, were fully grown and capable of taking over his business and coming to terms with the *Genco Pura* Oil Company.

But great men are not born great, they grow great, and so it was with Vito Corleone. When Prohibition came to pass and alcohol forbidden to be sold, Vito Corleone made the final step from a quite ordinary, somewhat ruthless businessman to a great Don in the world of criminal enterprise. It did not happen in a day, it did not happen in a year, but by the end of the Prohibition period and the start of the Great Depression, Vito Corleone had become the Godfather, the Don, Don Corleone.

It started casually enough. By this time the *Genco Pura* Oil Company had a fleet of six delivery trucks. Through Clemenza, Vito Corleone was approached by a group of Italian bootleggers who smuggled alcohol and whisky in from Canada. They needed trucks and deliverymen to distribute their produce over New York City. They needed deliverymen who

were reliable, discreet, and of a certain determination and force. They were willing to pay Vito Corleone for his trucks and for his men. The fee was so enormous that Vito Corleone cut back drastically on his oil business to use the trucks almost exclusively for the service of the bootlegger-smugglers. This despite the fact that these gentlemen had accompanied their offer with a silky threat. But even then Vito Corleone was so mature a man that he did not take insult at a threat or become angry and refuse a profitable offer because of it. He evaluated the threat, found it lacking in conviction, and lowered his opinion of his new partners because they had been so stupid to use threats where none were needed. This was useful information to be pondered at its proper time.

Again he prospered. But, more important, he acquired knowledge and contacts and experience. And he piled up good deeds as a banker piles up securities. For in the following years it became clear that Vito Corleone was not only a man of talent but, in his way, a genius.

He made himself the protector of the Italian families who set themselves up as small speakeasies in their homes, selling whisky at fifteen cents a glass to bachelor labourers. He became godfather to Mrs Colombo's youngest son when the lad made his confirmation and gave a handsome present of a twenty-dollar gold piece. Meanwhile, since it was inevitable that some of his trucks be stopped by the police, Genco Abbandando hired a fine lawyer with many contacts in the Police Department and the judiciary. A system of payoffs was set up and soon the Corleone organization had a sizeable 'sheet', the list of officials entitled to a monthly sum. When the lawyer tried to keep this list down, apologizing for the expense, Vito Corleone reassured him. 'No, no,' he said. 'Get everyone on it even if they can't help us right now. I believe in friendship and I am willing to show my friendship first.'

As time went by the Corleone empire became larger, more trucks were added, the 'sheet' grew longer. Also the men working directly for Tessio and Clemenza grew in number. The whole thing was becoming unwieldy. Finally Vito Corleone worked out a system of organization. He gave Clemenza and Tessio each the title of *Caporegime*, or captain,

and the men who worked beneath them the rank of soldier. He named Genco Abbandando his counsellor, or *Consigliori*. He put layers of insulation between himself and any operational act. When he gave an order it was to Genco or to one of the *caporegimes* alone. Rarely did he have a witness to any order he gave any particular one of them. Then he split Tessio's group and made it responsible for Brooklyn. He also split Tessio off from Clemenza and made it clear over the years that he did not want the two men to associate even socially except when absolutely necessary. He explained this to the more intelligent Tessio, who caught his drift immediately, though Vito explained it as a security measure against the law. Tessio understood that Vito did not want his two *caporegimes* to have any opportunity to conspire against him and he also understood there was no ill will involved, merely a tactical precaution. In return Vito gave Tessio a free hand in Brooklyn while he kept Clemenza's Bronx fief very much under his thumb. Clemenza was the braver, more reckless, the crueller man despite his outward jollity, and needed a tighter rein.

The Great Depression increased the power of Vito Corleone. And indeed it was about that time he came to be called Don Corleone. Everywhere in the city, honest men begged for honest work in vain. Proud men demeaned themselves and their families to accept official charity from a contemptuous officialdom. But the men of Don Corleone walked the streets with their heads held high, their pockets stuffed with silver and paper money. With no fear of losing their jobs. And even Don Corleone, that most modest of men, could not help feeling a sense of pride. He was taking care of his world, his people. He had not failed those who depended on him and gave him the sweat of their brows, risked their freedom and their lives in his service. And when an employee of his was arrested and sent to prison by some mischance, that unfortunate man's family received a living allowance; and not a miserly, beggarly, begrudging pittance but the same amount the man earned when free.

This of course was not pure Christian charity. Not his best friends would have called Don Corleone a saint from heaven. There was some self-interest in this generosity. An employee

sent to prison knew he had only to keep his mouth shut and his wife and children would be cared for. He knew that if he did not inform to the police a warm welcome would be his when he left prison. There would be a party waiting in his home, the best of food, homemade ravioli, wine, pastries, with all his friends and relatives gathered to rejoice in his freedom. And sometime during the night the *Consigliori*, Genco Abbandando, or perhaps even the Don himself, would drop by to pay his respects to such a stalwart, take a glass of wine in his honour, and leave a handsome present of money so that he could enjoy a week or two of leisure with his family before returning to his daily toil. Such was the infinite sympathy and understanding of Don Corleone.

It was at this time that the Don got the idea that he ran his world far better than his enemies ran the greater world which continually obstructed his path. And this feeling was nurtured by the poor people of the neighbourhood who constantly came to him for help. To get on the home relief, to get a young boy a job or out of jail, to borrow a small sum of money desperately needed, to intervene with landlords who against all reason demanded rent from jobless tenants.

Don Vito Corleone helped them all. Not only that, he helped them with goodwill, with encouraging words to take the bitter sting out of the charity he gave them. It was only natural then that when these Italians were puzzled and confused on who to vote for to represent them in the state legislature, in the city offices, in the Congress, they should ask the advice of their friend Don Corleone, their Godfather. And so he became a political power to be consulted by practical party chiefs. He consolidated this power with a far-seeing statesmanlike intelligence; by helping brilliant boys from poor Italian families through college, boys who would later become lawyers, assistant district attorneys, and even judges. He planned for the future of his empire with all the foresight of a great national leader.

The repeal of Prohibition dealt this empire a crippling blow but again he had taken his precautions. In 1933 he sent emissaries to the man who controlled all the gambling activities of Manhattan, the crap games on the docks, the shylocking that

went with it as hot dogs go with baseball games, the book-making on sports and horses, the illicit gambling houses that ran poker games, the policy or numbers racket of Harlem. This man's name was Salvatore Maranzano and he was one of the acknowledged *pezzonovanti*, .90 calibres, or big shots of the New York underworld. The Corleone emissaries proposed to Maranzano an equal partnership beneficial to both parties. Vito Corleone with his organization, his police and political contacts, could give the Maranzano operations a stout umbrella and the new strength to expand into Brooklyn and the Bronx. But Maranzano was a short-sighted man and spurned the Corleone offer with contempt. The great Al Capone was Maranzano's friend and he had his own organization, his own men, plus a huge war chest. He would not brook this upstart whose reputation was more that of a Parliamentary debater than a true *mafioso*. Maranzano's refusal touched off the great war of 1933 which was to change the whole structure of the underworld in New York City.

At first glance it seemed an uneven match. Salvatore Maranzano had a powerful organization with strong enforcers. He had a friendship with Capone in Chicago and could call on help in that quarter. He also had a good relationship with the Tattaglia Family, which controlled prostitution in the city and what there was of the thin drug traffic at that time. He also had political contacts with powerful business leaders who used his enforcers to terrorize the Jewish unionists in the garment centre and the Italian anarchist syndicates in the building trades.

Against this Don Corleone could throw two small but superbly organized *regimes* led by Clemenza and Tessio. His political and police contacts were negated by the business leaders who would support Maranzano. But in his favour was the enemy's lack of intelligence about his organization. The underworld did not know the true strength of his soldiers and even were deceived that Tessio in Brooklyn was a separate and independent operation.

And yet despite all this, it was an unequal battle until Vito Corleone evened out the odds with one master stroke.

Maranzano sent a call to Capone for his two best gunmen to

come to New York to eliminate the upstart. The Corleone Family had friends and intelligence in Chicago who relayed the news that the two gunmen were arriving by train. Vito Corleone dispatched Luca Brasi to take care of them with instructions that would liberate the strange man's most savage instincts.

Brasi and his people, four of them, received the Chicago hoods at the railroad station. One of Brasi's men procured and drove a taxicab for the purpose and the station porter carrying the bags led the Capone men to this cab. When they got in, Brasi and another of his men crowded in after them, guns ready, and made the two Chicago boys lie on the floor. The cab drove to a warehouse near the docks that Brasi had prepared for them.

The two Capone men were bound hand and foot and small bath towels were stuffed into their mouths to keep them from crying out.

Then Brasi took an axe from its place against the wall and started hacking at one of the Capone men. He chopped the man's feet off, then the legs at the knees, then the thighs where they joined the torso. Brasi was an extremely powerful man but it took him many swings to accomplish his purpose. By that time of course the victim had given up the ghost and the floor of the warehouse was slippery with the hacked fragments of his flesh and the gouting of his blood. When Brasi turned to his second victim he found further effort unnecessary. The second Capone gunman out of sheer terror had, impossibly, swallowed the bath towel in his mouth and suffocated. The bath towel was found in the man's stomach when the police performed their autopsy to determine the cause of death.

A few days later in Chicago the Capones received a message from Vito Corleone. It was to this effect: 'You know now how I deal with enemies. Why does a Neapolitan interfere in a quarrel between two Sicilians? If you wish me to consider you as a friend I owe you a service which I will pay on demand. A man like yourself must know how much more profitable it is to have a friend who, instead of calling on you for help, takes care of his own affairs and stands ever ready to help you in some future time of trouble. If you do not wish my friendship,

so be it. But then I must tell you that the climate in this city is damp; unhealthy for Neapolitans, and you are advised never to visit it.'

The arrogance of this letter was a calculated one. The Don held the Capones in small esteem as stupid, obvious cut-throats. His intelligence informed him that Capone had for-feited all political influence because of his public arrogance and the flaunting of his criminal wealth. The Don knew, in fact was positive, that without political influence, without the camouflage of society, Capone's world, and others like it, could be easily destroyed. He knew Capone was on the path to destruction. He also knew that Capone's influence did not extend beyond the boundaries of Chicago, terrible and all-pervading as that influence there might be.

The tactic was successful. Not so much because of its ferocity but because of the chilling swiftness, the quickness of the Don's reaction. If his intelligence was so good, any further moves would be fraught with danger. It was better, far wiser, to accept the offer of friendship with its implied payoff. The Capones sent back word that they would not interfere.

The odds were now equal. And Vito Corleone had earned an enormous amount of 'respect' throughout the United States underworld with his humiliation of the Capones. For six months he outgeneralled Maranzano. He raided the crap games under that man's protection, located his biggest policy banker in Harlem and had him relieved of a day's play not only in money but in records. He engaged his enemies on all fronts. Even in the garment centres he sent Clemenza and his men to fight on the side of the unionists against the enforcers on the payroll of Maranzano and the owners of the dress firms. And on all fronts his superior intelligence and organiz-ation made him the victor. Clemenza's jolly ferocity, which Corleone employed judiciously, also helped turn the tide of battle. And then Don Corleone sent the held-back reserve of the Tessio *regime* after Maranzano himself.

By this time Maranzano had dispatched emissaries suing for a peace. Vito Corleone refused to see them, put them off on one pretext or another. The Maranzano soldiers were deserting their leader, not wishing to die in a losing cause. Bookmakers

and shylocks were paying the Corleone organization their protection money. The war was all but over.

And then finally on New Year's Eve of 1933, Tessio got inside the defences of Maranzano himself. The Maranzano lieutenants were anxious for a deal and agreed to lead their chief to the slaughter. They told him that a meeting had been arranged in a Brooklyn restaurant with Corleone and they accompanied Maranzano as his bodyguards. They left him sitting at a checkered table, morosely munching a piece of bread, and fled the restaurant as Tessio and four of his men entered. The execution was swift and sure. Maranzano, his mouth full of half-chewed bread, was riddled with bullets. The war was over.

The Maranzano empire was incorporated into the Corleone operation. Don Corleone set up a system of tribute, allowing all incumbents to remain in their bookmaking and policy number spots. As a bonus he had a foothold in the unions of the garment centre which in later years was to prove extremely important. And now that he had settled his business affairs the Don found trouble at home.

Santino Corleone, Sonny, was sixteen years old and grown to an astonishing six feet with broad shoulders and a heavy face that was sensual but by no means effeminate. But where Fredo was a quiet boy, and Michael, of course, a toddler, Santino was constantly in trouble. He got into fights, did badly in school and, finally, Clemenza, who was the boy's godfather and had a duty to speak, came to Don Corleone one evening and informed him that his son had taken part in an armed robbery, a stupid affair which could have gone very badly. Sonny was obviously the ringleader, the two other boys in the robbery his followers.

It was one of the very few times that Vito Corleone lost his temper. Tom Hagen had been living in his home for three years and he asked Clemenza if the orphan boy had been involved. Clemenza shook his head. Don Corleone had a car sent to bring Santino to his offices in the *Genco Pura* Olive Oil Company.

For the first time, the Don met defeat. Alone with his son, he gave full vent to his rage, cursing the hulking Sonny in

Sicilian dialect, a language so much more satisfying than any other for expressing rage. He ended up with a question. 'What gave you the right to commit such an act? What made you wish to commit such an act?'

Sonny stood there, angry, refusing to answer. The Don said with contempt, 'And so stupid. What did you earn for that night's work. Fifty dollars each? Twenty dollars? You risked your life for twenty dollars, eh?'

As if he had not heard these last words, Sonny said defiantly, 'I saw you kill Fanucci.'

The Don said, 'Ahhh' and sank back in his chair. He waited.

Sonny said, 'When Fanucci left the building, Mama said I could go up the house. I saw you go up the roof and I followed you. I saw everything you did. I stayed up there and I saw you throw away the wallet and the gun.'

The Don sighed. 'Well, then I can't talk to you about how you should behave. Don't you want to finish school, don't you want to be a lawyer? Lawyers can steal more money with a briefcase than a thousand men with guns and masks.'

Sonny grinned at him and said slyly, 'I want to enter the family business.' When he saw that the Don's face remained impassive, that he did not laugh at the joke, he added hastily, 'I can learn how to sell olive oil.'

Still the Don did not answer. Finally he shrugged. 'Every man has one destiny,' he said. He did not add that the witnessing of Fanucci's murder had decided that of his son. He merely turned away and added quietly, 'Come in tomorrow morning at nine o'clock. Genco will show you what to do.'

But Genco Abbandando, with that shrewd insight that a *Consigliori* must have, realized the true wish of the Don and used Sonny mostly as a bodyguard for his father, a position in which he could also learn the subtleties of being a Don. And it brought out a professorial instinct in the Don himself, who often gave lectures on how to succeed for the benefit of his eldest son.

Besides his oft-repeated theory that a man has but one destiny, the Don constantly reproved Sonny for that young man's outbursts of temper. The Don considered a use of threats the most foolish kind of exposure; the unleashing of

anger without forethought as the most dangerous indulgence. No one had ever heard the Don utter a naked threat, no one had ever seen him in an uncontrollable rage. It was unthinkable. And so he tried to teach Sonny his own disciplines. He claimed that there was no greater natural advantage in life than having an enemy overestimate your faults, unless it was to have a friend underestimate your virtues.

The *caporegime*, Clemenza, took Sonny in hand and taught him how to shoot and to wield a garrotte. Sonny had no taste for the Italian rope, he was too Americanized. He preferred the simple, direct, impersonal Anglo-Saxon gun, which saddened Clemenza. But Sonny became a constant and welcome companion to his father, driving his car, helping him in little details. For the next two years he seemed like the usual son entering his father's business, not too bright, not too eager, content to hold down a soft job.

Meanwhile his boyhood chum and semi-adopted brother Tom Hagen was going to college. Fredo was still in high school; Michael, the youngest brother, was in grammar school, and baby sister Connie was a toddling girl of four. The family had long since moved to an apartment house in the Bronx. Don Corleone was considering buying a house in Long Island, but he wanted to fit this in with other plans he was formulating.

Vito Corleone was a man with vision. All the great cities of America were being torn by underworld strife. Guerrilla wars by the dozen flared up, ambitious hoodlums trying to carve themselves a bit of empire; men like Corleone himself were trying to keep their borders and rackets secure. Don Corleone saw that the newspapers and government agencies were using these killings to get stricter and stricter laws, to use harsher police methods. He foresaw that public indignation might even lead to a suspension of democratic procedures which could be fatal to him and his people. His own empire, internally, was secure. He decided to bring peace to all the warring factions in New York City and then in the nation.

He had no illusions about the dangerousness of his mission. He spent the first year meeting with different chiefs of gangs in New York, laying the groundwork, sounding them out, pro-

posing spheres of influence that would be honoured by a loosely bound confederated council. But there were too many factions, too many special interests that conflicted. Agreement was impossible. Like other great rulers and lawgivers in history Don Corleone decided that order and peace were impossible until the number of reigning states had been reduced to a manageable number.

There were five or six 'Families' too powerful to eliminate. But the rest, the neighbourhood Black Hand terrorists, the freelance shylocks, the strong-arm bookmakers operating without the proper, that is to say paid, protection of the legal authorities, would have to go. And so he mounted what was in effect a colonial war against these people and threw all the resources of the Corleone organization against them.

The pacification of the New York area took three years and had some unexpected rewards. At first it took the form of bad luck. A group of mad-dog Irish stick-up artists the Don had marked for extermination almost carried the day with sheer Emerald Isle élan. By chance, and with suicidal bravery, one of these Irish gunmen pierced the Don's protective cordon and put a shot into his chest. The assassin was immediately riddled with bullets but the damage was done.

However this gave Santino Corleone his chance. With his father out of action, Sonny took command of a troop, his own *regime*, with the rank of *caporegime*, and like a young, untrumpeted Napoleon, showed a genius for city warfare. He also showed a merciless ruthlessness, the lack of which had been Don Corleone's only fault as a conqueror.

From 1935 to 1937 Sonny Corleone made a reputation as the most cunning and relentless executioner the underworld had yet known. Yet for sheer terror even he was eclipsed by the awesome man named Luca Brasi.

It was Brasi who went after the rest of the Irish gunmen and single-handedly wiped them out. It was Brasi, operating alone when one of the six powerful families tried to interfere and become the protector of the independents, who assassinated the head of that family as a warning. Shortly after, the Don recovered from his wound and made peace with that particular family.

By 1937 peace and harmony reigned in New York City except for minor incidents, minor misunderstandings which were, of course, sometimes fatal.

As the rulers of ancient cities always kept an anxious eye on the barbarian tribes roving around their walls, so Don Corleone kept an eye on the affairs of the world outside his world. He noted the coming of Hitler, the fall of Spain, Germany's strong-arming of Britain at Munich. Unblinkered by that outside world, he saw clearly the coming global war and he understood the implications. His own world would be more impregnable than before. Not only that, fortunes could be made in time of war by alert, foresighted folk. But to do so peace must reign in his domain while war raged in the world outside.

Don Corleone carried his message through the United States. He conferred with compatriots in Los Angeles, San Francisco, Cleveland, Chicago, Philadelphia, Miami, and Boston. He was the underworld apostle of peace and, by 1939, more successful than any Pope, he had achieved a working agreement amongst the most powerful underworld organizations in the country. Like the Constitution of the United States this agreement respected fully the internal authority of each member in his state or city. The agreement covered only spheres of influence and an agreement to enforce peace in the underworld.

And so when World War II broke out in 1939, when the United States joined the conflict in 1941, the world of Don Vito Corleone was at peace, in order, fully prepared to reap the golden harvest on equal terms with all the other industries of a booming America. The Corleone Family had a hand in supplying black-market OPA food stamps, gasoline stamps, even travel priorities. It could help get war contracts and then help get black-market materials for those garment centre clothing firms who were not given enough raw material because they did not have government contracts. He could even get all the young men in his organization, those eligible for Army draft, excused from fighting in the foreign war. He did this with the aid of doctors who advised what drugs had to be taken before physical examination, or by placing the men in draft-exempt positions in the war industries.

And so the Don could take pride in his rule. His world was safe for those who had sworn their loyalty to him; other men who believed in law and order were dying by the millions. The only fly in the ointment was that his own son, Michael Corleone, refused to be helped, insisted on volunteering to serve his own country. And to the Don's astonishment, so did a few of his other young men in the organization. One of the men, trying to explain this to his *caporegime*, said, 'This country has been good to me.' Upon this story being relayed to the Don he said angrily to the *caporegime*, '*I* have been good to him.' It might have gone badly for these people but, as he had excused his son Michael, so must he excuse other young men who so misunderstood their duty to their Don and to themselves.

At the end of World War II Don Corleone knew that again his world would have to change its ways, that it would have to fit itself more snugly into the ways of the other, larger world. He believed he could do this with no loss of profit.

There was reason for this belief in his own experience. What had put him on the right track were two personal affairs. Early in his career the then-young Nazorine, only a baker's helper planning to get married, had come to him for assistance. He and his future bride, a good Italian girl, had saved their money and had paid the enormous sum of three hundred dollars to a wholesaler of furniture recommended to them. This wholesaler had let them pick out everything they wanted to furnish their tenement apartment. A fine sturdy bedroom set with two bureaux and lamps. Also the living room set of heavy stuffed sofa and stuffed armchairs, all covered with rich gold-threaded fabric. Nazorine and his fiancée had spent a happy day picking out what they wanted from the huge warehouse crowded with furniture. The wholesaler took their money, their three hundred dollars wrung from the sweat of their blood, and pocketed it and promised the furniture to be delivered within the week to the already rented flat.

The very next week however, the firm had gone into bankruptcy. The great warehouse stocked with furniture had been sealed shut and attached for payment of creditors. The wholesaler had disappeared to give other creditors time to unleash their anger on the empty air. Nazorine, one of these, went to

his lawyer, who told him nothing could be done until the case was settled in court and all creditors satisfied. This might take three years and Nazorine would be lucky to get back ten cents on the dollar.

Vito Corleone listened to this story with amused disbelief. It was not possible that the law could allow such thievery. The wholesaler owned his own palatial home, an estate in Long Island, a luxurious automobile, and was sending his children to college. How could he keep the three hundred dollars of the poor baker Nazorine and not give him the furniture he had paid for? But, to make sure, Vito Corleone had Genco Abbandando check it out with the lawyers who represented the *Genco Pura* company.

They verified the story of Nazorine. The wholesaler had all his personal wealth in his wife's name. His furniture business was incorporated and he was not personally liable. True, he had shown bad faith by taking the money of Nazorine when he knew he was going to file bankruptcy but this was a common practice. Under law there was nothing to be done.

Of course the matter was easily adjusted. Don Corleone sent his *Consigliori*, Genco Abbandando, to speak to the wholesaler, and as was to be expected, that wide-awake businessman caught the drift immediately and arranged for Nazorine to get his furniture. But it was an interesting lesson for the young Vito Corleone.

The second incident had more far-reaching repercussions. In 1939, Don Corleone had decided to move his family out of the city. Like any other parent he wanted his children to go to better schools and mix with better companions. For his own personal reasons he wanted the anonymity of suburban life where his reputation was not known. He bought the mall property in Long Beach, which at that time had only four newly built houses but with plenty of room for more. Sonny was formally engaged to Sandra and would soon marry, one of the houses would be for him. One of the houses was for the Don. Another was for Genco Abbandando and his family. The other was kept vacant at the time.

A week after the mall was occupied, a group of three work-men came in all innocence with their truck. They claimed to be

furnace inspectors for the town of Long Beach. One of the Don's young bodyguards let the men in and led them to the furnace in the basement. The Don, his wife and Sonny were in the garden taking their ease and enjoying the salty sea air.

Much to the Don's annoyance he was summoned into the house by his bodyguard. The three workmen, all big burly fellows, were grouped around the furnace. They had taken it apart, it was strewn around the cement basement floor. The leader, an authoritative man, said to the Don in a gruff voice, 'Your furnace is in lousy shape. If you want us to fix it and put it together again, it'll cost you one hundred fifty dollars for labour and parts and then we'll pass you for county inspection.' He took out a red paper label. 'We stamp this seal on it, see, then nobody from the county bothers you again.'

The Don was amused. It had been a boring, quiet week in which he had had to neglect his business to take care of such family details moving to a new house entailed. In more broken English than his usual slight accent he asked, 'If I don't pay you, what happens to my furnace?'

The leader of the three men shrugged. 'We just leave the furnace the way it is now.' He gestured at the metal parts strewn over the floor.

The Don said meekly, 'Wait, I'll get you your money.' Then he went out into the garden and said to Sonny, 'Listen, there's some men working on the furnace, I don't understand what they want. Go in and take care of the matter.' It was not simply a joke; he was considering making his son his *under-boss*. This was one of the tests a business executive had to pass.

Sonny's solution did not altogether please his father. It was too direct, too lacking in Sicilian subtleness. He was the Club, not the Rapier. For as soon as Sonny heard the leader's demand he held the three men at gunpoint and had them thoroughly bastinadoed by the bodyguards. Then he made them put the furnace together again and tidy up the basement. He searched them and found that they actually were employed by a house-improvement firm with headquarters in Suffolk County. He learned the name of the man who owned the firm. Then he kicked the three men to their truck. 'Don't let me see

you in Long Beach again,' he told them. 'I'll have your ball hanging from your ears.'

It was typical of the young Santino, before he became older and crueller, that he extended his protection to the community he lived in. Sonny paid a personal call to the home improvement firm owner and told him not to send any of his men into the Long Beach area ever again. As soon as the Corleone Family set up their usual business liaison with the local police force they were informed of all such complaints and all crimes by professional criminals. In less than a year Long Beach became the most crime-free town of its size in the United States. Professional stick-up artists and strong-arms received one warning not to ply their trade in the town. They were allowed one offence. When they committed a second they simply disappeared. The flimflam home-improvement gyp artists, the door-to-door con men were politely warned that they were not welcome in Long Beach. Those confident con men who disregarded the warning were beaten within an inch of their lives. Resident young punks who had no respect for law and proper authority were advised in the most fatherly fashion to run away from home. Long Beach became a model city.

What impressed the Don was the legal validity of these sales swindles. Clearly there was a place for a man of his talents in that other world which had been closed to him as an honest youth. He took appropriate steps to enter that world.

And so he lived happily on the mall in Long Beach, consolidating and enlarging his empire, until after the war was over, the Turk Sollozzo broke the peace and plunged the Don's world into its own war, and brought him to his hospital bed.

Book IV

CHAPTER FIFTEEN

In the New Hampshire village, every foreign phenomenon was properly noticed by housewives peering from windows, storekeepers lounging behind their doors. And so when the black automobile bearing New York licence plates stopped in front of the Adams' home, every citizen knew about it in a matter of minutes.

Kay Adams, really a small-town girl despite her college education, was also peering from her bedroom window. She had been studying for her exams and preparing to go downstairs for lunch when she spotted the car coming up the street, and for some reason she was not surprised when it rolled to a halt in front of her lawn. Two men got out, big burly men who looked like gangsters in the movies to her eyes, and she flew down the stairs to be the first at the door. She was sure they came from Michael or his family and she didn't want them talking to her father and mother without any introduction. It wasn't that she was ashamed of any of Mike's friends, she thought; it was just that her mother and father were old-fashioned New England Yankees and wouldn't understand her even knowing such people.

She got to the door just as the bell rang and she called to her mother, 'I'll get it.' She opened the door and the two big men stood there. One reached inside his breast pocket like a gangster reaching for a gun and the move so surprised Kay that she let out a little gasp but the man had taken out a small leather case which he flapped open to show an identification card. 'I'm Detective John Phillips from the New York Police Department,' he said. He motioned to the other man, a dark-complexioned man with very thick, very black eyebrows. 'This is my partner, Detective Siriani. Are you Miss Kay Adams?'

Kay nodded. Phillips said, 'May we come in and talk to you for a few minutes. It's about Michael Corleone.'

She stood aside to let them in. At that moment her father appeared in the small side hall that led to his study. 'Kay, what is it?' he asked.

Her father was a grey-haired, slender, distinguished-looking man who not only was the pastor of the town Baptist church but had a reputation in religious circles as a scholar. Kay really didn't know her father well, he puzzled her, but she knew he loved her even if he gave the impression he found her uninteresting as a person. Though they had never been close, she trusted him. So she said simply, 'These men are detectives from New York. They want to ask me questions about a boy I know.'

Mr Adams didn't seem surprised. 'Why don't we go into my study?' he said.

Detective Phillips said gently, 'We'd rather talk to your daughter alone, Mr Adams.'

Mr Adams said courteously, 'That depends on Kay, I think. My dear, would you rather speak to these gentlemen alone or would you prefer to have me present? Or perhaps your mother?'

Kay shook her head. 'I'll talk to them alone.'

Mr Adams said to Phillips, 'You can use my study. Will you stay for lunch?' The two men shook their heads. Kay led them into the study.

They rested uncomfortably on the edge of the couch as she sat in her father's big leather chair. Detective Phillips opened the conversation by saying, 'Miss Adams, have you seen or heard from Michael Corleone at any time in the last three weeks?' The one question was enough to warn her. Three weeks ago she had read the Boston newspapers with their headlines about the killing of a New York police captain and a narcotics smuggler named Virgil Sollozzo. The newspaper had said it was part of the gang war involving the Corleone Family.

Kay shook her head. 'No, the last time I saw him he was going to see his father in the hospital. That was perhaps a month ago.'

The other detective said in a harsh voice, 'We know all

about that meeting. Have you seen or heard from him since then?'

'No,' Kay said.

Detective Phillips said in a polite voice, 'If you do have contact with him we'd like you to let us know. It's very important we get to talk to Michael Corleone. I must warn you that if you do have contact with him you may be getting involved in a very dangerous situation. If you help him in any way, you may get yourself in very serious trouble.'

Kay sat up very straight in the chair. 'Why shouldn't I help him?' she asked. 'We're going to be married, married people help each other.'

It was Detective Siriani who answered her. 'If you help, you may be an accessory to murder. We're looking for your boyfriend because he killed a police captain in New York plus an informer the police officer was contacting. We *know* Michael Corleone is the person who did the shooting.'

Kay laughed. Her laughter was so unaffected, so incredulous, that the officers were impressed. 'Mike wouldn't do anything like that,' she said. 'He never had anything to do with his family. When we went to his sister's wedding it was obvious that he was treated as an outsider, almost as much as I was. If he's hiding now it's just so that he won't get any publicity, so his name won't be dragged through all this. Mike is not a gangster. I know him better than you or anybody else can know him. He is too nice a man to do anything as despicable as murder. He is the most law-abiding person I know, and I've never known him to lie.'

Detective Phillips asked gently, 'How long have you known him?'

'Over a year,' Kay said and was surprised when the two men smiled.

'I think there are a few things you should know,' Detective Phillips said. 'On the night he left you, he went to the hospital. When he came out he got into an argument with a police captain who had come to the hospital on official business. He assaulted that police officer but got the worst of it. In fact he got a broken jaw and lost some teeth. His friends took him out to the Corleone Family houses at Long Beach. The following

night the police captain he had the fight with was gunned down and Michael Corleone disappeared. Vanished. We have our contacts, our informers. They all point the finger at Michael Corleone but we have no evidence for a court of law. The waiter who witnessed the shooting doesn't recognize a picture of Mike but he may recognize him in person. And we have Sollozzo's driver, who refuses to talk, but we might make him talk if we have Michael Corleone in our hands. So we have all our people looking for him, the FBI is looking for him, everybody is looking for him. So far, no luck, so we thought you might be able to give us a lead.'

Kay said coldly, 'I don't believe a word of it.' But she felt a bit sick knowing the part about Mike getting his jaw broken must be true. Not that that would make Mike commit murder.

'Will you let us know if Mike contacts you?' Phillips asked.

Kay shook her head. The other detective, Siriani, said roughly, 'We know you two have been shacking up together. We have the hotel records and witnesses. If we let that information slip to the newspapers your father and mother would feel pretty lousy. Real respectable people like them wouldn't think much of a daughter shacking up with a gangster. If you don't come clean right now I'll call your old man in here and give it to him straight.'

Kay looked at him with astonishment. Then she got up and went to the door of the study and opened it. She could see her father standing at the living-room window, sucking at his pipe. She called out, 'Dad, can you join us?' He turned, smiled at her, and walked to the study. When he came through the door he put his arm around his daughter's waist and faced the detectives and said, 'Yes, gentlemen?'

When they didn't answer, Kay said coolly to Detective Siriani, 'Give it to him straight, officer.'

Siriani flushed. 'Mr Adams, I'm telling you this for your daughter's good. She is mixed up with a hoodlum we have reason to believe committed a murder on a police officer. I'm just telling her she can get into serious trouble unless she co-operates with us. But she doesn't seem to realize how serious this whole matter is. Maybe you can talk to her.'

'That is quite incredible,' Mr Adams said politely.

Siriani jutted his jaw. 'Your daughter and Michael Corleone have been going out together for over a year. They have stayed overnight in hotels together registered as man and wife. Michael Corleone is wanted for questioning in the murder of a police officer. Your daughter refuses to give us any information that may help us. Those are the facts. You can call them incredible but I can back everything up.'

'I don't doubt your word, sir,' Mr Adams said gently. 'What I find incredible is that my daughter could be in serious trouble. Unless you're suggesting that she is a' – here his face became one of scholarly doubt – 'a "moll", I believe it's called.'

Kay looked at her father in astonishment. She knew he was being playful in his donnish way and she was surprised that he could take the whole affair so lightly.

Mr Adams said firmly, 'However, rest assured that if the young man shows his face here I shall immediately report his presence to the authorities. As will my daughter. Now, if you will forgive us, our lunch is growing cold.'

He ushered the men out of the house with every courtesy and closed the door on their backs gently but firmly. He took Kay by the arm and led her towards the kitchen far in the rear of the house, 'Come, my dear, your mother is waiting lunch for us.'

By the time they reached the kitchen, Kay was weeping silently, out of relief from strain, at her father's unquestioning affection. In the kitchen her mother took no notice of her weeping, and Kay realized that her father must have told her about the two detectives. She sat down at her place and her mother served her silently. When all three were at the table her father said grace with bowed head.

Mrs Adams was a short stout woman always neatly dressed, hair always set. Kay had never seen her in disarray. Her mother too had always been a little disinterested in her, holding her at arm's length. And she did so now. 'Kay, stop being so dramatic. I'm sure it's all a great deal of fuss about nothing at all. After all, the boy was a Dartmouth boy, he couldn't possibly be mixed up in anything so sordid.'

Kay looked up in surprise. 'How did you know Mike went to Dartmouth?'

Her mother said complacently, 'You young people are so mysterious, you think you're so clever. We've known about him all along, but of course we couldn't bring it up until you did.'

'But how did you know?' Kay asked. She still couldn't face her father now that he knew about her and Mike sleeping together. So she didn't see the smile on his face when he said, 'We opened your mail, of course.'

Kay was horrified and angry. Now she could face him. What he had done was more shameful than her own sin. She could never believe it of him. 'Father, you didn't, you couldn't have.'

Mr Adams smiled at her. 'I debated which was the greater sin, opening your mail, or going in ignorance of some hazard my only child might be incurring. The choice was simple, and virtuous.'

Mrs Adams said between mouthfuls of boiled chicken, 'After all, my dear, you are terribly innocent for your age. We had to be aware. And you never spoke about him.'

For the first time Kay was grateful that Michael was never affectionate in his letters. She was grateful that her parents hadn't seen some of *her* letters. 'I never told you about him because I thought you'd be horrified about his family.'

'We were,' Mr Adams said cheerfully. 'By the way, has Michael got in touch with you?'

Kay shook her head. 'I don't believe he's guilty of anything.'

She saw her parents exchange a glance over the table. Then Mr Adams said gently, 'If he's not guilty and he's vanished, then perhaps something else happened to him.'

At first Kay didn't understand. Then she got up from the table and ran to her room.

Three days later Kay Adams got out of a taxi in front of the Corleone mall in Long Beach. She had phoned, she was expected. Tom Hagen met her at the door and she was disappointed that it was him. She knew he would tell her nothing.

In the living room he gave her a drink. She had seen a couple of other men lounging around the house but not Sonny. She asked Tom Hagen directly, 'Do you know where Mike is? Do you know where I can get in touch with him?'

Hagen said smoothly, 'We know he's all right but we don't know where he is right now. When he heard about that captain being shot he was afraid they'd accuse him. So he just decided to disappear. He told me he'd get in touch in a few months.'

The story was not only false but meant to be seen through, he was giving her that much. 'Did that captain really break his jaw?' Kay asked.

'I'm afraid that's true,' Tom said. 'But Mike was never a vindictive man. I'm sure that had nothing to do with what happened.'

Kay opened her purse and took out a letter. 'Will you deliver this to him if he gets in touch with you?'

Hagen shook his head. 'If I accepted that letter and you told a court of law I accepted that letter, it might be interpreted as my having knowledge of his whereabouts. Why don't you just wait a bit? I'm sure Mike will get in touch.'

She finished her drink and got up to leave. Hagen escorted her to the hall but as he opened the door, a woman came in from outside. A short, stout woman dressed in black. Kay recognized her as Michael's mother. She held out her hand and said, 'How are you, Mrs Corleone?'

The woman's small black eyes darted at her for a moment, then the wrinkled, leathery, olive-skinned face broke into a small curt smile of greeting that was yet in some curious way truly friendly. 'Ah, you Mikey's little girl,' Mrs Corleone said. She had a heavy Italian accent, Kay could barely understand her. 'You eat something?' Kay said no, meaning she didn't want anything to eat, but Mrs Corleone turned furiously on Tom Hagen and berated him in Italian ending with, 'You don't even give this poor girl coffee, you *disgrazia*.' She took Kay by the hand, the old woman's hand surprisingly warm and alive, and led her into the kitchen. 'You have coffee and eat something, then somebody drive you home. A nice girl like you, I don't want you to take the train.' She made Kay sit down and bustled around the kitchen, tearing off her coat and hat and draping them over a chair. In a few seconds there was bread and cheese and salami on the table and coffee perking on the stove.

239

Kay said timidly, 'I came to ask about Mike, I haven't heard from him. Mr Hagen said nobody knows where he is, that he'll turn up in a little while.'

Hagen spoke quickly, 'That's all we can tell her now, Ma.'

Mrs Corleone gave him a look of withering contempt. 'Now you gonna tell me what to do? My husband don't tell me what to do, God have mercy on him.' She crossed herself.

'Is Mr Corleone all right?' Kay asked.

'Fine,' Mrs Corleone said. 'Fine. He's getting old, he's getting foolish to let something like that happen.' She tapped her head disrespectfully. She poured the coffee and forced Kay to eat some bread and cheese.

After they drank their coffee Mrs Corleone took one of Kay's hands in her two brown ones. She said quietly, 'Mikey no gonna write you, you no gonna hear from Mikey. He hide two–three years. Maybe more, maybe much more. You go home to your family and find a nice young fellow and get married.'

Kay took the letter out of her purse. 'Will you send this to him?'

The old lady took the letter and patted Kay on the cheek. 'Sure, sure,' she said. Hagen started to protest and she screamed at him in Italian. Then she led Kay to the door. There she kissed her on the cheek very quickly and said, 'You forget about Mikey, he no the man for you any more.'

There was a car waiting for her with two men up front. They drove her all the way to her hotel in New York never saying a word. Neither did Kay. She was trying to get used to the fact that the young man she had loved was a cold-blooded murderer. And that she had been told by the most unimpeachable source: his mother.

CHAPTER SIXTEEN

CARLO RIZZI was punk sore at the world. Once married into the Corleone Family, he'd been shunted aside with a small bookmaker's business on the Upper East Side of Manhattan.

He'd counted on one of the houses in the mall on Long Beach, he knew the Don could move retainer families out when he pleased and he had been sure it would happen and he would be on the inside of everything. But the Don wasn't treating him right. The 'Great Don', he thought with scorn. An old Moustache Pete who'd been caught out on the street by gunmen like any dumb small-time hood. He hoped the old bastard croaked. Sonny had been his friend once and if Sonny became the head of the Family maybe he'd get a break, get on the inside.

He watched his wife pour his coffee. Christ, what a mess she turned out to be. Five months of marriage and she was already spreading, besides blowing up. Real guinea broads all these Italians in the East.

He reached out and felt Connie's soft spreading buttocks. She smiled at him and he said contemptuously, 'You got more ham than a hog.' It pleased him to see the hurt look on her face, the tears springing into her eyes. She might be a daughter of the Great Don but she was his wife, she was his property now and he could treat her as he pleased. It made him feel powerful that one of the Corleones was his doormat.

He had started her off just right. She had tried to keep that purse full of money presents for herself and he had given her a nice black eye and taken the money from her. Never told her what he'd done with it, either. That might have really caused some trouble. Even now he felt just the slightest twinge of remorse. Christ, he'd blown nearly fifteen grand on the track and show girl bimbos.

He could feel Connie watching his back and so he flexed his muscles as he reached for the plate of sweet buns on the other side of the table. He'd just polished off ham and eggs but he was a big man and needed a big breakfast. He was pleased with the picture he knew he presented to his wife. Not the usual greasy dark guinzo husband but crew-cut blond, huge golden-haired forearms and broad shoulders and thin waist. And he knew he was physically stronger than any of those so-called hard guys that worked for the family. Guys like Clemenza, Tessio, Rocco Lampone, and that guy Paulie that somebody had knocked off. He wondered what the story was about that.

Then for some reason he thought about Sonny. Man to man he could take Sonny, he thought, even though Sonny was a little bigger and a little heavier. But what scared him was Sonny's rep, though he himself had never seen Sonny anything but good-natured and kidding around. Yeah, Sonny was his buddy. Maybe with the old Don gone, things would open up.

He dawdled over his coffee. He hated this apartment. He was used to the bigger living quarters of the West and in a little while he would have to go crosstown to his 'book' to run the noontime action. It was a Sunday, the heaviest action of the week what with baseball going already and the tail end of basketball and the night trotters starting up. Gradually he became aware of Connie bustling around behind him and he turned his head to watch her.

She was getting dressed up in the real New York City guinzo style that he hated. A silk flowered-pattern dress with belt, showy bracelet and earrings, flouncy sleeves. She looked twenty years older. 'Where the hell are you going?' he asked.

She answered him coldly, 'To see my father out in Long Beach. He still can't get out of bed and he needs company.'

Carlo was curious. 'Is Sonny still running the show?'

Connie gave him a bland look. 'What show?'

He was furious. 'You lousy little guinea bitch, don't talk to me like that or I'll beat that kid right out of your belly.' She looked frightened and this enraged him even more. He sprang from his chair and slapped her across the face, the blow leaving a red welt. With quick precision he slapped her three more times. He saw her upper lip split bloody and puff up. That stopped him. He didn't want to leave a mark. She ran into the bedroom and slammed the door and he heard the key turning in the lock. He laughed and returned to his coffee.

He smoked until it was time for him to dress. He knocked on the door and said, 'Open it up before I kick it in.' There was no answer. 'Come on, I gotta get dressed,' he said in a loud voice. He could hear her getting up off the bed and coming towards the door, then the key turned in the lock. When he entered she had her back to him, walking back towards the bed, lying down on it with her face turned away to the wall.

He dressed quickly and then saw she was in her slip. He

wanted her to go visit her father, he hoped she would bring back information. 'What's the matter, a few slaps take all the energy out of you?' She was a lazy slut.

'I don't wanna go.' Her voice was tearful, the words mumbled. He reached out impatiently and pulled her around to face him. And then he saw why she didn't want to go and thought maybe it was just as well.

He must have slapped her harder than he figured. Her left cheek was blown up, the cut upper lip ballooned grotesquely puffy and white beneath her nose. 'OK,' he said, 'but I won't be home until late. Sunday is my busy day.'

He left the apartment and found a parking ticket on his car, a fifteen-dollar green one. He put it in the glove compartment with the stack of others. He was in a good humour. Slapping the spoiled little bitch around always made him feel good. It dissolved some of the frustration he felt at being treated so badly by the Corleones.

The first time he had marked her up, he'd been a little worried. She had gone right out to Long Beach to complain to her mother and father and to show her black eye. He had really sweated it out. But when she came back she had been surprisingly meek, the dutiful little Italian wife. He had made it a point to be the perfect husband over the next few weeks, treating her well in every way, being lovey and nice with her, banging her every day, morning and night. Finally she had told him what had happened since she thought he would never act that way again.

She had found her parents coolly unsympathetic and curiously amused. Her mother had had a little sympathy and had even asked her father to speak to Carlo Rizzi. Her father had refused. 'She is my daughter,' he had said, 'but now she belongs to her husband. He knows his duties. Even the King of Italy didn't dare to meddle with the relationship of husband and wife. Go home and learn how to behave so that he will not beat you.'

Connie had said angrily to her father, 'Did you ever hit your wife?' She was his favourite and could speak to him so impudently. He had answered, 'She never gave me reason to beat her.' And her mother had nodded and smiled.

She told them how her husband had taken the wedding present money and never told her what he did with it. Her father had shrugged and said, 'I would have done the same if my wife had been as presumptuous as you.'

And so she had returned home, a little bewildered, a little frightened. She had always been her father's favourite and she could not understand his coldness now.

But the Don had not been so unsympathetic as he pretended. He made inquiries and found out what Carlo Rizzi had done with the wedding present money. He had men assigned to Carlo Rizzi's bookmaking operation who would report to Hagen everything Rizzi did on the job. But the Don could not interfere. How expect a man to discharge his husbandly duties to a wife whose family he feared? It was an impossible situation and he dared not meddle. Then when Connie became pregnant he was convinced of the wisdom of his decision and felt he never could interfere though Connie complained to her mother about a few more beatings and the mother finally became concerned enough to mention it to the Don. Connie even hinted that she might want a divorce. For the first time in her life the Don was angry with her. 'He is the father of your child. What can a child come to in this world if he has no father?' he said to Connie.

Learning all this, Carlo Rizzi grew confident. He was perfectly safe. In fact he bragged to his two 'writers' on the book, Sally Rags and Coach, about how he bounced his wife around when she got snotty and saw their looks of respect that he had the guts to manhandle the daughter of the great Don Corleone.

But Rizzi would not have felt so safe if he had known that when Sonny Corleone learned of the beatings he had flown into a murderous rage and had been restrained only by the sternest and most imperious command of the Don himself, a command that even Sonny dared not disobey. Which was why Sonny avoided Rizzi, not trusting himself to control his temper.

So feeling perfectly safe on this beautiful Sunday morning, Carlo Rizzi sped crosstown on 96th Street to the East Side. He did not see Sonny's car coming the opposite way towards his house.

* * * * *

Sonny Corleone had left the protection of the mall and spent the night with Lucy Mancini in town. Now on the way home he was travelling with four bodyguards, two in front and two behind. He didn't need guards right beside him, he could take care of a single direct assault. The other men travelled in their own cars and had apartments on either side of Lucy's apartment. It was safe to visit her as long as he didn't do it too often. But now that he was in town he figured he would pick up his sister Connie and take her out to Long Beach. He knew Carlo would be working at his book and the cheap bastard wouldn't get her a car. So he'd give his sister a lift out.

He waited for the two men in front to go into the building and then followed them. He saw the two men in back pull up behind his car and get out to watch the streets. He kept his own eyes open. It was a million-to-one shot that the opposition even knew he was in town but he was always careful. He had learned that in the 1930s war.

He never used elevators. They were death traps. He climbed the eight flights to Connie's apartment, going fast. He knocked on her door. He had seen Carlo's car go by and knew she would be alone. There was no answer. He knocked again and then he heard his sister's voice, frightened, timid, asking, 'Who is it?'

The fright in the voice stunned him. His kid sister had always been fresh and snotty, tough as anybody in the family. What the hell had happened to her? He said, 'It's Sonny.' The bolt inside slid back and the door opened and Connie was in his arms sobbing. He was so surprised he just stood there. He pushed her away from him and saw her swollen face and he understood what had happened.

He pulled away from her to run down the stairs and go after her husband. Rage flamed up in him, contorting his own face. Connie saw the rage and clung to him, not letting him go, making him come into the apartment. She was weeping out of terror now. She knew her older brother's temper and feared it. She had never complained to him about Carlo for that reason. Now she made him come into the apartment with her.

'It was my fault,' she said. 'I started a fight with him and I tried to hit him so he hit me. He really didn't try to hit me that hard. I walked into it.'

Sonny's heavy Cupid face was under control. 'You going to see the old man today?'

She didn't answer, so he added, 'I thought you were, so I dropped over to give you a lift. I was in the city anyway.'

She shook her head. 'I don't want them to see me this way. I'll come next week.'

'OK,' Sonny said. He picked up her kitchen phone and dialled a number. 'I'm getting a doctor to come over here and take a look at you and fix you up. In your condition you have to be careful. How many months before you have the kid?'

'Two months,' Connie said. 'Sonny, please don't do anything. Please don't.'

Sonny laughed. His face was cruelly intent when he said, 'Don't worry, I won't make your kid an orphan before he's born.' He left the apartment after kissing her lightly on her uninjured cheek.

On East 112th Street a long line of cars were double-parked in front of a candy store that was the headquarters of Carlo Rizzi's book. On the sidewalk in front of the store, fathers played catch with small children they had taken for a Sunday morning ride and to keep them company as they placed their bets. When they saw Carlo Rizzi coming they stopped playing ball and bought their kids ice cream to keep them quiet. Then they started studying the newspapers that gave the starting pitchers, trying to pick out winning baseball bets for the day.

Carlo went into the large room in the back of the store. His two 'writers', a small wiry man called Sally Rags and a big husky fellow called Coach, were already waiting for the action to start. They had their huge lined pads in front of them ready to write down bets. On a wooden stand was a blackboard with the names of the sixteen big league baseball teams chalked on it, paired to show who was playing against who. Against each pairing was a blocked-out square to enter the odds.

Carlo asked Coach, 'Is the store phone tapped today?'

Coach shook his head. 'The tap is still off.'

Carlo went to the wall phone and dialled a number. Sally Rags and Coach watched him impassively as he jotted down the 'line', the odds on all the baseball games for that day. They

watched him as he hung up the phone and walked over to the blackboard and chalked up the odds against each game. Though Carlo did not know it, they had already got the line and were checking his work. In the first week in his job Carlo had made a mistake in transposing the odds on to the blackboard and had created that dream of all gamblers, a 'middle'. That is, by betting the odds with him and then betting against the same team with another bookmaker at the correct odds, the gambler could not lose. The only one who could lose was Carlo's book. That mistake had caused a six-thousand-dollar loss in the book for the week and confirmed the Don's judgement about his son-in-law. He had given the word that all of Carlo's work was to be checked.

Normally the highly placed members of the Corleone Family would never be concerned with such an operational detail. There was at least a five-layer insulation to their level. But since the book was being used as a testing ground for the son-in-law, it had been placed under the direct scrutiny of Tom Hagen, to whom a report was sent every day.

Now with the line posted, the gamblers were thronging into the back room of the candy store to jot down the odds on their newspapers next to the games printed there with probable pitchers. Some of them held their little children by the hand as they looked up at the blackboard. One guy who made big bets looked down at the little girl he was holding by the hand and said teasingly, 'Who do you like today, Honey, Giants or the Pirates?' The little girl, fascinated by the colourful names, said, 'Are Giants stronger than Pirates?' The father laughed.

A line began to form in front of the two writers. When a writer filled one of his sheets he tore it off, wrapped the money he had collected in it and handed it to Carlo. Carlo went out the back exit of the room and up a flight of steps to an apartment which housed the candy store owner's family. He called in the bets to his central exchange and put the money in a small wall safe that was hidden by an extended window drape. Then he went back down into the candy store after having first burned the bet sheet and flushed its ashes down the toilet bowl.

None of the Sunday games started before two PM because of

the blue laws, so after the first crowd of betters, family men who had to get their bets in and rush home to take their families to the beach, came the trickling of bachelor gamblers or the diehards who condemned their families to Sundays in the hot city apartments. These bachelor betters were the big gamblers, they bet heavier and came back around four o'clock to bet the second games of doubleheaders. They were the ones who made Carlo's Sundays a full-time day with overtime, though some married men called in from the beach to try and recoup their losses.

By one-thirty the betting had trickled off so that Carlo and Sally Rags could go out and sit on the stoop beside the candy store and get some fresh air. They watched the stickball game the kids were having. A police car went by. They ignored it. This book had very heavy protection at the precinct and couldn't be touched on a local level. A raid would have to be ordered from the very top and even then a warning would come through in plenty of time.

Coach came out and sat beside them. They gossiped a while about baseball and women. Carlo said laughingly, 'I had to bat my wife around again today, teach her who's boss.'

Coach said casually, 'She's knocked up pretty big now, ain't she?'

'Ahh, I just slapped her face a few times,' Carlo said. 'I didn't hurt her.' He brooded for a moment. 'She thinks she can boss me around, I don't stand for that.'

There were still a few betters hanging around shooting the breeze, talking baseball, some of them sitting on the steps above the two writers and Carlo. Suddenly the kids playing stickball in the street scattered. A car came screeching up the block and to a halt in front of the candy store. It stopped so abruptly that the tyres screamed and before it had stopped, almost, a man came hurtling out of the driver's seat, moving so fast that everybody was paralysed. The man was Sonny Corleone.

His heavy Cupid-featured face with its thick, curved mouth was an ugly mask of fury. In a split second he was at the stoop and had grabbed Carlo Rizzi by the throat. He pulled Carlo away from the others, trying to drag him into the street, but

Carlo wrapped his huge muscular arms around the iron railings of the stoop and hung on. He cringed away, trying to hide his head and face in the hollow of his shoulders. His shirt ripped away in Sonny's hand.

What followed then was sickening. Sonny began beating the cowering Carlo with his fists, cursing him in a thick, rage-choked voice. Carlo, despite his tremendous physique, offered no resistance, gave no cry for mercy or protest. Coach and Sally Rags dared not interfere. They thought Sonny meant to kill his brother-in-law and had no desire to share his fate. The kids playing stickball gathered to curse the driver who had made them scatter, but now were watching with awestruck interest. They were tough kids but the sight of Sonny in his rage silenced them. Meanwhile another car had drawn up behind Sonny's and two of his bodyguards jumped out. When they saw what was happening they too dared not interfere. They stood alert, ready to protect their chief if any bystanders had the stupidity to try to help Carlo.

What made the sight sickening was Carlo's complete subjection, but it was perhaps this that saved his life. He clung to the iron railings with his hands so that Sonny could not drag him into the street and despite his obvious equal strength, still refused to fight back. He let the blows rain on his unprotected head and neck until Sonny's rage ebbed. Finally, his chest heaving, Sonny looked down at him and said, 'You dirty bastard, you ever beat up my sister again I'll kill you.'

These words released the tension. Because of course, if Sonny intended to kill the man he would never have uttered the threat. He uttered it in frustration because he could not carry it out. Carlo refused to look at Sonny. He kept his head down and his hands and arms entwined in the iron railing. He stayed that way until the car roared off and he heard Coach say in his curiously paternal voice, 'OK, Carlo, come on into the store. Let's get out of sight.'

It was only then that Carlo dared to get out of his crouch against the stone steps of the stoop and unlock his hands from the railing. Standing up, he could see the kids look at him with the staring, sickened faces of people who had witnessed the degradation of a fellow human being. He was a little dizzy but

it was more from shock, the raw fear that had taken command of his body; he was not badly hurt despite the shower of heavy blows. He let Coach lead him by the arm into the back room of the candy store and put ice on his face, which, though it was not cut or bleeding, was lumpy with swelling bruises. The fear was subsiding now and the humiliation he had suffered made him sick to his stomach so that he had to throw up. Coach held his head over the sink, supported him as if he were drunk, then helped him upstairs to the apartment and made him lie down in one of the bedrooms. Carlo never noticed that Sally Rags had disappeared.

Sally Rags had walked down to Third Avenue and called Rocco Lampone to report what had happened. Rocco took the news calmly and in his turn called his *caporegime*, Pete Clemenza. Clemenza groaned and said, 'Oh, Christ, that goddamn Sonny and his temper,' but his finger had prudently clicked down on the hook so that Rocco never heard his remark.

Clemenza called the house in Long Beach and got Tom Hagen. Hagen was silent for a moment and then he said, 'Send some of your people and cars out on the road to Long Beach as soon as you can, just in case Sonny gets held up by traffic or an accident. When he gets sore like that he doesn't know what the hell he's doing. Maybe some of our friends on the other side will hear he was in town. You never can tell.'

Clemenza said doubtfully, 'By the time I could get anybody on the road, Sonny will be home. That goes for the Tattaglias too.'

'I know,' Hagen said patiently. 'But if something out of the ordinary happens, Sonny may be held up. Do the best you can, Pete.'

Grudgingly Clemenza called Rocco Lampone and told him to get a few people and cars and cover the road to Long Beach. He himself went out to his beloved Cadillac and with three of the platoon of guards who now garrisoned his home, started over the Atlantic Beach Bridge, towards New York City.

One of the hangers-on around the candy store, a small better on the payroll of the Tattaglia Family as an informer, called the contact he had with his people. But the Tattaglia Family had not streamlined itself for the war, the contact still had to go all

the way through the insulation layers before he finally got to the *caporegime* who contacted the Tattaglia chief. By that time Sonny Corleone was safely back in the mall, in his father's house, in Long Beach, about to face his father's wrath.

CHAPTER SEVENTEEN

THE WAR of 1947 between the Corleone Family and the Five Families combined against them proved to be expensive for both sides. It was complicated by the police pressure put on everybody to solve the murder of Captain McCluskey. It was rare that operating officials of the Police Department ignored political muscle that protected gambling and vice operations, but in this case the politicians were as helpless as the general staff of a rampaging, looting army whose field officers refuse to follow orders.

This lack of protection did not hurt the Corleone Family as much as it did their opponents. The Corleone group depended on gambling for most of its income, and was hit especially hard in its 'numbers' or 'policy' branch of operations. The runners who picked up the action were swept into police nets and usually given a medium shellacking before being booked. Even some of the 'banks' were located and raided, with heavy financial loss. The 'bankers', .90 calibres in their own right, complained to the *caporegimes*, who brought their complaints to the family council table. But there was nothing to be done. The bankers were told to go out of business. Local Negro freelancers were allowed to take over the operation in Harlem, the richest territory, and they operated in such scattered fashion that the police found it hard to pin them down.

After the death of Captain McCluskey, some newspapers printed stories involving him with Sollozzo. They published proof that McCluskey had received large sums of money in cash, shortly before his death. These stories had been planted by Hagen, the information supplied by him. The Police Department refused to confirm or deny these stories, but they

were taking effect. The police force got the word through informers, through police on the Family payroll, that McCluskey had been a rogue cop. Not that he had taken money or clean graft, there was no rank-and-file onus to that. But that he had taken the dirtiest of dirty money; murder and drugs money. And in the morality of policemen, this was unforgivable.

Hagen understood that the policeman believes in law and order in a curiously innocent way. He believed in it more than does the public he serves. Law and order is, after all, the magic from which he derives his power, individual power which he cherishes as nearly all men cherish individual power. And yet there is always the smouldering resentment against the public he serves. They are at the same time his ward and his prey. As wards they are ungrateful, abusive and demanding. As prey they are slippery and dangerous, full of guile. As soon as one is in the policeman's clutches the mechanism of the society the policeman defends marshals all its resources to cheat him of his prize. The fix is put in by politicians. Judges give lenient suspended sentences to the worst hoodlums. Governors of the States and the President of the United States himself give full pardons, assuming that respected lawyers have not already won his acquittal. After a time the cop learns. Why should he not collect the fees these hoodlums are paying? He needs it more. His children, why should they not go to college? Why shouldn't his wife shop in more expensive places? Why shouldn't he himself get the sun with a winter vacation in Florida? After all, he risks his life and that is no joke.

But usually he draws the line against accepting dirty graft. He will take money to let a bookmaker operate. He will take money from a man who hates getting parking tickets or speeding tickets. He will allow call girls and prostitutes to ply their trade; for a consideration. These are vices natural to man. But usually he will not take a payoff for drugs, armed robberies, rape, murder and other assorted perversions. In his mind these attack the very core of his personal authority and cannot be countenanced.

The murder of a police captain was comparable to regicide. But when it became known that McCluskey had been killed while in the company of a notorious narcotics peddler, when it

became known that he was suspected of conspiracy to murder, the police desire for vengeance began to fade. Also, after all, there were still mortgage payments to be made, cars to be paid off, children to be launched into the world. Without their 'sheet' money, policemen had to scramble to make ends meet. Unlicenced peddlers were good for lunch money. Parking ticket payoffs came to nickels and dimes. Some of the more desperate even began shaking down suspects (homosexuals, assaults and batteries) in the precinct squad rooms. Finally the brass relented. They raised the prices and let the Families operate. Once again the payoff sheet was typed up by the precinct bagman, listing every man assigned to the local station and what his cut was each month. Some semblance of social order was restored.

It had been Hagen's idea to use private detectives to guard Don Corleone's hospital room. These were, of course, supplemented by the much more formidable soldiers of Tessio's *regime*. But Sonny was not satisfied even with this. By the middle of February, when the Don could be moved without danger, he was taken by ambulance to his home in the mall. The house had been renovated so that his bedroom was now a hospital room with all equipment necessary for any emergency. Nurses specially recruited and checked had been hired for round-the-clock care, and Dr Kennedy, with the payment of a huge fee, had been persuaded to become the physician in residence to this private hospital. At least until the Don would need only nursing care.

The mall itself was made impregnable. Button men were moved into the extra houses, the tenants sent on vacations to their native villages in Italy, all expenses paid.

Freddie Corleone had been sent to Las Vegas to recuperate and also to scout out the ground for a Family operation in the luxury hotel-gambling casino complex that was springing up. Las Vegas was part of the West Coast empire still neutral and the Don of that empire had guaranteed Freddie's safety there. The New York five Families had no desire to make more enemies by going into Vegas after Freddie Corleone. They had enough trouble on their hands in New York.

Dr Kennedy had forbidden any discussion of business in front of the Don. This edict was completely disregarded. The Don insisted on the council of war being held in his room. Sonny, Tom Hagen, Pete Clemenza, and Tessio gathered there the very first night of his homecoming.

Don Corleone was too weak to speak much but he wished to listen and exercise veto powers. When it was explained that Freddie had been sent to Las Vegas to learn the gambling casino business, he nodded his head approvingly. When he learned that Bruno Tattaglia had been killed by Corleone button men he shook his head and sighed. But what distressed him most of all was learning that Michael had killed Sollozzo and Captain McCluskey and had then been forced to flee to Sicily. When he heard this he motioned them out and they continued the conference in the corner room that held the law library.

Sonny Corleone relaxed in the huge armchair behind the desk. 'I think we'd better let the old man take it easy for a couple of weeks, until the doc says he can do business.' He paused. 'I'd like to have it going again before he gets better. We have the go-ahead from the cops to operate. The first thing is the policy banks in Harlem. The black boys up there had their fun, now we have to take it back. They screwed up the works but good, just like they usually do when they run things. A lot of their runners didn't pay off winners. They drive up in Cadillacs and tell their players they gotta wait for their dough or maybe just pay them half what they win. I don't want any runner looking rich to his players. I don't want them dressing too good. I don't want them driving new cars. I don't want them welching on paying a winner. And I don't want any freelancers staying in business, they give us a bad name. Tom, let's get that project moving right away. Everything else will fall in line as soon as you send out the word that the lid is off.'

Hagen said, 'There are some very tough boys up in Harlem. They got a taste of the big money. They won't go back to being runners or sub-bankers again.'

Sonny shrugged. 'Just give their names to Clemenza. That's his job, straightening them out.'

Clemenza said to Hagen, 'No problem.'

It was Tessio who brought up the most important question. 'Once we start operating, the five Families start their raids. They'll hit our bankers in Harlem and our bookmakers on the East Side. They may even try to make things tough for the garment centre outfits we service. This war is going to cost a lot of money.'

'Maybe they won't,' Sonny said. 'They know we'll hit them right back. I've got peace feelers out and maybe we can settle everything by paying an indemnity for the Tattaglia kid.'

Hagen said, 'We're getting the cold shoulder on those negotiations. They lost a lot of dough the last few months and they blame us for it. With justice. I think what they want is for us to agree to come in on the narcotics trade, to use the Family influence politically. In other words, Sollozzo's deal minus Sollozzo. But they won't broach that until they've hurt us with some sort of combat action. Then after we've been softened up they figure we'll listen to a proposition on narcotics.'

Sonny said curtly, 'No deal on drugs. The Don said no and it's *no* until he changes it.'

Hagen said briskly, 'Then we're faced with a tactical problem. Our money is out in the open. Bookmaking and policy. We can be hit. But the Tattaglia Family has prostitution and call girls and the dock unions. How the hell are we going to hit them? The other Families are in some gambling. But most of them are in the construction trades, shylocking, controlling the unions, getting the government contracts. They get a lot from strong-arm and other stuff that involves innocent people. Their money isn't out in the street. The Tattaglia nightclub is too famous to touch, it would cause too much of a stink. And with the Don still out of action their political influence matches ours. So we've got a real problem here.'

'It's my problem, Tom,' Sonny said. 'I'll find the answer. Keep the negotiation alive and follow through on the other stuff. Let's go back into business and see what happens. Then we'll take it from there. Clemenza and Tessio have plenty of soldiers, we can match the whole Five Families gun for gun if that's the way they want it. We'll just go to the mattresses.'

There was no problem getting the freelance Negro bankers

out of business. The police were informed and cracked down. With a special effort. At that time it was not possible for a Negro to make a payoff to a high police or political official to keep such an operation going. This was due to racial prejudice and racial distrust more than anything else. But Harlem had always been considered a minor problem, and its settlement was expected.

The Five Families struck in an unexpected direction. Two powerful officials in the garment unions were killed, officials who were members of the Corleone Family. Then the Corleone Family shylocks were barred from the waterfront piers as were the Corleone Family bookmakers. The longshoremen's union locals had gone over to the Five Families. Corleone bookmakers all over the city were threatened to persuade them to change their allegiance. The biggest numbers banker in Harlem, an old friend and ally of the Corleone Family, was brutally murdered. There was no longer any option. Sonny told his *caporegimes* to go to the mattresses.

Two apartments were set up in the city and furnished with mattresses for the button men to sleep on, a refrigerator for food, and guns and ammunition. Clemenza staffed one apartment and Tessio the other. All Family bookmakers were given bodyguard teams. The policy bankers in Harlem, however, had gone over to the enemy and at the moment nothing could be done about that. All this cost the Corleone Family a great deal of money and very little was coming in. As the next few months went by, other things became obvious. The most important was that the Corleone Family had overmatched itself.

There were reasons for this. With the Don still too weak to take a part, a great deal of the Family's political strength was neutralized. Also, the last ten years of peace had seriously eroded the fighting qualities of the two *caporegimes*, Clemenza and Tessio. Clemenza was still a competent executioner and administrator but he no longer had the energy or the youthful strength to lead troops. Tessio had mellowed with age and was not ruthless enough. Tom Hagen, despite his abilities, was simply not suited to be a *Consigliori* in a time of war. His main fault was that he was not a Sicilian.

Sonny Corleone recognized these weaknesses in the Family's

wartime posture but could not take any steps to remedy them. He was not the Don and only the Don could replace the *caporegimes* and the *Consigliori*. And the very act of replacement would make the situation more dangerous, might precipitate some treachery. At first, Sonny had thought of fighting a holding action until the Don could become well enough to take charge, but with the defection of the policy bankers, the terrorization of the bookmakers, the Family position was becoming precarious. He decided to strike back.

But he decided to strike right at the heart of the enemy. He planned the execution of the heads of the five Families in one grand tactical manoeuvre. To that purpose he put into effect an elaborate system of surveillance of these leaders. But after a week the enemy chiefs promptly dived underground and were seen no more in public.

The Five Families and the Corleone Empire were in stalemate.

CHAPTER EIGHTEEN

AMERIGO BONASERA lived only a few blocks from his undertaking establishment on Mulberry Street and so always went home for supper. Evenings he returned to his place of business, dutifully joining those mourners paying their respects to the dead who lay in state in his sombre parlours.

He always resented the jokes made about his profession, the macabre technical details which were so unimportant. Of course none of his friends or family or neighbours would make such jokes. Any profession was worthy of respect to men who for centuries earned bread by the sweat of their brows.

Now at supper with his wife in their solidly furnished apartment, gilt statues of the Virgin Mary with their red-glassed candles flickering on the sideboard, Bonasera lit a Camel cigarette and took a relaxing glass of American whisky. His wife brought steaming plates of soup to the table. The two of them were alone now; he had sent his daughter to live in

Boston with her mother's sister, where she could forget her terrible experience and her injuries at the hands of the two ruffians Don Corleone had punished.

As they ate their soup his wife asked, 'Are you going back to work tonight?'

Amerigo Bonasera nodded. His wife respected his work but did not understand it. She did not understand that the technical part of his profession was the least important. She thought, like most other people, that he was paid for his skill in making the dead look so lifelike in their coffins. And indeed his skill in this was legendary. But even more important, even more necessary was his physical presence at the wake. When the bereaved family came at night to receive their blood relatives and their friends beside the coffin of their loved one, they needed Amerigo Bonasera with them.

For he was a strict chaperone to death. His face always grave, yet strong and comforting, his voice unwavering, yet muted to a low register, he commanded the mourning ritual. He could quiet grief that was too unseemly, he could rebuke unruly children whose parents had not the heart to chastise. Never cloying in the tender of his condolences, yet never was he offhand. Once a family used Amerigo Bonasera to speed a loved one on, they came back to him again and again. And he never, never, deserted one of his clients on that terrible last night above ground.

Usually he allowed himself a little nap after supper. Then he washed and shaved afresh, talcum powder generously used to shroud the heavy black beard. A mouthwash always. He respectfully changed into fresh linen, white gleaming shirt, the black tie, a freshly pressed dark suit, dull black shoes and black socks. And yet the effect was comforting instead of sombre. He also kept his hair dyed black, an unheard-of frivolity in an Italian male of his generation; but not out of vanity. Simply because his hair had turned a lively pepper and salt, a colour which struck him as unseemly for his profession.

After he finished his soup, his wife placed a small steak before him with a few forkfuls of green spinach oozing yellow oil. He was a light eater. When he finished this he drank a cup of coffee and smoked another Camel cigarette. Over his coffee

he thought about his poor daughter. She would never be the same. Her outward beauty had been restored but there was the look of a frightened animal in her eyes that had made him unable to bear the sight of her. And so they had sent her to live in Boston for a time. Time would heal her wounds. Pain and terror were not so final as death, as he well knew. His work made him an optimist.

He had just finished the coffee when his phone in the living room rang. His wife never answered it when he was home, so he got up and drained his cup and stubbed out his cigarette. As he walked to the phone he pulled off his tie and started to unbutton his shirt, getting ready for his little nap. Then he picked up the phone and said with quiet courtesy, 'Hello.'

The voice on the other end was harsh, strained. 'This is Tom Hagen,' it said. 'I'm calling for Don Corleone, at his request.'

Amerigo Bonasera felt the coffee churning sourly in his stomach, felt himself going a little sick. It was more than a year since he had put himself in the debt of the Don to avenge his daughter's honour and in that time the knowledge that he must pay that debt had receded. He had been so grateful seeing the bloody faces of those two ruffians that he would have done anything for the Don. But time erodes gratitude more quickly than it does beauty. Now Bonasera felt the sickness of a man faced with disaster. His voice faltered as he answered, 'Yes, I understand. I'm listening.'

He was surprised at the coldness in Hagen's voice. The *Consigliori* had always been a courteous man, though not Italian, but now he was being rudely brusque. 'You owe the Don a service,' Hagen said. 'He has no doubt that you will repay him. That you will be happy to have this opportunity. In one hour, not before, perhaps later, he will be at your funeral parlour to ask for your help. Be there to greet him. Don't have any people who work for you there. Send them home. If you have any objections to this, speak now and I'll inform Don Corleone. He has other friends who can do him this service.'

Amerigo Bonasera almost cried out in his fright, 'How can you think I would refuse the Godfather? Of course I'll do

anything he wishes. I haven't forgotten my debt. I'll go to my business immediately, at once.'

Hagen's voice was gentler now, but there was something strange about it. 'Thank you,' he said. 'The Don never doubted you. The question was mine. Oblige him tonight and you can always come to me in any trouble, you'll earn my personal friendship.'

This frightened Amerigo Bonasera even more. He stuttered, 'The Don himself is coming to me tonight?'

'Yes,' Hagen said.

'Then he's completely recovered from his injuries, thank God,' Bonasera said. His voice made it a question.

There was a pause at the other end of the phone, then Hagen's voice said very quietly, 'Yes.' There was a click and the phone went dead.

Bonasera was sweating. He went into the bedroom and changed his shirt and rinsed his mouth. But he didn't shave or use a fresh tie. He put on the same one he had used during the day. He called the funeral parlour and told his assistant to stay with the bereaved family using the front parlour that night. He himself would be busy in the laboratory working area of the building. When the assistant started asking questions Bonasera cut him off very curtly and told him to follow orders exactly.

He put on his suit jacket and his wife, still eating, looked up at him in surprise. 'I have work to do,' he said and she did not dare question him because of the look on his face. Bonasera went out of the house and walked the few blocks to his funeral parlour.

This building stood by itself on a large lot with a white picket fence running all around it. There was a narrow roadway leading from the street to the rear, just wide enough for ambulances and hearses. Bonasera unlocked the gate and left it open. Then he walked to the rear of the building and entered it through the wide door there. As he did so he could see mourners already entering the front door of the funeral parlour to pay their respects to the current corpse.

Many years ago when Bonasera had bought this building from an undertaker planning to retire, there had been a stoop of about ten steps that mourners had to mount before entering

the funeral parlour. This had posed a problem. Old and crippled mourners determined to pay their respects had found the steps almost impossible to mount, so the former undertaker had used the freight elevator for these people, a small metal platform, that rose out of the ground beside the building. The elevator was for coffins and bodies. It would descend underground, then rise into the funeral parlour itself, so that a crippled mourner would find himself rising through the floor beside the coffin as other mourners moved their black chairs aside to let the elevator rise through the trapdoor. Then when the crippled or aged mourner had finished paying his respects, the elevator would again come up through the polished floor to take him down and out again.

Amerigo Bonasera had found this solution to the problem unseemly and penny-pinching. So he had had the front of the building remodelled, the stoop done away with and a slightly inclining walk put in its place. But of course the elevator was still used for coffins and corpses.

In the rear of the building, cut off from the funeral parlour and reception rooms by a massive soundproof door, was the business office, the embalming room, a storeroom for coffins, and a carefully locked closet holding chemicals and the awful tools of his trade. Bonasera went to the office, sat at his desk and lit up a Camel, one of the few times he had ever smoked in this building. Then he waited for Don Corleone.

He waited with a feeling of the utmost despair. For he had no doubt as to what services he would be called upon to perform. For the last year the Corleone Family had waged war against the five great Mafia Families of New York and the carnage had filled the newspapers. Many men on both sides had been killed. Now the Corleone Family had killed somebody so important that they wished to hide his body, make it disappear, and what better way than to have it officially buried by a registered undertaker? And Amerigo Bonasera had no illusions about the act he was to commit. He would be an accessory to murder. If it came out, he would spend years in jail. His daughter and wife would be disgraced, his good name, the respected name of Amerigo Bonasera, dragged through the bloody mud of the Mafia war.

He indulged himself by smoking another Camel. And then he thought of something even more terrifying. When the other Mafia Families found out that he had aided the Corleones they would treat him as an enemy. They would murder him. And now he cursed the day he had gone to the Godfather and begged for his vengeance. He cursed the day his wife and the wife of Don Corleone had become friends. He cursed his daughter and America and his own success. And then his optimism returned. It could all go well. Don Corleone was a clever man. Certainly everything had been arranged to keep the secret. He had only to keep his nerve. For of course the one thing more fatal than any other was to earn the Don's displeasure.

He heard tyres on gravel. His practised ear told him a car was coming through the narrow driveway and parking in the back yard. He opened the rear door to let them in. The huge fat man, Clemenza, entered, followed by two very rough-looking young fellows. They searched the rooms without saying a word to Bonasera, then Clemenza went out. The two young men remained with the undertaker.

A few moments later Bonasera recognized the sound of a heavy ambulance coming through the narrow driveway. Then Clemenza appeared in the doorway followed by two men carrying a stretcher. And Amerigo Bonasera's worst fears were realized. On the stretcher was a corpse swaddled in a grey blanket but with bare yellow feet sticking out the end.

Clemenza motioned the stretcher-bearers into the embalming room. And then from the blackness of the yard another man stepped into the lighted office room. It was Don Corleone.

The Don had lost weight during his illness and moved with a curious stiffness. He was holding his hat in his hands and his hair seemed thin over his massive skull. He looked older, more shrunken than when Bonasera had seen him at the wedding, but he still radiated power. Holding his hat against his chest, he said to Bonasera, 'Well, old friend, are you ready to do me this service?'

Bonasera nodded. The Don followed the stretcher into the embalming room and Bonasera trailed after him. The corpse was on one of the guttered tables. Don Corleone made a tiny gesture with his hat and the other men left the room.

Bonasera whispered, 'What do you wish me to do?'

Don Corleone was staring at the table. 'I want you to use all our powers, all your skill, as you love me,' he said. 'I do not wish his mother to see him as he is.' He went to the table and drew down the grey blanket. Amerigo Bonasera against all his will, against all his years of training and experience, let out a gasp of horror. On the embalming table was the bullet-smashed face of Sonny Corleone. The left eye drowned in blood had a star fracture in its lens. The bridge of his nose and left cheekbone were hammered into pulp.

For one fraction of a second the Don put out his hand to support himself against Bonasera's body. 'See how they have massacred my son,' he said.

CHAPTER NINETEEN

PERHAPS IT was the stalemate that made Sonny Corleone embark on the bloody course of attrition that ended in his own death. Perhaps it was his dark violent nature given full rein. In any case, that spring and summer he mounted senseless raids on enemy auxiliaries. Tattaglia Family pimps were shot to death in Harlem, dock goons were massacred. Union officials who owed allegiance to the Five Families were warned to stay neutral, and when the Corleone bookmakers and shylocks were still barred from the docks, Sonny sent Clemenza and his *regime* to wreak havoc upon the long shore.

This slaughter was senseless because it could not affect the outcome of the war. Sonny was a brilliant tactician and won his brilliant victories. But what was needed was the strategical genius of Don Corleone. The whole thing degenerated into such a deadly guerrilla war that both sides found themselves losing a great deal of revenue and lives to no purpose. The Corleone Family was finally forced to close down some of its most profitable bookmaking stations, including the book given to son-in-law Carlo Rizzi for his living. Carlo took to drink and running with chorus girls and giving his wife Connie a hard

time. Since his beating at the hands of Sonny he had not dared to hit his wife again but he had not slept with her. Connie had thrown herself at his feet and he had spurned her, as he thought, like a Roman, with exquisite patrician pleasure. He had sneered at her, 'Go call your brother and tell him I won't screw you, maybe he'll beat me up until I get a hard on.'

But he was in deadly fear of Sonny though they treated each other with cold politeness. Carlo had the sense to realize that Sonny would kill him, that Sonny was a man who could, with the naturalness of an animal, kill another man, while he himself would have to call up all his courage, all his will, to commit murder. It never occurred to Carlo that because of this he was a better man than Sonny Corleone, if such terms could be used; he envied Sonny his awesome savagery, a savagery which was now becoming a legend.

Tom Hagen, as the *Consigliori*, disapproved of Sonny's tactics and yet decided not to protest to the Don simply because the tactics, to some extent, worked. The Five Families seemed to be cowed, finally, as the attrition went on, and their counterblows weakened and finally ceased altogether. Hagen at first distrusted this seeming pacification of the enemy but Sonny was jubilant. 'I'll pour it on,' he told Hagen, 'and then those bastards will come begging for a deal.'

Sonny was worried about other things. His wife was giving him a hard time because the rumours had got to her that Lucy Mancini had bewitched her husband. And though she joked publicly about her Sonny's equipment and technique, he had stayed away from her too long and she missed him in her bed, and she was making life miserable for him with her nagging.

In addition to this Sonny was under the enormous strain of being a marked man. He had to be extraordinarily careful in all his movements and he knew that his visits to Lucy Mancini had been charted by the enemy. But here he took elaborate precautions since this was the traditional vulnerable spot. He was safe there. Though Lucy had not the slightest suspicion, she was watched twenty-four hours a day by men of the Santino *regime* and when an apartment became vacant on her floor it was immediately rented by one of the most reliable men of that *regime*.

The Don was recovering and would soon be able to resume command. At that time the tide of battle must swing to the Corleone Family. This Sonny was sure of. Meanwhile he would guard his Family's empire, earn the respect of his father, and, since the position was not hereditary to an absolute degree, cement his claim as heir to the Corleone Empire.

But the enemy was making its plans. They too had analysed the situation and had come to the conclusion that the only way to stave off complete defeat was to kill Sonny Corleone. They understood the situation better now and felt it was possible to negotiate with the Don, known for his logical reasonableness. They had come to hate Sonny for his bloodthirstiness, which they considered barbaric. Also not good business sense. Nobody wanted the old days back again with all its turmoil and trouble.

One evening Connie Corleone received an anonymous phone call, a girl's voice, asking for Carlo. 'Who is this?' Connie asked.

The girl on the other end giggled and said, 'I'm a friend of Carlo's. I just wanted to tell him I can't see him tonight. I have to go out of town.'

'You lousy bitch,' Connie Corleone said. She screamed it again into the phone. 'You lousy tramp bitch.' There was a click on the other end.

Carlo had gone to the track for that afternoon and when he came home in the late evening he was sore at losing and half drunk from the bottle he always carried. As soon as he stepped into the door, Connie started screaming curses at him. He ignored her and went in to take a shower. When he came out he dried his naked body in front of her and started dolling up to go out.

Connie stood with hands on hips, her face pointy and white with rage. 'You're not going any place,' she said. 'Your girlfriend called and said she can't make it tonight. You lousy bastard, you have the nerve to give your whores my phone number. I'll kill you, you bastard.' She rushed at him, kicking and scratching.

He held her off with one muscular forearm. 'You're crazy,' he said coldly. But she could see he was worried, as if he knew

the crazy girl he was screwing would actually pull such a stunt. 'She was kidding around, some nut,' Carlo said.

Connie ducked around his arm and clawed at his face. She got a little bit of his cheek under her fingernails. With surprising patience he pushed her away. She noticed he was careful because of her pregnancy and that gave her the courage to feed her rage. She was also excited. Pretty soon she wouldn't be able to do anything, the doctor had said no sex for the last two months and she wanted it, before the last two months started. Yet her wish to inflict a physical injury on Carlo was very real too. She followed him into the bedroom.

She could see he was scared and that filled her with contemptuous delight. 'You're staying home,' she said, 'you're not going out.'

'OK, OK,' he said. He was still undressed, only wearing his shorts. He liked to go around the house like that, he was proud of his V-shaped body, the golden skin. Connie looked at him hungrily. He tried to laugh. 'You gonna give me something to eat at least?'

That mollified her, his calling on her duties, one of them at least. She was a good cook, she had learned that from her mother. She sautéed veal and peppers, preparing a mixed salad while the pan simmered. Meanwhile Carlo stretched out on his bed to read the next day's racing form. He had a water glass full of whisky beside him which he kept sipping at.

Connie came into the bedroom. She stood in the doorway as if she could not come close to the bed without being invited. 'The food is on the table,' she said.

'I'm not hungry yet,' he said, still reading the racing form.

'It's on the table,' Connie said stubbornly.

'Stick it up your ass,' Carlo said. He drank off the rest of the whisky in the water glass, tilted the bottle to fill it again. He paid no more attention to her.

Connie went into the kitchen, picked up the plates filled with food and smashed them against the sink. The loud crashes brought Carlo in from the bedroom. He looked at the greasy veal and peppers splattered all over the kitchen walls and his finicky neatness was outraged. 'You filthy guinea spoiled brat,'

he said venomously. 'Clean that up right now or I'll kick the shit out of you.'

'Like hell I will,' Connie said. She held her hands like claws ready to scratch his bare chest to ribbons.

Carlo went back into the bedroom and when he came out he was holding his belt doubled in his hand. 'Clean it up,' he said and there was no mistaking the menace in his voice. She stood there not moving and he swung the belt against her heavily padded hips, the leather stinging but not really hurting. Connie retreated to the kitchen cabinets and her hand went into one of the drawers to haul out the long bread knife. She held it ready.

Carlo laughed. 'Even the female Corleones are murderers,' he said. He put the belt down on the kitchen table and advanced towards her. She tried a sudden lunge but her pregnant heavy body made her slow and he eluded the thrust she aimed at his groin in such deadly earnest. He disarmed her easily and then he started to slap her face with a slow medium-heavy stroke so as not to break the skin. He hit her again and again as she retreated around the kitchen table trying to escape him and he pursued her into the bedroom. She tried to bite his hand and he grabbed her by the hair to lift her head up. He slapped her face until she began to weep like a little girl, with pain and humiliation. Then he threw her contemptuously on to the bed. He drank from the bottle of whisky still on the night table. He seemed very drunk now, his light blue eyes had a crazy glint in them and finally Connie was truly afraid.

Carlo straddled his legs apart and drank from the bottle. He reached down and grabbed a chunk of her pregnant heavy thigh in his hand. He squeezed very hard, hurting her and making her beg for mercy. 'You're fat as a pig,' he said with disgust and walked out of the bedroom.

Thoroughly frightened and cowed, she lay on the bed, not daring to see what her husband was doing in the other room. Finally she rose and went to the door to peer into the living room. Carlo had opened a fresh bottle of whisky and was sprawled on the sofa. In a little while he would drink himself into sodden sleep and she could sneak into the kitchen and call her family in Long Beach. She would tell her mother to send

someone out here to get her. She just hoped Sonny didn't answer the phone, she knew it would be best to talk to Tom Hagen or her mother.

It was nearly ten o'clock at night when the kitchen phone in Don Corleone's house rang. It was answered by one of the Don's bodyguards who dutifully turned the phone over to Connie's mother. But Mrs Corleone could hardly understand what her daughter was saying, the girl was hysterical yet trying to whisper so that her husband in the next room would not hear her. Also her face had become swollen because of the slaps, and her puffy lips thickened her speech. Mrs Corleone made a sign to the bodyguard that he should call Sonny, who was in the living room with Tom Hagen.

Sonny came into the kitchen and took the phone from his mother. 'Yeah, Connie,' he said.

Connie was so frightened both of her husband and of what her brother would do that her speech became worse. She babbled, 'Sonny, just send a car to bring me home, I'll tell you then, it's nothing, Sonny. Don't you come. Send Tom, please, Sonny. It's nothing. I just want to come home.'

By this time Hagen had come into the room. The Don was already under a sedated sleep in the bedroom above and Hagen wanted to keep an eye on Sonny in all crises. The two interior bodyguards were also in the kitchen. Everybody was watching Sonny as he listened on the phone.

There was no question that the violence in Sonny Corleone's nature rose from some deep mysterious physical well. As they watched they could actually see the blood rushing to his heavily corded neck, could see the eyes film with hatred, the separate features of his face tightening, growing pinched, then his face took on the greyish hue of a sick man fighting off some sort of death, except that the adrenaline pumping through his body made his hands tremble. But his voice was controlled, pitched low, as he told his sister, 'You wait there. You just wait there.' He hung up the phone.

He stood there for a moment quite stunned with his own rage, then he said, 'The fucking sonofabitch, the fucking son-ofabitch.' He ran out of the house.

Hagen knew the look on Sonny's face, all reasoning power

had left him. At this moment Sonny was capable of anything. Hagen also knew that the ride into the city would cool Sonny off, make him more rational. But that rationality might make him even more dangerous, though the rationality would enable him to protect himself against the consequences of his rage. Hagen heard the car motor roaring into life and he said to the two bodyguards, 'Go after him.'

Then he went to the phone and made some calls. He arranged for some men of Sonny's *regime* living in the city to go up to Carlo Rizzi's apartment and get Carlo out of there. Other men would stay with Connie until Sonny arrived. He was taking a chance, thwarting Sonny, but he knew the Don would back him up. He was afraid that Sonny might kill Carlo in front of witnesses. He did not expect trouble from the enemy. The Five Families had been quiet too long and obviously were looking for peace of some kind.

By the time Sonny roared out of the mall in his Buick, he had already regained, partly, his senses. He noted the two bodyguards getting into a car to follow him and approved. He expected no danger, the Five Families had quit counterattacking, were not really fighting any more. He had grabbed his jacket in the foyer and there was a gun in a secret dashboard compartment of the car, the car registered in the name of a member of his *regime*, so that he personally could not get into any legal trouble. But he did not anticipate needing any weapon. He did not even know what he was going to do with Carlo Rizzi.

Now that he had a chance to think, Sonny knew he could not kill the father of an unborn child, and that father his sister's husband. Not over a domestic spat. Except that it was not just a domestic spat. Carlo was a bad guy and Sonny felt responsible that his sister had met the bastard through him.

The paradox in Sonny's violent nature was that he could not hit a woman and had never done so. That he could not harm a child or anything helpless. When Carlo had refused to fight back against him that day, it had kept Sonny from killing him, complete submission disarmed his violence. As a boy, he had been truly tenderhearted. That he had become a murderer as a man was simply his destiny.

But he would settle this thing once and for all, Sonny

thought, as he headed the Buick towards the causeway that would take him over the water from Long Beach to the parkways on the other side of Jones Beach. He always used this route when he went to New York. There was less traffic.

He decided he would send Connie home with the bodyguards and then he would have a session with his brother-in-law. What would happen after that he didn't know. If the bastard had really hurt Connie, he'd make a cripple out of the bastard. But the wind coming over the causeway, the salty freshness of the air, cooled his anger. He put the window down all the way.

He had taken the Jones Beach Causeway, as always, because it was usually deserted this time of night, at this time of year, and he could speed recklessly until he hit the parkways on the other side. And even there traffic would be light. The release of driving very fast would help dissipate what he knew was a dangerous tension. He had already left his bodyguards' car far behind.

The causeway was badly lit, there was not a single car. Far ahead he saw the white cone of the manned tollbooth. There were other tollbooths beside it but they were staffed only during the day, for heavier traffic. Sonny started braking the Buick and at the same time searched his pockets for change. He had none. He reached for his wallet, flipped it open with one hand and fingered out a bill. He came within the arcade of light and he saw to his mild surprise a car in the tollbooth slot blocking it, the driver obviously asking some sort of directions from the toll taker. Sonny honked his horn and the other car obediently rolled through to let his car slide into the slot.

Sonny handed the toll taker the dollar bill and waited for his change. He was in a hurry now to close the window. The Atlantic Ocean air had chilled the whole car. But the toll taker was fumbling with his change; the dumb son of a bitch actually dropped it. Head and body disappeared as the toll man stooped down in his booth to pick up the money.

At that moment Sonny noticed that the other car had not kept going but had parked a few feet ahead, still blocking his way. At that same moment his lateral vision caught sight of

another man in the darkened tollbooth to his right. But he did not have time to think about that because two men came out of the car parked in front and walked towards him. The toll collector still had not appeared. And then in the fraction of a second before anything actually happened, Santino Corleone knew he was a dead man. And in that moment his mind was lucid, drained of all violence, as if the hidden fear finally real and present had purified him.

Even so, his huge body in a reflex for life, crashed through the Buick door, bursting its lock. The man in the darkened tollbooth opened fire and the shots caught Sonny Corleone in the head and neck as his massive frame spilled out of the car. The two men in front held up their guns now, the man in the darkened tollbooth cut his fire, and Sonny's body sprawled on the asphalt with the legs still partly inside. The two men each fired shots into Sonny's body, then kicked him in the face to disfigure his features even more, to show a mark made by a more personal human power.

Seconds afterwards, all four men, the three actual assassins and the bogus toll collector, were in their car and speeding towards the Meadowbrook Parkway on the other side of Jones Beach. Their pursuit was blocked by Sonny's car and body in the tollgate slot but when Sonny's bodyguards pulled up a few minutes later and saw his body lying there, they had no intention to pursue. They swung their car around in a huge arc and returned to Long Beach. At the first public phone off the causeway one of them hopped out and called Tom Hagen. He was very curt and very brisk. 'Sonny's dead, they got him at the Jones Beach toll.'

Hagen's voice was perfectly calm. 'OK,' he said. 'Go to Clemenza's house and tell him to come here right away. He'll tell you what to do.'

Hagen had taken the call in the kitchen, with Mama Corleone bustling around preparing a snack for the arrival of her daughter. He had kept his composure and the old woman had not noticed anything amiss. Not that she could not have, if she wanted to, but in her life with the Don she had learned it was far wiser *not* to perceive. That if it was necessary to know anything painful, it would be told to her soon enough. And if it

was a pain that could be spared her, she could do without. She was quite content not to share the pain of her men, after all did they share the pain of women? Impassively she boiled her coffee and set the table with food. In her experience pain and fear did not dull physical hunger; in her experience the taking of food dulled pain. She would have been outraged if a doctor had tried to sedate her with a drug, but coffee and a crust of bread were another matter; she came, of course, from a more primitive culture.

And so she let Tom Hagen escape to his corner conference room and once in that room, Hagen began to tremble so violently he had to sit down with his legs squeezed together, his head hunched into his contracted shoulders, hands clasped together between his knees as if he were praying to the devil.

He was, he knew now, no fit *Consigliori* for a Family at war. He had been fooled, faked out, by the Five Families and their seeming timidity. They had remained quiet, laying their terrible ambush. They had planned and waited, holding their bloody hands no matter what provocation they had been given. They had waited to land one terrible blow. And they had. Old Genco Abbandando would never have fallen for it, he would have smelled a rat, he would have smoked them out, tripled his precautions. And through all this Hagen felt his grief. Sonny had been his true brother, his saviour; his hero when they had been boys together. Sonny had never been mean or bullying with him, had always treated him with affection, had taken him in his arms when Sollozzo had turned him loose. Sonny's joy at that reunion had been real. That he had grown up to be a cruel and violent and bloody man was, for Hagen, not relevant.

He had walked out of the kitchen because he knew he could never tell Mama Corleone about her son's death. He had never thought of her as his mother as he thought of the Don as his father and Sonny as his brother. His affection for her was like his affection for Freddie and Michael and Connie. The affection for someone who has been kind but not loving. But he could not tell her. In a few short months she had lost all her sons; Freddie exiled to Nevada, Michael hiding for his life in Sicily, and now Santino dead. Which of the three had she loved most of all? She had never shown.

It was no more than a few minutes. Hagen got control of himself again and picked up the phone. He called Connie's number. It rang for a long time before Connie answered in a whisper.

Hagen spoke to her gently. 'Connie, this is Tom. Wake your husband up, I have to talk to him.'

Connie said in a low frightened voice, 'Tom, is Sonny coming here?'

'No,' Hagen said. 'Sonny's not coming there. Don't worry about that. Just wake Carlo up and tell him it's very important I speak to him.'

Connie's voice was weepy. 'Tom, he beat me up, I'm afraid he'll hurt me again if he knows I called home.'

Hagen said gently, 'He won't. He'll talk to me and I'll straighten him out. Everything will be OK. Tell him it's very important, very, very important he comes to the phone. OK?'

It was almost five minutes before Carlo's voice came over the phone, a voice half slurred by whisky and sleep. Hagen spoke sharply to make him alert.

'Listen, Carlo,' he said, 'I'm going to tell you something very shocking. Now prepare yourself because when I tell it to you I want you to answer me very casually as if it's less than it is. I told Connie it was important so you have to give her a story. Tell her the Family has decided to move you both to one of the houses in the mall and to give you a big job. That the Don has finally decided to give you a chance in the hope of making your home life better. You got that?'

There was a hopeful note in Carlo's voice as he answered, 'Yeah, OK.'

Hagen went on, 'In a few minutes a couple of my men are going to knock on your door to take you away with them. Tell them I want them to call me first. Just tell them that. Don't say anything else. I'll instruct them to leave you there with Connie. OK?'

'Yeah, yeah, I got it,' Carlo said. His voice was excited. The tension in Hagen's voice seemed to have finally alerted him that the news coming up was going to be really important.

Hagen gave it to him straight. 'They killed Sonny tonight. Don't say anything. Connie called him while you were asleep

and he was on his way over there, but I don't want her to know that, even if she guesses it, I don't want her to know it for sure. She'll start thinking it's all her fault. Now I want you to stay with her tonight and not tell her anything. I want you to make up with her. I want you to be the perfect loving husband. And I want you to stay that way until she has her baby at least. Tomorrow morning somebody, maybe you, maybe the Don, maybe her mother, will tell Connie that her brother got killed. And I want you by her side. Do me this favour and I'll take care of you in the times to come. You got that?'

Carlo's voice was a little shaky. 'Sure, Tom, sure. Listen, me and you always got along. I'm grateful. Understand?'

'Yeah,' Hagen said. 'Nobody will blame your fight with Connie for causing this, don't worry about that. I'll take care of that.' He paused and softly, encouragingly, 'Go ahead now, take care of Connie.' He broke the connexion.

He had learned never to make a threat, the Don had taught him that, but Carlo had got the message all right: he was a hair away from death.

Hagen made another call to Tessio, telling him to come to the mall in Long Beach immediately. He didn't say why and Tessio did not ask. Hagen sighed. Now would come the part he dreaded.

He would have to waken the Don from his drugged slumber. He would have to tell the man he most loved in the world that he had failed him, that he had failed to guard his domain and the life of his eldest son. He would have to tell the Don everything was lost unless the sick man himself could enter the battle. For Hagen did not delude himself. Only the great Don himself could snatch even a stalemate from this terrible defeat. Hagen didn't even bother checking with Don Corleone's doctors, it would be to no purpose. No matter what the doctors ordered, even if they told him that the Don could not rise from his sickbed on pain of death, he must tell his adopted father and then follow him. And of course there was no question about what the Don would do. The opinions of medical men were irrelevant now, everything was irrelevant now. The Don must be told and he must either take command or order Hagen to surrender the Corleone power to the Five Families.

And yet with all his heart, Hagen dreaded the next hour. He tried to prepare his own manner. He would have to be in all ways strict with his own guilt. To reproach himself would only add to the Don's burden. To point out his own shortcomings as a wartime *Consigliori*, would only make the Don reproach himself for his own bad judgement for picking such a man for such an important post.

He must, Hagen knew, tell the news, present his analysis of what must be done to rectify the situation and then keep silent. His reactions thereafter must be the reactions invited by his Don. If the Don wanted him to show guilt, he would show guilt; if the Don invited grief, he would lay bare his genuine sorrow.

Hagen lifted his head at the sound of motors, cars rolling up on to the mall. The *caporegimes* were arriving. He would brief them first and then he would go up and wake Don Corleone. He got up and went to the liquor cabinet by the desk and took out a glass and bottle. He stood there for a moment so unnerved he could not pour the liquid from bottle to glass. Behind him, he heard the door to the room close softly and, turning, he saw, fully dressed for the first time since he had been shot, Don Corleone.

The Don walked across the room to his huge leather armchair and sat down. He walked a little stiffly, his clothes hung a little loosely on his frame but to Hagen's eyes he looked the same as always. It was almost as if by his will alone the Don had discarded all external evidence of his still weakened frame. His face was sternly set with all its old force and strength. He sat straight in the armchair and he said to Hagen, 'Give me a drop of anisette.'

Hagen switched bottles and poured them both a portion of the fiery, liquorice-tasting alcohol. It was peasant, homemade stuff, much stronger than that sold in stores, the gift of an old friend who every year presented the Don with a small truck-load.

'My wife was weeping before she fell asleep,' Don Corleone said. 'Outside my window I saw my *caporegimes* coming to the house and it is midnight. So, *Consigliori* of mine, I think you should tell your Don what everyone knows.'

Hagen said quietly, 'I didn't tell Mama anything. I was about to come up and wake you and tell you the news myself. In another moment I would have come to waken you.'

Don Corleone said impassively, 'But you needed a drink first.'

'Yes,' Hagen said.

'You've had your drink,' the Don said. 'You can tell me now.' There was just the faintest hint of reproach for Hagen's weakness.

'They shot Sonny on the causeway,' Hagen said. 'He's dead.'

Don Corleone blinked. For just the fraction of a second the wall of his will disintegrated and the draining of his physical strength was plain on his face. Then he recovered.

He clasped his hands in front of him on top of the desk and looked directly into Hagen's eyes. 'Tell me everything that happened,' he said. He held up one of his hands. 'No, wait until Clemenza and Tessio arrive so you won't have to tell it all again.'

It was only a few moments later that the two *caporegimes* were escorted into the room by a bodyguard. They saw at once that the Don knew about his son's death because the Don stood up to receive them. They embraced him as old comrades were permitted to do. They all had a drink of anisette which Hagen poured them before he told them the story of that night.

Don Corleone asked only one question at the end. 'Is it certain my son is dead?'

Clemenza answered. 'Yes,' he said. 'The bodyguards were of Santino's *regime* but picked by me. I questioned them when they came to my house. They saw his body in the light of the tollhouse. He could not live with the wounds they saw. They place their lives in forfeit for what they say.'

Don Corleone accepted this final verdict without any sign of emotion except for a few moments of silence. Then he said, 'None of you are to concern yourselves with this affair. None of you are to commit any acts of vengeance, none of you are to make any inquiries to track down the murderers of my son without my express command. There will be no further acts of war against the Five Families without my express and personal wish. Our Family will cease all business operations and

cease to protect any of our business operations until after my son's funeral. Then we will meet here again and decide what must be done. Tonight we must do what we can for Santino, we must bury him as a Christian. I will have friends of mine arrange things with the police and all other proper authorities. Clemenza, you will remain with me at all times as my body-guard, you and the men of your *regime*. Tessio, you will guard all other members of my Family. Tom, I want you to call Amerigo Bonasera and tell him I will need his services at some time during this night. To wait for me at his establishment. It may be an hour, two hours, three hours. Do you all under-stand that?'

The three men nodded. Don Corleone said, 'Clemenza, get some men and cars and wait for me. I will be ready in a few minutes. Tom, you did well. In the morning I want Con-stanzia with her mother. Make arrangements for her and her husband to live in the mall. Have Sandra's friends, the women, go to her house to stay with her. My wife will go there also when I have spoken with her. My wife will tell her the mis-fortune and the women will arrange for the church to say their masses and pray for his soul.'

The Don got up from his leather armchair. The other men rose with him and Clemenza and Tessio embraced him again. Hagen held the door open for the Don, who paused to look at him for a moment. Then the Don put his hand on Hagen's cheek, embraced him quickly, and said, in Italian, 'You've been a good son. You comfort me.' Telling Hagen that he had acted properly in this terrible time. The Don went up to his bedroom to speak to his wife. It was then that Hagen made the call to Amerigo Bonasera for the undertaker to redeem the favour he owed to the Corleones.

Book V

CHAPTER TWENTY

THE DEATH of Santino Corleone sent shock waves through the underworld of the nation. And when it became known that Don Corleone had risen from his sick bed to take charge of the Family affairs, when spies at the funeral reported that the Don seemed to be fully recovered, the heads of the Five Families made frantic efforts to prepare a defence against the bloody retaliatory war that was sure to follow. Nobody made the mistake of assuming that Don Corleone could be held cheaply because of his past misfortunes. He was a man who had made only a few mistakes in his career and had learned from every one of them.

Only Hagen guessed the Don's real intentions and was not surprised when emissaries were sent to the Five Families to propose a peace. Not only to propose a peace but a meeting of all the Families in the city and with invitations to Families all over the United States to attend. Since the New York Families were the most powerful in the country, it was understood that their welfare affected the welfare of the country as a whole.

At first there were suspicions. Was Don Corleone preparing a trap? Was he trying to throw his enemies off their guard? Was he attempting to prepare a wholesale massacre to avenge his son? But Don Corleone soon made it clear that he was sincere. Not only did he involve all the Families in the country in this meeting, but made no move to put his own people on a war footing or to enlist allies. And then he took the final irrevocable step that established the authenticity of these intentions and assured the safety of the grand council to be assembled. He called on the services of the Bocchicchio Family.

The Bocchicchio Family was unique in that, once a particularly ferocious branch of the Mafia in Sicily, it had become

278

an instrument of peace in America. Once a group of men who earned their living by a savage determination, they now earned their living in what perhaps could be called a saintly fashion. The Bocchicchios' one asset was a closely knit structure of blood relationships, a family loyalty severe even for a society where family loyalty came before loyalty to a wife.

The Bocchicchio Family, extending out to third cousins, had once numbered nearly two hundred when they ruled the particular economy of a small section of southern Sicily. The income for the entire family then came from four or five flour mills, by no means owned communally, but assuring labour and bread and a minimal security for all Family members. This was enough, with intermarriages, for them to present a common front against their enemies.

No competing mill, no dam, that would create a water supply to their competitors or ruin their own selling of water, was allowed to be built in their corner of Sicily. A powerful landowning baron once tried to erect his own mill strictly for his personal use. The mill was burned down. He called on the *carabineri* and higher authorities, who arrested three of the Bocchicchio Family. Even before the trial the manor house of the baron was torched. The indictment and accusations were withdrawn. A few months later one of the highest functionaries in the Italian government arrived in Sicily and tried to solve the chronic water shortage of that island by proposing a huge dam. Engineers arrived from Rome to do surveys while watched by grim natives, members of the Bocchicchio clan. Police flooded the area, housed in a specially built barracks.

It looked like nothing could stop the dam from being built and supplies and equipment had actually been unloaded in Palermo. That was as far as they got. The Bocchicchios had contacted fellow Mafia chiefs and extracted agreements for their aid. The heavy equipment was sabotaged, the lighter equipment stolen. Mafia deputies in the Italian Parliament launched a bureaucratic counterattack against the planners. This went on for several years and in that time Mussolini came to power. The dictator decreed that the dam must be built. It was not. The dictator had known that the Mafia would be a threat to his regime, forming what amounted to a separate

authority from his own. He gave full powers to a high police official, who promptly solved the problem by throwing everybody into jail or deporting them to penal work islands. In a few short years he had broken the power of the Mafia, simply by arbitrarily arresting anyone even suspected of being a *mafioso*. And so also brought ruin to a great many innocent families.

The Bocchicchios had been rash enough to resort to force against this unlimited power. Half of the men were killed in armed combat, the other half deported to penal island colonies. There were only a handful left when arrangements were made for them to emigrate to America via the clandestine underground route of jumping ship through Canada. There were almost twenty immigrants and they settled in a small town not far from New York City, in the Hudson Valley, where by starting at the very bottom they worked their way up to owning a garbage hauling firm and their own trucks. They became prosperous because they had no competition. They had no competition because competitors found their trucks burned and sabotaged. One persistent fellow who undercut prices was found buried in the garbage he had picked up during the day, smothered to death.

But as the men married, to Sicilian girls, needless to say, children came, and the garbage business though providing a living, was not really enough to pay for the finer things America had to offer. And so, as a diversification, the Bocchicchio Family became negotiators and hostages in the peace efforts of warring Mafia families.

A strain of stupidity ran through the Bocchicchio clan, or perhaps they were just primitive. In any case they recognized their limitations and knew they could not compete with other Mafia families in the struggle to organize and control more sophisticated business structures like prostitution, gambling, dope, and public fraud. They were straight-from-the-shoulder people who could offer a gift to an ordinary patrolman but did not know how to approach a political bagman. They had only two assets. Their honour and their ferocity.

A Bocchicchio never lied, never committed an act of treachery. Such behaviour was too complicated. Also, a

Bocchicchio never forgot an injury and never left it unavenged no matter what the cost. And so by accident they stumbled into what would prove to be their most lucrative profession.

When warring families wanted to make peace and arrange a parley, the Bocchicchio clan was contacted. The head of the clan would handle the initial negotiations and arrange for the necessary hostages. For instance, when Michael had gone to meet Sollozzo, a Bocchicchio had been left with the Corleone Family as surety for Michael's safety, the service paid for by Sollozzo. If Michael were killed by Sollozzo, then the Bocchicchio male hostage held by the Corleone Family would be killed by the Corleones. In this case the Bocchicchios would take their vengeance on Sollozzo as the cause of their clansman's death. Since the Bocchicchios were so primitive, they never let anything, any kind of punishment, stand in their way of vengeance. They would give up their own lives and there was no protection against them if they were betrayed. A Bocchicchio hostage was gilt-edged insurance.

And so now when Don Corleone employed the Bocchicchios as negotiators and arranged for them to supply hostages for all the Families to come to the peace meeting, there could be no question as to his sincerity. There could be no question of treachery. The meeting would be as safe as a wedding.

Hostages given, the meeting took place in the director's conference room of a small commercial bank whose president was indebted to Don Corleone and indeed some of whose stock belonged to Don Corleone though it was in the president's name. The president always treasured that moment when he had offered to give Don Corleone a written document proving his ownership of the shares, to preclude any treachery. Don Corleone had been horrified. 'I would trust you with my whole fortune,' he told the president. 'I would trust you with my life and the welfare of my children. It is inconceivable to me that you would ever trick me or otherwise betray me. My whole world, all my faith in my judgement of human character would collapse. Of course I have my own written records so that if something should happen to me my heirs would know that you hold something in trust for them. But I know that

even if I were not here in this world to guard the interests of my children, you would be faithful to their needs.'

The president of the bank, though not Sicilian, was a man of tender sensibilities. He understood the Don perfectly. Now the Godfather's request was the president's command and so on a Saturday afternoon, the executive suite of the bank, the conference room with its deep leather chairs, its absolute privacy, was made available to the Families.

Security at the bank was taken over by a small army of hand-picked men wearing bank guard uniforms. At ten o'clock on a Saturday morning the conference room began to fill up. Besides the Five Families of New York, there were representatives from ten other Families across the country, with the exception of Chicago, that black sheep of their world. They had given up trying to civilize Chicago, and they saw no point in including those mad dogs in this important conference.

A bar had been set up and a small buffet. Each representative to the conference had been allowed one aide. Most of the Dons had brought their *Consiglioris* as aides so there were comparatively few young men in the room. Tom Hagen was one of those young men and the only one who was not Sicilian. He was an object of curiosity, a freak.

Hagen knew his manners. He did not speak, he did not smile. He waited on his boss, Don Corleone, with all the respect of a favourite earl waiting on his king; bringing him a cold drink, lighting his cigar, positioning his ashtray; with respect but no obsequiousness.

Hagen was the only one in that room who knew the identity of the portraits hanging on the dark panelled walls. They were mostly portraits of fabulous financial figures done in rich oils. One was of Secretary of the Treasury Hamilton. Hagen could not help thinking that Hamilton might have approved of this peace meeting being held in a banking institution. Nothing was more calming, more conducive to pure reason, than the atmosphere of money.

The arrival time had been staggered for between nine-thirty to ten AM. Don Corleone, in a sense the host since he had initiated the peace talks, had been the first to arrive; one of his many virtues was punctuality. The next to arrive was Carlo

Tramonti, who had made the southern part of the United States his territory. He was an impressively handsome middle-aged man, tall for a Sicilian, with a very deep sunburn, exquisitely tailored and barbered. He did not look Italian, he looked more like one of those pictures in the magazines of millionaire fishermen lolling on their yachts. The Tramonti Family earned its livelihood from gambling, and no one meeting their Don would ever guess with what ferocity he had won his empire.

Emigrating from Sicily as a small boy, he had settled in Florida and grown to manhood there, employed by the American syndicate of Southern small-town politicians who controlled gambling. These were very tough men backed up by very tough police officials and they never suspected that they could be overthrown by such a greenhorn immigrant. They were unprepared for his ferocity and could not match it simply because the rewards being fought over were not, to their minds, worth so much bloodshed. Tramonti won over the police with bigger shares of the gross; he exterminated those redneck hooligans who ran their operation with such a complete lack of imagination. It was Tramonti who opened ties with Cuba and the Batista regime and eventually poured money into the pleasure resorts of Havana gambling houses, whorehouses, to lure gamblers from the American mainland. Tramonti was now a millionaire many times over and owned one of the most luxurious hotels in Miami Beach.

When he came into the conference room followed by his aide, an equally sunburned *Consigliori*, Tramonti embraced Don Corleone, made a face of sympathy to show he sorrowed for the dead son.

Other Dons were arriving. They all knew each other, they had met over the years, either socially or when in the pursuit of their businesses. They had always showed each other professional courtesies and in their younger, leaner days had done each other little services. The second Don to arrive was Joseph Zaluchi from Detroit. The Zaluchi Family, under appropriate disguises and covers, owned one of the horse-racing tracks in the Detroit area. They also owned a good part of the gambling. Zaluchi was a moon-faced, amiable-looking

man who lived in a one-hundred-thousand-dollar house in the fashionable Grosse Point section of Detroit. One of his sons had married into an old, well-known American family. Zaluchi, like Don Corleone, was sophisticated. Detroit had the lowest incidence of physical violence of any of the cities controlled by the Families; there had been only two executions in the last three years in that city. He disapproved of traffic in drugs.

Zaluchi had brought his *Consigliori* with him and both men came to Don Corleone to embrace him. Zaluchi had a booming American voice with only the slightest trace of an accent. He was conservatively dressed, very businessman, and with a hearty goodwill to match. He said to Don Corleone, 'Only your voice could have brought me here.' Don Corleone bowed his head in thanks. He could count on Zaluchi for support.

The next two Dons to arrive were from the West Coast, motoring from there in the same car since they worked together closely in any case. They were Frank Falcone and Anthony Molinari and both were younger than any of the other men who would come to the meeting; in their early forties. They were dressed a little more informally than the others, there was a touch of Hollywood in their style and they were a little more friendly than necessary. Frank Falcone controlled the movie unions and the gambling at the studios plus a complex of pipeline prostitution that supplied girls to the whorehouses of the states in the Far West. It was not in the realm of possibility for any Don to become 'show biz' but Falcone had just a touch. His fellow Dons distrusted him accordingly.

Anthony Molinari controlled the waterfronts of San Francisco and was pre-eminent in the empire of sports gambling. He came of Italian fishermen stock and owned the best San Francisco sea food restaurant, in which he took such pride that the legend had it he lost money on the enterprise by giving too good value for the prices charged. He had the impassive face of the professional gambler and it was known that he also had something to do with dope smuggling over the Mexican border and from the ships plying the lanes of the oriental oceans. Their aides were young, powerfully built men, ob-

viously not counsellors but bodyguards, though they would not dare to carry arms to this meeting. It was general knowledge that these bodyguards knew karate, a fact that amused the other Dons but did not alarm them in the slightest, no more than if the California Dons had come wearing amulets blessed by the Pope. Though it must be noted that some of these men were religious and believed in God.

Next arrived the representative from the Family in Boston. This was the only Don who did not have the respect of his fellows. He was known as a man who did not do right by his 'people', who cheated them unmercifully. This could be forgiven, each man measures his own greed. What could not be forgiven was that he could not keep order in his empire. The Boston area had too many murders, too many petty wars for power, too many unsupported freelance activities; it flouted the law too brazenly. If the Chicago Mafia were savages, then the Boston people were *gavoones*, or uncouth louts; ruffians. The Boston Don's name was Domenick Panza. He was short, squat; as one Don put it, he looked like a thief.

The Cleveland syndicate, perhaps the most powerful of the strictly gambling operations in the United States, was represented by a sensitive-looking elderly man with gaunt features and snow-white hair. He was known, of course not to his face, as 'the Jew' because he had surrounded himself with Jewish assistants rather than Sicilians. It was even rumoured that he would have named a Jew as his *Consigliori* if he had dared. In any case, as Don Corleone's Family was known as the Irish Gang because of Hagen's membership, so Don Vincent Forlenza's Family was known as the Jewish Family with somewhat more accuracy. But he ran an extremely efficient organization and he was not known ever to have fainted at the sight of blood, despite his sensitive features. He ruled with an iron hand in a velvet political glove.

The representatives of the Five Families of New York were the last to arrive and Tom Hagen was struck by how much more imposing, impressive, these five men were than the out-of-towners, the hicks. For one thing, the five New York Dons were in the old Sicilian tradition, they were 'men with a belly' meaning, figuratively, power and courage; and literally,

physical flesh, as if the two went together, as indeed they seemed to have done in Sicily. The five New York Dons were stout, corpulent men with massive leonine heads, features on a large scale, fleshy imperial noses, thick mouths, heavy folded cheeks. They were not too well tailored or barbered; they had the look of no-nonsense busy men without vanity.

There was Anthony Stracci, who controlled the New Jersey area and the shipping on the West Side docks of Manhattan. He ran the gambling in Jersey and was very strong with the Democratic political machine. He had a fleet of freight hauling trucks that made him a fortune primarily because his trucks could travel with a heavy overload and not be stopped and fined by highway weight inspectors. These trucks helped ruin the highways and then his road-building firm, with lucrative state contracts, repaired the damage wrought. It was the kind of operation that would warm any man's heart, business of itself creating more business. Stracci, too, was old-fashioned and never dealt in prostitution, but because his business was on the waterfront it was impossible for him not to be involved in the drug-smuggling traffic. Of the five New York Families opposing the Corleones his was the least powerful but the most well disposed.

The Family that controlled upper New York State, that arranged smuggling of Italian immigrants from Canada, all up-state gambling, and exercised veto power on state licensing of racing tracks, was headed by Ottilio Cuneo. This was a completely disarming man with the face of a jolly round peasant baker, whose legitimate activity was one of the big milk companies. Cuneo was one of those men who loved children and carried a pocket full of sweets in the hopes of being able to pleasure one of his many grandchildren or the small offspring of his associates. He wore a round fedora with the brim turned down all the way round like a woman's sun hat, which broadened his already moon-shaped face into the mask of joviality. He was one of the few Dons who had never been arrested and whose true activities had never even been suspected. So much so that he had served on civic committees and had been voted as 'Businessman of the Year for the State of New York' by the Chamber of Commerce.

The closest ally to the Tattaglia Family was Don Emilio Barzini. He had some of the gambling in Brooklyn and some in Queens. He had some prostitution. He had strong-arm. He completely controlled Staten Island. He had some of the sports betting in the Bronx and Westchester. He was in narcotics. He had close ties to Cleveland and the West Coast and he was one of the few men shrewd enough to be interested in Las Vegas and Reno, the open cities of Nevada. He also had interests in Miami Beach and Cuba. After the Corleone Family, his was perhaps the strongest in New York and therefore in the country. His influence reached even to Sicily. His hand was in every unlawful pie. He was even rumoured to have a toehold in Wall Street. He had supported the Tattaglia Family with money and influence since the start of the war. It was his ambition to supplant Don Corleone as the most powerful and respected Mafia leader in the country and to take over part of the Corleone empire. He was a man much like Don Corleone, but more modern, more sophisticated, more business-like. He could never be called an old Moustache Pete and he had the confidence of the newer, younger, brasher leaders on their way up. He was a man of great personal force in a cold way, with none of Don Corleone's warmth and he was perhaps at this moment the most 'respected' man in the group.

The last to arrive was Don Phillip Tattaglia, the head of the Tattaglia Family that had directly challenged the Corleone power by supporting Sollozzo, and had so nearly succeeded. And yet curiously enough he was held in a slight contempt by the others. For one thing, it was known that he had allowed himself to be dominated by Sollozzo, had in fact been led by the nose by that fine Turkish hand. He was held responsible for all this commotion, this uproar that had so affected the conduct of everyday business by the New York Families. Also he was a sixty-year-old dandy and woman-chaser. And he had ample opportunity to indulge his weakness.

For the Tattaglia Family dealt in women. Its main business was prostitution. It also controlled most of the nightclubs in the United States and could place any talent anywhere in the country. Phillip Tattaglia was not above using strong-arm to get control of promising singers and comics and muscling in

on record firms. But prostitution was the main source of the Family income.

His personality was unpleasant to these men. He was a whiner, always complaining of the costs in his Family business. Laundry bills, all those towels, ate up the profits (but he owned the laundry firm that did the work). The girls were lazy and unstable, running off, committing suicide. The pimps were treacherous and dishonest and without a shred of loyalty. Good help was hard to find. Young lads of Sicilian blood turned up their noses at such work, considered it beneath their honour to traffic and abuse women; those rascals who would slit a throat with a song on their lips and the cross of an Easter palm in the lapel of their jackets. So Phillip Tattaglia would rant on to audiences unsympathetic and contemptuous. His biggest howl was reserved for authorities who had it in their power to issue and cancel liquor licences for his nightclubs and cabarets. He swore he had made more millionaires than Wall Street with the money he had paid those thieving guardians of official seals.

In a curious way his almost victorious war against the Corleone Family had not won him the respect it deserved. They knew his strength had come first from Sollozzo and then from the Barzini Family. Also the fact that with the advantage of surprise he had not won complete victory was evidence against him. If he had been more efficient, all this trouble could have been avoided. The death of Don Corleone would have meant the end of the war.

It was proper, since they had both lost sons in their war against each other, that Don Corleone and Phillip Tattaglia should acknowledge each other's presence only with a formal nod. Don Corleone was the object of attention, the other men studying him to see what mark of weakness had been left on him by his wounds and defeats. The puzzling factor was why Don Corleone had sued for peace after the death of his favourite son. It was an acknowledgement of defeat and would almost surely lead to a lessening of his power. But they would soon know.

There were greetings, there were drinks to be served and almost another half hour went by before Don Corleone took

his seat at the polished walnut table. Unobtrusively, Hagen sat in the chair slightly to the Don's left and behind him. This was the signal for the other Dons to make their way to the table. Their aides sat behind them, the *Consiglioris* up close so they could offer any advice when needed.

Don Corleone was the first to speak and he spoke as if nothing had happened. As if he had not been grievously wounded and his eldest son slain, his empire in a shambles, his personal family scattered, Freddie in the West and under the protection of the Molinari Family and Michael secreted in the wastelands of Sicily. He spoke naturally, in Sicilian dialect.

'I want to thank you all for coming,' he said. 'I consider it a service done to me personally and I am in the debt of each and every one of you. And so I will say at the beginning that I am here not to quarrel or convince, but only to reason and as a reasonable man do everything possible for us all to part friends here too. I give my word on that, and some of you who know me well know I do not give my word lightly. Ah, well, let's get down to business. We are all honourable men here, we don't have to give each other assurances as if we were lawyers.'

He paused. None of the others spoke. Some were smoking cigars, others sipping their drinks. All of these men were good listeners, patient men. They had one other thing in common. They were those rarities, men who had refused to accept the rule of organized society, men who refused the dominion of other men. There was no force, no mortal man who could bend them to their will unless they wished it. They were men who guarded their free will with wiles and murder. Their wills could be subverted only by death. Or the utmost reasonableness.

Don Corleone sighed. 'How did things ever go so far?' he asked rhetorically. 'Well, no matter. A lot of foolishness has come to pass. It was so unfortunate, so unnecessary. But let me tell what happened, as I see it.'

He paused to see if someone would object to his telling his side of the story.

'Thank God my health has been restored and maybe I can help set this affair aright. Perhaps my son was too rash, too

headstrong, I don't say no to that. Anyway let me just say that Sollozzo came to me with a business affair in which he asked me for my money and my influence. He said he had the interest of the Tattaglia Family. The affair involved drugs, in which I have no interest. I'm a quiet man and such endeavours are too lively for my taste. I explained this to Sollozzo, with all respect for him and the Tattaglia Family. I gave him my "no" with all courtesy. I told him his business would not interfere with mine, that I had no objection to his earning his living in this fashion. He took it ill and brought misfortune down on all our heads. Well, that's life. Everyone here could tell his own tale of sorrow. That's not to my purpose.'

Don Corleone paused and motioned to Hagen for a cold drink, which Hagen swiftly furnished him. Don Corleone wet his mouth. 'I'm willing to make the peace,' he said. 'Tattaglia has lost a son, I have lost a son. We are quits. What would the world come to if people kept carrying grudges against all reason? That has been the cross of Sicily, where men are so busy with vendettas they have no time to earn bread for their families. It's foolishness. So I say now, let things be as they were before. I have not taken any steps to learn who betrayed and killed my son. Given peace, I will not do so. I have a son who cannot come home and I must receive assurances that when I arrange matters so that he can return safely that there will be no interference, no danger from the authorities. Once that's settled maybe we can talk about other matters that interest us and do ourselves, all of us, a profitable service today.' Corleone gestured expressively, submissively, with his hands. 'That is all I want.'

It was very well done. It was the Don Corleone of old. Reasonable. Pliant. Soft-spoken. But every man there had noted that he had claimed good health, which meant he was a man not to be held cheaply despite the misfortunes of the Corleone Family. It was noted that he had said the discussion of other business was useless until the peace he asked for was given. It was noted that he had asked for the old status quo, that he would lose nothing despite his having got the worst of it over the past year.

However, it was Emilio Barzini who answered Don Cor-

leone, not Tattaglia. He was curt and to the point without being rude or insulting.

'That is all true enough,' Barzini said. 'But there's a little more. Don Corleone is too modest. The fact is that Sollozzo and the Tattaglias could not go into their new business without the assistance of Don Corleone. In fact, his disapproval injured them. That's not his fault of course. The fact remains that judges and politicians who would accept favours from Don Corleone, even on drugs, would not allow themselves to be influenced by anybody else when it came to narcotics. Sollozzo couldn't operate if he didn't have some insurance of his people being treated gently. We all know that. We would all be poor men otherwise. And now that they have increased the penalties the judges and the prosecuting attorneys drive a hard bargain when one of our people gets in trouble with narcotics. Even a Sicilian sentenced to twenty years might break the *omerta* and talk his brains out. That can't happen. Don Corleone controls all that apparatus. His refusal to let us use it is not the act of a friend. He takes the bread out of the mouths of our families. Times have changed, it's not like the old days where everyone can go his own way. If Corleone has all the judges in New York, then he must share them or let us others use them. Certainly he can present a bill for such services, we're not communists, after all. But he has to let us draw water from the well. It's that simple.'

When Barzini had finished talking there was a silence. The lines were now drawn, there could be no return to the old status quo. What was more important was that Barzini by speaking out was saying that if peace was not made he would openly join the Tattaglia in their war against the Corleone. And he had scored a telling point. Their lives and their fortunes depended upon their doing each other services, the denial of a favour asked by a friend was an act of aggression. Favours were not asked lightly and so could not be lightly refused.

Don Corleone finally spoke to answer. 'My friends,' he said, 'I didn't refuse out of spite. You all know me. When have I ever refused an accommodation? That's simply not in my nature. But I had to refuse this time. Why? Because I think

this drug business will destroy us in the years to come. There is too much strong feeling about such traffic in this country. It's not like whisky or gambling or even women which most people want and is forbidden them by the *pezzonovante* of the church and the government. But drugs are dangerous for everyone connected with them. It could jeopardize all other business. And let me say I'm flattered by the belief that I am so powerful with the judges and law officials, I wish it were true. I do have some influence but many of the people who respect my counsel might lose this respect if drugs become involved in our relationship. They are afraid to be involved in such business and they have strong feelings about it. Even police-men who help us in gambling and other things would refuse to help in drugs. So to ask me to perform a service in these matters is to ask me to do a disservice to myself. But I'm will-ing to do even that if all of you think it proper in order to adjust other matters.'

When Don Corleone had finished speaking the room be-came much more relaxed with more whisperings and cross talk. He had conceded the important point. He would offer his protection to any organized business venture in drugs. He was, in effect, agreeing almost entirely to Sollozzo's original proposal if that proposal was endorsed by the national group gathered here. It was understood that he would never parti-cipate in the operational phase, nor would he invest his money. He would merely use his protective influence with the legal apparatus. But this was a formidable concession.

The Don of Los Angeles, Frank Falcone, spoke to answer. 'There's no way of stopping our people from going into that business. They go in on their own and get in trouble. There's too much money in it to resist. So it's more dangerous if we don't go in. At least if we control it we can cover it better, organize it better, make sure it causes less trouble. Being in it is not so bad, there has to be control, there has to be protec-tion, there has to be organization, we can't have everybody running around doing just what they please like a bunch of anarchists.'

The Don of Detroit, more friendly to Corleone than any of the others, also now spoke against his friend's position, in the

interest of reasonableness. 'I don't believe in drugs,' he said. 'For years I paid my people extra so they wouldn't do that kind of business. But it didn't matter, it didn't help. Somebody comes to them and says, "I have powders, if you put up the three-, four-thousand-dollar investment we can make fifty thousand distributing." Who can resist such a profit? And they are so busy with their little side business they neglect the work I pay them to do. There's more money in drugs. It's getting bigger all the time. There's no way to stop it so we have to control the business and keep it respectable. I don't want any of it near schools, I don't want any of it sold to children. That is an *infamita*. In my city I would try to keep the traffic in the dark people, the coloured. They are the best customers, the least troublesome and they are animals anyway. They have no respect for their wives or their families or for themselves. Let them lose their souls with drugs. But something has to be done, we just can't let people do as they please and make trouble for everyone.'

This speech of the Detroit Don was received with loud murmurs of approval. He had hit the nail on the head. You couldn't even pay people to stay out of the drug traffic. As for his remarks about children, that was his well-known sensibility, his tenderheartedness speaking. After all, who would sell drugs to children? Where would children get the money? As for his remarks about the coloureds, that was not even heard. The Negroes were considered of absolutely no account, of no force whatsoever. That they had allowed society to grind them into the dust proved them of no account and his mentioning them in any way proved that the Don of Detroit had a mind that always wavered towards irrelevancies.

All the Dons spoke. All of them deplored the traffic in drugs as a bad thing that would cause trouble but agreed there was no way to control it. There was, simply, too much money to be made in the business, therefore it followed that there would be men who would dare anything to dabble in it. That was human nature.

It was finally agreed. Drug traffic would be permitted and Don Corleone must give it some legal protection in the East. It was understood that the Barzini and Tattaglia Families

would do most of the large-scale operations. With this out of the way the conference was able to move on to other matters of a wider interest. There were many complex problems to be solved. It was agreed that Las Vegas and Miami were to be open cities where any of the Families could operate. They all recognized that these were the cities of the future. It was also agreed that no violence would be permitted in these cities and that petty criminals of all types were to be discouraged. It was agreed that in momentous affairs, in executions that were necessary but might cause too much of a public outcry, the execution must be approved by this council. It was agreed that button men and other soldiers were to be restrained from violent crimes and acts of vengeance against each other on personal matters. It was agreed that Families would do each other services when requested, such as providing executioners, technical assistance in pursuing certain courses of action such as bribing jurors, which in some instances could be vital. These discussions, informal, colloquial, and on a high level, took time and were broken by lunch and drinks from the buffet bar.

Finally Don Barzini sought to bring the meeting to an end. 'That's the whole matter then,' he said. 'We have the peace and let me pay my respects to Don Corleone, whom we all have known over the years as a man of his word. If there are any more differences we can meet again, we need not become foolish again. On my part the road is new and fresh. I'm glad this is all settled.'

Only Phillip Tattaglia was a little worried still. The murder of Santino Corleone made him the most vulnerable person in this group if war broke out again. He spoke at length for the first time.

'I've agreed to everything here, I'm willing to forget my own misfortune. But I would like to hear some strict assurances from Corleone. Will he attempt any individual vengeance? When time goes by and his position perhaps becomes stronger, will he forget that we have sworn our friendship? How am I to know that in three or four years he won't feel that he's been ill served, forced against his will to this agreement and so free to break it? Will we have to guard against each other all the time? Or can we truly go in peace with peace

of mind? Would Corleone give us all his assurances as I now give mine?'

It was then that Don Corleone gave the speech that would be long remembered, and that reaffirmed his position as the most far-seeing statesman among them, so full of common sense, so direct from the heart; and to the heart of the matter. In it he coined a phrase that was to become as famous in its way as Churchill's Iron Curtain, though not public knowledge until more than ten years later.

For the first time he stood up to address the council. He was short and a little thin from his 'illness', perhaps his sixty years showed a bit more but there was no question that he had regained all his former strength, and had all his wits.

'What manner of men are we then, if we do not have our reason,' he said. 'We are all no better than beasts in a jungle if that were the case. But we have reason, we can reason with each other and we can reason with ourselves. To what purpose would I start all these troubles again, the violence and the turmoil? My son is dead and that is a misfortune and I must bear it, not make the innocent world around me suffer with me. And so I say, I give my honour, that I will never seek vengeance, I will never seek knowledge of the deeds that have been done in the past. I will leave here with a pure heart.

'Let me say that we must always look to our interests. We are all men who have refused to be fools, who have refused to be puppets dancing on a string pulled by the men on high. We have been fortunate here in this country. Already most of our children have found a better life. Some of you have sons who are professors, scientists, musicians, and you are fortunate. Perhaps your grandchildren will become the new *pezzonovanti*. None of us here want to see our children follow in our footsteps, it's too hard a life. They can be as others, their position and security won by our courage. I have grandchildren now and I hope their children may someday, who knows, be a governor, a President, nothing's impossible here in America. But we have to progress with the times. The time is past for guns and killings and massacres. We have to be cunning like the business people, there's more money in it and it's better for our children and our grandchildren.

'As for our own deeds, we are not responsible for the .90 calibres, the *pezzonovanti* who take it upon themselves to decide what we shall do with our lives, who declare wars they wish us to fight in to protect what they own. Who is to say we should obey the laws they make for their own interest and to our hurt? And who are they then to meddle when we look after our own interests? *Sonna cosa nostra*,' Don Corleone said, 'these are our own affairs. We will manage our world for ourselves because it is our world, *cosa nostra*. And so we have to stick together to guard against outside meddlers. Otherwise they will put the ring in our nose as they have put the ring in the nose of all the millions of Neapolitans and other Italians in the country.

'For this reason I forgo my vengeance for my dead son, for the common good. I swear now that as long as I am responsible for the actions of my Family there will not be one finger lifted against any man here without just cause and utmost provocation. I am willing to sacrifice my commercial interests for the common good. This is my word, this is my honour, there are those of you here who know I have never betrayed either.

'But I have a selfish interest. My youngest son had to flee, accused of Sollozzo's murder and that of a police captain. I must now make arrangements so that he can come home with safety, cleared of all those false charges. That is my affair and I will make those arrangements. I must find the real culprits perhaps, or perhaps I must convince the authorities of his innocence, perhaps the witnesses and informants will recant their lies. But again I say that this is my affair and I believe I will be able to bring my son home.

'But let me say this. I am a superstitious man, a ridiculous failing but I must confess it here. And so if some unlucky accident should befall my youngest son, if some police officer should accidentally shoot him, if he should hang himself in his cell, if new witnesses appear to testify to his guilt, my superstition will make me feel that it was the result of the ill will still borne me by some people here. Let me go further. If my son is struck by a bolt of lightning I will blame some of the people here. If his plane should fall into the sea or his ship sink be-

neath the waves of the ocean, if he should catch a mortal fever, if his automobile should be struck by a train, such is my superstition that I would blame the ill will felt by people here. Gentlemen, that ill will, that bad luck, I could never forgive. But aside from that let me swear by the souls of my grandchildren that I will never break the peace we have made. After all, are we or are we not better men than those *pezzonovanti* who have killed countless millions of men in our lifetimes?'

With this Don Corleone stepped from his place and went down the table to where Don Phillip Tattaglia was sitting. Tattaglia rose to greet him and the two men embraced, kissing each other's cheeks. The other Dons in the room applauded and rose to shake hands with everybody in sight and to congratulate Don Corleone and Don Tattaglia on their new friendship. It was not perhaps the warmest friendship in the world, they would not send each other Christmas gift greetings, but they would not murder each other. That was friendship enough in this world, all that was needed.

Since his son Freddie was under the protection of the Molinari Family in the West, Don Corleone lingered with the San Francisco Don after the meeting to thank him. Molinari said enough for Don Corleone to gather that Freddie had found his niche out there, was happy and had become something of a ladies' man. He had a genius for running a hotel, it seemed. Don Corleone shook his head in wonder, as many fathers do when told of undreamed-of talents in their children. Wasn't it true that sometimes the greatest misfortunes brought unforeseen rewards? They both agreed that this was so. Meanwhile Corleone made it clear to the San Francisco Don that he was in his debt for the great service done in protecting Freddie. He let it be known that his influence would be exerted so that the important racing wires would always be available to his people no matter what changes occurred in the power structure in the years to come, an important guarantee since the struggle over this facility was a constant open wound complicated by the fact that the Chicago people had their heavy hand in it. But Don Corleone was not without influence even in that land of barbarians and so his promise was a gift of gold.

It was evening before Don Corleone, Tom Hagen, and the

bodyguard-chauffeur, who happened to be Rocco Lampone, arrived at the mall in Long Beach. When they went into the house the Don said to Hagen, 'Our driver, that man Lampone, keep an eye on him. He's a fellow worth something better I think.' Hagen wondered at this remark. Lampone had not said a word all day, had not even glanced at the two men in the back seat. He had opened the door for the Don, the car had been in front of the bank when they emerged, he had done everything correctly but no more than any well-trained chauffeur might do. Evidently the Don's eye had seen something he had not seen.

The Don dismissed Hagen and told him to come back to the house after supper. But to take his time and rest a little since they would put in a long night of discussion. He also told Hagen to have Clemenza and Tessio present. They should come at 10 PM, not before. Hagen was to brief Clemenza and Tessio on what had happened at the meeting that afternoon.

At ten the Don was waiting for the three men in his office, the corner room of the house with its law library and special phone. There was a tray with whisky bottles, ice, and soda water. The Don gave his instructions.

'We made the peace this afternoon,' he said. 'I gave my word and my honour and that should be enough for all of you. But our friends are not so trustworthy so let's all be on our guard still. We don't want any more nasty little surprises.' The Don turned to Hagen, 'You've let the Bocchicchio hostages go?'

Hagen nodded. 'I called Clemenza as soon as I got home.'

Corleone turned to the massive Clemenza. The *caporegime* nodded. 'I released them. Tell me, Godfather, is it possible for a Sicilian to be as dumb as the Bocchicchios pretend to be?'

Don Corleone smiled a little. 'They are clever enough to make a good living. Why is it so necessary to be more clever than that? It's not the Bocchicchios who cause the troubles of this world. But it's true, they haven't got the Sicilian head.'

They were all in a relaxed mood, now that the war was over. Don Corleone himself mixed drinks and brought one to each man. The Don sipped his carefully and lit up a cigar.

'I want nothing set forth to discover what happened to

Sonny, that's done with and to be forgotten. I want all co-operation with the other Families even if they become a little greedy and we don't get our proper share in things. I want nothing to break this peace no matter what the provocation until we've found a way to bring Michael home. And I want that to be first thing on your minds. Remember this, when he comes back he must come back in absolute safety. I don't mean from the Tattaglias or the Barzinis. What I'm concerned about are the police. Sure, we can get rid of the real evidence against him; that waiter won't testify, nor that spectator or gunman or whatever he was. The real evidence is the least of our worries since we know about it. What we have to worry about is the police framing false evidence because their informers have assured them that Michael Corleone is the man who killed their captain. Very well. We have to demand that the Five Families do everything in their power to correct this belief of the police. All their informers who work with the police must come up with new stories. I think after my speech this afternoon they will understand it is to their interest to do so. But that's not enough. We have to come up with something special so Michael won't ever have to worry about that again. Otherwise there's no point in him coming back to this country. So let's all think about that. That's the most important matter.

'Now, any man should be allowed one foolishness in his life. I have had mine. I want all the land around the mall bought, the houses bought. I don't want any man able to look out his window into my garden even if it's a mile away. I want a fence around the mall and I want the mall to be on full protection all the time. I want a gate in that fence. In short, I wish now to live in a fortress. Let me say to you now that I will never go into the city to work again. I will be semi-retired. I feel an urge to work in the garden, to make a little wine when the grapes are in season. I want to live in my house. The only time I'll leave is to go on a little vacation or to see someone on important business and then I want all precautions taken. Now don't take this amiss. I'm not preparing anything. I'm being prudent, I've always been a prudent man, there is nothing I find so little to my taste as carelessness in life. Women and children can afford to be careless, men cannot. Be leisurely in

all these things, no frantic preparations to alarm our friends. It can be done in such a way as to seem natural.

'Now I'm going to leave things more and more up to each of you three. I want the Santino *regime* disbanded and the men placed in your *regimes*. That should reassure our friends and show that I mean peace. Tom, I want you to put together a group of men who will go to Las Vegas and give me a full report on what is going on out there. Tell me about Fredo, what is really happening out there. I hear I wouldn't recognize my own son. It seems he's a cook now, that he amuses himself with young girls more than a grown man should. Well, he was always too serious when he was young and he was never the man for Family business. But let's find out what really can be done out there.'

Hagen said quietly, 'Should we send your son-in-law? After all, Carlo is a native of Nevada, he knows his way around.'

Don Corleone shook his head. 'No, my wife is lonely here without any of her children. I want Constanzia and her husband moved into one of the houses on the mall. I want Carlo given a responsible job, maybe I've been too harsh on him, and' – Don Corleone made a grimace – 'I'm short of sons. Take him out of the gambling and put him in with the unions where he can do some paper work and a lot of talking. He's a good talker.' There was the tiniest note of contempt in the Don's voice.

Hagen nodded. 'OK, Clemenza and I will go over all the people and put together a group to do the Vegas job. Do you want me to call Freddie home for a few days?'

The Don shook his head. He said cruelly, 'What for? My wife can still cook our meals. Let him stay out there.' The three men shifted uneasily in their seats. They had not realized Freddie was in such severe disfavour with his father and they suspected it must be because of something they did not know.

Don Corleone sighed. 'I hope to grow some good green peppers and tomatoes in the garden this year, more than we can eat. I'll make you presents of them. I want a little peace, a little quiet and tranquillity for my old age. Well, that's all. Have another drink if you like.'

It was a dismissal. The men rose. Hagen accompanied

Clemenza and Tessio to their cars and arranged meetings with them to thrash out the operational details that would accomplish the stated desires of their Don. Then he went back into the house where he knew Don Corleone would be waiting for him.

The Don had taken off his jacket and tie and was lying down on the couch. His stern face was relaxed into lines of fatigue. He waved Hagen into a chair and said, 'Well, *Consigliori*, do you disapprove of any of my deeds today?'

Hagen took his time answering. 'No,' he said. 'But I don't find it consistent, nor true to your nature. You say you don't want to find out how Santino was killed or want vengeance for it. I don't believe that. You gave your word for peace and so you'll keep the peace but I can't believe you will give your enemies the victory they seem to have won today. You've constructed a magnificent riddle that I can't solve, so how can I approve or disapprove?'

A look of content came over the Don's face. 'Well, you know me better than anyone else. Even though you're not a Sicilian, I made you one. Everything you say is true, but there's a solution and you'll comprehend it before it spins out to the end. You agree everyone has to take my word and I'll keep my word. And I want my orders obeyed exactly. But, Tom, the most important thing is we have to get Michael home as soon as possible. Make that first in your mind and in your work. Explore all the legal alleys, I don't care how much money you have to spend. It has to be foolproof when he comes home. Consult the best lawyers on criminal law. I'll give you the names of some judges who will give you a private audience. Until that time we have to guard against all treacheries.'

Hagen said, 'Like you, I'm not worried so much about the real evidence as the evidence they will manufacture. Also some police friend may kill Michael after he's arrested. They may kill him in his cell or have one of the prisoners do it. As I see it, we can't even afford to have him arrested or accused.'

Don Corleone sighed. 'I know, I know. That's the difficulty. But we can't take too long. There are troubles in Sicily. The young fellows over there don't listen to their elders any more and a lot of the men deported from America are just too much

for the old-fashioned Dons to handle. Michael could get caught in between. I've taken some precautions against that and he's still got a good cover but that cover won't last for ever. That's one of the reasons I had to make the peace. Barzini has friends in Sicily and they were beginning to sniff Michael's trail. That gives you one of the answers to your riddle. I had to make the peace to insure my son's safety. There was nothing else to do.'

Hagen didn't bother asking the Don how he had got this information. He was not even surprised, and it was true that this solved part of the riddle. 'When I meet with Tattaglia's people to firm up the details, should I insist that all his drug middlemen be clean? The judges will be a little skittish about giving light sentences to a man with a record.'

Don Corleone shrugged. 'They should be smart enough to figure that out themselves. Mention it, don't insist. We'll do our best but if they use a real snowbird and he gets caught, we won't lift a finger. We'll just tell them nothing can be done. But Barzini is a man who will know that without being told. You notice how he never committed himself in this affair. One might never have known he was in any way concerned. That is a man who doesn't get caught on the losing side.'

Hagen was startled. 'You mean he was behind Sollozzo and Tattaglia all the time?'

Don Corleone sighed. 'Tattaglia is a pimp. He could never have outfought Santino. That's why I don't have to know about what happened. It's enough to know that Barzini had a hand in it.'

Hagen let this sink in. The Don was giving him clues but there was something very important left out. Hagen knew what it was but he knew it was not his place to ask. He said good-night and turned to go. The Don had a last word for him.

'Remember, use all your wits for a plan to bring Michael home,' the Don said. 'And one other thing. Arrange with the telephone man so that every month I get a list of all the telephone calls, made and received, by Clemenza and Tessio. I suspect them of nothing. I would swear they would never betray me. But there's no harm in knowing any little thing that may help us before the event.'

Hagen nodded and went out. He wondered if the Don was keeping a check on him also in some way and then was ashamed of his suspicion. But now he was sure that in the subtle and complex mind of the Godfather a far-ranging plan of action was being initiated that made the day's happenings no more than a tactical retreat. And there was that one dark fact that no one mentioned, that he himself had not dared to ask, that Don Corleone ignored. All pointed to a day of reckoning in the future.

CHAPTER TWENTY-ONE

BUT IT was to be nearly another year before Don Corleone could arrange for his son Michael to be smuggled back into the United States. During that time the whole Family racked their brains for suitable schemes. Even Carlo Rizzi was listened to now that he was living in the mall with Connie. (During that time they had a second child, a boy.) But none of the schemes met with the Don's approval.

Finally it was the Bocchicchio Family who through a misfortune of its own solved the problem. There was one Bocchicchio, a young cousin of no more than twenty-five years of age, named Felix, who was born in America and with more brains than anyone in the clan had ever had before. He had refused to be drawn into the Family garbage hauling business and married a nice American girl of English stock to further his split from the clan. He went to school at night, to become a lawyer, and worked during the day as a civil service post office clerk. During that time he had three children but his wife was a prudent manager and they lived on his salary until he got his law degree.

Now Felix Bocchicchio, like many young men, thought that having struggled to complete his education and master the tools of his profession, his virtue would automatically be rewarded and he would earn a decent living. This proved not to be the case. Still proud, he refused all help from his clan. But

a lawyer friend of his, a young man well connected and with a budding career in a big law firm, talked Felix into doing him a little favour. It was very complicated, seemingly legal, and had to do with a bankruptcy fraud. It was a million-to-one shot against its being found out. Felix Bocchicchio took the chance. Since the fraud involved using the legal skills he had learned in a university, it seemed not so reprehensible, and, in an odd way, not even criminal.

To make a foolish story short, the fraud was discovered. The lawyer friend refused to help Felix in any manner, refused to even answer his telephone calls. The two principals in the fraud, shrewd middle-aged businessmen who furiously blamed Felix Bocchicchio's legal clumsiness for the plan going awry, pleaded guilty and cooperated with the state, naming Felix Bocchicchio as the ringleader of the fraud and claiming he had used threats of violence to control their business and force them to cooperate with him in his fraudulent schemes. Testimony was given that linked Felix with uncles and cousins in the Bocchicchio clan who had criminal records for strong-arm, and this evidence was damning. The two businessmen got off with suspended sentences. Felix Bocchicchio was given a sentence of one to five years and served three of them. The clan did not ask help from any of the Families or Don Corleone because Felix had refused to ask their help and had to be taught a lesson: that mercy comes only from the Family, that the Family is more loyal and more to be trusted than society.

In any case, Felix Bocchicchio was released from prison after serving three years, went home and kissed his wife and three children and lived peacefully for a year, and then showed that he was of the Bocchicchio clan after all. Without any attempt to conceal his guilt, he procured a weapon, a pistol, and shot his lawyer friend to death. He then searched out the two businessmen and calmly shot them both through the head as they came out of a luncheonette. He left the bodies lying in the street and went into the luncheonette and ordered a cup of coffee which he drank while he waited for the police to come and arrest him.

His trial was swift and his judgement merciless. A member of the criminal underworld had cold-bloodedly murdered state

witnesses who had sent him to the prison he richly deserved. It was a flagrant flouting of society and for once the public, the press, the structure of society and even soft-headed and soft-hearted humanitarians were united in their desire to see Felix Bocchicchio in the electric chair. The governor of the state would no more grant him clemency than the officials of the pound spare a mad dog, which was the phrase of one of the governor's closest political aides. The Bocchicchio clan of course would spend whatever money was needed for appeals to higher courts, they were proud of him now, but the conclusion was certain. After the legal folderol, which might take a little time, Felix Bocchicchio would die in the electric chair.

It was Hagen who brought this case to the attention of the Don at the request of one of the Bocchicchios who hoped that something could be done for the young man. Don Corleone curtly refused. He was not a magician. People asked him the impossible. But the next day the Don called Hagen into his office and had him go over the case in the most intimate detail. When Hagen was finished, Don Corleone told him to summon the head of the Bocchicchio clan to the mall for a meeting.

What happened next had the simplicity of genius. Don Corleone guaranteed to the head of the Bocchicchio clan that the wife and children of Felix Bocchicchio would be rewarded with a handsome pension. The money for this would be handed over to the Bocchicchio clan immediately. In turn, Felix must confess to the murder of Sollozzo and the police captain McCluskey.

There were many details to be arranged. Felix Bocchicchio would have to confess convincingly, that is, he would have to know some of the true details to confess to. Also, he must implicate the police captain in narcotics. Then the waiter at the Luna Restaurant must be persuaded to identify Felix Bocchicchio as the murderer. This would take some courage, as the description would change radically, Felix Bocchicchio being much shorter and heavier. But Don Corleone would attend to that. Also since the condemned man had been a great believer in higher education and a college graduate, he would want his children to go to college. And so a sum of money would have to be paid by Don Corleone that would

take care of the children's college. Then the Bocchicchio clan had to be reassured that there was no hope for clemency on the original murders. The new confession of course would seal the man's already almost certain doom.

Everything was arranged, the money paid and suitable contact made with the condemned man so that he could be instructed and advised. Finally the plan was sprung and the confession made headlines in all the newspapers. The whole thing was a huge success. But Don Corleone, cautious as always, waited until Felix Bocchicchio was actually executed four months later before finally giving the command that Michael Corleone could return home.

CHAPTER TWENTY-TWO

LUCY MANCINI, a year after Sonny's death, still missed him terribly, grieved for him more fiercely than any lover in any romance. And her dreams were not the insipid dreams of a schoolgirl, her longings not the longings of a devoted wife. She was not rendered desolate by the loss of her 'life's companion', or miss him because of his stalwart character. She held no fond remembrances of sentimental gifts, of girlish hero worship, his smile, the amused glint of his eyes when he said something endearing or witty.

No. She missed him for the more important reason that he had been the only man in the world who could make her body achieve the act of love. And, in her youth and innocence, she still believed that he was the only man who could possibly do so.

Now a year later she sunned herself in the balmy Nevada air. At her feet the slender, blond young man was playing with her toes. They were at the side of the hotel pool for the Sunday afternoon and despite the people all around them his hand was sliding up her bare thigh.

'Oh, Jules, stop,' Lucy said. 'I thought doctors at least weren't as silly as other men.'

Jules grinned at her. 'I'm a Las Vegas doctor.' He tickled the inside of her thigh and was amazed how just a little thing like that could excite her so powerfully. It showed on her face though she tried to hide it. She was really a very primitive, innocent girl. Then why couldn't he make her come across? He had to figure that one out and never mind the crap about a lost love that could never be replaced. This was living tissue here under his hand and living tissue required other living tissue. Dr Jules Segal decided he would make the big push tonight at his apartment. He'd wanted to make her come across without any trickery but if trickery there had to be, he was the man for it. All in the interests of science of course. And, besides, this poor kid was dying for it.

'Jules, stop, please stop,' Lucy said. Her voice was trembling.

Jules was immediately contrite. 'OK, honey,' he said. He put his head in her lap and using her soft thighs as a pillow, he took a little nap. He was amused at her squirming, the heat that registered from her loins and when she put her hand on his head to smooth his hair, he grasped her wrist playfully and held it loverlike but really to feel her pulse. It was galloping. He'd get her tonight and he'd solve the mystery, what the hell ever it was. Fully confident, Dr Jules Segal fell asleep.

Lucy watched the people around the pool. She could never have imagined her life would change so in less than two years. She never regretted her 'foolishness' at Connie Corleone's wedding. It was the most wonderful thing that had ever happened to her and she lived it over and over again in her dreams. As she lived over and over again the months that followed.

Sonny had visited her once a week, sometimes more, never less. The days before she saw him again her body was in torment. Their passion for each other was of the most elementary kind, undiluted by poetry or any form of intellectualism. It was love of the coarsest nature, a fleshy love, a love of tissue for opposing tissue.

When Sonny called to tell her he was coming she made certain there was enough liquor in the apartment and enough food for supper and breakfast because usually he would not

leave until late the next morning. He wanted his fill of her as she wanted her fill of him. He had his own key and when he came in the door she would fly into his massive arms. They would both be brutally direct, brutally primitive. During their first kiss they would be fumbling at each other's clothing and he would be lifting her in the air, and she would be wrapping her legs around his huge thighs. They would be making love standing up in the foyer of her apartment as if they had to repeat their first act of love together, and then he would carry her so to the bedroom.

They would lie in bed making love. They would live together in the apartment for sixteen hours, completely naked. She would cook for him, enormous meals. Sometimes he would get phone calls obviously about business but she never even listened to the words. She would be too busy toying with his body, fondling it, kissing it, burying her mouth in it. Sometimes when he got up to get a drink and he walked by her, she couldn't help reaching out to touch his naked body, hold him, make love to him as if those special parts of his body were a plaything, a specially constructed, intricate but innocent toy revealing its known, but still surprising, ecstasies. At first she had been ashamed of these excesses on her part but soon saw that they pleased her lover, that her complete sensual enslavement to his body flattered him. In all this there was an animal innocence. They were happy together.

When Sonny's father was gunned down in the street, she understood for the first time that her lover might be in danger. Alone in her apartment, she did not weep, she wailed aloud, an animal wailing. When Sonny did not come to see her for almost three weeks she subsisted on sleeping pills, liquor, and her own anguish. The pain she felt was physical pain, her body ached. When he finally did come she held on to his body at almost every moment. After that he came at least once a week until he was killed.

She learned of his death through the newspaper accounts and that very same night she took a massive overdose of sleeping pills. For some reason, instead of killing, the pills made her so ill that she staggered out into the hall of her apartment and collapsed in front of the elevator door where

she was found and taken to the hospital. Her relationship to Sonny was not generally known so her case received only a few inches in the tabloid newspapers.

It was while she was in the hospital that Tom Hagen came to see her and console her. It was Tom Hagen who arranged a job for her in Las Vegas working in the hotel run by Sonny's brother Freddie. It was Tom Hagen who told her that she would receive an annuity from the Corleone Family, that Sonny had made provisions for her. He had asked her if she was pregnant, as if that were the reason for her taking the pills and she had told him no. He asked her if Sonny had come to see her that fatal night or had called that he would come to see her and she told him no, that Sonny had not called. That she was always home waiting for him when she finished working. And she had told Hagen the truth. 'He's the only man I could ever love,' she said. 'I can't love anybody else.' She saw him smile a little but he also looked surprised. 'Do you find that so unbelievable?' she asked. 'Wasn't he the one who brought you home when you were a kid?'

'He was a different person,' Hagen said, 'he grew up to be a different kind of man.'

'Not to me,' Lucy said. 'Maybe to everybody else, but not to me.' She was still too weak to explain how Sonny had never been anything but gentle with her. He'd never been angry with her, never even irritable or nervous.

Hagen made all the arrangements for her to move to Las Vegas. A rented apartment was waiting, he took her to the airport himself and he made her promise that if she ever felt lonely or if things didn't go right, she would call him and he would help her in any way he could.

Before she got on the plane she asked him hesitantly, 'Does Sonny's father know what you're doing?'

Hagen smiled, 'I'm acting for him as well as myself. He's old-fashioned in these things and he would never go against the legal wife of his son. But he feels that you were just a young girl and Sonny should have known better. And your taking all those pills shook everybody up.' He didn't explain how incredible it was to a man like the Don that any person should try suicide.

Now, after nearly eighteen months in Las Vegas, she was surprised to find herself almost happy. Some nights she dreamed about Sonny and lying awake before dawn continued her dream with her own caresses until she could sleep again. She had not had a man since. But the life in Vegas agreed with her. She went swimming in the hotel pools, sailed on Lake Mead, and drove through the desert on her day off. She became thinner and this improved her figure. She was still voluptuous but more in the American than the old Italian style. She worked in the public relations section of the hotel as a receptionist and had nothing to do with Freddie though when he saw her he would stop and chat a little. She was surprised at the change in Freddie. He had become a ladies' man, dressed beautifully, and seemed to have a real flair for running a gambling resort. He controlled the hotel side, something not usually done by casino owners. With the long, very hot summer seasons, or perhaps his more active sex life, he too had become thinner and Hollywood tailoring made him look almost debonair in a deadly sort of way.

It was after six months that Tom Hagen came out to see how she was doing. She had been receiving a cheque for six hundred dollars a month, every month, in addition to her salary. Hagen explained that this money had to be shown as coming from some place and asked her to sign complete powers of attorney so that he could channel the money properly. He also told her that as a matter of form she would be listed as owner of five 'points' in the hotel in which she worked. She would have to go through all the legal formalities required by the Nevada laws but everything would be taken care of for her and her own personal inconvenience would be at a minimum. However she was not to discuss this arrangement with anyone without his consent. She would be protected legally in every way and her money every month would be assured. If the authorities or any law-enforcement agencies ever questioned her, she was to simply refer them to her lawyer and she would not be bothered any further.

Lucy agreed. She understood what was happening but had no objections to how she was being used. It seemed a reasonable favour. But when Hagen asked her to keep her eyes open

around the hotel, keep an eye on Freddie and on Freddie's boss, the man who owned and operated the hotel, as a major stockholder, she said to him, 'Oh, Tom, you don't want me to spy on *Freddie*?'

Hagen smiled. 'His father worries about Freddie. He's in fast company with Moe Greene and we just want to make sure he doesn't get into any trouble.' He didn't bother to explain to her that the Don had backed the building of this hotel in the desert of Las Vegas not only to supply a haven for his son, but to get a foot in the door for bigger operations.

It was shortly after this interview that Dr Jules Segal came to work as the hotel house physician. He was very thin, very handsome and charming and seemed very young to be a doctor, at least to Lucy. She met him when a lump grew above her wrist on her forearm. She worried about it for a few days, then one morning went to the doctor's suite of offices in the hotel. Two of the show girls from the chorus line were in the waiting room, gossiping with each other. They had the blonde peach-coloured prettiness Lucy always envied. They looked angelic. But one of the girls was saying, 'I swear if I have another dose I'm giving up dancing.'

When Dr Jules Segal opened his office door to motion one of the show girls inside, Lucy was tempted to leave, and if it had been something more personal and serious she would have. Dr Segal was wearing slacks and an open shirt. The horn-rimmed glasses helped and his quiet reserved manner, but the impression he gave was an informal one, and like many basically old-fashioned people, Lucy didn't believe that medicine and informality mixed.

When she finally got into his office there was something so reassuring in his manner that all her misgivings fled. He spoke hardly at all and yet he was not brusque, and he took his time. When she asked him what the lump was he patiently explained that it was a quite common fibrous growth that could in no way be malignant or a cause for serious concern. He picked up a heavy medical book and said, 'Hold out your arm.'

She held out her arm tentatively. He smiled at her for the first time. 'I'm going to cheat myself out of a surgical fee,' he said. 'I'll just smash it with this book and it will flatten out. It

may pop up again but if I remove it surgically, you'll be out of money and have to wear bandages and all that. OK?'

She smiled at him. For some reason she had an absolute trust in him. 'OK,' she said. In the next instant she let out a yell as he brought down the heavy medical volume on her forearm. The lump had flattened out, almost.

'Did it hurt that much?' he asked.

'No,' she said. She watched him completing her case history card. 'Is that all?'

He nodded, not paying any more attention to her. She left.

A week later he saw her in the coffee shop and sat next to her at the counter. 'How's the arm?' he asked.

She smiled at him. 'Fine,' she said. 'You're pretty unorthodox but you're pretty good.'

He grinned at her. 'You don't know how unorthodox I am. And I didn't know how rich you were. The Vegas *Sun* just published the list of point owners in the hotel and Lucy Mancini has a big ten points. I could have made a fortune on that little bump.'

She didn't answer him, suddenly reminded of Hagen's warnings. He grinned again. 'Don't worry, I know the score, you're just one of the dummies, Vegas is full of them. How about seeing one of the shows with me tonight and I'll even buy you some roulette chips.'

She was a little doubtful. He urged her. Finally she said, 'I'd like to come but I'm afraid you might be disappointed by how the night ends. I'm not really a swinger like most of the girls here in Vegas.'

'That's why I asked you,' Jules said cheerfully. 'I've prescribed a night's rest for myself.'

Lucy smiled at him and said a little sadly, 'Is it that obvious?' He shook his head and she said, 'OK, supper then, but I'll buy my own roulette chips.'

They went to the supper show and Jules kept her amused by describing different types of bare thighs and breasts in medical terms; but without sneering, all in good humour. Afterwards they played roulette together at the same wheel and won over a hundred dollars. Still later they drove up to Boulder Dam in the moonlight and he tried to make love to her but when she

esisted after a few kisses he knew she really meant no and
stopped. Again he took his defeat with great good humour.
I told you I wouldn't,' Lucy said with half-guilty reproach.

'You would have been awfully insulted if I didn't even try,'
Jules said. And she had to laugh because it was true.

The next few months they became best friends. It wasn't love
because they didn't make love, Lucy wouldn't let him. She
could see he was puzzled by her refusal but not hurt the way
most men would be and that made her trust him even more.
She found out that beneath his professional doctor's exterior
he was wildly fun-loving and reckless. On weekends he drove
a souped-up MG in the California races. When he took a
vacation he went down into the interior of Mexico, the real
wild country, he told her, where strangers were murdered
for their shoes and life was as primitive as a thousand years
ago. Quite accidentally she learned that he was a surgeon and
had been connected with a famous hospital in New York.

All this made her more puzzled than ever at his having taken
the job at the hotel. When she asked him about it, Jules said,
'You tell me your dark secret and I'll tell you mine.'

She blushed and let the matter drop. Jules didn't pursue it
either and their relationship continued, a warm friendship that
she counted on more than she realized.

Now, sitting at the side of the pool with Jules' blond head in
her lap, she felt an overwhelming tenderness for him. Her
loins ached and without realizing it her fingers sensuously
stroked the skin of his neck. He seemed to be sleeping, not
noticing, and she became excited just by the feel of him against
her. Suddenly he raised his head from her lap and stood up.
He took her by the hand and led her over the grass on to the
cement walk. She followed him dutifully even when he led her
into one of the cottages that held his private apartment. When
they were inside he fixed them both big drinks. After the
blazing sun and her own sensuous thoughts the drink went to
her head and made her dizzy. Then Jules had his arms around
her and their bodies, naked except for scanty bathing suits,
were pressed against each other. Lucy was murmuring, 'Don't,'
but there was no conviction in her voice and Jules paid no

attention to her. He quickly stripped her bathing bra off so that he could fondle her heavy breasts, kissed them and then stripped off her bathing trunks and as he did so kept kissing her body, her rounded belly and the insides of her thighs. He stood up, struggling out of his own bathing shorts and embracing her, and then, naked in each other's arms, they were lying on his bed and she could feel him entering her and it was enough, just the slight touch, for her to reach her climax and then in the second afterwards she could read in the motions of his body, his surprise. She felt the overwhelming shame she had felt before she knew Sonny, but Jules was twisting her body over the edge of the bed, positioning her legs a certain way and she let him control her limbs and her body, and then he was entering her again and kissing her and this time she could feel him but more important she could tell that he was feeling something too and coming to his climax.

When he rolled off her body, Lucy huddled into one corner of the bed and began to cry. She felt so ashamed. And then she was shockingly surprised to hear Jules laugh softly and say, 'You poor benighted Eye-talian girl, so that's why you kept refusing me all these months? You dope.' He said 'you dope' with such friendly affection that she turned towards him and he took her naked body against his saying, 'You are medieval, you are positively medieval.' But the voice was soothingly comforting as she continued to weep.

Jules lit a cigarette and put it in her mouth so that she choked on the smoke and had to stop crying. 'Now listen to me,' he said, 'if you had had a decent modern raising with a family culture that was part of the twentieth century your problem would have been solved years ago. Now let me tell you what your problem is: it's not the equivalent of being ugly, of having bad skin and squinty eyes that facial surgery really doesn't solve. Your problem is like having a wart or a mole on your chin, or an improperly formed ear. Stop thinking of it in sexual terms. Stop thinking in your head that you have a big box no man can love because it won't give his penis the necessary friction. What you have is a pelvic malformation and what we surgeons call a weakening of the pelvic floor. It usually comes after child-bearing but it can be simply bad bone

314

structure. It's a common condition and many women live a life of misery because of it when a simple operation could fix them up. Some women even commit suicide because of it. But I never figured you for that condition because you have such a beautiful body. I thought it was psychological, since I know your story, you told it to me often enough, you and Sonny. But let me give you a thorough physical examination and I can tell you just exactly how much work will have to be done. Now go in and take a shower.'

Lucy went in and took her shower. Patiently and over her protests, Jules made her lie on the bed, legs spread apart. He had an extra doctor's bag in his apartment and it was open. He also had a small glass-topped table by the bed which held some other instruments. He was all business now, examining her, sticking his fingers inside her and moving them around. She was beginning to feel humiliated when he kissed her on the navel and said, almost absentmindedly, 'First time I've enjoyed my work.' Then he flipped her over and thrust a finger in her rectum, feeling around, but his other hand was stroking her neck affectionately. When he was finished he turned her right side up again, kissed her tenderly on the mouth and said, 'Baby, I'm going to build you a whole new thing down there, and then I'll try it out personally. It will be a medical first, I'll be able to write a paper on it for the official journals.'

Jules did everything with such good-humoured affection, he so obviously cared for her, that Lucy got over her shame and embarrassment. He even had the medical textbook down off its shelf to show her a case like her own and the surgical procedure to correct it. She found herself quite interested.

'It's a health thing too,' Jules said. 'If you don't get it corrected you're going to have a hell of a lot of trouble later on with your whole plumbing system. The structure becomes progressively weaker unless it's corrected by surgery. It's a damn shame that old-fashioned prudery keeps a lot of doctors from properly diagnosing and correcting the situation, and a lot of women from complaining about it.'

'Don't talk about it, please don't talk about it,' Lucy said.

He could see that she was still to some extent ashamed of her secret, embarrassed by her 'ugly defect'. Though to his

medically trained mind this seemed the height of silliness, he was sensitive enough to identify with her. It also put him on the right track to making her feel better.

'OK, I know your secret so now I'll tell you mine,' he said. 'You always ask me what I'm doing here in this town, one of the youngest and most brilliant surgeons in the East.' He was mocking some newspaper reports about himself. 'The truth is that I'm an abortionist, which in itself is not so bad, so is half the medical profession; but I got caught. I had a friend, a doctor named Kennedy, we interned together, and he's a really straight guy but he said he'd help me. I understand Tom Hagen had told him if he ever needed help on anything the Corleone Family was indebted to him. So he spoke to Hagen. The next thing I know the charges were dropped, but the Medical Association and the Eastern establishment had me blacklisted. So the Corleone Family got me this job out here. I make a good living. I do a job that has to be done. These show girls are always getting knocked up and aborting them is the easiest thing in the world if they come to me right away. I curette 'em like you scrape a frying pan. Freddie Corleone is a real terror. By my count he's knocked up fifteen girls while I've been here. I've seriously considered giving him a father-to-father talk about sex. Especially since I've had to treat him three times for clap and once for syphilis. Freddie is the original bareback rider.'

Jules stopped talking. He had been deliberately indiscreet, something he never did, so that Lucy would know that other people, including someone she knew and feared a little like Freddie Corleone, also had shameful secrets.

'Think of it as a piece of elastic in your body that has lost its elasticity,' Jules said. 'By cutting out a piece, you make it tighter, snappier.'

'I'll think about it,' Lucy said, but she was sure she was going to go through with it, she trusted Jules absolutely. Then she thought of something else. 'How much will it cost?'

Jules frowned. 'I haven't the facilities here for surgery like that and I'm not the expert at it. But I have a friend in Los Angeles who's the best in the field and has facilities at the best hospital. In fact he tightens up all the movie stars, when those

dames find out that getting their faces and breasts lifted isn't the whole answer to making a man love them. He owes me a few favours so it won't cost anything. I do his abortions for him. Listen, if it weren't unethical I'd tell you the names of some of the movie sex queens who have had the operation.'

She was immediately curious. 'Oh, come on, tell me,' she said. 'Come on.' It would be a delicious piece of gossip and one of the things about Jules was that she could show her feminine love of gossip without him making fun of it.

'I'll tell you if you have dinner with me and spend the night with me,' Jules said. 'We have a lot of lost time to make up for because of your silliness.'

Lucy felt an overwhelming affection to him for being so kind and she was able to say, 'You don't have to sleep with me, you know you won't enjoy it the way I am now.'

Jules burst out laughing. 'You dope, you incredible dope. Didn't you ever hear of any other way of making love, far more ancient, far more civilized. Are you really that innocent?'

'Oh that,' she said.

'Oh that,' he mimicked her. 'Nice girls don't do that, manly men don't do that. Even in the year 1948. Well, baby, I can take you to the house of a little old lady right here in Las Vegas who was the youngest madam of the most popular whorehouse in the wild west days, back in 1880, I think it was. She likes to talk about the old days. You know what she told me? That those gunslingers, those manly, virile, straight-shooting cowboys would always ask the girls for a "French", what we doctors call fellatio, what you call "oh that". Did you ever think of doing "oh that" with your beloved Sonny?'

For the first time she truly surprised him. She turned on him with what he could think of only as a Mona Lisa smile (his scientific mind immediately darting off on a tangent, could this be the solving of that centuries-old mystery?) and said quietly, 'I did everything with Sonny.' It was the first time she had ever admitted anything like that to anyone.

Two weeks later Jules Segal stood in the operating room of the Los Angeles hospital and watched his friend Dr Frederick Kellner perform the specialty. Before Lucy was put under anaesthesia, Jules leaned over and whispered, 'I told him you

were my special girl so he's going to put in some real tight walls.' But the preliminary pill had already made her dopey and she didn't laugh or smile. His teasing remark did take away some of the terror of the operation.

Dr Kellner made his incision with the confidence of a pool shark making an easy shot. The technique of any operation to strengthen the pelvic floor required the accomplishment of two objectives. The musculofibrous pelvis sling had to be shortened so that the slack was taken up. And of course the vaginal opening, the weak spot itself in the pelvic floor, had to be brought forward, brought under the pubic arch and so relieved from the line of direct pressure above. Repairing the pelvic sling was called perincorrhaphy. Suturing the vaginal wall was called colporrhaphy.

Jules saw that Dr Kellner was working carefully now, the big danger in the cutting was going too deep and hitting the rectum. It was a fairly uncomplicated case, Jules had studied all the X-rays and tests. Nothing should go wrong except that in surgery something could always go wrong.

Kellner was working on the diaphragm sling, the T forceps held the vaginal flap, and exposing the ani muscle and the fasci which formed its sheath. Kellner's gauze-covered fingers were pushing aside loose connective tissue. Jules kept his eyes on the vaginal wall for the appearance of the veins, the telltale danger signal of injuring the rectum. But old Kellner knew his stuff. He was building a new snatch as easily as a carpenter nails together two-by-four studs.

Kellner was trimming away the excess vaginal wall using the fastening-down stitch to close the 'bite' taken out of the tissue of the redundant angle, insuring that no troublesome projections would form. Kellner was trying to insert three fingers into the narrowed opening of the lumen, then two. He just managed to get two fingers in, probing deeply and for a moment he looked up at Jules and his china-blue eyes over the gauze mask twinkled as though asking if that was narrow enough. Then he was busy again with his sutures.

It was all over. They wheeled Lucy out to the recovery room and Jules talked to Kellner. Kellner was cheerful, the best sign that everything had gone well. 'No complications at all, my

boy,' he told Jules. 'Nothing growing in there, very simple case. She has wonderful body tone, unusual in these cases and now she's in first-class shape for fun and games. I envy you, my boy. Of course you'll have to wait a little while but then I guarantee you'll like my work.'

Jules laughed. 'You're a true Pygmalion, Doctor. Really, you were marvellous.'

Dr Kellner grunted. 'That's all child's play, like your abortions. If society would only be realistic, people like you and I, really talented people, could do important work and leave this stuff for the hacks. By the way, I'll be sending you a girl next week, a very nice girl, they seem to be the ones who always get in trouble. That will make us all square for this job today.'

Jules shook his hand. 'Thanks, Doctor. Come out yourself sometime and I'll see that you get all the courtesies of the house.'

Kellner gave him a wry smile. 'I gamble every day, I don't need your roulette wheels and crap tables. I knock heads with fate too often as it is. You're going to waste out there, Jules. Another couple of years and you can forget about serious surgery. You won't be up to it.' He turned away.

Jules knew it was not meant as a reproach but as a warning. Yet it took the heart out of him anyway. Since Lucy wouldn't be out of the recovery room for at least twelve hours, he went out on the town and got drunk. Part of the getting drunk was his feeling of relief that everything had worked out so well with Lucy.

The next morning when he went to the hospital to visit her he was surprised to find two men at her bedside and flowers all over the room. Lucy was propped up on pillows, her face radiant. Jules was surprised because Lucy had broken with her family and had told him not to notify them unless something went wrong. Of course Freddie Corleone knew she was in the hospital for a minor operation; that had been necessary so that they both could get time off, and Freddie had told Jules that the hotel would pick up all the bills for Lucy.

Lucy was introducing them and one of the men Jules recognized instantly. The famous Johnny Fontane. The other was a big, muscular, snotty-looking Italian guy whose name was

Nino Valenti. They both shook hands with Jules and then paid no further attention to him. They were kidding Lucy, talking about the old neighbourhood in New York, about people and events Jules had no way of sharing. So he said to Lucy, 'I'll drop by later, I have to see Dr Kellner anyway.'

But Johnny Fontane was turning the charm on him. 'Hey, buddy, we have to leave ourselves, you keep Lucy company. Take good care of her, Doc.' Jules noticed a peculiar hoarseness in Johnny Fontane's voice and remembered suddenly that the man hadn't sung in public for over a year now, that he had won the Academy Award for his acting. Could the man's voice have changed so late in life and the papers keeping it a secret, everybody keeping it a secret? Jules loved inside gossip and he kept listening to Fontane's voice in an attempt to diagnose the trouble. It could be simple strain, or too much booze and cigarettes or even too much women. The voice had an ugly timbre to it, he could never be called the sweet crooner any more.

'You sound like you have a cold,' Jules said to Johnny Fontane.

Fontane said politely, 'Just strain, I tried to sing last night. I guess I just can't accept the fact that my voice changed, getting old you know.' He gave Jules a what-the-hell grin.

Jules said casually, 'Didn't you get a doctor to look at it? Maybe it's something that can be fixed.'

Fontane was not so charming now. He gave Jules a long cool look. 'That's the first thing I did nearly two years ago. Best specialists. My own doctor who's supposed to be the top guy out here in California. They told me to get a lot of rest. Nothing wrong, just getting older. A man's voice changes when he gets older.'

Fontane ignored him after that, paying attention to Lucy, charming her as he charmed all women. Jules kept listening to the voice. There had to be a growth on those vocal chords. But then why the hell hadn't the specialists spotted it? Was it malignant and inoperable? Then there was other stuff.

He interrupted Fontane to ask, 'When was the last time you got examined by a specialist?'

Fontane was obviously irritated but trying to be polite for Lucy's sake. 'About eighteen months ago,' he said.

'Does your own doctor take a look once in a while?' Jules asked.

'Sure he does,' Johnny Fontane said irritably. 'He gives me a codeine spray and checks me out. He told me it's just my voice ageing, that all the drinking and smoking and other stuff. Maybe you know more than he does?'

Jules asked, 'What's his name?'

Fontane said with just a faint flicker of pride, 'Tucker, Dr James Tucker. What do you think of him?'

The name was familiar, linked to famous movie stars, female, and to an expensive health farm.

'He's a sharp dresser,' Jules said with a grin.

Fontane was angry now. 'You think you're a better doctor than he is?'

Jules laughed. 'Are you a better singer than Carmen Lombardo?' He was surprised to see Nino Valenti break up in laughter, banging his head on his chair. The joke hadn't been that good. Then on the wings of those guffaws he caught the smell of bourbon and knew that even this early in the morning Mr Valenti, whoever the hell he was, was at least half drunk.

Fontane was grinning at his friend. 'Hey, you're supposed to be laughing at my jokes, not his.' Meanwhile Lucy stretched out her hand to Jules and drew him to her bedside.

'He looks like a bum but he's a brilliant surgeon,' Lucy told them. 'If he says he's better than Dr Tucker then he's better than Dr Tucker. You listen to him, Johnny.'

The nurse came in and told them they would have to leave. The resident was going to do some work on Lucy and needed privacy. Jules was amused to see Lucy turn her head away so when Johnny Fontane and Nino Valenti kissed her they would hit her cheek instead of her mouth, but they seemed to expect it. She let Jules kiss her on the mouth and whispered, 'Come back this afternoon, please?' He nodded.

Out in the corridor, Valenti asked him, 'What was the operation for? Anything serious?'

Jules shook his head. 'Just a little female plumbing.

Absolutely routine, please believe me. I'm more concerned than you are, I hope to marry the girl.'

They were looking at him appraisingly so he asked, 'How did you find out she was in the hospital?'

'Freddie called us and asked us to look in,' Fontane said. 'We all grew up in the same neighbourhood. Lucy was maid of honour when Freddie's sister got married.'

'Oh,' Jules said. He didn't let on that he knew the whole story, perhaps because they were so cagey about protecting Lucy and her affair with Sonny.

As they walked down the corridor, Jules said to Fontane, 'I have visiting doctor's privileges here, why don't you let me have a look at your throat?'

Fontane shook his head. 'I'm in a hurry.'

Nino Valenti said, 'That's a million-dollar throat, he can't have cheap doctors looking down it.' Jules saw Valenti was grinning at him, obviously on his side.

Jules said cheerfully, 'I'm no cheap doctor. I was the brightest young surgeon and diagnostician on the East Coast until they got me on an abortion rap.'

As he had known it would, that made them take him seriously. By admitting his crime he inspired belief in his claim of high competence. Valenti recovered first. 'If Johnny can't use you, I got a girlfriend I want you to look at, not at her throat though.'

Fontane said to him nervously, 'How long will you take?'

'Ten minutes,' Jules said. It was a lie but he believed in telling lies to people. Truth telling and medicine just didn't go together except in dire emergencies, if then.

'OK,' Fontane said. His voice was darker, hoarser, with fright.

Jules recruited a nurse and a consulting room. It didn't have everything he needed but there was enough. In less than ten minutes he knew there was a growth on the vocal chords, that was easy. Tucker, that incompetent sartorial son of a bitch of a Hollywood phony, should have been able to spot it. Christ, maybe the guy didn't even have a licence and if he did it should be taken away from him. Jules didn't pay any attention to the two men now. He picked up the phone and asked for

the throat man at the hospital to come down. Then he swung around and said to Nino Valenti, 'I think it might be a long wait for you, you'd better leave.'

Fontane stared at him in utter disbelief. 'You son of a bitch, you think you're going to keep me here? You think you're going to fuck around with my throat?'

Jules, with more pleasure than he would have thought possible, gave it to him straight between the eyes. 'You can do whatever you like,' he said. 'You've got a growth of some sort on your vocal chords, in your larynx. If you stay here the next few hours, we can nail it down, whether it's malignant or non-malignant. We can make a decision for surgery or treatment. I can give you the whole story. I can give you the name of the top specialist in America and we can have him out here on the plane tonight, with your money that is, and if I think it necessary. But you can walk out of here and see your quack buddy or sweat while you decide to see another doctor, or get referred to somebody incompetent. Then if it's malignant and gets big enough they'll cut out your whole larynx or you'll die. Or you can just sweat. Stick here with me and we can get it all squared away in a few hours. You got anything more important to do?'

Valenti said, 'Let's stick around, Johnny, what the hell. I'll go down the hall and call the studio. I won't tell them anything, just that we're held up. Then I'll come back here and keep you company.'

It proved to be a very long afternoon but a rewarding one. The diagnosis of the staff throat man was perfectly sound as far as Jules could see after the X-rays and swab analysis. Half-way through, Johnny Fontane, his mouth soaked with iodine, retching over the roll of gauze stuck in his mouth, tried to quit. Nino Valenti grabbed him by the shoulders and slammed him back into the chair. When it was all over Jules grinned at Fontane and said, 'Warts.'

Fontane didn't grasp it. Jules said again, 'Just some warts. We'll slice them right off like skin off baloney. In a few months you'll be OK.'

Valenti let out a yell but Fontane was still frowning. 'How about singing afterwards, how will it affect my singing?'

Jules shrugged. 'On that there's no guarantee. But since you can't sing now what's the difference?'

Fontane looked at him with distaste. 'Kid, you don't know what the hell you're talking about. You act like you're giving me good news when what you're telling me is maybe I won't sing any more. Is that right, maybe I won't sing any more?'

Finally Jules was disgusted. He'd operated as a real doctor and it had been a pleasure. He had done this bastard a real favour and he was acting as if he'd been done dirt. Jules said coldly, 'Listen, Mr Fontane, I'm a doctor of medicine and you can call me Doctor, not kid. And I did give you very good news. When I brought you down here I was certain that you had a malignant growth in your larynx which would entail cutting out your whole voice box. Or which could kill you. I was worried that I might have to tell you that you were a dead man. And I was so delighted when I could say the word "warts". Because your singing gave me so much pleasure, helped me seduce girls when I was younger, and you're a real artist. But also you're a very spoiled guy. Do you think because you're Johnny Fontane you can't get cancer? Or a brain tumour that's inoperable? Or a failure of the heart? Do you think you're never going to die? Well, it's not all sweet music and if you want to see real trouble take a walk through this hospital and you'll sing a love song about warts. So just stop the crap and get on with what you have to do. Your Adolphe Menjou medical man can get you the proper surgeon but if he tries to get into the operating room I suggest you have him arrested for attempted murder.'

Jules started to walk out of the room when Valenti said, 'Attaboy, Doc, that's telling him.'

Jules whirled around and said, 'Do you always get looped before noontime?'

Valenti said, 'Sure,' and grinned at him and with such good humour that Jules said more gently than he had meant to, 'You have to figure you'll be dead in five years if you keep that up.'

Valenti was lumbering up to him with little dancing steps. He threw his arms around Jules, his breath stank of bourbon.

He was laughing very hard. 'Five years?' he asked still laughing. 'Is it going to take *that long*?'

A month after her operation Lucy Mancini sat beside the Vegas hotel pool, one hand holding a cocktail, the other hand stroking Jules' head, which lay in her lap.

'You don't have to build up your courage,' Jules said teasingly. 'I have champagne waiting in our suite.'

'Are you sure it's OK so soon?' Lucy asked.

'I'm the doctor,' Jules said. 'Tonight's the big night. Do you realize I'll be the first surgeon in medical history who tried out the results of his "medical first" operation? You know, the Before and After. I'm going to enjoy writing it up for the journals. Let's see, "while the Before was distinctly pleasurable for psychological reasons and the sophistication of the surgeon-instructor, the post-operative coitus was extremely rewarding strictly for its neurological"' – he stopped talking because Lucy had yanked on his hair hard enough for him to yell with pain.

She smiled down at him. 'If you're not satisfied tonight I can really say it's your fault,' she said.

'I guarantee my work. I planned it even though I just let old Kellner do the manual labour,' Jules said. 'Now let's just rest up, we have a long night of research ahead.'

When they went up to their suite – they were living together now – Lucy found a surprise waiting: a gourmet supper and next to her champagne glass, a jeweller's box with a huge diamond engagement ring inside it.

'That shows you how much confidence I have in my work,' Jules said. 'Now let's see you earn it.'

He was very tender, very gentle with her. She was a little scary at first, her flesh jumping away from his touch but then, reassured, she felt her body building up to a passion she had never known, and when they were done the first time and Jules whispered, 'I do good work,' she whispered back, 'Oh, yes, you do; yes, you do.' And they both laughed to each other as they started making love again.

Book VI

CHAPTER TWENTY-THREE

AFTER FIVE months of exile in Sicily, Michael Corleone came finally to understand his father's character and his destiny. He came to understand men like Luca Brasi, the ruthless *capo-regime* Clemenza, his mother's resignation and acceptance of her role. For in Sicily he saw what they would have been if they had chosen *not* to struggle against their fate. He understood why the Don always said, 'A man has only one destiny.' He came to understand the contempt for authority and legal government, the hatred for any man who broke *omerta*, the law of silence.

Dressed in old clothes and a billed cap, Michael had been transported from the ship docked at Palermo to the interior of the Sicilian island, to the very heart of a province controlled by the Mafia, where the local *capo-mafioso* was greatly indebted to his father for some past service. The province held the town of Corleone, whose name the Don had taken when he emigrated to America so long ago. But there were no longer any of the Don's relatives alive. The women had died of old age. All the men had been killed in vendettas or had also emigrated, either to America, Brazil or to some other province on the Italian mainland. He was to learn later that this small poverty-stricken town had the highest murder rate of any place in the world.

Michael was installed as a guest in the home of a bachelor uncle of the *capo-mafioso*. The uncle, in his seventies, was also the doctor for the district. The *capo-mafioso* was a man in his late fifties named Don Tommasino and he operated as the *gabbellotto* for a huge estate belonging to one of Sicily's most noble families. The *gabbellotto*, a sort of overseer to the estates of the rich, also guaranteed that the poor would not try to claim land not being cultivated, would not try to encroach in any way on the estate, by poaching or trying to farm it as

squatters. In short, the *gabbellotto* was a *mafioso* who for a certain sum of money protected the real estate of the rich from all claims made on it by the poor, legal or illegal. When any poor peasant tried to implement the law which permitted him to buy uncultivated land, the *gabbellotto* frightened him off with threats of bodily harm or death. It was that simple.

Don Tommasino also controlled the water rights in the area and vetoed the local building of any new dams by the Roman government. Such dams would ruin the lucrative business of selling water from the artesian wells he controlled, make water too cheap, ruin the whole important water economy so laboriously built up over hundreds of years. However, Don Tommasino was an old-fashioned Mafia chief and would have nothing to do with dope traffic or prostitution. In this Don Tommasino was at odds with the new breed of Mafia leaders springing up in big cities like Palermo, new men who, influenced by American gangsters deported to Italy, had no such scruples.

The Mafia chief was an extremely portly man, a 'man with a belly', literally as well as in the figurative sense that meant a man able to inspire fear in his fellow men. Under his protection, Michael had nothing to fear, yet it was considered necessary to keep the fugitive's identity a secret. And so Michael was restricted to the walled estate of Dr Taza, the Don's uncle.

Dr Taza was tall for a Sicilian, almost six feet, and had ruddy cheeks and snow-white hair. Though in his seventies, he went every week to Palermo to pay his respects to the younger prostitutes of that city, the younger the better. Dr Taza's other vice was reading. He read everything and talked about what he read to his fellow townsmen, patients who were illiterate peasants, the estate shepherds, and this gave him a local reputation for foolishness. What did books have to do with them?

In the evenings Dr Taza, Don Tommasino and Michael sat in the huge garden populated with those marble statues that on this island seemed to grow out of the garden as magically as the black heady grapes. Dr Taza loved to tell stories about the Mafia and its exploits over the centuries and in Michael Corleone he had a fascinated listener. There were times when even

Don Tommasino would be carried away by the balmy air, the fruity, intoxicating wine, the elegant and quiet comfort of the garden, and tell a story from his own practical experience. The doctor was the legend, the Don the reality.

In this antique garden, Michael Corleone learned about the roots from which his father grew. That the word 'Mafia' had originally meant place of refuge. Then it became the name for the secret organization that sprang up to fight against the rulers that had crushed the country and its people for centuries. Sicily was a land that had been more cruelly raped than any other in history. The Inquisition had tortured rich and poor alike. The landowning barons and the princes of the Catholic Church exercised absolute power over the shepherds and farmers. The police were the instruments of their power and so identified with them that to be called a policeman is the foulest insult one Sicilian can hurl at another.

Faced with the savagery of this absolute power, the suffering people learned never to betray their anger and their hatred for fear of being crushed. They learned never to make themselves vulnerable by uttering any sort of threat since giving such a warning insured a quick reprisal. They learned that society was their enemy and so when they sought redress for their wrongs they went to the rebel underground, the Mafia. And the Mafia cemented its power by originating the law of silence, the *omerta*. In the countryside of Sicily a stranger asking directions to the nearest town will not even receive the courtesy of an answer. And the greatest crime any member of the Mafia could commit would be to tell the police the name of the man who had just shot him or done him any kind of injury. *Omerta* became the religion of the people. A woman whose husband has been murdered would not tell the police the name of her husband's murderer, not even of her child's murderer, her daughter's raper.

Justice had never been forthcoming from the authorities and so the people had always gone to the Robin Hood Mafia. And to some extent the Mafia still fulfilled this role. People turned to their local *capo-mafioso* for help in every emergency. He was their social worker, their district captain ready with a basket of food and a job, their protector.

But what Dr Taza did not add, what Michael learned on his own in the months that followed, was that the Mafia in Sicily had become the illegal arm of the rich and even the auxiliary police of the legal and political structure. It had become a degenerate capitalist structure, anti-communist, anti-liberal, placing its own taxes on every form of business endeavour no matter how small.

Michael Corleone understood for the first time why men like his father chose to become thieves and murderers rather than members of the legal society. The poverty and fear of degradation were too awful to be acceptable to any man of spirit. And in America some emigrating Sicilians had assumed there would be an equally cruel authority.

Dr Taza offered to take Michael into Palermo with him on his weekly visit to the bordello but Michael refused. His flight to Sicily had prevented him from getting proper medical treatment for his smashed jaw and he now carried a memento from Captain McCluskey on the left side of his face. The bones had knitted badly, throwing his profile askew, giving him the appearance of depravity when viewed from that side. He had always been vain about his looks and this upset him more than he thought possible. The pain that came and went he didn't mind at all, Dr Taza gave him some pills that deadened it. Taza offered to treat his face but Michael refused. He had been there long enough to learn that Dr Taza was perhaps the worst physician in Sicily. Dr Taza read everything but his medical literature, which he admitted he could not understand. He had passed his medical exams through the good offices of the most important Mafia chief in Sicily who had made a special trip to Palermo to confer with Taza's professors about what grades they should give him. And this too showed how the Mafia in Sicily was cancerous to the society it inhabited. Merit meant nothing. Talent meant nothing. Work meant nothing. The Mafia Godfather gave you your profession as a gift.

Michael had plenty of time to think things out. During the day he took walks in the countryside, always accompanied by two of the shepherds attached to Don Tommasino's estate. The shepherds of the island were often recruited to act as the Mafia's hired killers and did their job simply to earn money to

live. Michael thought about his father's organization. If it continued to prosper it would grow into what had happened here on this island, so cancerous that it would destroy the whole country. Sicily was already a land of ghosts, its men emigrating to every other country on earth to be able to earn their bread, or simply to escape being murdered for exercising their political and economic freedoms.

On his long walks the most striking thing in Michael's eyes was the magnificent beauty of the country; he walked through the orange orchards that formed shady deep caverns through the countryside with their ancient conduits splashing water out of the fanged mouths of great snake stones carved before Christ. Houses built like ancient Roman villas, with huge marble portals and great vaulted rooms, falling into ruins or inhabited by stray sheep. On the horizon the bony hills shone like picked bleached bones piled high. Gardens and fields, sparkly green, decorated the desert landscape like bright emerald necklaces. And sometimes he walked as far as the town of Corleone, its eighteen thousand people strung out in dwellings that pitted the side of the nearest mountain, the mean hovels built out of black rock quarried from the mountain. In the last year there had been over sixty murders in Corleone and it seemed that death shadowed the town. Further on, the wood of Ficuzza broke the savage monotony of arable plain.

His two shepherd bodyguards always carried their *luparas* with them when accompanying Michael on his walks. The deadly Sicilian shotgun was the favourite weapon of the Mafia. Indeed the police chief sent by Mussolini to clean the Mafia out of Sicily had, as one of his first steps, ordered all stone walls in Sicily to be knocked down to not more than three feet in height so that murderers with their *luparas* could not use the walls as ambush points for their assassinations. This didn't help much and the police minister solved his problem by arresting and deporting to penal colonies any male suspected of being a *mafioso*.

When the island of Sicily was liberated by the Allied Armies, the American military government officials believed that anyone imprisoned by the Fascist regime was a democrat and many of these *mafiosi* were appointed as mayors of villages or

interpreters to the military government. This good fortune enabled the Mafia to reconstitute itself and become more formidable than ever before.

The long walks, a bottle of strong wine at night with a heavy plate of pasta and meat, enabled Michael to sleep. There were books in Italian in Dr Taza's library and though Michael spoke dialect Italian and had taken some college courses in Italian, his reading of these books took a great deal of effort and time. His speech became almost accentless and, though he could never pass as a native of the district, it would be believed that he was one of those strange Italians from the far north of Italy bordering the Swiss and Germans.

The distortion of the left side of his face made him more native. It was the kind of disfigurement common in Sicily because of the lack of medical care. The little injury that cannot be patched up simply for lack of money. Many children, many men, bore disfigurements that in America would have been repaired by minor surgery or sophisticated medical treatments.

Michael often thought of Kay, of her smile, her body, and always felt a twinge of conscience at leaving her so brutally without a word of farewell. Oddly enough his conscience was never troubled by the two men he had murdered; Sollozzo had tried to kill his father, Captain McCluskey had disfigured him for life.

Dr Taza always kept after him about getting surgery done for his lopsided face, especially when Michael asked him for pain-killing drugs, the pain getting worse as time went on, and more frequent. Taza explained that there was a facial nerve below the eye from which radiated a whole complex of nerves. Indeed, this was the favourite spot for Mafia torturers, who searched it out on the cheeks of their victims with the needle-fine point of an ice pick. That particular nerve in Michael's face had been injured or perhaps there was a splinter of bone lanced into it. Simple surgery in a Palermo hospital would permanently relieve the pain.

Michael refused. When the doctor asked why, Michael grinned and said, 'It's something from home.'

And he really didn't mind the pain, which was more an ache,

a small throbbing in his skull, like a motored apparatus running in liquid to purify it.

It was nearly seven months of leisurely rustic living before Michael felt real boredom. At about this time Don Tommasino became very busy and was seldom seen at the villa. He was having his troubles with the 'new Mafia' springing up in Palermo, young men who were making a fortune out of the postwar construction boom in that city. With this wealth they were trying to encroach on the country fiefs of old-time Mafia leaders whom they contemptuously labelled Moustache Petes. Don Tommasino was kept busy defending his domain. And so Michael was deprived of the old man's company and had to be content with Dr Taza's stories, which were beginning to repeat themselves.

One morning Michael decided to take a long hike to the mountains beyond Corleone. He was, naturally, accompanied by the two shepherd bodyguards. This was not really a protection against enemies of the Corleone Family. It was simply too dangerous for anyone not a native to go wandering about by himself. It was dangerous enough for a native. The region was loaded with bandits, with Mafia partisans fighting against each other and endangering everybody else in the process. He might also be mistaken for a *pagliaio* thief.

A *pagliaio* is a straw-thatched hut erected in the fields to house farming tools and to provide shelter for the agricultural labourers so that they will not have to carry them on the long walk from their homes in the village. In Sicily the peasant does not live on the land he cultivates. It is too dangerous and any arable land, if he owns it, is too precious. Rather, he lives in his village and at sunrise begins his voyage out to work in distant fields, a commuter on foot. A worker who arrived at his *pagliaio* and found it looted was an injured man indeed. The bread was taken out of his mouth for that day. The Mafia, after the law proved helpless, took this interest of the peasant under its protection and solved the problem in typical fashion. It hunted down and slaughtered all *pagliaio* thieves. It was inevitable that some innocents suffered. It was possible that if Michael wandered past a *pagliaio* that had just been looted he might be adjudged the criminal unless he had somebody to vouch for him.

So on one sunny morning he started hiking across the fields followed by his two faithful shepherds. One of them was a plain simple fellow, almost moronic, silent as the dead and with a face as impassive as an Indian. He had the wiry build of the typical Sicilian before they ran to the fat of middle age. His name was Calo.

The other shepherd was more outgoing, younger, and had seen something of the world. Mostly oceans, since he had been a sailor in the Italian navy during the war and had just had time enough to get himself tattooed before his ship was sunk and he was captured by the British. But the tattoo made him a famous man in his village. Sicilians do not often let themselves be tattooed, they do not have the opportunity nor the inclination. (The shepherd, Fabrizzio, had done so primarily to cover a splotchy red birthmark on his belly.) And yet the Mafia market carts had gaily painted scenes on their sides, beautifully primitive paintings done with loving care. In any case, Fabrizzio, back in his native village, was not too proud of that tattoo on his chest, though it showed a subject dear to the Sicilian 'honour', a husband stabbing a naked man and woman entwined together on the hairy floor of his belly. Fabrizzio would joke with Michael and ask questions about America, for of course it was impossible to keep them in the dark about his true nationality. Still, they did not know exactly who he was except that he was in hiding and there could be no babbling about him. Fabrizzio sometimes brought Michael a fresh cheese still sweating the milk that formed it.

They walked along dusty country roads passing donkeys pulling gaily painted carts. The land was filled with pink flowers, orange orchards, groves of almond and olive trees, all blooming. That had been one of the surprises. Michael had expected a barren land because of the legendary poverty of Sicilians. And yet he had found it a land of gushing plenty, carpeted with flowers scented by lemon blossoms. It was so beautiful that he wondered how its people could bear to leave it. How terrible man had been to his fellow man could be measured by the great exodus from what seemed to be a Garden of Eden.

He had planned to walk to the coastal village of Mazara, and

then take a bus back to Corleone in the evening, and so tire himself out and be able to sleep. The two shepherds wore rucksacks filled with bread and cheese they could eat on the way. They carried their *luparas* quite openly as if out for a day's hunting.

It was a most beautiful morning. Michael felt as he had felt when as a child he had gone out early on a summer day to play ball. Then each day had been freshly washed, freshly painted. And so it was now. Sicily was carpeted in gaudy flowers, the scent of orange and lemon blossoms so heavy that even with his facial injury which pressed on the sinuses, he could smell it.

The smashing on the left side of his face had completely healed but the bone had formed improperly and the pressure on his sinuses made his left eye hurt. It also made his nose run continually, he filled up handkerchiefs with mucus and often blew his nose out on to the ground as the local peasants did, a habit that had disgusted him when he was a boy and had seen old Italians, disdaining handkerchiefs as English foppery, blow out their noses in the asphalt gutters.

His face too felt 'heavy'. Dr Taza had told him that this was due to the pressure on his sinuses caused by the badly healed fracture. Dr Taza called it an eggshell fracture of the zygoma; that if it had been treated before the bones knitted, it could have been easily remedied by a minor surgical procedure using an instrument like a spoon to push out the bone to its proper shape. Now, however, said the doctor, he would have to check into a Palermo hospital and undergo a major procedure called maxillo-facial surgery where the bone would be broken again. That was enough for Michael. He refused. And yet more than the pain, more than the nose dripping, he was bothered by the feeling of heaviness in his face.

He never reached the coast that day. After going about fifteen miles he and his shepherds stopped in the cool green watery shade of an orange grove to eat lunch and drink their wine. Fabrizzio was chattering about how he would someday get to America. After drinking and eating they lolled in the shade and Fabrizzio unbuttoned his shirt and contracted his stomach muscles to make the tattoo come alive. The naked couple on his chest writhed in a lover's agony and the dagger

thrust by the husband quivered in their transfixed flesh. It amused them. It was while this was going on that Michael was hit with what Sicilians call 'the thunderbolt'.

Beyond the orange grove lay the green ribboned fields of a baronial estate. Down the road from the grove was a villa so Roman it looked as if it had been dug up from the ruins of Pompeii. It was a little palace with a huge marble portico and fluted Grecian columns and through those columns came a bevy of village girls flanked by two stout matrons clad in black. They were from the village and had obviously fulfilled their ancient duty to the local baron by cleaning his villa and otherwise preparing it for his winter sojourn. Now they were going into the fields to pick the flowers with which they would fill the rooms. They were gathering the pink *sulla*, purple wisteria, mixing them with orange and lemon blossoms. The girls, not seeing the men resting in the orange grove, came closer and closer.

They were dressed in cheap gaily printed frocks that clung to their bodies. They were still in their teens but with the full womanliness sun-drenched flesh ripened into so quickly. Three or four of them started chasing one girl, chasing her towards the grove. The girl being chased held a bunch of huge purple grapes in her left hand and with her right hand was picking grapes off the cluster and throwing them at her pursuers. She had a crown of ringleted hair as purple-black as the grapes and her body seemed to be bursting out of its skin.

Just short of the grove she poised, startled, her eyes having caught the alien colour of the men's shirts. She stood there up on her toes poised like a deer to run. She was very close now, close enough for the men to see every detail of her face.

She was all ovals – oval-shaped eyes, the bones of her face, the contour of her brow. Her skin was an exquisite dark creaminess and her eyes, enormous, dark violet or brown but dark with long heavy lashes shadowed her lovely face. Her mouth was rich without being gross, sweet without being weak and dyed dark red with the juice of the grapes. She was so incredibly lovely that Fabrizzio murmured, 'Jesus Christ, take my soul, I'm dying,' as a joke, but the words came out a little too hoarsely. As if she had heard him, the girl came down off

335

her toes and whirled away from them and fled back to her pursuers. Her haunches moved like an animal's beneath the tight print of her dress; as pagan and as innocently lustful. When she reached her friends she whirled around again and her face was like a dark hollow against the field of bright flowers. She extended an arm, the hand full of grapes pointed towards the grove. The girls fled laughing, with the black-clad, stout matrons scolding them on.

As for Michael Corleone, he found himself standing, his heart pounding in his chest; he felt a little dizzy. The blood was surging through his body, through all its extremities and pounding against the tips of his fingers, the tips of his toes. All the perfumes of the island came rushing in on the wind, orange, lemon blossoms, grapes, flowers. It seemed as if his body had sprung away from him out of himself. And then he heard the two shepherds laughing.

'You got hit by the thunderbolt, eh?' Fabrizzio said, clapping him on the shoulder. Even Calo became friendly, patting him on the arm and saying, 'Easy, man, easy,' but with affection. As if Michael had been hit by a car. Fabrizzio handed him a wine bottle and Michael took a long slug. It cleared his head.

'What the hell are you damn sheep lovers talking about?' he said.

Both men laughed. Calo, his honest face filled with the utmost seriousness, said, 'You can't hide the thunderbolt. When it hits you, everybody can see it. Christ, man, don't be ashamed of it, some men pray for the thunderbolt. You're a lucky fellow.'

Michael wasn't too pleased about his emotions being so easily read. But this was the first time in his life such a thing had happened to him. It was nothing like his adolescent crushes, it was nothing like the love he'd had for Kay, a love based as much on her sweetness, her intelligence, and the polarity of the fair and dark. This was an overwhelming desire for possession, this was an inerasable printing of the girl's face on his brain and he knew she would haunt his memory every day of his life if he did not possess her. His life had become simplified, focused on one point, everything else was unworthy of even a moment's attention. During his exile he had always thought of Kay, though he felt they could never again be

lovers or even friends. He was, after all was said, a murderer, a *mafioso* who had 'made his bones'. But now Kay was wiped completely out of his consciousness.

Fabrizzio said briskly, 'I'll go to the village, we'll find out about her. Who knows, she may be more available than we think. There's only one cure for the thunderbolt, eh, Calo?'

The other shepherd nodded his head gravely. Michael didn't say anything. He followed the two shepherds as they started down the road to the nearby village into which the flock of girls had disappeared.

The village was grouped around the usual central square with its fountain. But it was on a main route so there were some stores, wine shops, and one little café with three tables out on a small terrace. The shepherds sat at one of the tables and Michael joined them. There was no sign of the girls, not a trace. The village seemed deserted except for small boys and a meandering donkey.

The proprietor of the café came to serve them. He was a short, burly man, almost dwarfish but he greeted them cheerfully and set a dish of chickpeas at their table. 'You're strangers here,' he said, 'so let me advise you. Try my wine. The grapes come from my own farm and it's made by my sons themselves. They mix it with oranges and lemons. It's the best wine in Italy.'

They let him bring the wine in a jug and it was even better than he claimed, dark purple and as powerful as a brandy. Fabrizzio said to the café proprietor, 'You know all the girls here, I'll bet. We saw some beauties coming down the road, one in particular got our friend here hit with the thunderbolt.' He motioned to Michael.

The café owner looked at Michael with new interest. The cracked face had seemed quite ordinary to him before, not worth a second glance. But a man hit with the thunderbolt was another matter. 'You had better bring a few bottles home with you tonight, my friend,' he said. 'You'll need help in getting to sleep tonight.'

Michael asked the man, 'Do you know a girl with her hair all curly? Very creamy skin, very big eyes, very dark eyes. Do you know a girl like that in the village?'

The café owner said curtly, 'No. I don't know any girl like that.' He vanished from the terrace into his café.

The three men drank their wine slowly, finished off the jug and called for more. The owner did not reappear. Fabrizzio went into the café after him. When Fabrizzio came out he grimaced and said to Michael, 'Just as I thought, it's his daughter we were talking about and now he's in the back boiling up his blood to do us a mischief. I think we'd better start walking towards Corleone.'

Despite his months on the island Michael still could not get used to the Sicilian touchiness on matters of sex, and this was extreme even for a Sicilian. But the two shepherds seemed to take it as a matter of course. They were waiting for him to leave. Fabrizzio said, 'The old bastard mentioned he has two sons, big tough lads that he has only to whistle up. Let's get going.'

Michael gave him a cold stare. Up to now he had been a quiet, gentle young man, a typical American, except that since he was hiding in Sicily he must have done something manly. This was the first time the shepherds had seen the Corleone stare. Don Tommasino, knowing Michael's true identity and deed, had always been wary of him, treating him as a fellow 'man of respect'. But these unsophisticated sheep herders had come to their own opinion of Michael, and not a wise one. The cold look, Michael's rigid white face, his anger that came off him like cold smoke off ice, sobered their laughter and snuffed out their familiar friendliness.

When he saw he had their proper, respectful attention Michael said to them, 'Get that man out here to me.'

They didn't hesitate. They shouldered their *luparas* and went into the dark coolness of the café. A few seconds later they reappeared with the café owner between them. The stubby man looked in no way frightened but his anger had a certain wariness about it.

Michael leaned back in his chair and studied the man for a moment. Then he said very quietly, 'I understand I've offended you by talking about your daughter. I offer you my apologies, I'm a stranger in this country, I don't know the customs that well. Let me say this. I meant no disrespect to you or her.'

The shepherd bodyguards were impressed. Michael's voice

had never sounded like this before when speaking to them. There was command and authority in it though he was making an apology. The café owner shrugged, more wary still, knowing he was not dealing with some farmboy. 'Who are you and what do you want from my daughter?'

Without even hesitating Michael said, 'I am an American hiding in Sicily, from the police of my country. My name is Michael. You can inform the police and make your fortune but then your daughter would lose a father rather than gain a husband. In any case I want to meet your daughter. With your permission and under the supervision of your family. With all decorum. With all respect. I'm an honourable man and I don't think of dishonouring your daughter. I want to meet her, talk to her, and then if it hits us both right we'll marry. If not, you'll never see me again. She may find me unsympathetic after all, and no man can remedy that. But when the proper time comes I'll tell you everything about me that a wife's father should know.'

All three men were looking at him with amazement. Fabrizzio whispered in awe, 'It's the real thunderbolt.' The café owner, for the first time, didn't look so confident, or contemptuous; his anger was not so sure. Finally he asked, 'Are you a friend of the friends?'

Since the word Mafia could never be uttered aloud by the ordinary Sicilian, this was as close as the café owner could come to asking if Michael was a member of the Mafia. It was the usual way of asking if someone belonged but it was ordinarily not addressed to the person directly concerned.

'No,' Michael said. 'I'm a stranger in this country.'

The café owner gave him another look, the smashed left side of his face, the long legs rare in Sicily. He took a look at the two shepherds carrying their *luparas* quite openly without fear and remembered how they had come into his café and told him their *padrone* wanted to talk to him. The café owner had snarled that he wanted the son of a bitch out of his terrace and one of the shepherds had said, 'Take my word, it's best you go out and speak to him yourself.' And something had made him come out. Now something made him realize that it would be best to show this stranger some courtesy. He said

grudgingly, 'Come Sunday afternoon. My name is Vitelli and my house is up there on the hill, above the village. But come here to the café and I'll take you up.'

Fabrizzio started to say something but Michael gave him one look and the shepherd's tongue froze in his mouth. This was not lost on Vitelli. So when Michael stood up and stretched out his hand, the café owner took it and smiled. He would make some inquiries and if the answers were wrong he could always greet Michael with his two sons bearing their own shotguns. The café owner was not without his contacts among the 'friends of the friends'. But something told him this was one of those wild strokes of good fortune that Sicilians always believed in, something told him that his daughter's beauty would make her fortune and her family secure. And it was just as well. Some of the local youths were already beginning to buzz around and this stranger with his broken face could do the necessary job of scaring them off. Vitelli, to show his goodwill, sent the strangers off with a bottle of his best and coldest wine. He noticed that one of the shepherds paid the bill. This impressed him even more, made it clear that Michael was the superior of the two men who accompanied him.

Michael was no longer interested in his hike. They found a garage and hired a car and driver to take them back to Corleone, and some time before supper, Dr Taza must have been informed by the shepherds of what had happened. That evening, sitting in the garden, Dr Taza said to Don Tommasino, 'Our friend got hit by the thunderbolt today.'

Don Tommasino did not seem surprised. He grunted. 'I wish some of those young fellows in Palermo would get a thunderbolt, maybe I could get some peace.' He was talking about the new-style Mafia chiefs rising in the big cities like Palermo and challenging the power of old-regime stalwarts like himself.

Michael said to Tommasino, 'I want you to tell those two sheep herders to leave me alone Sunday. I'm going to go to this girl's family for dinner and I don't want them hanging around.'

Don Tommasino shook his head. 'I'm responsible to your father for you, don't ask me that. Another thing, I hear you've

even talked marriage. I can't allow that until I've sent some-body to speak to your father.'

Michael Corleone was very careful, this was after all a man of respect. 'Don Tommasino, you know my father. He's a man who goes deaf when somebody says the word no to him. And he doesn't get his hearing back until they answer him with a yes. Well, he has heard my no many times. I understand about the two guards, I don't want to cause you trouble, they can come with me Sunday, but if I want to marry I'll marry. Surely if I don't permit my own father to interfere with my personal life it would be an insult to him to allow you to do so.'

The *capo-mafioso* sighed. 'Well, then, marriage it will have to be. I know your thunderbolt. She's a good girl from a re-spectable family. You can't dishonour them without the father trying to kill you, and then you'll have to shed blood. Besides, I know the family well, I can't allow it to happen.'

Michael said, 'She may not be able to stand the sight of me, and she's a very young girl, she'll think me old.' He saw the two men smiling at him. 'I'll need some money for presents and I think I'll need a car.'

The Don nodded. 'Fabrizzio will take care of everything, he's a clever boy, they taught him mechanics in the navy. I'll give you some money in the morning and I'll let your father know what's happening. That I must do.'

Michael said to Dr Taza, 'Have you got anything that can dry up this damn snot always coming out of my nose? I can't have that girl seeing me wiping it all the time.'

Dr Taza said, 'I'll coat it with a drug before you have to see her. It makes your flesh a little numb but, don't worry, you won't be kissing her for a while yet.' Both doctor and Don smiled at this witticism.

By Sunday, Michael had an Alfa Romeo, battered but ser-viceable. He had also made a bus trip to Palermo to buy pre-sents for the girl and her family. He had learned that the girl's name was Apollonia and every night he thought of her lovely face and her lovely name. He had to drink a good deal of wine to get some sleep and orders were given to the old women ser-vants in the house to leave a chilled bottle at his bedside. He drank it empty every night.

On Sunday, to the tolling of church bells that covered all of Sicily, he drove the Alfa Romeo to the village and parked it just outside the café. Calo and Fabrizzio were in the back seat with their *luparas* and Michael told them they were to wait in the café, they were not to come to the house. The café was closed but Vitelli was there waiting for them, leaning against the railing of his empty terrace.

They shook hands all around and Michael took the three packages, the presents, and trudged up the hill with Vitelli to his home. This proved to be larger than the usual village hut, the Vitellis were not poverty-stricken.

Inside the house was familiar with statues of the Madonna entombed in glass, votive lights flickering redly at their feet. The two sons were waiting, also dressed in their Sunday black. They were two sturdy young men just out of their teens but looking older because of their hard work on the farm. The mother was a vigorous woman, as stout as her husband. There was no sign of the girl.

After the introductions, which Michael did not even hear, they sat in the room that might possibly have been a living room or just as easily the formal dining room. It was cluttered with all kinds of furniture and not very large but for Sicily it was middle-class splendour.

Michael gave Signor Vitelli and Signora Vitelli their presents. For the father it was a gold cigar-cutter, for the mother a bolt of the finest cloth purchasable in Palermo. He still had one package for the girl. His presents were received with reserved thanks. The gifts were a little too premature, he should not have given anything until his second visit.

The father said to him, in man-to-man country fashion, 'Don't think we're so of no account to welcome strangers into our house so easily. But Don Tommasino vouched for you personally and nobody in this province would ever doubt the word of that good man. And so we make you welcome. But I must tell you that if your intentions are serious about my daughter, we will have to know a little more about you and your family. You can understand, your family is from this country.'

Michael nodded and said politely, 'I will tell you anything you want to know any time.'

Signor Vitelli held up a hand. 'I'm not a nosy man. Let's see if it's necessary first. Right now you're welcome in my house as a friend of Don Tommasino.'

Despite the drug painted inside his nose, Michael actually smelled the girl's presence in the room. He turned and she was standing in the arched doorway that led to the back of the house. The smell was of fresh flowers and lemon blossoms but she wore nothing in her hair of jet black curls, nothing on her plain severe black dress, obviously her Sunday best. She gave him a quick glance and a tiny smile before she cast her eyes down demurely and sat down next to her mother.

Again Michael felt that shortness of breath, that flooding through his body of something that was not so much desire as an insane possessiveness. He understood for the first time the classical jealousy of the Italian male. He was at that moment ready to kill anyone who touched this girl, who tried to claim her, take her away from him. He wanted to own her as wildly as a miser wants to own gold coins, as hungrily as a share-cropper wants to own his own land. Nothing was going to stop him from owning this girl, possessing her, locking her in a house, and keeping her prisoner only for himself. He didn't want anyone even to see her. When she turned to smile at one of her brothers Michael gave that young man a murderous look without even realizing it. The family could see it was a classical case of the 'thunderbolt' and they were reassured. This young man would be putty in their daughter's hands until they were married. After that of course things would change but it wouldn't matter.

Michael had bought himself some new clothes in Palermo and was no longer the roughly dressed peasant, and it was obvious to the family that he was a Don of some kind. His smashed face did not make him as evil-looking as he believed; because his other profile was so handsome it made the disfigurement interesting even. And in any case this was a land where to be called disfigured you had to compete with a host of men who had suffered extreme physical misfortune.

Michael looked directly at the girl, the lovely ovals of her face. Her lips now he could see were almost blue so dark was the blood pulsating in them. He said, not daring to speak her

343

name, 'I saw you by the orange groves the other day. When you ran away. I hope I didn't frighten you?'

The girl raised her eyes to him for just a fraction. She shook her head. But the loveliness of those eyes had made Michael look away. The mother said tartly, 'Apollonia, speak to the poor fellow, he's come miles to see you,' but the girl's long jet lashes remained closed like wings over her eyes. Michael handed her the present wrapped in gold paper and the girl put it in her lap. The father said, 'Open it, girl,' but her hands did not move. Her hands were small and brown, an urchin's hands. The mother reached over and opened the package impatiently, yet careful not to tear the precious paper. The red velvet jeweller's box gave her pause, she had never held such a thing in her hands and didn't know how to spring its catch. But she got it open on pure instinct and then took out the present.

It was a heavy gold chain to be worn as a necklace, and it awed them not only because of its obvious value but because a gift of gold in this society was also a statement of the most serious intentions. It was no less than a proposal of matrimony, or rather the signal that there was the intention to propose matrimony. They could no longer doubt the seriousness of this stranger. And they could not doubt his substance.

Apollonia still had not touched her present. Her mother held it up for her to see and she raised those long lashes for a moment and then she looked directly at Michael, her doelike brown eyes grave, and said, '*Grazia.*' It was the first time he had heard her voice.

It had all the velvety softness of youth and shyness and it set Michael's ears ringing. He kept looking away from her and talking to the father and mother simply because looking at her confused him so much. But he noticed that despite the conservative looseness of her dress her body almost shone through the cloth with sheer sensuality. And he noticed the darkening of her skin blushing, the dark creamy skin, going darker with the blood surging to her face.

Finally Michael rose to go and the family rose too. They said their goodbyes formally, the girl at last confronting him as they shook hands, and he felt the shock of her skin on his

344

skin, her skin warm and rough, peasant skin. The father walked down the hill with him to his car and invited him to Sunday dinner the next week. Michael nodded but knew he couldn't wait a week to see the girl again.

He didn't. The next day, without his shepherds, he drove to the village and sat on the garden terrace of the café to chat with her father. Signor Vitelli took pity on him and sent for his wife and daughter to come down to the café to join them. This meeting was less awkward. The girl Apollonia was less shy, and spoke more. She was dressed in her everyday print frock which suited her colouring much better.

The next day the same thing happened. Only this time Apollonia was wearing the gold chain he had given her. He smiled at her then, knowing that this was a signal to him. He walked with her up the hill, her mother close behind them. But it was impossible for the two young people to keep their bodies from brushing against each other and once Apollonia stumbled and fell against him so that he had to hold her and her body so warm and alive in his hands started a deep wave of blood rising in his body. They could not see the mother behind them smiling because her daughter was a mountain goat and had not stumbled on this path since she was an infant in diapers. And smiling because this was the only way this young man was going to get his hands on her daughter until the marriage.

This went on for two weeks. Michael brought her presents every time he came and gradually she became less shy. But they could never meet without a chaperone being present. She was just a village girl, barely literate, with no idea of the world, but she had a freshness, an eagerness for life that, with help of the language barrier, made her seem interesting. Everything went very swiftly at Michael's request. And because the girl was not only fascinated by him but knew he must be rich, a wedding date was set for the Sunday two weeks away.

Now Don Tommasino took a hand. He had received word from America that Michael was not subject to orders but that all elementary precautions should be taken. So Don Tommasino appointed himself the parent of the bridegroom to insure the presence of his own bodyguards. Calo and Fabrizzio were also members of the wedding party from Corleone

as was Dr Taza. The bride and groom would live in Dr Taza's villa surrounded by its stone wall.

The wedding was the usual peasant one. The villagers stood in the streets and threw flowers as the bridal party, principals and guests, went on foot from the church to the bride's home. The wedding procession pelted the neighbours with sugar-coated almonds, the traditional wedding candies, and with candies left over made sugary white mountains on the bride's wedding bed, in this case only a symbolic one since the first night would be spent in the villa outside Corleone. The wedding feast went on until midnight but bride and groom would leave before that in the Alfa Romeo. When that time came Michael was surprised to find that the mother was coming with them to the Corleone villa at the request of the bride. The father explained: the girl was young, a virgin, a little frightened, she would need someone to talk to on the morning following her bridal night; to put her on the right track if things went wrong. These matters could sometimes get very tricky. Michael saw Apollonia looking at him with doubt in her huge doe-brown eyes. He smiled at her and nodded.

And so it came about that they drove back to the villa outside Corleone with the mother-in-law in the car. But the older woman immediately put her head together with the servants of Dr Taza, gave her daughter a hug and a kiss and disappeared from the scene. Michael and his bride were allowed to go to their huge bedroom alone.

Apollonia was still wearing her bridal costume with a cloak thrown over it. Her trunk and case had been brought up to the room from the car. On a small table was a bottle of wine and a plate of small wedding cakes. The huge canopied bed was never out of their vision. The young girl in the centre of the room waited for Michael to make the first move.

And now that he had her alone, now that he legally possessed her, now that there was no barrier to his enjoying that body and face he had dreamed about every night, Michael could not bring himself to approach her. He watched as she took off the bridal shawl and draped it over a chair, and placed the bridal crown on the small dressing table. That table had an array of perfumes and creams that Michael had had sent

from Palermo. The girl tallied them with her eyes for a moment.

Michael turned off the lights, thinking the girl was waiting for some darkness to shield her body while she undressed. But the Sicilian moon came through the unshuttered windows, bright as gold, and Michael went to close the shutters but not all the way, the room would be too warm.

The girl was still standing by the table and so Michael went out of the room and down the hall to the bathroom. He and Dr Taza and Don Tommasino had taken a glass of wine together in the garden while the women had prepared themselves for bed. He had expected to find Apollonia in her nightgown when he returned, already between the covers. He was surprised that the mother had not done this service for her daughter. Maybe Apollonia had wanted him to help her to undress. But he was certain she was too shy, too innocent for such forward behaviour.

Coming back into the bedroom, he found it completely dark, someone had closed the shutters all the way. He groped his way towards the bed and could make out the shape of Apollonia's body lying under the covers, her back to him, her body curved away from him and huddled up. He undressed and slipped naked beneath the sheets. He stretched out one hand and touched silky naked skin. She had not put on her gown and this boldness delighted him. Slowly, carefully, he put one hand on her shoulder and pressed her body gently so that she would turn to him. She turned slowly and his hand touched her breast, soft, full and then she was in his arms so quickly that their bodies came together in one line of silken electricity and he finally had his arms around her, was kissing her warm mouth deeply, was crushing her body and breasts against him and then rolling his body on top of hers.

Her flesh and hair, taut silk, now she was all eagerness, surging against him wildly in a virginal erotic frenzy. When he entered her she gave a little gasp and was still for just a second and then in a powerful forward thrust of her pelvis she locked her satiny legs around his hips. When they came to the end they were locked together so fiercely, straining against

each other so violently, that falling away from each other was like the tremble before death.

That night and the weeks that followed, Michael Corleone came to understand the premium put on virginity by socially primitive people. It was a period of sensuality that he had never before experienced, a sensuality mixed with a feeling of masculine power. Apollonia in those first days became almost his slave. Given trust, given affection, a young full-blooded girl aroused from virginity to erotic awareness was as delicious as an exactly ripe fruit.

She on her part brightened up the rather gloomy masculine atmosphere of the villa. She had packed her mother off the very next day after her bridal night and presided at the communal table with bright girlish charm. Don Tommasino dined with them every night and Dr Taza told all his old stories as they drank wine in the garden full of statues garlanded with blood-red flowers, and so the evenings passed pleasantly enough. At night in their bedroom the newly married couple spent hours of feverish lovemaking. Michael could not get enough of Apollonia's beautifully sculpted body, her honey-coloured skin, her huge brown eyes glowing with passion. She had a wonderfully fresh smell, a fleshly smell perfumed by her sex yet almost sweet and unbearably aphrodisiacal. Her virginal passion matched his nuptial lust and often it was dawn when they fell into an exhausted slumber. Sometimes, spent but not yet ready for sleep, Michael sat on the window ledge and stared at Apollonia's naked body while she slept. Her face too was lovely in repose, a perfect face he had seen before only in art books of painted Italian Madonnas who by no stretch of the artist's skill could be thought virginal.

In the first week of their marriage they went on picnics and small trips in the Alfa Romeo. But then Don Tommasino took Michael aside and explained that the marriage had made his presence and identity common knowledge in that part of Sicily and precautions had to be taken against the enemies of the Corleone Family, whose long arms also stretched to this island refuge. Don Tommasino put armed guards around his villa and the two shepherds, Calo and Fabrizzio, were fixtures inside the walls. So Michael and his wife had to remain on the villa

grounds. Michael passed the time by teaching Apollonia to read and write English and to drive the car along the inner walls of the villa. About this time Don Tommasino seemed to be preoccupied and poor company, he was still having trouble with the new Mafia in the town of Palermo, Dr Taza said.

One night in the garden an old village woman who worked in the house as a servant brought a dish of fresh olives and then turned to Michael and said, 'Is it true what everybody is saying that you are the son of Don Corleone in New York City, the Godfather?'

Michael saw Don Tommasino shaking his head in disgust at the general knowledge of their secret. But the old crone was looking at him in so concerned a fashion, as if it was important for her to know the truth, that Michael nodded. 'Do you know my father?' he asked.

The woman's name was Filomena and her face was as wrinkled and brown as a walnut, her brown-stained teeth showing through the shell of her flesh. For the first time since he had been in the villa she smiled at him. 'The Godfather saved my life once,' she said, 'and my brains too.' She made a gesture towards her head.

She obviously wanted to say something else so Michael smiled to encourage her. She asked almost fearfully, 'Is it true that Luca Brasi is dead?'

Michael nodded again and was surprised at the look of release on the old woman's face. Filomena crossed herself and said, 'God forgive me, but may his soul roast in hell for eternity.'

Michael remembered his old curiosity about Brasi, and had the sudden intuition that this woman knew the story Hagen and Sonny had refused to tell him. He poured the woman a glass of wine and made her sit down. 'Tell me about my father and Luca Brasi,' he said gently. 'I know some of it, but how did they become friends and why was Brasi so devoted to my father? Don't be afraid, come tell me.'

Filomena's wrinkled face, her raisin-black eyes, turned to Don Tommasino, who in some way signalled his permission. And so Filomena passed the evening for them by telling her story.

349

Thirty years before, Filomena had been a midwife in New York City, on Tenth Avenue, servicing the Italian colony. The women were always pregnant and she prospered. She taught doctors a few things when they tried to interfere in a difficult birth. Her husband was then a prosperous grocery store owner, dead now poor soul, she blessed him, though he had been a card player and wencher who never thought to put aside for hard times. In any event one cursed night thirty years ago when all honest people were long in their beds, there came a knocking on Filomena's door. She was by no means frightened, it was the quiet hour babes prudently chose to enter safely into this sinful world, and so she dressed and opened the door. Outside it was Luca Brasi whose reputation even then was fearsome. It was known also that he was a bachelor. And so Filomena was immediately frightened. She thought he had come to do her husband harm, that perhaps her husband had foolishly refused Brasi some small favour.

But Brasi had come on the usual errand. He told Filomena that there was a woman about to give birth, that the house was out of the neighbourhood some distance away and that she was to come with him. Filomena immediately sensed something was amiss. Brasi's brutal face looked almost like that of a madman that night, he was obviously in the grip of some demon. She tried to protest that she attended only women whose history she knew but he shoved a handful of green dollars in her hand and ordered her roughly to come along with him. She was too frightened to refuse.

In the street was a Ford, its driver of the same feather as Luca Brasi. The drive was no more than thirty minutes to a small frame house in Long Island City right over the bridge. A two-family house but obviously now tenanted only by Brasi and his gang. For there were some other ruffians in the kitchen playing cards and drinking. Brasi took Filomena up the stairs to a bedroom. In the bed was a young pretty girl who looked Irish, her face painted, her hair red; and with a belly swollen like a sow. The poor girl was so frightened. When she saw Brasi she turned her head away in terror, yes terror, and indeed the look of hatred on Brasi's evil face was the most frightening thing she had ever seen in her life. (Here Filomena crossed herself again.)

To make a long story short, Brasi left the room. Two of his men assisted the midwife and the baby was born, the mother was exhausted and went into a deep sleep. Brasi was summoned and Filomena, who had wrapped the newborn child in an extra blanket, extended the bundle to him and said, 'If you're the father, take her. My work is finished.'

Brasi glared at her, malevolent, insanity stamped on his face. 'Yes, I'm the father,' he said. 'But I don't want any of that race to live. Take it down to the basement and throw it into the furnace.'

For a moment Filomena thought she had not understood him properly. She was puzzled by his use of the word 'race'. Did he mean because the girl was not Italian? Or did he mean because the girl was obviously of the lowest type; a whore in short? Or did he mean that anything springing from his loins he forbade to live. And then she was sure he was making a brutal joke. She said shortly, 'It's your child, do what you want.' And she tried to hand him the bundle.

At this time the exhausted mother awoke and turned on her side to face them. She was just in time to see Brasi thrust violently at the bundle, crushing the newborn infant against Filomena's chest. She called out weakly, 'Luc, Luc, I'm sorry,' and Brasi turned to face her.

It was terrible, Filomena said now. So terrible. They were like two mad animals. They were not human. The hatred they bore each other blazed through the room. Nothing else, not even the newborn infant, existed for them at that moment. And yet there was a strange passion. A bloody, demonical lust so unnatural you knew they were damned forever. Then Luca Brasi turned back to Filomena and said harshly, 'Do what I tell you, I'll make you rich.'

Filomena could not speak in her terror. She shook her head. Finally she managed to whisper, 'You do it, you're the father, do it if you like.' But Brasi didn't answer. Instead he drew a knife from inside his shirt. 'I'll cut your throat,' he said.

She must have gone into shock then because the next thing she remembered they were all standing in the basement of the house in front of a square iron furnace. Filomena was still holding the blanketed baby, which had not made a sound.

(Maybe if it had cried, maybe if I had been shrewd enough to pinch it, Filomena said, that monster would have shown mercy.)

One of the men must have opened the furnace door, the fire now was visible. And then she was alone with Brasi in that basement with its sweating pipes, its mousy odour. Brasi had his knife out again. And there could be no doubting that he would kill her. There were the flames, there were Brasi's eyes. His face was the gargoyle of the devil, it was not human, it was not sane. He pushed her towards the open furnace door.

At this point, Filomena fell silent. She folded her bony hands in her lap and looked directly at Michael. He knew what she wanted, how she wanted to tell him, without using her voice. He asked gently, 'Did you do it?' She nodded.

It was only after another glass of wine and crossing herself and muttering a prayer that she continued her story. She was given a bundle of money and driven home. She understood that if she uttered a word about what had happened she would be killed. But two days later Brasi murdered the young Irish girl, the mother of the infant, and was arrested by the police. Filomena, frightened out of her wits, went to the Godfather and told her story. He ordered her to keep silent, that he would attend to everything. At that time Brasi did not work for Don Corleone.

Before Don Corleone could set matters right, Luca Brasi tried to commit suicide in his cell, hacking at his throat with a piece of glass. He was transferred to the prison hospital and by the time he recovered Don Corleone had arranged everything. The police did not have a case they could prove in court and Luca Brasi was released.

Though Don Corleone assured Filomena that she had nothing to fear from either Luca Brasi or the police, she had no peace. Her nerves were shattered and she could no longer work at her profession. Finally she persuaded her husband to sell the grocery store and they returned to Italy. Her husband was a good man, had been told everything and understood. But he was a weak man and in Italy squandered the fortune they had both slaved in America to earn. And so after he died she had become a servant. So Filomena ended her story. She

352

had another glass of wine and said to Michael, 'I bless the name of your father. He always sent me money when I asked, he saved me from Brasi. Tell him I say a prayer for his soul every night and that he shouldn't fear dying.'

After she had left, Michael asked Don Tommasino, 'Is her story true?' The *capo-mafioso* nodded. And Michael thought, no wonder nobody had wanted to tell him the story. Some story. Some Luca.

The next morning Michael wanted to discuss the whole thing with Don Tommasino but learned that the old man had been called to Palermo by an urgent message delivered by a courier. That evening Don Tommasino returned and took Michael aside. News had come from America, he said. News that it grieved him to tell. Santino Corleone had been killed.

CHAPTER TWENTY-FOUR

THE SICILIAN sun, early-morning lemon-coloured, filled Michael's bedroom. He awoke and, feeling Apollonia's satiny body against his own sleep-warm skin, made her come awake with love. When they were done, even all the months of complete possession could not stop him from marvelling at her beauty and her passion.

She left the bedroom to wash and dress in the bathroom down the hall. Michael, still naked, the morning sun refreshing his body, lit a cigarette and relaxed on the bed. This was the last morning they would spend in this house and the villa. Don Tommasino had arranged for him to be transferred to another town on the southern coast of Sicily. Apollonia, in the first month of pregnancy, wanted to visit with her family for a few weeks and would join him at the new hiding place after the visit.

The night before, Don Tommasino had sat with Michael in the garden after Apollonia had gone to bed. The Don had been worried and tired, and admitted that he was concerned about Michael's safety. 'Your marriage brought you into sight,' he

told Michael. 'I'm surprised your father hasn't made arrangements for you to go some place else. In any case I'm having my own troubles with the young Turks in Palermo. I've offered some fair arrangements so that they can wet their beaks more than they deserve, but those scum want everything. I can't understand their attitude. They've tried a few little tricks but I'm not so easy to kill. They must know I'm too strong for them to hold me so cheaply. But that's the trouble with young people, no matter how talented. They don't reason things out and they want all the water in the well.'

And then Don Tommasino had told Michael that the two shepherds, Fabrizzio and Calo, would go with him as bodyguards in the Alfa Romeo. Don Tommasino would say his goodbyes tonight since he would be off early in the morning, at dawn, to see to his affairs in Palermo. Also, Michael was not to tell Dr Taza about the move, since the doctor planned to spend the evening in Palermo and might blab.

Michael had known Don Tommasino was in trouble. Armed guards patrolled the walls of the villa at night and a few faithful shepherds with their *luparas* were always in the house. Don Tommasino himself went heavily armed and a personal bodyguard attended him at all times.

The morning sun was now too strong. Michael stubbed out his cigarette and put on work pants, work shirt, and the peaked cap most Sicilian men wore. Still barefooted, he leaned out his bedroom window and saw Fabrizzio sitting in one of the garden chairs. Fabrizzio was lazily combing his thick dark hair, his *lupara* was carelessly thrown across the garden table. Michael whistled and Fabrizzio looked up to his window.

'Get the car,' Michael called down to him. 'I'll be leaving in five minutes. Where's Calo?'

Fabrizzio stood up. His shirt was open, exposing the blue and red lines of the tattoo on his chest. 'Calo is having a cup of coffee in the kitchen,' Fabrizzio said. 'Is your wife coming with you?'

Michael squinted down at him. It occurred to him that Fabrizzio had been following Apollonia too much with his eyes the last few weeks. Not that he would dare ever to make an advance towards the wife of a friend of the Don's. In Sicily

354

there was no surer road to death. Michael said coldly, 'No, she's going to her family first, she'll join us in a few days.' He watched Fabrizzio hurry into the stone hut that served as a garage for the Alfa Romeo.

Michael went down the hall to wash. Apollonia was gone. She was most likely in the kitchen preparing his breakfast with her own hands to wash out the guilt she felt because she wanted to see her family one more time before going so far away to the other end of Sicily. Don Tommasino would arrange transportation for her to where Michael would be.

Down in the kitchen the old woman Filomena brought him his coffee and shyly bid him a goodbye. 'I'll remember you to my father,' Michael said and she nodded.

Calo came into the kitchen and said to Michael, 'The car's outside, shall I get your bag?'

'No, I'll get it,' Michael said. 'Where's Apolla?'

Calo's face broke into an amused grin. 'She's sitting in the driver's seat of the car, dying to step on the gas. She'll be a real American woman before she gets to America.' It was unheard of for one of the peasant women in Sicily to attempt driving a car. But Michael sometimes let Apollonia guide the Alfa Romeo around the inside of the villa walls, always beside her however because she sometimes stepped on the gas when she meant to step on the brake.

Michael said to Calo, 'Get Fabrizzio and wait for me in the car.' He went out of the kitchen and ran up the stairs to the bedroom. His bag was already packed. Before picking it up he looked out the window and saw the car parked in front of the portico steps rather than the kitchen entrance. Apollonia was sitting in the car, her hands on the wheel like a child playing. Calo was just putting the lunch basket in the rear seat. And then Michael was annoyed to see Fabrizzio disappearing through the gates of the villa on some errand outside. What the hell was he doing? He saw Fabrizzio take a look over his shoulder, a look that was somehow furtive. He'd have to straighten that damn shepherd out. Michael went down the stairs and decided to go through the kitchen to see Filomena again and give her a final farewell. He asked the old woman, 'Is Dr Taza still sleeping?'

Filomena's wrinkled face was sly. 'Old roosters can't greet the sun. The doctor went to Palermo last night.'

Michael laughed. He went out the kitchen entrance and the smell of lemon blossoms penetrated even his sinus-filled nose. He saw Apollonia wave to him from the car just ten paces up the villa's driveway and then he realized she was motioning him to stay where he was, that she meant to drive the car to where he stood. Calo stood grinning beside the car, his *lupara* dangling in his hand. But there was still no sign of Fabrizzio. At that moment, without any conscious reasoning process, everything came together in his mind, and Michael shouted to the girl, 'No! No!' But his shout was drowned in the roar of the tremendous explosion as Apollonia switched on the ignition. The kitchen door shattered into fragments and Michael was hurled along the wall of the villa for a good ten feet. Stones tumbling from the villa roof hit him on the shoulders and one glanced off his skull as he was lying on the ground. He was conscious just long enough to see that nothing remained of the Alfa Romeo but its four wheels and the steel shafts which held them together.

He came to consciousness in a room that seemed very dark and heard voices that were so low that they were pure sound rather than words. Out of animal instinct he tried to pretend he was still unconscious but the voices stopped and someone was leaning from a chair close to his bed and the voice was distinct now, saying, 'Well, he's with us finally.' A lamp went on, its light like white fire on his eyeballs and Michael turned his head. It felt very heavy, numb. And then he could see the face over his bed was that of Dr Taza.

'Let me look at you a minute and I'll put the light out,' Dr Taza said gently. He was busy shining a small pencil flashlight into Michael's eyes. 'You'll be all right,' Dr Taza said and turned to someone else in the room. 'You can speak to him.'

It was Don Tommasino sitting on a chair near his bed, Michael could see him clearly now. Don Tommasino was saying, 'Michael, Michael, can I talk to you? Do you want to rest?'

It was easier to raise a hand to make a gesture and Michael

did so and Don Tommasino said, 'Did Fabrizzio bring from the garage?'

Michael, without knowing he did so, smiled. It was in some strange way, a chilling smile, of assent. Don Tommasino said, 'Fabrizzio has vanished. Listen to me, Michael. You've been unconscious for nearly a week. Do you understand? Everybody thinks you're dead, so you're safe now, they've stopped looking for you. I've sent messages to your father and he's sent back instructions. It won't be long now, you'll be back in America. Meanwhile you'll rest here quietly. You're safe up in the mountains, in a special farmhouse I own. The Palermo people have made their peace with me now that you're supposed to be dead, so it was you they were after all the time. They wanted to kill you while making people think it was me they were after. That's something you should know. As for everything else, leave it all to me. You recover your strength and be tranquil.'

Michael was remembering everything now. He knew his wife was dead, that Calo was dead. He thought of the old woman in the kitchen. He couldn't remember if she had come outside with him. He whispered, 'Filomena?' Don Tommasino said quietly, 'She wasn't hurt, just a bloody nose from the blast. Don't worry about her.'

Michael said, 'Fabrizzio. Let your shepherds know that the one who gives me Fabrizzio will own the finest pastures in Sicily.'

Both men seemed to sigh with relief. Don Tommasino lifted a glass from a nearby table and drank from it an amber fluid that jolted his head up. Dr Taza sat on the bed and said almost absently, 'You know, you're a widower. That's rare in Sicily.' As if the distinction might comfort him.

Michael motioned to Don Tommasino to lean closer. The Don sat on the bed and bent his head. 'Tell my father to get me home,' Michael said. 'Tell my father I wish to be his son.'

But it was to be another month before Michael recovered from his injuries and another two months after that before all the necessary papers and arrangements were ready. Then he was flown from Palermo to Rome and from Rome to New York. In all that time no trace had been found of Fabrizzio.

Book VII

CHAPTER TWENTY-FIVE

WHEN KAY Adams received her college degree, she took a job teaching grade school in her New Hampshire hometown. The first six months after Michael vanished she made weekly telephone calls to his mother asking about him. Mrs Corleone was always friendly and always wound up saying, 'You a very very nice girl. You forget about Mikey and find a nice husband.' Kay was not offended at her bluntness and understood that the mother spoke out of concern for her as a young girl in an impossible situation.

When her first school term ended, she decided to go to New York to buy some decent clothes and see some old college girl-friends. She thought also about looking for some sort of interesting job in New York. She had lived like a spinster for almost two years, reading and teaching, refusing dates, refusing to go out at all, even though she had given up making calls to Long Beach. She knew she couldn't keep that up, she was becoming irritable and unhappy. But she had always believed Michael would write her or send her a message of some sort. That he had not done so humiliated her, it saddened her that he was so distrustful even of her.

She took an early train and was checked into her hotel by mid-afternoon. Her girlfriends worked and she didn't want to bother them at their jobs, she planned to call them at night. And she didn't really feel like going shopping after the exhausting train trip. Being alone in the hotel room, remembering all the times she and Michael had used hotel rooms to make love, gave her a feeling of desolation. It was that more than anything else that gave her the idea of calling Michael's mother out in Long Beach.

The phone was answered by a rough masculine voice with a typical, to her, New York accent. Kay asked to speak to Mrs

Corleone. There was a few minutes' silence and then Kay heard the heavily accented voice asking who it was.

Kay was a little embarrassed now. 'This is Kay Adams, Mrs Corleone,' she said. 'Do you remember me?'

'Sure, sure, I remember you,' Mrs Corleone said. 'How come you no call up no more? You get a married?'

'Oh, no,' Kay said. 'I've been busy.' She was surprised at the mother obviously being annoyed that she had stopped calling. 'Have you heard anything from Michael? Is he all right?'

There was silence at the other end of the phone and then Mrs Corleone's voice came strong. 'Mikey is at home. He no call you up? He no see you?'

Kay felt her stomach go weak from shock and a humiliating desire to weep. Her voice broke a little when she asked, 'How long has he been home?'

Mrs Corleone said, 'Six months.'

'Oh, I see,' Kay said. And she did. She felt hot waves of shame that Michael's mother knew he was treating her so cheaply. And then she was angry. Angry at Michael, at his mother, angry at all foreigners, Italians who didn't have the common courtesy to keep up a decent show of friendship even if a love affair was over. Didn't Michael know she would be concerned for him as a friend even if he no longer wanted her for a bed companion, even if he no longer wanted to marry her? Did he think she was one of those poor benighted Italian girls who would commit suicide or make a scene after giving up her virginity and then being thrown over? But she kept her voice as cool as possible. 'I see, thank you very much,' she said. 'I'm glad Michael is home again and all right. I just wanted to know. I won't call you again.'

Mrs Corleone's voice came impatiently over the phone as if she had heard nothing that Kay had said. 'You wanta see Mikey, you come out here now. Give him a nice surprise. You take a taxi, and I tell the man at the gate to pay the taxi for you. You tell the taxi man he get two times his clock, otherwise he no come way out the Long Beach. But don't you pay. My husband's man at the gate pay the taxi.'

'I couldn't do that, Mrs Corleone,' Kay said coldly. 'If

Michael wanted to see me, he would have called me at home before this. Obviously he doesn't want to resume our relationship.'

Mrs Corleone's voice came briskly over the phone. 'You a very nice girl, you gotta nice legs, but you no gotta much brains.' She chuckled. 'You come out to see *me*, not Mikey. I wanta talk to you. You come right now. An' no pay the taxi. I wait for you.' The phone clicked. Mrs Corleone had hung up.

Kay could have called back and said she wasn't coming but she knew she had to see Michael, to talk to him, even if it was just polite talk. If he was home now, openly, that meant he was no longer in trouble, he could live normally. She jumped off the bed and started to get ready to see him. She took a great deal of care with her makeup and dress. When she was ready to leave she stared at her reflection in the mirror. Was she better-looking than when Michael had disappeared? Or would he find her unattractively older? Her figure had become more womanly, her hips rounder, her breasts fuller, Italians liked that supposedly, though Michael had always said he loved her being so thin. It didn't matter really, Michael obviously didn't want anything to do with her any more, otherwise he most certainly would have called in the six months he had been home.

The taxi she hailed refused to take her to Long Beach until she gave him a pretty smile and told him she would pay double the meter. It was nearly an hour's ride and the mall in Long Beach had changed since she last saw it. There were iron fences around it and an iron gate barred the mall entrance. A man wearing slacks and a white jacket over a red shirt opened the gate, poked his head into the cab to read the meter and gave the cab driver some bills. Then when Kay saw the driver was not protesting and was happy with the money paid, she got out and walked across the mall to the central house.

Mrs Corleone herself opened the door and greeted Kay with a warm embrace that surprised her. Then she surveyed Kay with an appraising eye. 'You a beautiful girl,' she said flatly. 'I have stupid sons.' She pulled Kay inside the door and led her to the kitchen, where a platter of food was already set out

and a pot of coffee perked on the stove. 'Michael comes home pretty soon,' she said. 'You surprise him.'

They sat down together and the old woman forced Kay to eat, meanwhile asking questions with great curiosity. She was delighted that Kay was a schoolteacher and that she had come to New York to visit old girlfriends and that Kay was only twenty-four years old. She kept nodding her head as if all the facts accorded with some private specifications in her mind. Kay was so nervous that she just answered the questions, never saying anything else.

She saw him first through the kitchen window. A car pulled up in front of the house and two other men got out. Then Michael. He straightened up to talk with one of the other men. His profile, the left one, was exposed to her view. It was cracked, indented, like the plastic face of a doll that a child has wantonly kicked. In a curious way it did not mar his handsomeness in her eyes but moved her to tears. She saw him put a snow-white handkerchief to his mouth and nose and hold it there for a moment while he turned away to come into the house.

She heard the door open and his footsteps in the hall turning into the kitchen and then he was in the open space, seeing her and his mother. He seemed impassive, and then he smiled ever so slightly, the broken half of his face halting the widening of his mouth. And Kay, who had meant just to say 'Hello, how are you,' in the coolest possible way, slipped out of her seat to run into his arms, bury her face against his shoulder. He kissed her wet cheek and held her until she finished weeping and then he walked her out to his car, waved his bodyguard away and drove off with her beside him, she repairing her makeup by simply wiping what was left of it away with her handkerchief.

'I never meant to do that,' Kay said. 'It's just that nobody told me how badly they hurt you.'

Michael laughed and touched the broken side of his face. 'You mean this? That's nothing. Just gives me sinus trouble. Now that I'm home I'll probably get it fixed. I couldn't write you or anything,' Michael said. 'You have to understand that before anything else.'

'OK,' she said.

'I've got a place in the city,' Michael said. 'Is it all right if we go there or should it be dinner and drinks at a restaurant?'

'I'm not hungry,' Kay said.

They drove towards New York in silence for a while. 'Did you get your degree?' Michael asked.

'Yes,' Kay said. 'I'm teaching grade school in my hometown now. Did they find the man who really killed the policeman, is that why you were able to come home?'

For a moment Michael didn't answer. 'Yes, they did,' he said. 'It was in all the New York papers. Didn't you read about it?'

Kay laughed with the relief of him denying he was a murderer. 'We only get the New York *Times* up in our town,' she said. 'I guess it was buried back in page eighty-nine. If I'd read it I'd have called your mother sooner.' She paused and then said, 'It's funny, the way your mother used to talk, I almost believed you had done it. And just before you came, while we were drinking coffee, she told me about that crazy man who confessed.'

Michael said, 'Maybe my mother did believe it at first.'

'Your own mother?' Kay asked.

Michael grinned. 'Mothers are like cops. They always believe the worst.'

Michael parked the car in a garage on Mulberry Street where the owner seemed to know him. He took Kay around the corner to what looked like a fairly decrepit brownstone house which fitted into the rundown neighbourhood. Michael had a key to the front door and when they went inside Kay saw that it was as expensively and comfortably furnished as a millionaire's town house. Michael led her to the upstairs apartment which consisted of an enormous living room, a huge kitchen and door that led to the bedroom. In one corner of the living room was a bar and Michael mixed them both a drink. They sat on a sofa together and Michael said quietly, 'We might as well go into the bedroom.' Kay took a long pull from her drink and smiled at him. 'Yes,' she said.

For Kay the lovemaking was almost like it had been before except that Michael was rougher, more direct, not as tender

362

as he had been. As if he were on guard against her. But she didn't want to complain. It would wear off. In a funny way, men were more sensitive in a situation like this, she thought. She had found making love to Michael after a two-year absence the most natural thing in the world. It was as if he had never been away.

'You could have written me, you could have trusted me,' she said, nestling against his body. 'I would have practised the New England *omerta*. Yankees are pretty closemouthed too, you know.'

Michael laughed softly in the darkness. 'I never figured you to be waiting,' he said. 'I never figured you to wait after what happened.'

Kay said quickly, 'I never believed you killed those two men. Except maybe when your mother seemed to think so. But I never believed it in my heart. I know you too well.'

She could hear Michael give a sigh. 'It doesn't matter whether I did or not,' he said. 'You have to understand that.'

Kay was a little stunned by the coldness in his voice. She said, 'So just tell me now, did you or didn't you?'

Michael sat up on his pillow and in the darkness a light flared as he got a cigarette going. 'If I asked you to marry me, would I have to answer that question first before you'd give me an answer to mine?'

Kay said, 'I don't care, I love you, I don't care. If you loved me you wouldn't be afraid to tell me the truth. You wouldn't be afraid I might tell the police. That's it, isn't it? You're really a gangster then, isn't that so? But I really don't care. What I care about is that you obviously don't love me. You didn't even call me up when you got back home.'

Michael was puffing on his cigarette and some burning ashes fell on Kay's bare back. She flinched a little and said jokingly, 'Stop torturing me, I won't talk.'

Michael didn't laugh. His voice sounded absentminded. 'You know, when I came home I wasn't that glad when I saw my family, my father, my mother, my sister Connie, and Tom. It was nice but I didn't really give a damn. Then I came home tonight and saw you in the kitchen and I was glad. Is that what you mean by love?'

'That's close enough for me,' Kay said.

They made love again for a while. Michael was more tender this time. And then he went out to get them both a drink. When he came back he sat on an armchair facing the bed. 'Let's get serious,' he said. 'How do you feel about marrying me?' Kay smiled at him and motioned him into the bed. Michael smiled back at her. 'Be serious,' he said. 'I can't tell you about anything that happened. I'm working for my father now. I'm being trained to take over the family olive oil business. But you know my family has enemies, my father has enemies. You might be a very young widow, there's a chance, not much of a one, but it could happen. And I won't be telling you what happened at the office every day. I won't be telling you anything about my business. You'll be my wife but you won't be my partner in life, as I think they say. Not an equal partner. That can't be.'

Kay sat up in bed. She switched on a huge lamp standing on the night table and then she lit a cigarette. She leaned back on the pillows and said quietly, 'You're telling me you're a gangster, isn't that it? You're telling me that you're responsible for people being killed and other sundry crimes related to murder. And that I'm not ever to ask about that part of your life, not even to think about it. Just like in the horror movies when the monster asks the beautiful girl to marry him.' Michael grinned, the cracked part of his face turned towards her, and Kay said in contrition, 'Oh, Mike, I don't even notice that stupid thing, I swear I don't.'

'I know,' Michael said laughing. 'I like having it now except that it makes the snot drip out of my nose.'

'You said be serious,' Kay went on. 'If we get married what kind of a life am I supposed to lead? Like your mother, like an Italian housewife with just the kids and home to take care of? And what about if something happens? I suppose you could wind up in jail someday.'

'No, that's not possible,' Michael said. 'Killed, yes; jail, no.'

Kay laughed at this confidence, it was a laugh that had a funny mixture of pride with its amusement. 'But how can you say that?' she said. 'Really.'

Michael sighed. 'These are all the things I can't talk to you about, I don't want to talk to you about.'

Kay was silent for a long time. 'Why do you want me to marry you after never calling me all these months? Am I so good in bed?'

Michael nodded gravely. 'Sure,' he said. 'But I'm getting it for nothing so why should I marry you for that? Look, I don't want an answer now. We're going to keep seeing each other. You can talk it over with your parents. I hear your father is a real tough guy in his own way. Listen to his advice.'

'You haven't answered why, why you want to marry me,' Kay said.

Michael took a white handkerchief from the drawer of the night table and held it to his nose. He blew into it and then wiped. 'There's the best reason for not marrying me,' he said. 'How would that be having a guy around who always has to blow his nose?'

Kay said impatiently, 'Come on, be serious, I asked you a question.'

Michael held the handkerchief in his hand. 'OK,' he said, 'this one time. You are the only person I felt any affection for, that I care about. I didn't call you because it never occurred to me that you'd still be interested in me after everything that's happened. Sure, I could have chased you, I could have conned you, but I didn't want to do that. Now here's something I'll trust you with and I don't want you to repeat it even to your father. If everything goes right, the Corleone Family will be completely legitimate in about five years. Some very tricky things have to be done to make that possible. That's when you may become a wealthy widow. Now what do I want you for? Well, because I want you and I want a family. I want kids; it's time. And I don't want those kids to be influenced by me the way I was influenced by my father. I don't mean my father deliberately influenced me. He never did. He never even wanted me in the family business. He wanted me to become a professor or a doctor, something like that. But things went bad and I had to fight for my Family. I had to fight because I love and admire my father. I never knew a man more worthy of respect. He was a good husband and a good father and a

good friend to people who were not so fortunate in life. There's another side to him, but that's not relevant to me as his son. Anyway I don't want that to happen to my kids. I want them to be influenced by you. I want them to grow up to be All-American kids, real All-American, the whole works. Maybe they or their grandchildren will go into politics.' Michael grinned. 'Maybe one of them will be President of the United States. Why the hell not? In my history course at Dartmouth we did some background on all the Presidents and they had fathers and grandfathers who were lucky they didn't get hanged. But I'll settle for my kids being doctors or musicians or teachers. They'll never be in the Family business. By the time they are that old I'll be retired anyway. And you and I will be part of some country club crowd, the good simple life of well-to-do Americans. How does that strike you for a proposition?'

'Marvellous,' Kay said. 'But you sort of skipped over the widow part.'

'There's not much chance of that. I just mentioned it to give a fair presentation.' Michael patted his nose with the handkerchief.

'I can't believe it, I can't believe you're a man like that, you're just not,' Kay said. Her face had a bewildered look. 'I just don't understand the whole thing, how it could possibly be.'

'Well, I'm not giving any more explanations,' Michael said gently. 'You know, you don't have to think about any of this stuff, it has nothing to do with you really, or with our life together if we get married.'

Kay shook her head. 'How can you want to marry me, how can you hint that you love me, you never say the word but you just now said you loved your father, you never said you loved me, how could you if you distrust me so much you can't tell me about the most important things in your life? How can you want to have a wife you can't trust? Your father trusts your mother. I know that.'

'Sure,' Michael said. 'But that doesn't mean he tells her everything. And, you know, he has reason to trust her. Not because they got married and she's his wife. But she bore him four children in times when it was not that safe to bear chil-

366

dren. She nursed and guarded him when people shot him. She believed in him. He was always her first loyalty for forty years. After you do that maybe I'll tell you a few things you really don't want to hear.'

'Will we have to live in the mall?' Kay asked.

Michael nodded. 'We'll have our own house, it won't be so bad. My parents don't meddle. Our lives will be our own. But until everything gets straightened out, I have to live in the mall.'

'Because it's dangerous for you to live outside it,' Kay said.

For the first time since she had come to know him, she saw Michael angry. It was cold chilling anger that was not externalized in any gesture or change in voice. It was a coldness that came off him like death and Kay knew that it was this coldness that would make her decide not to marry him if she so decided.

'The trouble is all that damn trash in the movies and the newspapers,' Michael said. 'You've got the wrong idea of my father and the Corleone Family. I'll make a final explanation and this one will be really final. My father is a businessman trying to provide for his wife and children and those friends he might need someday in a time of trouble. He doesn't accept the rules of the society we live in because those rules would have condemned him to a life not suitable to a man like himself, a man of extraordinary force and character. What you have to understand is that he considers himself the equal of all those great men like Presidents and Prime Ministers and Supreme Court Justices and Governors of the States. He refuses to accept their will over his own. He refuses to live by rules set up by others, rules which condemn him to a defeated life. But his ultimate aim is to enter that society with a certain power since society doesn't really protect its members who do not have their own individual power. In the meantime he operates on a code of ethics he considers far superior to the legal structures of society.'

Kay was looking at him incredulously. 'But that's ridiculous,' she said. 'What if everybody felt the same way? How could society ever function, we'd be back in the times of the cavemen. Mike, you don't believe what you're saying, do you?'

Michael grinned at her. 'I'm just telling you what my father believes. I just want you to understand that whatever else he is, he's not irresponsible, or at least not in the society which he has created. He's not a crazy machine-gunning mobster as you seem to think. He's a responsible man in his own way.'

'And what do you believe?' Kay asked quietly.

Michael shrugged. 'I believe in my family,' he said. 'I believe in you and the family we may have. I don't trust society to protect us, I have no intention of placing my fate in the hands of men whose only qualification is that they managed to con a block of people to vote for them. But that's for now. My father's time is done. The things he did can no longer be done except with a great deal of risk. Whether we like it or not the Corleone Family has to join that society. But when they do I'd like us to join it with plenty of our own power; that is, money and ownership of other valuables. I'd like to make my children as secure as possible before they join that general destiny.'

'But you volunteered to fight for your country, you were a war hero,' Kay said. 'What happened to make you change?'

Michael said, 'This is really getting us no place. But maybe I'm just one of those real old-fashioned conservatives they grow up in your hometown. I take care of myself, individual. Governments really don't do much for their people, that's what it comes down to, but that's not it really. All I can say, I have to help my father, I have to be on his side. And you have to make your decision about being on my side.' He smiled at her. 'I guess getting married was a bad idea.'

Kay patted the bed. 'I don't know about marrying, but I've gone without a man for two years and I'm not letting you off so easy now. Come on in here.'

When they were in bed together, the light out, she whispered to him, 'Do you believe me about not having a man since you left?'

'I believe you,' Michael said.

'Did you?' she whispered in a softer voice.

'Yes,' Michael said. He felt her stiffen a little. 'But not in the last six months.' It was true. Kay was the first woman he had made love to since the death of Apollonia.

CHAPTER TWENTY-SIX

THE GARISH suite overlooked the fake fairyland grounds in the rear of the hotel; transplanted palm trees lit up by climbers of orange lights, two huge swimming pools shimmering dark blue by the light of the desert stars. On the horizon were the sand and stone mountains that ringed Las Vegas nestling in its neon valley. Johnny Fontane let the heavy, richly embroidered grey drape fall and turned back to the room.

A special detail of four men, a pit boss, a dealer, extra relief man, and a cocktail waitress in her scanty nightclub costume were getting things ready for private action. Nino Valenti was lying on the sofa in the living room part of the suite, a water glass of whisky in his hand. He watched the people from the casino setting up the blackjack table with the proper six padded chairs around its horseshoe outer rim. 'That's great, that's great,' he said in a slurred voice that was not quite drunken. 'Johnny, come on and gamble with me against these bastards. I got the luck. We'll beat their crullers in.'

Johnny sat on a footstool opposite the couch. 'You know I don't gamble,' he said. 'How you feeling, Nino?'

Nino Valenti grinned at him. 'Great. I got broads coming up at midnight, then some supper, then back to the blackjack table. You know I got the house beat for almost fifty grand and they've been grinding me for a week?'

'Yeah,' Johnny Fontane said. 'Who do you want to leave it to when you croak?'

Nino drained his glass empty. 'Johnny, where the hell did you get your rep as a swinger? You're a deadhead, Johnny. Christ, the tourists in this town have more fun than you do.'

Johnny said, 'Yeah. You want a lift to that blackjack table?'

Nino struggled erect on the sofa and planted his feet firmly on the rug. 'I can make it,' he said. He let the glass slip to the floor and got up and walked quite steadily to where the blackjack table had been set up. The dealer was ready. The pit boss stood behind the dealer watching. The relief dealer sat on a

chair away from the table. The cocktail waitress sat on another chair in a line of vision so that she could see any of Nino Valenti's gestures.

Nino rapped on the green baize with his knuckles. 'Chips,' he said.

The pit boss took a pad from his pocket and filled out a slip and put it in front of Nino with a small fountain pen. 'Here you are, Mr Valenti,' he said. 'The usual five thousand to start.' Nino scrawled his signature on the bottom of the slip and the pit boss put it in his pocket. He nodded to the dealer.

The dealer with incredibly deft fingers took stacks of black and gold one-hundred-dollars chips from the built-in racks before him. In not more than five seconds Nino had five even stacks of one-hundred-dollar chips before him, each stack had ten chips.

There were six squares a little larger than playing card shapes etched in white on the green baize, each square placed to correspond to where a player would sit. Now Nino was placing bets on three of these squares, single chips, and so playing three hands each for a hundred dollars. He refused to take a hit on all three hands because the dealer had a six up, a bust card, and the dealer did bust. Nino raked in his chips and turned to Johnny Fontane. 'That's how to start the night, huh, Johnny?'

Johnny smiled. It was unusual for a gambler like Nino to have to sign a chit while gambling. A word was usually good enough for the high rollers. Maybe they were afraid Nino wouldn't remember his take-out because of his drinking. They didn't know that Nino remembered everything.

Nino kept winning and after the third round lifted a finger at the cocktail waitress. She went to the bar at the end of the room and brought him his usual rye in a water glass. Nino took the drink, switched it to his other hand so he could put an arm around the waitress. 'Sit with me, honey, play a few hands; bring me luck.'

The cocktail waitress was a very beautiful girl, but Johnny could see she was all cold hustle, no real personality, though she worked at it. She was giving Nino a big smile but her tongue was hanging out for one of those black and gold chips.

What the hell, Johnny thought, why shouldn't she get some of it? He just regretted that Nino wasn't getting something better for his money.

Nino let the waitress play his hands for a few rounds and then gave her one of the chips and a pat on the behind to send her away from the table. Johnny motioned to her to bring him a drink. She did so but she did it as if she were playing the most dramatic moment in the most dramatic movie ever made. She turned all her charm on the great Johnny Fontane. She made her eyes sparkle with invitation, her walk was the sexiest walk ever walked, her mouth was very slightly parted as if she were ready to bite the nearest object of her obvious passion. She resembled nothing so much as a female animal in heat, but it was a deliberate act. Johnny Fontane thought, oh, Christ, one of them. It was the most popular approach of women who wanted to take him to bed. It only worked when he was very drunk and he wasn't drunk now. He gave the girl one of his famous grins and said, 'Thank you, honey.' The girl looked at him and parted her lips in a thank-you smile, her eyes went all smoky, her body tensed with the torso leaning slightly back from the long tapering legs in their mesh stockings. An enormous tension seemed to be building up in her body, her breasts seemed to grow fuller and swell burstingly against her thin scantily cut blouse. Then her whole body gave a slight quiver that almost let off a sexual twang. The whole impression was one of a woman having an orgasm simply because Johnny Fontane had smiled at her and said, 'Thank you, honey.' It was very well done. It was done better than Johnny had ever seen it done before. But by now he knew it was fake. And the odds were always good that the broads who did it were a lousy lay.

He watched her go back to her chair and nursed his drink slowly. He didn't want to see that little trick again. He wasn't in the mood for it tonight.

It was an hour before Nino Valenti began to go. He started leaning first, wavered back, and then plunged off the chair straight to the floor. But the pit boss and the relief dealer had been alerted by the first weave and caught him before he hit the ground. They lifted him and carried him through the parted drapes that led to the bedroom of the suite.

Johnny kept watching as the cocktail waitress helped the other two men undress Nino and shove him under the bed covers. The pit boss was counting Nino's chips and making a note on his pad of chits, then guarding the table with its dealer's chips. Johnny said to him, 'How long has that been going on?'

The pit boss shrugged. 'He went early tonight. The first time we got the house doc and he fixed Mr Valenti up with something and gave him some sort of a lecture. Then Nino told us that we shouldn't call the doc when that happened, just put him to bed and he'd be OK in the morning. So that's what we do. He's pretty lucky, he was a winner again tonight, almost three grand.'

Johnny Fontane said, 'Well, let's get the house doc up here tonight, OK? Page the casino floor if you have to.'

It was almost fifteen minutes before Jules Segal came into the suite. Johnny noted with irritation that this guy never looked like a doctor. Tonight he was wearing a blue loose-knit polo shirt with white trim, some sort of white suede shoes, and no socks. He looked funny as hell carrying the traditional black doctor's bag.

Johnny said, 'You oughta figure out a way to carry your stuff in a cut-down golf bag.'

Jules grinned understandingly, 'Yeah, this medical school carry-all is a real drag. Scares the hell out of people. They should change the colour anyway.'

He went over to where Nino was lying in bed. As he opened his bag he said to Johnny, 'Thanks for that cheque you sent me as a consultant. It was excessive. I didn't do that much.'

'Like hell you didn't,' Johnny said. 'Anyway, forget that, that was a long time ago. What's with Nino?'

Jules was making a quick examination of heartbeat, pulse, and blood pressure. He took a needle out of his bag and shoved it casually into Nino's arm and pressed the plunger. Nino's sleeping face lost its waxy paleness, colour came into the cheeks, as if the blood had started pumping faster.

'Very simple diagnosis,' Jules said briskly. 'I had a chance to examine him and run some tests when he first came here and fainted. I had him moved to the hospital before he re-

gained consciousness. He's got diabetes, mild adult stabile, which is no problem if you take care of it with medication and diet and so forth. He insists on ignoring it. Also he is firmly determined to drink himself to death. His liver is going and his brain will go. Right now he's in a mild diabetic coma. My advice is to have him put away.'

Johnny felt a sense of relief. It couldn't be too serious, all Nino had to do was take care of himself. 'You mean in one of those joints where they dry you out?' Johnny asked.

Jules went over to the bar in the far corner of the room and made himself a drink. 'No,' he said. 'I mean committed. You know, the crazy house.'

'Don't be funny,' Johnny said.

'I'm not joking,' Jules said. 'I'm not up on all the psychiatric jazz but I know something about it, part of my trade. Your friend Nino can be put back into fairly good shape unless the liver damage has gone too far, which we can't know until an autopsy really. But the real disease is in his head. In essence he doesn't care if he dies, maybe he even wants to kill himself. Until that is cured there's no hope for him. That's why I say, have him committed and then he can undergo the necessary psychiatric treatment.'

There was a knock on the door and Johnny went to answer it. It was Lucy Mancini. She came into Johnny's arms and kissed him. 'Oh, Johnny, it's so good to see you,' she said.

'It's been a long time,' Johnny Fontane said. He noticed that Lucy had changed. She had got much slimmer, her clothes were a hell of a lot better and she wore them better. Her hair style fitted her face in a sort of boyish cut. She looked younger and better than he had ever seen her and the thought crossed his mind that she could keep him company here in Vegas. It would be a pleasure hanging out with a real broad. But before he could turn on the charm he remembered she was the doc's girl. So it was out. He made his smile just friendly and said, 'What are you doing coming to Nino's apartment at night, eh?'

She punched him in the shoulder. 'I heard Nino was sick and that Jules came up. I just wanted to see if I could help. Nino's OK, isn't he?'

'Sure,' Johnny said. 'He'll be fine.'

Jules Segal had sprawled out on the couch. 'Like hell he is,' Jules said. 'I suggest we all sit here and wait for Nino to come to. And then we all talk him into committing himself. Lucy, he likes you, maybe you can help. Johnny, if you're a real friend of his you'll go along. Otherwise old Nino's liver will shortly be exhibit A in some university medical lab.'

Johnny was offended by the doctor's flippant attitude. Who the hell did he think he was? He started to say so but Nino's voice came from the bed, 'Hey, old buddy, how about a drink?'

Nino was sitting up in bed. He grinned at Lucy and said, 'Hey, baby, come to old Nino.' He held his arms wide open. Lucy sat on the edge of the bed and gave him a hug. Oddly enough Nino didn't look bad at all now, almost normal.

Nino snapped his fingers. 'Come on, Johnny, gimmee a drink. The night's young yet. Where the hell's my blackjack table?'

Jules took a long slug from his own glass and said to Nino, 'You can't have a drink. Your doctor forbids it.'

Nino scowled. 'Screw my doctor.' Then a play-acting look of contrition came on his face. 'Hey, Julie, that's you. You're my doctor, right? I don't mean you, old buddy. Johnny, get me a drink or I get up out of bed and get it myself.'

Johnny shrugged and moved towards the bar. Jules said indifferently, 'I'm saying he shouldn't have it.'

Johnny knew why Jules irritated him. The doctor's voice was always cool, the words never stressed no matter how dire, the voice always low and controlled. If he gave a warning the warning was in the words alone, the voice itself was neutral, as if uncaring. It was this that made Johnny sore enough to bring Nino his water glass of whisky. Before he handed it over he said to Jules, 'This won't kill him, right?'

'No, it won't kill him,' Jules said calmly. Lucy gave him an anxious glance, started to say something, then kept still. Meanwhile Nino had taken the whisky and poured it down his throat.

Johnny was smiling down at Nino; they had shown the punk doctor. Suddenly Nino gasped, his face seemed to turn blue, he couldn't catch his breath and was choking for air.

374

His body leaped upwards like a fish, his face was gorged with blood, his eyes bulging. Jules appeared on the other side of the bed facing Johnny and Lucy. He took Nino by the neck and held him still and plunged the needle into the shoulder near where it joined the neck. Nino went limp in his hands, the heaves of his body subsided, and after a moment he slumped down back on to his pillow. His eyes closed in sleep.

Johnny, Lucy, and Jules went back into the living room part of the suite and sat around the huge solid coffee table. Lucy picked up one of the aquamarine phones and ordered coffee and some food to be sent up. Johnny had gone over to the bar and mixed himself a drink.

'Did you know he would have that reaction from the whisky?' Johnny asked.

Jules shrugged. 'I was pretty sure he would.'

Johnny said sharply, 'Then why didn't you warn me?'

'I warned you,' Jules said.

'You didn't warn me right,' Johnny said with cold anger. 'You are really one hell of a doctor. You don't give a shit. You tell me to get Nino in a crazy house, you don't bother to use a nice word like sanatorium. You really like to stick it to people, right?'

Lucy was staring down in her lap. Jules kept smiling at Fontane. 'Nothing was going to stop you from giving Nino that drink. You had to show you didn't have to accept my warnings, my orders. Remember when you offered me a job as your personal physician after that throat business? I turned you down because I knew we could never get along. A doctor thinks he's God, he's the high priest in modern society, that's one of his rewards. But you would never treat me that way. I'd be a flunky God to you. Like those doctors you guys have in Hollywood. Where do you get those people from anyway? Christ, don't they know anything or don't they just care? They must know what's happening to Nino but they just give him all kinds of drugs to keep him going. They wear those silk suits and they kiss your ass because you're a power movie man and so you think they are great doctors. Show biz, docs, you gotta have heart? Right? But they don't give a fuck if you live or die. Well, my little hobby, unforgivable as it is, is to

375

keep people alive. I let you give Nino that drink to show you what could happen to him.' Jules leaned towards Johnny Fontane, his voice still calm, unemotional. 'Your friend is almost terminal. Do you understand that? He hasn't got a chance without therapy and strict medical care. His blood pressure and diabetes and bad habits can cause a cerebral haemorrhage in this very next instant. His brain will blow itself apart. Is that vivid enough for you? Sure, I said crazy house. I want you to understand what's needed. Or you won't make a move. I'll put it to you straight. You can save your buddy's life by having him committed. Otherwise kiss him goodbye.'

Lucy murmured, 'Jules, darling, Jules, don't be so tough. Just tell him.'

Jules stood up. His usual cool was gone, Johnny Fontane noticed with satisfaction. His voice too had lost its quiet unaccented monotone.

'Do you think this is the first time I've had to talk to people like you in a situation like this?' Jules said. 'I did it every day. Lucy says don't be so tough, but she doesn't know what she's talking about. You know, I used to tell people, "Don't eat so much or you'll die, don't smoke so much or you'll die, don't work so much or you'll die, don't drink so much or you'll die." Nobody listens. You know why? Because I don't say, "You will die tomorrow." Well, I can tell you that Nino may very well die tomorrow.'

Jules went over to the bar and mixed himself another drink. 'How about it, Johnny, are you going to get Nino committed?'

Johnny said, 'I don't know.'

Jules took a quick drink at the bar and filled his glass again. 'You know, it's a funny thing, you can smoke yourself to death, drink yourself to death, work yourself to death, and even eat yourself to death. But that's all acceptable. The only thing you can't do medically is screw yourself to death and yet that's where they put all the obstacles.' He paused to finish his drink. 'But even that's trouble, for women anyway. I used to have women who weren't supposed to have any more babies. "It's dangerous," I'd tell them. "You could die," I'd tell them. And a month later they pop in, their faces all rosy, and say,

"Doctor, I think I'm pregnant," and sure enough they'd kill the rabbit. "But it's *dangerous*," I'd tell them. My voice used to have expression in those days. And they'd smile at me and say, "But my husband and I are very strict Catholic," they'd say.'

There was a knock on the door and two waiters wheeled in a cart covered with food and silver service coffeepots. They took a portable table from the bottom of the cart and set it up. Then Johnny dismissed them.

They sat at the table and ate the hot sandwiches Lucy had ordered and drank the coffee. Johnny leaned back and lit up a cigarette. 'So you save lives. How come you became an abortionist?'

Lucy spoke up for the first time. 'He wanted to help girls in trouble, girls who might commit suicide or do something dangerous to get rid of the baby.'

Jules smiled at her and sighed. 'It's not that simple. I became a surgeon finally. I've the good hands, as ballplayers say. But I was so good I scared myself silly. I'd open up some poor bastard's belly and know he was going to die. I'd operate and know that the cancer or tumour would come back but I'd send them off home with a smile and a lot of bullshit. Some poor broad comes in and I slice off one tit. A year later she's back and I slice off the other tit. A year after that, I scoop out her insides like you scoop the seeds out of a cantaloupe. After all that she dies anyway. Meanwhile husbands keep calling up and asking, "What do the tests show? What do the tests show?"

'So I hired an extra secretary to take all those calls. I saw the patient only when she was fully prepared for examination, tests, or operation. I spent the minimum possible time with the victim because I was, after all, a busy man. And then finally I'd let the husband talk to me for two minutes. "It's terminal," I'd say. And they could never hear that last word. They understood what it meant but they never heard it. I thought at first that unconsciously I was dropping my voice on the last word, so I consciously said it louder. But still they never heard it. One guy even said, "What the hell do you mean, it's germinal?"' Jules started to laugh. 'Germinal, terminal, what the

hell. I started to do abortions. Nice and easy, everybody happy, like washing the dishes and leaving a clean sink. That was my class. I loved it, I loved being an abortionist. I don't believe that a two-month foetus is a human being so no problems there. I was helping young girls and married women who were in trouble, I was making good money. I was out of the front lines. When I got caught I felt like a deserter that has been hauled in. But I was lucky, a friend pulled some strings and got me off but now the big hospitals won't let me operate. So here I am. Giving good advice again which is being ignored just like in the old days.'

'I'm not ignoring it,' Johnny Fontane said. 'I'm thinking it over.'

Lucy finally changed the subject. 'What are you doing in Vegas, Johnny? Relaxing from your duties as big-time Hollywood wheel or working?'

Johnny shook his head. 'Mike Corleone wants to see me and have a talk. He's flying in tonight with Tom Hagen. Tom said they'll be seeing you, Lucy. You know what it's all about?'

Lucy shook her head. 'We're all having dinner together tomorrow night. Freddie too. I think it might have something to do with the hotel. The casino has been dropping money lately, which shouldn't be. The Don might want Mike to check it out.'

'I hear Mike finally got his face fixed,' Johnny said.

Lucy laughed. 'I guess Kay talked him into it. He wouldn't do it when they were married. I wonder why? It looked so awful and made his nose drip. He should have had it done sooner.' She paused for a moment. 'Jules was called in by the Corleone Family for that operation. They used him as a consultant and an observer.'

Johnny nodded and said dryly, 'I recommended him for it.'

'Oh,' Lucy said. 'Anyway, Mike said he wanted to do something for Jules. That's why he's having us to dinner tomorrow night.'

Jules said musingly, 'He didn't trust anybody. He warned me to keep track of what everybody did. It was fairly straight, ordinary surgery. Any competent man could do it.'

There was a sound from the bedroom of the suite and they

looked towards the drapes. Nino had become conscious again. Johnny went and sat on the bed. Jules and Lucy went over to the foot of the bed. Nino gave them a wan grin. 'OK, I'll stop being a wise guy. I feel really lousy. Johnny, remember about a year ago, what happened when we were with those two broads down in Palm Springs? I swear to you I wasn't jealous about what happened. I was glad. You believe me, Johnny?'

Johnny said reassuringly, 'Sure, Nino, I believe you.'

Lucy and Jules looked at each other. From everything they had heard and knew about Johnny Fontane it seemed impossible that he would take a girl away from a close friend like Nino. And why was Nino saying he wasn't jealous a year after it happened? The same thought crossed both their minds, that Nino was drinking himself to death romantically because a girl had left him to go with Johnny Fontane.

Jules checked Nino again. 'I'll get a nurse to be in the room with you tonight,' Jules said. 'You really have to stay in bed for a couple of days. No kidding.'

Nino smiled. 'OK, Doc, just don't make the nurse too pretty.'

Jules made a call for the nurse and then he and Lucy left. Johnny sat in a chair near the bed to wait for the nurse. Nino was falling asleep again, an exhausted look on his face. Johnny thought about what he had said, about not being jealous about what had happened over a year ago with those two broads down in Palm Springs. The thought had never entered his head that Nino might be jealous.

A year ago Johnny Fontane had sat in his plush office, the office of the movie company he headed, and felt as lousy as he had ever felt in his life. Which was surprising because the first movie he had produced, with himself as star and Nino in a featured part, was making tons of money. Everything had worked. Everybody had done their job. The picture was brought in under budget. Everybody was going to make a fortune out of it and Jack Woltz was losing ten years of his life. Now Johnny had two more pictures in production, one starring himself, one starring Nino. Nino was great on the

screen as one of those charming, dopey lover-boys that women loved to shove between their tits. Little boy lost. Everything he touched made money, it was rolling in. The Godfather was getting his percentage through the bank, and that made Johnny feel really good. He had justified his Godfather's faith. But today that wasn't helping much.

And now that he was a successful independent movie producer he had as much power, maybe more, than he had ever had as a singer. Beautiful broads fell all over him just like before, though for a more commercial reason. He had his own plane, he lived more lavishly even, with the special tax benefits a businessman had that artists didn't get. Then what the hell was bothering him?

He knew what it was. The front of his head hurt, his nasal passages hurt, his throat itched. The only way he could scratch and relieve that itch was by singing and he was afraid to even try. He had called Jules Segal about it, when it would be safe to try to sing and Jules had said any time he felt like it. So he'd tried and sounded so hoarse and lousy he'd given up. And his throat would hurt like hell the next day, hurt in a different way than before the warts had been taken off. Hurt worse, burning. He was afraid to keep singing, afraid that he'd lose his voice for ever, or ruin it.

And if he couldn't sing, what the hell was the use of everything else? Everything else was just bullshit. Singing was the only thing he really knew. Maybe he knew more about singing and his kind of music than anybody else in the world. He was that good, he realized now. All those years had made him a real pro. Nobody could tell him the right and the wrong, he didn't have to ask anybody. He knew. What a waste, what a damn waste.

It was a Friday and he decided to spend the weekend with Virginia and the kids. He called her up as he always did to tell her he was coming. Really to give her a chance to say no. She never said no. Not in all the years they had been divorced. Because she would never say no to a meeting of her daughters and their father. What a broad, Johnny thought. He'd been lucky with Virginia. And though he knew he cared more about her than any other woman he knew it was impossible for them

to live together sexually. Maybe when they were sixty-five, like when you retire, they'd retire together, retire from everything.

But reality shattered these thoughts when he arrived there and found Virginia was feeling a little grouchy herself and the two girls not that crazy to see him because they had been promised a weekend visit with some girlfriends on a California ranch where they could ride horses.

He told Virginia to send the girls off to the ranch and kissed them goodbye with an amused smile. He understood them so well. What kid wouldn't rather go riding horses on a ranch than hang around with a grouchy father who picked his own spots as a father. He said to Virginia, 'I'll have a few drinks and then shove off too.'

'All right,' she said. She was having one of her bad days, rare, but recognizable. It wasn't too easy for her leading this kind of life.

She saw him taking an extra large drink. 'What are you cheering yourself up for?' Virginia asked. 'Everything is going so beautifully for you. I never dreamed you had it in you to be such a good businessman.'

Johnny smiled at her. 'It's not so hard,' he said. At the same time he was thinking, so that's what was wrong. He understood women and he understood now that Virginia was down because she thought he was having everything his own way. Women really hated seeing their men doing too well. It irritated them. It made them less sure of the hold they exerted over them through affection, sexual custom or marriage ties. So more to cheer her up than voice his own complaints, Johnny said, 'What the hell difference does it make if I can't sing.'

Virginia's voice was annoyed. 'Oh, Johnny, you're not a kid any more. You're over thirty-five. Why do you keep worrying about that silly singing stuff? You make more money as a producer anyhow.'

Johnny looked at her curiously and said, 'I'm a singer. I love to sing. What's being old got to do with that?'

Virginia was impatient. 'I never liked your singing anyway. Now that you've shown you can make movies, I'm glad you can't sing any more.'

They were both surprised when Johnny said with fury, 'That's a fucking lousy thing to say.' He was shaken. How could Virginia feel like that, how could she dislike him so much?

Virginia smiled at his being hurt and because it was so outrageous that he should be angry at her she said, 'How do you think I felt when all those girls came running after you because of the way you sang? How would you feel if I went ass-naked down the street to get men running after me? That's what your singing was and I used to wish you'd lose your voice and could never sing again. But that was before we got divorced.'

Johnny finished his drink. 'You don't understand a thing. Not a damn thing.' He went into the kitchen and dialled Nino's number. He quickly arranged for them both to go down to Palm Springs for the weekend and gave Nino the number of a girl to call, a real fresh young beauty he'd been meaning to get around to. 'She'll have a friend for you,' Johnny said. 'I'll be at your place in an hour.'

Virginia gave him a cool goodbye when he left. He didn't give a damn, it was one of the few times he was angry with her. The hell with it, he'd just tear loose for the weekend and get all the poison out of his system.

Sure enough, everything was fine down in Palm Springs. Johnny used his own house down there, it was always kept open and staffed this time of year. The two girls were young enough to be great fun and not too rapacious for some kind of favour. Some people came over to keep them company at the pool until suppertime. Nino went to his room with his girl to get ready for supper and a quick bang while he was still warm from the sun. Johnny wasn't in the mood, so he sent his girl, a short bandbox blonde named Tina, up to shower by herself. He never could make love to another woman after he'd had a fight with Virginia.

He went into the glass-walled patio living room that held a piano. When singing with the band he had fooled around with the piano just for laughs, so he could pick out a song in a fake moonlight-soft ballad style. He sat down now and hummed along a bit with the piano, very softly, muttering a few words

but not really singing. Before he knew it Tina was in the living room making him a drink and sitting beside him at the piano. He played a few tunes and she hummed with him. He left her at the piano and went up to take his shower. In the shower he sang short phrases, more like speaking. He got dressed and went back down. Tina was still alone; Nino was really working his girl over or getting drunk.

Johnny sat down at the piano again while Tina wandered off outside to watch the pool. He started singing one of his old songs. There was no burning in his throat. The tones were coming out muted but with proper body. He looked at the patio. Tina was still out there, the glass door was closed, she wouldn't hear him. For some reason he didn't want anybody to hear him. He started off fresh on an old ballad that was his favourite. He sang full out as if he were singing in public, letting himself go, waiting for the familiar burning rasp in his throat but there was none. He listened to his voice, it was different somehow, but he liked it. It was darker, it was a man's voice, not a kid's, rich he thought, dark rich. He finished the song easing up and sat there at the piano thinking about it.

Behind him Nino said, 'Not bad, old buddy, not bad at all.'

Johnny swivelled his body around. Nino was standing in the doorway, alone. His girl wasn't with him. Johnny was relieved. He didn't mind Nino hearing him.

'Yeah,' Johnny said. 'Let's get rid of those two broads. Send them home.'

Nino said, 'You send them home. They're nice kids, I'm not gonna hurt their feelings. Besides I just banged mine twice. How would it look if I sent her away without even giving her dinner?'

The hell with it, Johnny thought. Let the girls listen even if he sounded lousy. He called up a band leader he knew in Palm Springs and asked him to send over a mandolin for Nino. The band leader protested, 'Hell, nobody plays a mandolin in California.' Johnny yelled, 'Just get one.'

The house was loaded with recording equipment and Johnny had the two girls work the turn-off and volumes. After they had dinner, Johnny went to work. He had Nino playing

the mandolin as accompaniment and sang all his old songs. He sang them all the way out, not nursing his voice at all. His throat was fine, he felt that he could sing for ever. In the months he had not been able to sing he had often thought about singing, planned out how he would phrase lyrics differently now than as a kid. He had sung the songs in his head with more sophisticated variations of emphasis. Now he was doing it for real. Sometimes it would go wrong in the actual singing, stuff that had sounded good when he heard it just in his head didn't work out when he tried it really singing out loud. OUT LOUD, he thought. He wasn't listening to himself now, he was concentrating on performing. He fumbled a little on timing but that was OK, just rusty. He had a metronome in his head that would never fail him. Just a little practice was all he needed.

Finally he stopped singing. Tina came over to him with eyes shining and gave him a long kiss. 'Now I know why Mother goes to all your movies,' she said. It was the wrong thing to say at any time except this. Johnny and Nino laughed.

They played the feedback and now Johnny could really listen to himself. His voice had changed, changed a hell of a lot but was still unquestionably the voice of Johnny Fontane. It had become much richer and darker as he had noticed before but there was also the quality of a man singing rather than a boy. The voice had more true emotion, more character. And the technical part of his singing was far superior to anything he had ever done. It was nothing less than masterful. And if he was that good now, rusty as hell, how good would he be when he got in shape again? Johnny grinned at Nino. 'Is that as good as I think it is?'

Nino looked at his happy face thoughtfully. 'It's very damn good,' he said. 'But let's see how you sing tomorrow.'

Johnny was hurt that Nino should be so downbeat. 'You son of a bitch, you know you can't sing like that. Don't worry about tomorrow. I feel great.' But he didn't sing any more that night. He and Nino took the girls to a party and Tina spent the night in his bed but he wasn't much good there. The girl was a little disappointed. But what the hell, you couldn't do everything all in one day, Johnny thought.

He woke up in the morning with a sense of apprehension, with a vague terror that he had dreamed his voice had come back. Then when he was sure it was not a dream he got scared that his voice would be shot again. He went to the window and hummed a bit, then he went down to the living room still in his pyjamas. He picked out a tune on the piano and after a while tried singing with it. He sang mutedly but there was no pain, no hoarseness in his throat, so he turned it on. The chords were true and rich, he didn't have to force it at all. Easy, easy, just pouring out. Johnny realized that the bad time was over, he had it all now. And it didn't matter a damn if he fell on his face with movies, it didn't matter if he couldn't get it up with Tina the night before, it didn't matter that Virginia would hate him being able to sing again. For a moment he had just one regret. If only his voice had come back to him while trying to sing for his daughters, how lovely that would have been. That would have been so lovely.

The hotel nurse had come into the room wheeling a cart loaded with medication. Johnny got up and stared down at Nino, who was sleeping or maybe dying. He knew Nino wasn't jealous of his getting his voice back. He understood that Nino was only jealous because he was *so happy* about getting his voice back. That he cared so much about singing. For what was very obvious now was that Nino Valenti didn't care enough about anything to make him want to stay alive.

CHAPTER TWENTY-SEVEN

MICHAEL CORLEONE arrived late in the evening and, by his own order, was not met at the airport. Only two men accompanied him: Tom Hagen and a new bodyguard, named Albert Neri.

The most lavish suite of rooms in the hotel had been set aside for Michael and his party. Already waiting in that suite were the people it would be necessary for Michael to see.

Freddie greeted his brother with a warm embrace. Freddie was much stouter, more benevolent-looking, *cheerful*, and far more dandified. He wore an exquisitely tailored grey silk suit and accessories to match. His hair was razor cut and arranged as carefully as a movie star's, his face glowed with perfect barbering, and his hands were manicured. He was an altogether different man than the one who had been shipped out of New York four years before.

He leaned back and surveyed Michael fondly. 'You look a hell of a lot better now that you got your face fixed. Your wife finally talked you into it, huh? How is Kay? When she gonna come out and visit us out here?'

Michael smiled at his brother. 'You're looking pretty good too. Kay would have come out this time, but she's carrying another kid and she has the baby to look after. Besides this is business, Freddie, I have to fly back tomorrow night or the morning after.'

'You have to eat something first,' Freddie said. 'We've got a great chef in the hotel, you'll get the best food you ever ate. Go take your shower and change and everything will be set up right here. I have all the people you want to see lined up, they'll be waiting around for when you're ready, I just have to call them.'

Michael said pleasantly, 'Let's save Moe Greene to the end, OK? Ask Johnny Fontane and Nino up to eat with us. And Lucy and her doctor friend. We can talk while we eat.' He turned to Hagen. 'Anybody you want to add to that, Tom?'

Hagen shook his head. Freddie had greeted him much less affectionately than Michael, but Hagen understood. Freddie was on his father's shit list and Freddie naturally blamed the *Consigliori* for not straightening things out. Hagen would gladly have done so, but he didn't know why Freddie was in his father's bad graces. The Don did not give voice to specific grievances. He just made his displeasure felt.

It was after midnight before they gathered around the special dinner table set up in Michael's suite. Lucy kissed Michael and didn't comment on his face looking so much better after the operation. Jules Segal boldly studied the repaired cheekbone and said to Michael, 'A good job. It's knitted nicely. Is the sinus OK?'

'Fine,' Michael said. 'Thanks for helping out.'

Dinner focused on Michael as they ate. They all noted his resemblance in speech and manner to the Don. In some curious way he inspired the same respect, the same awe, and yet he was perfectly natural, at pains to put everyone at their ease. Hagen as usual remained in the background. The new man they did not know; Albert Neri was also very quiet and unobtrusive. He had claimed he was not hungry and sat in an armchair close to the door reading a local newspaper.

After they had had a few drinks and food, the waiters were dismissed. Michael spoke to Johnny Fontane. 'Hear your voice is back as good as ever, you got all your old fans back. Congratulations.'

'Thanks,' Johnny said. He was curious about exactly why Michael wanted to see him. What favour would he be asked?

Michael addressed them all in general. 'The Corleone Family is thinking of moving out here to Vegas. Selling out all our interests in the olive oil business and settling here. The Don and Hagen and myself have talked it over and we think here is where the future is for the Family. That doesn't mean right now or next year. It may take two, three, even four years to get things squared away. But that's the general plan. Some friends of ours own a good percentage of this hotel and casino so that will be our foundation. Moe Greene will sell us his interest so it can be wholly owned by friends of the Family.'

Freddie's moon face was anxious. 'Mike, you sure about Moe Greene selling? He never mentioned it to me and he loves the business. I really don't think he'll sell.'

Michael said quietly, 'I'll make him an offer he can't refuse.'

The words were said in an ordinary voice, yet the effect was chilling, perhaps because it was a favourite phrase of the Don's. Michael turned to Johnny Fontane. 'The Don is counting on you to help us get started. It's been explained to us that entertainment will be the big factor in drawing gamblers. We hope you'll sign a contract to appear five times a year for maybe a week-long engagement. We hope your friends in movies do the same. You've done them a lot of favours, now you can call them in.'

'Sure,' Johnny said. 'I'll do anything for my Godfather, you

know that, Mike.' But there was just the faint shadow of doubt in his voice.

Michael smiled and said, 'You won't lose money on the deal and neither will your friends. You get points in the hotel, and if there's somebody else you think important enough, they get some points too. Maybe you don't believe me, so let me say I'm speaking the Don's words.'

Johnny said hurriedly, 'I believe you, Mike. But there's ten more hotels and casinos being built on the Strip right now. When you come in, the market may be glutted, you may be too late with all that competition already there.'

Tom Hagen spoke up. 'The Corleone Family has friends who are financing three of those hotels.' Johnny understood immediately that he meant the Corleone Family owned the three hotels, with their casinos. And that there would be plenty of points to give out.

'I'll start working on it,' Johnny said.

Michael turned to Lucy and Jules Segal. 'I owe you,' he said to Jules. 'I hear you want to go back to cutting people up and that hospitals won't let you use their facilities because of that old abortion business. I have to know from you, is that what you want?'

Jules smiled. 'I guess so. But you don't know the medical set-up. Whatever power you have doesn't mean anything to them. I'm afraid you can't help me in that.'

Michael nodded absentmindedly. 'Sure, you're right. But some friends of mine, pretty well-known people, are going to build a big hospital for Las Vegas. The town will need it the way it's growing and the way it's projected to grow. Maybe they'll let you into the operating room if it's put to them right. Hell, how many surgeons as good as you can they get to come out to this desert? Or any half as good? We'll be doing the hospital a favour. So stick around. I hear you and Lucy are going to get married?'

Jules shrugged. 'When I see that I have any future.'

Lucy said wryly, 'Mike, if you don't build that hospital, I'll die an old maid.'

They all laughed. All except Jules. He said to Michael, 'If I took a job like that there couldn't be any strings attached.'

Michael said coldly, 'No strings. I just owe you and I want to even out.'

Lucy said gently, 'Mike, don't get sore.'

Michael smiled at her. 'I'm not sore.' He turned to Jules. 'That was a dumb thing for you to say. The Corleone Family has pulled some strings for you. Do you think I'm so stupid I'd ask you to do things you'd hate to do? But if I did, so what? Who the hell else ever lifted a finger to help you when you were in trouble? When I heard you wanted to get back to being a real surgeon, I took a lot of time to find out if I could help. I can. I'm not asking you for anything. But at least you can consider our relationship friendly, and I assume you would do for me what you'd do for any good friend. That's my string. But you can refuse it.'

Tom Hagen lowered his head and smiled. Not even the Don himself could have done it any better.

Jules was flushing. 'Mike, I didn't mean it that way at all. I'm very grateful to you and your father. Forget I said it.'

Michael nodded and said, 'Fine. Until the hospital gets built and opens up you'll be medical director for the four hotels. Get yourself a staff. Your money goes up too, but you can discuss that with Tom at a later time. And Lucy, I want you to do something more important. Maybe coordinate all the shops that will be opening up in the hotel arcades. On the financial side. Or maybe hiring the girls we need to work in the casinos, something like that. So if Jules doesn't marry you, you can be a rich old maid.'

Freddie had been puffing on his cigar angrily. Michael turned to him and said gently, 'I'm just the errand boy for the Don, Freddie. What he wants you to do he'll tell you himself, naturally, but I'm sure it will be something big enough to make you happy. Everybody tells us what a great job you've been doing out here.'

'Then why is he sore at me?' Freddie asked plaintively. 'Just because the casino has been losing money? I don't control that end, Moe Greene does. What the hell does the old man want from me?'

'Don't worry about it,' Michael said. He turned to Johnny

Fontane. 'Where's Nino? I was looking forward to seeing him again.'

Johnny shrugged. 'Nino is pretty sick. A nurse is taking care of him in his room. But the doc here says he should be committed, that he's trying to kill himself. Nino!'

Michael said thoughtfully, really surprised, 'Nino was always a real good guy. I never knew him to do anything lousy, say anything to put anybody down. He never gave a damn about anything. Except the booze.'

'Yeah,' Johnny said. 'The money is rolling in, he could get a lot of work, singing or in the movies. He gets fifty grand a picture now and he blows it. He doesn't give a damn about being famous. All the years we've been buddies I've never known him to do anything creepy. And the son of a bitch is drinking himself to death.'

Jules was about to say something when there was a knock on the door of the suite. He was surprised when the man in the armchair, the man nearest the door, did not answer it but kept reading the newspaper. It was Hagen who went to open it. And was almost brushed aside when Moe Greene came striding into the room followed by his two bodyguards.

Moe Greene was a handsome hood who had made his rep as a Murder Incorporated executioner in Brooklyn. He had branched out into gambling and gone west to seek his fortune, had been the first person to see the possibilities of Las Vegas and built one of the first hotel casinos on the Strip. He still had murderous tantrums and was feared by everyone in the hotel, not excluding Freddie, Lucy and Jules Segal. They always stayed out of his way whenever possible.

His handsome face was grim now. He said to Michael Corleone, 'I've been waiting around to talk to you, Mike. I got a lot of things to do tomorrow so I figured I'd catch you tonight. How about it?'

Michael Corleone looked at him with what seemed to be friendly astonishment. 'Sure,' he said. He motioned in Hagen's direction. 'Get Mr Greene a drink, Tom.'

Jules noticed that the man called Albert Neri was studying Moe Greene intently, not paying any attention to the bodyguards who were leaning against the door. He knew there was

no chance of any violence, not in Vegas itself. That was strictly forbidden as fatal to the whole project of making Vegas the legal sanctuary of American gamblers.

Moe Greene said to his bodyguards, 'Draw some chips for all these people so that they can gamble on the house.' He obviously meant Jules, Lucy, Johnny Fontane, and Michael's bodyguard, Albert Neri.

Michael Corleone nodded agreeably. 'That's a good idea.' It was only then that Neri got out of his chair and prepared to follow the others out.

After the goodbyes were said, there were Freddie, Tom Hagen, Moe Greene and Michael Corleone left in the room.

Greene put his drink down on the table and said with barely controlled fury, 'What's this I hear the Corleone Family is going to buy me out? I'll buy *you* out. You don't buy me out.'

Michael said reasonably, 'Your casino has been losing money against all the odds. There's something wrong with the way you operate. Maybe we can do better.'

Greene laughed harshly. 'You goddamn Dagos, I do you a favour and take Freddie in when you're having a bad time and now you push me out. That's what you think. I don't get pushed out by nobody and I got friends that will back me up.'

Michael was still quietly reasonable. 'You took Freddie in because the Corleone Family gave you a big chunk of money to finish furnishing your hotel. And bankroll your casino. And because the Molinari Family on the Coast guaranteed his safety and gave you some service for taking him in. The Corleone Family and you are evened out. I don't know what you're getting sore about. We'll buy your share at any reasonable price you name, what's wrong with that? What's unfair about that? With your casino losing money we're doing you a favour.'

Greene shook his head. 'The Corleone Family don't have that much muscle any more. The Godfather is sick. You're getting chased out of New York by the other Families and you think you can find easier pickings here. I'll give you some advice, Mike, don't try.'

Michael said softly, 'Is that why you thought you could slap Freddie around in public?'

Tom Hagen, startled, turned his attention to Freddie. Freddie Corleone's face was getting red. 'Ah, Mike, that wasn't anything. Moe didn't mean anything. He flies off the handle sometimes, but me and him are good friends. Right, Moe?'

Greene was wary. 'Yeah, sure. Sometimes I got to kick asses to make this place run right. I got sore at Freddie because he was banging all the cocktail waitresses and letting them goof off on the job. We had a little argument and I straightened him out.'

Michael's face was impassive when he said to his brother, 'You straightened out, Freddie?'

Freddie stared sullenly at his younger brother. He didn't answer. Greene laughed and said, 'The son of a bitch was taking them to bed two at a time, the old sandwich job. Freddie, I gotta admit you really put it to those broads. Nobody else could make them happy after you got through with them.'

Hagen saw that this had caught Michael by surprise. They looked at each other. This was perhaps the real reason the Don was displeased with Freddie. The Don was straitlaced about sex. He would consider such cavorting by his son Freddie, two girls at a time, as degeneracy. Allowing himself to be physically humiliated by a man like Moe Greene would decrease respect for the Corleone Family. That too would be part of the reason for being in his father's bad books.

Michael rising from his chair, said, in a tone of dismissal, 'I have to get back to New York tomorrow, so think about your price.'

Greene said savagely, 'You son of a bitch, you think you can just brush me off like that? I killed more men than you before I could jerk off. I'll fly to New York and talk to the Don himself. I'll make him an offer.'

Freddie said nervously to Tom Hagen, 'Tom, you're the *Consigliori*, you can talk to the Don and advise him.'

It was then that Michael turned the full chilly blast of his personality on the two Vegas men. 'The Don has sort of semi-retired,' he said. 'I'm running the Family business now. And I've moved Tom from the *Consigliori* spot. He'll be strictly my lawyer here in Vegas. He'll be moving out with his family

in a couple of months to get all the legal work started. So anything you have to say, say it to me.'

Nobody answered. Michael said formally, 'Freddie, you're my older brother, I have respect for you. But don't ever take sides with anybody against the Family again. I won't even mention it to the Don.' He turned to Moe Greene. 'Don't insult people who are trying to help you. You'd do better to use your energy to find out why the casino is losing money. The Corleone Family has big dough invested here and we're not getting our money's worth, but I still didn't come here to abuse you. I offer you a helping hand. Well, if you prefer to spit on that helping hand, that's your business. I can't say any more.'

He had not once raised his voice but his words had a sobering effect on both Greene and Freddie. Michael stared at both of them, moving away from the table to indicate that he expected them both to leave. Hagen went to the door and opened it. Both men left without saying goodnight.

The next morning Michael Corleone got the message from Moe Greene: he would not sell his share of the hotel at any price. It was Freddie who delivered the message. Michael shrugged and said to his brother, 'I want to see Nino before I go back to New York.'

In Nino's suite they found Johnny Fontane sitting on the couch eating breakfast. Jules was examining Nino behind the closed drapes of the bedroom. Finally the drapes were drawn back.

Michael was shocked at how Nino looked. The man was visibly disintegrating. The eyes were dazed, the mouth loose, all the muscles of his face slack. Michael sat on his bedside and said, 'Nino, it's good to catch up with you. The Don always asks about you.'

Nino grinned, it was the old grin. 'Tell him I'm dying. Tell him show business is more dangerous than the olive oil business.'

'You'll be OK,' Michael said. 'If there's anything bothering you that the Family can help, just tell me.'

Nino shook his head. 'There's nothing,' he said. 'Nothing.'

Michael chatted for a few more moments and then left.

Freddie accompanied him and his party to the airport, but at Michael's request didn't hang around for departure time. As they boarded the plane with Tom Hagen and Al Neri, Michael turned to Neri and said, 'Did you make him good?'

Neri tapped his forehead. 'I got Moe Greene mugged and numbered up here.'

CHAPTER TWENTY-EIGHT

ON THE plane ride back to New York, Michael Corleone relaxed and tried to sleep. It was useless. The most terrible period of his life was approaching, perhaps even a fatal time. It could no longer be put off. Everything was in readiness, all precautions had been taken, two years of precautions. There could be no further delay. Last week when the Don had formally announced his retirement to the *caporegimes* and other members of the Corleone Family, Michael knew that this was his father's way of telling him the time was ripe.

It was almost three years now since he had returned home and over two years since he had married Kay. The three years had been spent in learning the Family business. He had put in long hours with Tom Hagen, long hours with the Don. He was amazed at how wealthy and powerful the Corleone Family truly was. It owned tremendously valuable real estate in midtown New York, whole office buildings. It owned, through fronts, partnerships in two Wall Street brokerage houses, pieces of banks on Long Island, partnerships in some garment centre firms, all this in addition to its illegal operations in gambling.

The most interesting thing Michael Corleone learned, in going back over past transactions of the Corleone Family, was that the Family had received some protection income shortly after the war from a group of music record counterfeiters. The counterfeiters duplicated and sold phonograph records of famous artists, packaging everything so skilfully they were never caught. Naturally on the records they sold to stores the

artists and original production company received not a penny. Michael Corleone noticed that Johnny Fontane had lost a lot of money owing to this counterfeiting because at that time, just before he lost his voice, his records were the most popular in the country.

He asked Tom Hagen about it. Why did the Don allow the counterfeiters to cheat his godson? Hagen shrugged. Business was business. Besides, Johnny was in the Don's bad graces, Johnny having divorced his childhood sweetheart to marry Margot Ashton. This had displeased the Don greatly.

'How come these guys stopped their operation?' Michael asked. 'The cops got on to them?'

Hagen shook his head. 'The Don withdrew his protection. That was right after Connie's wedding.'

It was a pattern he was to see often, the Don helping those in misfortune whose misfortune he had partly created. Not perhaps out of cunning or planning but because of his variety of interests or perhaps because of the nature of the universe, the interlinking of good and evil, natural of itself.

Michael had married Kay up in New England, a quiet wedding, with only her family and a few of her friends present. Then they had moved into one of the houses on the mall in Long Beach. Michael was surprised at how well Kay got along with his parents and the other people living on the mall. And of course she had got pregnant right away, like a good, old-style Italian wife was supposed to, and that helped. The second kid on the way in two years was just icing.

Kay would be waiting for him at the airport, she always came to meet him, she was always so glad when he came back from a trip. And he was too. Except now. For the end of this trip meant that he finally had to take the action he had been groomed for over the last three years. The Don would be waiting for him. The *caporegimes* would be waiting for him. And he, Michael Corleone, would have to give the orders, make the decisions which would decide his and his Family's fate.

Every morning when Kay Adams Corleone got up to take care of the baby's early feeding, she saw Mama Corleone, the

Don's wife, being driven away from the mall by one of the bodyguards, to return an hour later. Kay soon learned that her mother-in-law went to church every single morning. Often on her return, the old woman stopped by for morning coffee and to see her new grandchild.

Mama Corleone always started off by asking Kay why she didn't think of becoming a Catholic, ignoring the fact that Kay's child had already been baptized a Protestant. So Kay felt it was proper to ask the old woman why she went to church every morning, whether that was a necessary part of being a Catholic.

As if she thought that this might have stopped Kay from converting the old woman said, 'Oh, no, no, some Catholics only go to church on Easter and Christmas. You go when you feel like going.'

Kay laughed. 'Then why do you go every single morning?'

In a completely natural way, Mama Corleone said, 'I go for my husband,' she pointed down towards the floor, 'so he don't go down there.' She paused. 'I say prayers for his soul every day so he go up there.' She pointed heavenward. She said this with an impish smile, as if she were subverting her husband's will in some way, or as if it were a losing cause. It was said jokingly almost, in her grim, Italian, old crone fashion. And as always when her husband was not present, there was an attitude of disrespect to the great Don.

'How is your husband feeling?' Kay asked politely.

Mama Corleone shrugged. 'He's not the same man since they shot him. He lets Michael do all the work, he just plays the fool with his garden, his peppers, his tomatoes. As if he were some peasant still. But men are always like that.'

Later in the morning Connie Corleone would walk across the mall with her two children to pay Kay a visit and chat. Kay liked Connie, her vivaciousness, her obvious fondness for her brother Michael. Connie had taught Kay how to cook some Italian dishes but sometimes brought her own more expert concoctions over for Michael to taste.

Now this morning as she usually did, she asked Kay what Michael thought of her husband, Carlo. Did Michael really like Carlo, as he seemed to? Carlo had always had a little

trouble with the Family but now over the last years he had straightened out. He was really doing well in the labour union but he had to work so hard, such long hours. Carlo really liked Michael, Connie always said. But then, everybody liked Michael, just as everybody liked her father. Michael was the Don all over again. It was the best thing that Michael was going to run the Family olive oil business.

Kay had observed before that when Connie spoke about her husband in relation to the Family, she was always nervously eager for some word of approval for Carlo. Kay would have been stupid if she had not noticed the almost terrified concern Connie had for whether Michael liked Carlo or not. One night she spoke to Michael about it and mentioned the fact that nobody ever spoke about Sonny Corleone, nobody even referred to him, at least not in her presence. Kay had once tried to express her condolences to the Don and his wife and had been listened to with almost rude silence and then ignored. She had tried to get Connie talking about her older brother without success.

Sonny's wife, Sandra, had taken her children and moved to Florida, where her own parents now lived. Certain financial arrangements had been made so that she and her children could live comfortably, but Sonny had left no estate.

Michael reluctantly explained what had happened the night Sonny was killed. That Carlo had beaten his wife and Connie had called the mall and Sonny had taken the call and rushed out in a blind rage. So naturally Connie and Carlo were always nervous that the rest of the Family blamed her for indirectly causing Sonny's death. Or blamed her husband, Carlo. But this wasn't the case. The proof was that they had given Connie and Carlo a house in the mall itself and promoted Carlo to an important job in the labour union set-up. And Carlo had straightened out, stopped drinking, stopped whoring, stopped trying to be a wise guy. The Family was pleased with his work and attitude for the last two years. Nobody blamed him for what had happened.

'Then why don't you invite them over some evening and you can reassure your sister?' Kay said. 'The poor thing is always so nervous about what you think of her husband.

Tell her. And tell her to put those silly worries out of her head.'

'I can't do that,' Michael said. 'We don't talk about those things in our family.'

'Do you want me to tell her what you've told me?' Kay said.

She was puzzled because he took such a long time thinking over a suggestion that was obviously the proper thing to do. Finally he said, 'I don't think you should, Kay. I don't think it will do any good. She'll worry anyway. It's something nobody can do anything about.'

Kay was amazed. She realized that Michael was always a little colder to his sister Connie than he was to anyone else, despite Connie's affection. 'Surely you don't blame Connie for Sonny being killed?' she said.

Michael sighed. 'Of course not,' he said. 'She's my kid sister and I'm very fond of her. I feel sorry for her. Carlo straightened out, but he's really the wrong kind of husband. It's just one of those things. Let's forget about it.'

It was not in Kay's nature to nag; she let it drop. Also she had learned that Michael was not a man to push, that he could become coldly disagreeable. She knew she was the only person in the world who could bend his will, but she also knew that to do it too often would be to destroy that power. And living with him the last two years had made her love him more.

She loved him because he was always fair. An odd thing. But he always was fair to everybody around him, never arbitrary even in little things. She had observed that he was now a very powerful man, people came to the house to confer with him and ask favours, treating him with deference and respect but one thing had endeared him to her above everything else.

Ever since Michael had come back from Sicily with his broken face, everybody in the Family had tried to get him to undergo corrective surgery. Michael's mother was after him constantly; one Sunday dinner with all the Corleones gathered on the mall she shouted at Michael, 'You look like a gangster in the movies, get your face fixed for the sake of Jesus Christ and your poor wife. And so your nose will stop running like a drunken Irish.'

398

The Don, at the head of the table, watching everything, said to Kay, 'Does it bother you?'

Kay shook her head. The Don said to his wife, 'He's out of your hands, it's no concern of yours.' The old woman immediately held her peace. Not that she feared her husband but because it would have been disrespectful to dispute him in such a matter before the others.

But Connie, the Don's favourite, came in from the kitchen where she was cooking the Sunday dinner, her face flushed from the stove, and said, 'I think he should get his face fixed. He was the most handsome one in the family before he got hurt. Come on, Mike, say you'll do it.'

Michael looked at her in an absentminded fashion. It seemed as if he really and truly had not heard anything said. He didn't answer.

Connie came to stand beside her father. 'Make him do it,' she said to the Don. Her two hands rested affectionately on his shoulders and she rubbed his neck. She was the only one who was ever so familiar with the Don. Her affection for her father was touching. It was trusting, like a little girl's. The Don patted one of her hands and said, 'We're all starving here. Put the spaghetti on the table and then chatter.'

Connie turned to her husband and said, 'Carlo, you tell Mike to get his face fixed. Maybe he'll listen to you.' Her voice implied that Michael and Carlo Rizzi had some friendly relationship over and above anyone else's.

Carlo, handsomely sunburned, blond hair neatly cut and combed, sipped at his glass of homemade wine and said, 'Nobody can tell Mike what to do.' Carlo had become a different man since moving into the mall. He knew his place in the Family and kept to it.

There was something that Kay didn't understand in all this, something that didn't quite meet the eye. As a woman she could see that Connie was deliberately charming her father, though it was beautifully done and even sincere. Yet it was not spontaneous. Carlo's reply had been a manly knuckling of his forehead. Michael had absolutely ignored everything.

Kay didn't care about her husband's disfigurement but she worried about his sinus trouble which sprang from it. Surgery

399

repair of the face would cure the sinus also. For that reason she wanted Michael to enter the hospital and get the necessary work done. But she understood that in a curious way he desired his disfigurement. She was sure that the Don understood this too.

But after Kay gave birth to her first child, she was surprised by Michael asking her, 'Do you want me to get my face fixed?'

Kay nodded. 'You know how kids are, your son will feel bad about your face when he gets old enough to understand it's not normal. I just don't want our child to see it. I don't mind at all, honestly, Michael.'

'OK.' He smiled at her. 'I'll do it.'

He waited until she was home from the hospital and then made all the necessary arrangements. The operation was successful. The cheek indentation was now just barely noticeable.

Everybody in the Family was delighted, but Connie more so than anyone. She visited Michael every day in the hospital, dragging Carlo along. When Michael came home, she gave him a big hug and a kiss and looked at him admiringly and said, 'Now you're my handsome brother again.'

Only the Don was unimpressed, shrugging his shoulders and remarking, 'What's the difference?'

But Kay was grateful. She knew that Michael had done it against all his own inclinations. Had done it because she had asked him to, and that she was the only person in the world who could make him act against his own nature.

On the afternoon of Michael's return from Vegas, Rocco Lampone drove the limousine to the mall to pick up Kay so that she could meet her husband at the airport. She always met her husband when he arrived from out of town, mostly because she felt lonely without him, living as she did in the fortified mall.

She saw him come off the plane with Tom Hagen and the new man he had working for him, Albert Neri. Kay didn't care much for Neri, he reminded her of Luca Brasi in his quiet ferociousness. She saw Neri drop behind Michael and off to the side, saw his quick penetrating glance as his eyes swept over everybody nearby. It was Neri who first spotted Kay and

ouched Michael's shoulder to make him look in the proper direction.

Kay ran into her husband's arms and he quickly kissed her and let her go. He and Tom Hagen and Kay got into the limousine and Albert Neri vanished. Kay did not notice that Neri had got into another car with two other men and that this car rode behind the limousine until it reached Long Beach.

Kay never asked Michael how his business had gone. Even such polite questions were understood to be awkward, not that he wouldn't give her an equally polite answer, but it would remind them both of the forbidden territory their marriage could never include. Kay didn't mind any more. But when Michael told her he would have to spend the evening with his father to tell him about the Vegas trip, she couldn't help making a little frown of disappointment.

'I'm sorry,' Michael said. 'Tomorrow night we'll go into New York and see a show and have dinner, OK?' He patted her stomach, she was almost seven months pregnant. 'After the kid comes you'll be tied down again. Hell, you're more Italian than Yankee. Two kids in two years.'

Kay said tartly, 'And you're more Yankee than Italian. Your first evening home and you spend it on business.' But she smiled at him when she said it. 'You won't be home late?'

'Before midnight,' Michael said. 'Don't wait up for me if you feel tired.'

'I'll wait up,' Kay said.

At the meeting that night, in the corner room library of Don Corleone's house, were the Don himself, Michael, Tom Hagen, Carlo Rizzi, and the two *caporegimes*, Clemenza and Tessio.

The atmosphere of the meeting was by no means so congenial as in former days. Ever since Don Corleone had announced his semi-retirement and Michael's take-over of the Family business, there had been some strain. Succession in control of such an enterprise as the Family was by no means hereditary. In any other Family powerful *caporegimes* such as Clemenza and Tessio might have succeeded to the position of Don. Or at least they might have been allowed to split off and form their own Family.

Then, too, ever since Don Corleone had made the peace with the Five Families, the strength of the Corleone Family had declined. The Barzini Family was now indisputably the most powerful one in the New York area; allied as they were to the Tattaglias, they now held the position the Corleone Family had once held. Also they were slyly whittling down the power of the Corleone Family, muscling into their gambling areas, testing the Corleones' reactions and, finding them weak, establishing their own bookmakers.

The Barzinis and Tattaglias were delighted with the Don's retirement. Michael, formidable as he might prove to be, could never hope to equal the Don in cunning and influence for at least another decade. The Corleone Family was definitely in a decline.

It had, of course, suffered serious misfortunes. Freddie had proved to be nothing more than an innkeeper and a ladies' man, the idiom for ladies' man untranslatable but connoting a greedy infant always at its mother's nipple – in short, unmanly. Sonny's death too, had been a disaster. Sonny had been a man to be feared, not to be taken lightly. Of course he had made a mistake in sending his younger brother, Michael, to kill the Turk and the police captain. Though necessary in a tactical sense, as a long-term strategy it proved to be a serious error. It had forced the Don, eventually, to rise from his sickbed. It had deprived Michael of two years of valuable experience and training under his father's tutelage. And of course an Irish as a *Consigliori* had been the only foolishness the Don had ever perpetrated. No Irish man could hope to equal a Sicilian for cunning. So went the opinion of all the Families and they were naturally more respectful to the Barzini–Tattaglia alliance than to the Corleones. Their opinion of Michael was that he was not equal to Sonny in force though more intelligent certainly, but not as intelligent as his father. A mediocre successor and a man not to be feared too greatly.

Also, though the Don was generally admired for his statesmanship in making the peace, the fact that he had not avenged Sonny's murder lost the Family a great deal of respect. It was recognized that such statesmanship sprang out of weakness.

All this was known to the men sitting in the room and

perhaps even believed by a few. Carlo Rizzi liked Michael but did not fear him as he had feared Sonny. Clemenza, too, though he gave Michael credit for a bravura performance with the Turk and the police captain, could not help thinking Michael was too soft to be a Don. Clemenza had hoped to be given permission to form his own Family, to have his own empire split away from the Corleone. But the Don had indicated that this was not to be and Clemenza respected the Don too much to disobey. Unless of course the whole situation became intolerable.

Tessio had a better opinion of Michael. He sensed something else in the young man: a force cleverly kept hidden, a man jealously guarding his true strength from public gaze, following the Don's precept that a friend should always underestimate your virtues and an enemy overestimate your faults.

The Don himself and Tom Hagen were of course under no illusions about Michael. The Don would never have retired if he had not had absolute faith in his son's ability to retrieve the Family position. Hagen had been Michael's teacher for the last two years and was amazed at how quickly Michael grasped all the intricacies of the Family business. Truly his father's son.

Clemenza and Tessio were annoyed with Michael because he had reduced the strength of their *regimes* and had never reconstituted Sonny's *regime*. The Corleone Family, in effect, had now only two fighting divisions with less personnel than formerly. Clemenza and Tessio considered this suicidal, especially with the Barzini–Tattaglia encroachments on their empires. So now they were hopeful these errors might be corrected at this extraordinary meeting convened by the Don.

Michael started off by telling them about his trip to Vegas and Moe Greene's refusing the offer to buy him out. 'But we'll make him an offer he can't refuse,' Michael said. 'You already know the Corleone Family plans to move its operations West. We'll have four of the hotel casinos on the Strip. But it can't be right away. We need time to get things straightened out.' He spoke directly to Clemenza. 'Pete, you and Tessio, I want you to go along with me for a year without questioning and

without reservations. At the end of that year, both of you can split off from the Corleone Family and be your own bosses, have your own Families. Of course it goes without saying we'd maintain our friendship, I wouldn't insult you and your respect for my father by thinking otherwise for a minute. But up until that time I want you just to follow my lead and don't worry. There are negotiations going on that will solve problems that you think are not solvable. So just be a little patient.'

Tessio spoke up. 'If Moe Greene wanted to talk to your father, why not let him? The Don could always persuade anybody, there was never anyone who could stand up to his reasonableness.'

The Don answered this directly. 'I've retired. Michael would lose respect if I interfered. And besides that's a man I'd rather not talk to.'

Tessio remembered the stories he'd heard about Moe Greene slapping Freddie Corleone around one night in the Vegas hotel. He began to smell a rat. He leaned back. Moe Greene was a dead man, he thought. The Corleone Family *did not wish* to persuade him.

Carlo Rizzi spoke up. 'Is the Corleone Family going to stop operating in New York altogether?'

Michael nodded. 'We're selling the olive oil business. Everything we can, we turn over to Tessio and Clemenza. But, Carlo, I don't want you to worry about your job. You grew up in Nevada, you know the state, you know the people. I'm counting on you being my right-hand man when we make our move out there.'

Carlo leaned back, his face flushed with gratification. His time was coming, he would move in the constellations of power.

Michael went on. 'Tom Hagen is no longer the *Consigliori*. He's going to be our lawyer in Vegas. In about two months he'll move out there permanently with his family. Strictly as a lawyer. Nobody goes to him with any other business as of now, this minute. He's a lawyer and that's all. No reflection on Tom. That's the way I want it. Besides, if I ever need any advice, who's a better counsellor than my father?' They all laughed. But they had got the message despite the joke. Tom

Hagen was out; he no longer held any power. They all took their fleeting glances to check Hagen's reaction but his face was impassive.

Clemenza spoke up in his fat man's wheeze. 'Then in a year's time we're on our own, is that it?'

'Maybe less,' Michael said courteously. 'Of course you can always remain part of the Family, that's your choice. But most of our strength will be out West and maybe you'd do better organized on your own.'

Tessio said quietly, 'In that case I think you should give us permission to recruit new men for our *regimes*. Those Barzini bastards keep chiselling in on my territory. I think maybe it would be wise to teach them a little lesson in manners.'

Michael shook his head. 'No. No good. Just stay still. All that stuff will be negotiated, everything will be straightened out before we leave.'

Tessio was not to be so easily satisfied. He spoke to the Don directly, taking a chance on incurring Michael's ill will. 'Forgive me, Godfather, let our years of friendship be my excuse. But I think you and your son are all wrong with this Nevada business. How can you hope for success there without your strength here to back you up? The two go hand in hand. And with you gone from here the Barzini and the Tattaglia will be too strong for us. Me and Pete will have trouble, we'll come under their thumb sooner or later. And Barzini is a man not to my taste. I say the Corleone Family has to make its move from strength, not from weakness. We should build up our *regimes* and take back our lost territories in Staten Island at least.'

The Don shook his head. 'I made the peace, remember, I can't go back on my word.'

Tessio refused to be silenced. 'Everybody knows Barzini gave you provocation since then. And besides, if Michael is the new chief of the Corleone Family, what's to stop him from taking any action he sees fit? Your word doesn't strictly bind him.'

Michael broke in sharply. He said to Tessio, very much the chief now, 'There are things being negotiated which will answer your questions and resolve your doubts. If my word isn't enough for you, ask your Don.'

But Tessio understood he had finally gone too far. If he dared to question the Don he would make Michael his enemy. So he shrugged and said, 'I spoke for the good of the Family, not for myself. I can take care of myself.'

Michael gave him a friendly smile. 'Tessio, I never doubt you in any way. I never did. But trust in me. Of course I'm not equal to you and Pete in these things, but after all I've my father to guide me. I won't do too badly, we'll all come out fine.'

The meeting was over. The big news was that Clemenza and Tessio would be permitted to form their own Families from their *regimes*. Tessio would have his gambling and docks in Brooklyn, Clemenza the gambling in Manhattan and the Family contacts in the racing tracks of Long Island.

The two *caporegimes* left not quite satisfied, still a little uneasy. Carlo Rizzi lingered hoping that the time had come when he finally would be treated as one of the family, but he quickly saw that Michael was not of that mind. He left the Don, Tom Hagen, and Michael alone in the corner library room. Albert Neri ushered him out of the house and Carlo noticed that Neri stood in the doorway watching him walk across the floodlit mall.

In the library the three men had relaxed as only people can who have lived years together in the same house, in the same family. Michael served some anisette to the Don and Scotch to Tom Hagen. He took a drink himself, which he rarely did.

Tom Hagen spoke up first. 'Mike, why are you cutting me out of the action?'

Michael seemed surprised. 'You'll be my number one man in Vegas. We'll be legitimate all the way and you're the legal man. What can be more important than that?'

Hagen smiled a little sadly. 'I'm not talking about that. I'm talking about Rocco Lampone building a secret *regime* without my knowledge. I'm talking about you dealing direct with Neri rather than through me or a *caporegime*. Unless of course you don't know what Lampone's doing.'

Michael said softly, 'How did you find out about Lampone's *regime*?'

Hagen shrugged. 'Don't worry, there's no leak, nobody else

nows. But in my position I can see what's happening. You
gave Lampone his own living, you gave him a lot of freedom.
So he needs people to help him in his little empire. But every-
body he recruits has to be reported back to me. And I notice
everybody he puts on the payroll is a little too good for that
particular job, is getting a little more money than that parti-
cular exercise is worth. You picked the right man when you
picked Lampone, by the way. He's operating perfectly.'

Michael grimaced. 'Not so damn perfect if you noticed.
Anyway the Don picked Lampone.'

'OK,' Tom said, 'so why am I cut out of the action?'

Michael faced him and without flinching gave it to him
straight. 'Tom, you're not a wartime *Consigliori*. Things may
get tough with this move we're trying to make and we may
have to fight. And I want to get you out of the line of fire too,
just in case.'

Hagen's face reddened. If the Don had told him the same
thing, he would have accepted it humbly. But where the hell
did Mike come off making such a snap judgement?

'OK,' he said, 'but I happen to agree with Tessio. I think
you're going about this all wrong. You're making the move
out of weakness, not strength. That's always bad. Barzini is
like a wolf, and if he tears you limb from limb, the other
families won't come rushing to help the Corleones.'

The Don finally spoke. 'Tom, it's not just Michael. I ad-
vised him on these matters. There are things that may have to
be done that I don't want in any way to be responsible for.
That is my wish, not Michael's. I never thought you were a
bad *Consigliori*. I thought Santino a bad Don, may his soul rest
in peace. He had a good heart, but he wasn't the right man to
lead the Family when I had my little misfortune. And who
would have thought that Fredo would become a lackey of
women? So don't feel badly. Michael has all my confidence as
you do. For reasons which you can't know, you must have
no part in what may happen. By the way, I told Michael that
Lampone's secret *regime* would not escape your eye. So that
shows I have faith in you.'

Michael laughed. 'I honestly didn't think you'd pick that up,
Tom.'

Hagen knew he was being mollified. 'Maybe I can help,' he said.

Michael shook his head decisively. 'You're out, Tom.'

Tom finished his drink and before he left he gave Michael mild reproof. 'You're nearly as good as your father,' he told Michael. 'But there's one thing you still have to learn.'

'What's that?' Michael said politely.

'How to say no,' Hagen answered.

Michael nodded gravely. 'You're right,' he said. 'I'll remember that.'

When Hagen had left. Michael said jokingly to his father, 'So you've taught me everything else. Tell me how to say no to people in a way they'll like.'

The Don moved to sit behind the big desk. 'You cannot say "no" to the people you love, not often. That's the secret. And then when you do, it has to sound like a "yes". Or you have to make them say "no". You have to take time and trouble. But I'm old-fashioned, you're the new modern generation, don't listen to me.'

Michael laughed. 'Right. You agree about Tom being out though, don't you?'

The Don nodded. 'He can't be involved in this.'

Michael said quietly, 'I think it's time for me to tell you that what I'm going to do is not purely out of vengeance for Apollonia and Sonny. It's the right thing to do. Tessio and Tom are right about the Barzinis.'

Don Corleone nodded. 'Revenge is a dish that tastes best when it is cold,' he said. 'I would not have made that peace but that I knew you would never come home alive otherwise. I'm surprised, though, that Barzini still made a last try at you. Maybe it was arranged before the peace talk and he couldn't stop it. Are you sure they were not after Don Tommasino?

Michael said, 'That's the way it was supposed to look. And it would have been perfect, even you would never have suspected. Except that I came out alive. I saw Fabrizzio going through the gate, running away. And of course I've checked it all out since I've been back.'

'Have they found that shepherd?' the Don asked.

'I found him,' Michael said. 'I found him a year ago. He'

got his own little pizza place up in Buffalo. New name, phony passport and identification. He's doing very well is Fabrizzio the shepherd.'

The Don nodded. 'So it's to no purpose to wait any longer. When will you start?'

Michael said, 'I want to wait until after Kay has the baby. Just in case something goes wrong. And I want Tom settled in Vegas so he won't be concerned in the affair. I think a year from now.'

'You've prepared for everything?' the Don asked. He did not look at Michael when he said this.

Michael said gently, 'You have no part. You're not responsible. I take all responsibility. I would refuse to let you even veto. If you tried to do that now, I would leave the Family and go my own way. You're not responsible.'

The Don was silent for a long time and then he sighed. He said, 'So be it. Maybe that's why I retired, maybe that's why I've turned everything over to you. I've done my share in life, I haven't got the heart any more. And there are some duties the best of men can't assume. That's it then.'

During that year Kay Adams Corleone was delivered of a second child, another boy. She delivered easily, without any trouble whatsoever, and was welcomed back to the mall like a royal princess. Connie Corleone presented the baby with a silk layette handmade in Italy, enormously expensive and beautiful. She told Kay, 'Carlo found it. He shopped all over New York to get something extra special after I couldn't find anything I really liked.' Kay smiled her thanks, understood immediately that she was to tell Michael this fine tale. She was on her way to becoming a Sicilian.

Also during that year, Nino Valenti died of a cerebral haemorrhage. His death made the front pages of the tabloids because the movie Johnny Fontane had featured him in had opened a few weeks before and was a smash hit, establishing Nino as a major star. The papers mentioned that Johnny Fontane was handling the funeral arrangements, that the funeral would be private, only family and close friends to attend. One sensational story even claimed that in an interview Johnny Fontane had blamed himself for his friend's death,

that he should have forced his friend to place himself under medical care, but the reporter made it sound like the usual self-reproach of the sensitive but innocent bystander to a tragedy. Johnny Fontane had made his childhood friend, Nino Valenti, a movie star and what more could a friend do?

No member of the Corleone Family attended the California funeral except Freddie. Lucy and Jules Segal attended. The Don himself had wanted to go to California but had suffered a slight heart attack, which kept him in his bed for a month. He sent a huge floral wreath instead. Albert Neri was also sent West as the official representative of the Family.

Two days after Nino's funeral, Moe Greene was shot to death in the Hollywood home of his movie-star mistress; Albert Neri did not reappear in New York until almost a month later. He had taken his vacation in the Caribbean and returned to duty tanned almost black. Michael Corleone welcomed him with a smile and a few words of praise, which included the information that Neri would from then on receive an extra 'living', the Family income from an East Side 'book' considered especially rich. Neri was content, satisfied that he lived in a world that properly rewarded a man who did his duty.

CHAPTER TWENTY-NINE

MICHAEL CORLEONE had taken precautions against every eventuality. His planning was faultless, his security impeccable. He was patient, hoping to use the full year to prepare. But he was not to get his necessary year because fate itself took a stand against him, and in the most surprising fashion. For it was the Godfather, the great Don himself, who failed Michael Corleone.

On one sunny Sunday morning, while the women were at church, Don Vito Corleone dressed in his gardening uniform: baggy grey trousers, a faded blue shirt, battered dirty-brown fedora decorated by a stained grey silk hatband. The Don ha-

gained considerable weight in his few years and worked on his tomato vines, he said, for the sake of his health. But he deceived no one.

The truth was, he loved tending his garden; he loved the sight of it early on a morning. It brought back his childhood in Sicily sixty years ago, brought it back without the terror, the sorrow of his own father's death. Now the beans in their rows grew little white flowers on top; strong green stalks of scallion fenced everything in. At the foot of the garden a spouted barrel stood guard. It was filled with liquidy cow manure, the finest garden fertilizer. Also in that lower part of the garden were the square wooden frames he had built with his own hands, the sticks cross-tied with thick white string. Over these frames crawled the tomato vines.

The Don hastened to water his garden. It must be done before the sun waxed too hot and turned the water into a prism of fire that could burn his lettuce leaves like paper. Sun was more important than water, water also was important; but the two, imprudently mixed, could cause great misfortune.

The Don moved through his garden hunting for ants. If ants were present, it meant that lice were in his vegetables and the ants were going after the lice and he would have to spray.

He had watered just in time. The sun was becoming hot and the Don thought, 'Prudence. Prudence.' But there were just a few more plants to be supported by sticks and he bent down again. He would go back into the house when he finished this last row.

Quite suddenly it felt as if the sun had come down very close to his head. The air was filled with dancing golden specks. Michael's oldest boy came running through the garden towards where the Don knelt and the boy was enveloped by a yellow shield of blinding light. But the Don was not to be tricked, he was too old a hand. Death hid behind that flaming yellow shield ready to pounce out on him and the Don with a wave of his hand warned the boy away from his presence. Just in time. The sledgehammer blow inside his chest made him choke for air. The Don pitched forward into the earth.

The boy raced away to call his father. Michael Corleone and some men at the mall gate ran to the garden and found the Don

411

lying prone, clutching handfuls of earth. They lifted the Don up and carried him to the shade of his stone-flagged patio. Michael knelt beside his father, holding his hand, while the other men called for an ambulance and doctor.

With a great effort the Don opened his eyes to see his son once more. The massive heart attack had turned his ruddy face almost blue. He was in extremis. He smelled the garden, the yellow shield of light smote his eyes, and he whispered 'Life is so beautiful.'

He was spared the sight of his women's tears, dying before they came back from church, dying before the ambulance arrived, or the doctor. He died surrounded by men, holding the hand of the son he had most loved.

The funeral was royal. The Five Families sent their Dons and *caporegimes*, as did the Tessio and Clemenza Families. Johnny Fontane made the tabloid headlines by attending the funeral despite the advice of Michael not to appear. Fontane gave a statement to the newspapers that Vito Corleone was his Godfather and the finest man he had ever known and that he was honoured to be permitted to pay his last respects to such a man and didn't give a damn who knew it.

The wake was held in the house of the mall, in the old fashioned style. Amerigo Bonasera had never done finer work, had discharged all obligations, by preparing his old friend and Godfather as lovingly as a mother prepares a bride for her wedding. Everyone commented on how not even death itself had been able to erase the nobility and the dignity of the great Don's countenance and such remarks made Amerigo Bonasera fill with knowing pride, a curious sense of power. Only he knew what a terrible massacre death had perpetrated on the Don's appearance.

All the old friends and servitors came. Nazorine, his wife, his daughter and her husband and their children, Lucy Mancini came with Freddie from Las Vegas. Tom Hagen and his wife and children, the Dons from San Francisco and Los Angeles, Boston and Cleveland. Rocco Lampone and Albert Neri were pallbearers with Clemenza and Tessio and, of course, the sons of the Don. The mall and all its houses were filled with floral wreaths.

Outside the gates of the mall were the newspapermen and photographers and a small truck that was known to contain FBI men with their movie cameras recording this epic. Some newspapermen who tried to crash the funeral inside found that the gate and fence were manned with security guards who demanded identification and an invitation card. And though they were treated with the utmost courtesy, refreshments sent out to them, they were not permitted inside. They tried to speak with some of the people coming out but were met with stony stares and not a syllable.

Michael Corleone spent most of the day in the corner library room with Kay, Tom Hagen, and Freddie. People were ushered in to see him, to offer their condolences. Michael received them with all courtesy even when some of them addressed him as Godfather or Don Michael, only Kay noticing his lips tighten with displeasure.

Clemenza and Tessio came to join this inner circle and Michael personally served them with a drink. There was some gossip of business. Michael informed them that the mall and all its houses were to be sold to a development and construction company. At an enormous profit, still another proof of the great Don's genius.

They all understood that now the whole empire would be in the West. That the Corleone Family would liquidate its power in New York. Such action had been awaiting the retirement or death of the Don.

It was nearly ten years since there had been such a celebration of people in this house, nearly ten years since the wedding of Constanzia Corleone and Carlo Rizzi, so somebody said. Michael walked to the window that looked out on the garden. That long time ago he had sat in the garden with Kay never dreaming that so curious a destiny was to be his. And his father dying had said, 'Life is so beautiful.' Michael could never remember his father ever having uttered a word about death, as if the Don respected death too much to philosophize about

It was time for the cemetery. It was time to bury the great Don. Michael linked his arm with Kay's and went out into the garden to join the host of mourners. Behind him came the

caporegimes followed by their soldiers and then all the humb people the Godfather had blessed during his lifetime. The baker Nazorine, the widow Colombo and her sons and all the countless others of his world he had ruled so firmly but justly There were even some who had been his enemies, come to d him honour.

Michael observed all this with a tight, polite smile. He wa not impressed. Yet, he thought, if I can die saying, 'Life is s beautiful,' then nothing else is important. If I can believe i myself that much, nothing else matters. He would follow h father. He would care for his children, his family, his worle But his children would grow in a different world. They woul be doctors, artists, scientists. Governors. Presidents. Anythin at all. He would see to it that they joined the general family (humanity, but he, as a powerful and prudent parent woul most certainly keep a wary eye on that general family.

On the morning after the funeral, all the most importar officials of the Corleone Family assembled on the mall. Shortl before noon they were admitted into the empty house of th Don. Michael Corleone received them.

They almost filled the corner library room. There were th two *caporegimes*, Clemenza and Tessio; Rocco Lampone, wit his reasonable, competent air; Carlo Rizzi, very quiet, ver much knowing his place; Tom Hagen, forsaking his strictl legal role to rally around in this crisis; Albert Neri, trying t stay physically close to Michael, lighting his new Don's cigar ette, mixing his drink, all to show an unswerving loyalty de spite the recent disaster to the Corleone Family.

The death of the Don was a great misfortune for the Family Without him it seemed that half their strength was gone an almost all their bargaining power against the Barzini–Tattagli alliance. Everyone in the room knew this and they waited fo what Michael would say. In their eyes he was not yet the nev Don; he had not earned the position or the title. If the God father had lived, he might have assured his son's succession now it was by no means certain.

Michael waited until Neri had served drinks. Then he sai quietly, 'I just want to tell everybody here that I understand

how they feel. I know you all respected my father, but now you have to worry about yourselves and your families. Some of you wonder how what happened is going to affect the planning we've done and the promises I made. Well, the answer to that is: nothing. Everything goes on as before.'

Clemenza shook his great shaggy buffalo head. His hair was an iron grey and his features more deeply embedded in added layers of fat, were unpleasant. 'The Barzinis and Tattaglias are going to move in on us real hard, Mike. You gotta fight or have a "sit-down" with them.' Everyone in the room noticed that Clemenza had not used a formal form of address to Michael, much less the title of Don.

'Let's wait and see what happens,' Michael said. 'Let them break the peace first.'

Tessio spoke up in his soft voice. 'They already have Mike. They opened up two "books" in Brooklyn this morning. I got the word from the police captain who runs the protection list at the station house. In a month I won't have a place to hang my hat in all Brooklyn.'

Michael stared at him thoughtfully. 'Have you done anything about it?'

Tessio shook his small, ferretlike head. 'No,' he said. 'I didn't want to give you any problems.'

'Good,' Michael said. 'Just sit tight. And I guess that's what I want to say to all of you. Just sit tight. Don't react to any provocation. Give me a few weeks to straighten things out, to see which way the wind is going to blow. Then I'll make the best deal I can for everybody here. Then we'll have a final meeting and make some final decisions.'

He ignored their surprise and Albert Neri started ushering them out. Michael said sharply, 'Tom, stick around a few minutes.'

Hagen went to the window that faced the mall. He waited until he saw the *caporegimes* and Carlo Rizzi and Rocco Lampone being shepherded through the guarded gate by Neri. Then he turned to Michael and said, 'Have you got all the political connexions wired into you?'

Michael shook his head regretfully. 'Not all. I needed about four more months. The Don and I were working on it. But

I've got all the judges, we did that first, and some of the more important people in Congress. And the big party boys here in New York were no problem, of course. The Corleone Family is a lot stronger than anybody thinks, but I hoped to make it foolproof.' He smiled at Hagen. 'I guess you've figured everything out by now.'

Hagen nodded. 'It wasn't hard. Except why you wanted me out of the action. But I put on my Sicilian hat and I finally figured that too.'

Michael laughed. 'The old man said you would. But that's a luxury I can't afford any more. I need you here. At least for the next few weeks. You better phone Vegas and talk to your wife. Just tell her a few weeks.'

Hagen said musingly, 'How do you think they'll come at you?'

Michael sighed. 'The Don instructed me. Through somebody close. Barzini will set me up through somebody close that, supposedly, I won't suspect.'

Hagen smiled at him. 'Somebody like me.'

Michael smiled back. 'You're Irish, they won't trust you.'

'I'm German–American,' Hagen said.

'To them that's Irish,' Michael said. 'They won't go to you and they won't go to Neri because Neri was a cop. Plus both of you are *too close* to me. They can't take that gamble. Rocco Lampone isn't close enough. No, it will be Clemenza, Tessio or Carlo Rizzi.'

Hagen said softly, 'I'm betting it's Carlo.'

'We'll see,' Michael said. 'It won't be long.'

It was the next morning, while Hagen and Michael were having breakfast together. Michael took a phone call in the library, and when he came back to the kitchen, he said to Hagen, 'It's all set up. I'm going to meet Barzini a week from now. To make a new peace now that the Don is dead.' Michael laughed.

Hagen asked, 'Who phoned you, who made the contact?' They both knew that whoever in the Corleone Family had made the contact had turned traitor.

Michael gave Hagen a sad regretful smile. 'Tessio,' he said.

They ate the rest of their breakfast in silence. Over coffee Hagen shook his head. 'I could have sworn it would have been Carlo or maybe Clemenza. I never figured Tessio. He's the best of the lot.'

'He's the most intelligent,' Michael said. 'And he did what seems to him to be the smart thing. He sets me up for the hit by Barzini and inherits the Corleone Family. He sticks with me and he gets wiped out; he's figuring I can't win.'

Hagen paused before he asked reluctantly, 'How right is he figuring?'

Michael shrugged. 'It looks bad. But my father was the only one who understood that political connexions and power are worth ten *regimes*. I think I've got most of my father's political power in my hands now, but I'm the only one who really knows that.' He smiled at Hagen, a reassuring smile. 'I'll make them call me Don. But I feel lousy about Tessio.'

Hagen said, 'Have you agreed to the meeting with Barzini?'

'Yeah,' Michael said. 'A week from tonight. In Brooklyn, on Tessio's ground where I'll be safe.' He laughed again.

Hagen said, 'Be careful before then.'

For the first time Michael was cold with Hagen. 'I don't need a *Consigliori* to give me that kind of advice,' he said.

During the week preceding the peace meeting between the Corleone and Barzini Families, Michael showed Hagen just how careful he could be. He never set foot outside the mall and never received anyone without Neri beside him. There was only one annoying complication. Connie and Carlo's oldest boy was to receive his Confirmation in the Catholic Church and Kay asked Michael to be the Godfather. Michael refused.

'I don't often beg you,' Kay said. 'Please do this just for me. Connie wants it so much. And so does Carlo. It's very important to them. Please, Michael.'

She could see he was angry with her for insisting and expected him to refuse. So she was surprised when he nodded and said, 'OK. But I can't leave the mall. Tell them to arrange for the priest to confirm the kid here. I'll pay whatever it costs. If they run into trouble with the church people, Hagen will straighten it out.'

And so the day before the meeting with the Barzini Family, Michael Corleone stood Godfather to the son of Carlo and Connie Rizzi. He presented the boy with an extremely expensive wristwatch and gold band. There was a small party in Carlo's house, to which were invited the *caporegimes*, Hagen, Lampone, and everyone who lived on the mall, including, of course, the Don's widow. Connie was so overcome with emotion that she hugged and kissed her brother and Kay all during the evening. And even Carlo Rizzi became sentimental, wringing Michael's hand and calling him Godfather at every excuse – old country style. Michael himself had never been so affable, so outgoing. Connie whispered to Kay, 'I think Carlo and Mike are going to be real friends now. Something like this always brings people together.'

Kay squeezed her sister-in-law's arm. 'I'm *so* glad,' she said.

Book VIII

CHAPTER THIRTY

ALBERT NERI sat in his Bronx apartment and carefully brushed the blue serge of his old policeman's uniform. He unpinned the badge and set it on the table to be polished. The regulation holster and gun were draped over a chair. This old routine of detail made him happy in some strange way, one of the few times he had felt happy since his wife had left him, nearly two years ago.

He had married Rita when she was a high school kid and he was a rookie policeman. She was shy, dark-haired, from a straitlaced Italian family who never let her stay out later than ten o'clock at night. Neri was completely in love with her, her innocence, her virtue, as well as her dark prettiness.

At first Rita Neri was fascinated by her husband. He was immensely strong and she could see people were afraid of him because of that strength and his unbending attitude towards what was right and wrong. He was rarely tactful. If he disagreed with a group's attitude or an individual's opinion, he kept his mouth shut or brutally spoke his contradiction. He never gave a polite agreement. He also had a true Sicilian temper and his rages could be awesome. But he was never angry with his wife.

Neri in the space of five years became one of the most feared policemen on the New York City force. Also one of the most honest. But he had his own ways of enforcing the law. He hated punks and when he saw a bunch of young rowdies making a disturbance on a street corner at night, disturbing passersby, he took quick and decisive action. He employed a physical strength that was truly extraordinary, which he himself did not fully appreciate.

One night in Central Park West he jumped out of the patrol car and lined up six punks in black silk jackets. His partner

remained in the driver's seat, not wanting to get involved knowing Neri. The six boys, all in their late teens, had bee stopping people and asking them for cigarettes in a youth fully menacing way but not doing anyone any real physica harm. They had also teased girls going by with a sexual gestur more French than American.

Neri lined them up against the stone wall that closed o Central Park from Eighth Avenue. It was twilight, but Nex carried his favourite weapon, a huge flashlight. He neve bothered drawing his gun; it was never necessary. His fac when he was angry was so brutally menacing, combined wit his uniform, that the usual punks were cowed. These were n exception.

Neri asked the first youth in the black silk jacket, 'What' your name?' The kid answered with an Irish name. Neri tol him, 'Get off the street. I see you again tonight I'll crucify you He motioned with his flashlight and the youth walked quickl away. Neri followed the same procedure with the next tw boys. He let them walk off. But the fourth boy gave an Italia name and smiled at Neri as if to claim some sort of kinship Neri was unmistakably of Italian descent. Neri looked at thi youth for a moment and asked superfluously, 'You Italian?' The boy grinned confidently.

Neri hit him a stunning blow on the forehead with hi flashlight. The boy dropped to his knees. The skin and flesl of his forehead had cracked open and blood poured down hi face. But it was strictly a flesh wound. Neri said to him harshly, 'You son of a bitch, you're a disgrace to the Italians You give us all a bad name. Get on your feet.' He gave th youth a kick in the side, not gently, not too hard. 'Get hom and stay off the street. Don't ever let me catch you wearin; that jacket again either. I'll send you to the hospital. Now ge home. You're lucky I'm not your father.'

Neri didn't bother with the other two punks. He just booted their asses down the Avenue, telling them he didn't want then on the street that night.

In such encounters all was done so quickly that there was nc time for a crowd to gather or for someone to protest hi actions. Neri would get into the patrol car and his partne

would zoom it away. Of course once in a while there would be a real hard case who wanted to fight and might even pull a knife. These were truly unfortunate people. Neri would, with awesome ferocity, beat them bloody and throw them into the patrol car. They would be put under arrest and charged with assaulting an officer. But usually their case would have to wait until they were discharged from the hospital.

Eventually Neri was transferred to the beat that held the United Nations building area, mainly because he had not shown his precinct sergeant the proper respect. The United Nations people with their diplomatic immunity parked their limousines all over the streets without regard to police regulations. Neri complained to the precinct and was told not to make waves, to just ignore it. But one night there was a whole side street that was impassable because of the carelessly parked autos. It was after midnight, so Neri took his huge flashlight from the patrol car and went down the street smashing windshields to smithereens. It was not easy, even for high-ranking diplomats, to get the windshields repaired in less than a few days. Protests poured into the police precinct station house demanding protection against this vandalism. After a week of windshield smashing the truth gradually hit somebody about what was actually happening and Albert Neri was transferred to Harlem.

One Sunday shortly afterwards, Neri took his wife to visit his widowed sister in Brooklyn. Albert Neri had the fierce protective affection for his sister common to all Sicilians and he always visited her at least once every couple of months to make sure she was all right. She was much older than he was and had a son who was twenty. This son, Thomas, without a father's hand, was giving trouble. He had got into a few minor scrapes, was running a little wild. Neri had once used his contacts on the police force to keep the youth from being charged with larceny. On that occasion he had kept his anger in check but had given his nephew warning. 'Tommy, you make my sister cry over you and I'll straighten you out myself.' It was intended as a friendly pally-uncle warning, not really as a threat. But even though Tommy was the toughest kid in that tough Brooklyn neighbourhood, he was afraid of his Uncle Al.

On this particular visit Tommy had come in very late

Saturday night and was still sleeping in his room. His mother went to wake him, telling him to get dressed so that he could eat Sunday dinner with his uncle and aunt. The boy's voice came harshly through the partly opened door, 'I don't give a shit, let me sleep,' and his mother came back out into the kitchen smiling apologetically.

So they had to eat their dinner without him. Neri asked his sister if Tommy was giving her any real trouble and she shook her head.

Neri and his wife were about to leave when Tommy finally got up. He barely grumbled a hello and went into the kitchen. Finally he yelled in to his mother, 'Hey, Ma, how about cooking me something to eat?' But it was not a request. It was the spoiled complaint of an indulged child.

His mother said shrilly, 'Get up when it's dinnertime and then you can eat. I'm not going to cook again for you.'

It was the sort of little ugly scene that was fairly commonplace, but Tommy still a little irritable from his slumber made a mistake. 'Ah, fuck you and your nagging, I'll go out and eat.' As soon as he said it he regretted it.

His Uncle Al was on him like a cat on a mouse. Not so much for the insult to his sister this particular day but because it was obvious that he often talked to his mother in such a fashion when they were alone. Tommy never dared say such a thing in front of her brother. This particular Sunday he had just been careless. To his misfortune.

Before the frightened eyes of the two women, Al Neri gave his nephew a merciless, careful, physical beating. At first the youth made an attempt at self-defence but soon gave that up and begged for mercy. Neri slapped his face until the lips were swollen and bloody. He rocked the kid's head back and slammed him against the wall. He punched him in the stomach, then got him prone on the floor and slapped his face into the carpet. He told the two women to wait and made Tommy go down the street and get into his car. There he put the fear of God into him. 'If my sister ever tells me you talk like that to her again, this beating will seem like kisses from a broad,' he told Tommy. 'I want to see you straighten out. Now go up the house and tell my wife I'm waiting for her.'

It was two months after this that Al Neri got back from a late shift on the force and found his wife had left him. She had packed all her clothes and gone back to her family. Her father told him that Rita was afraid of him, that she was afraid to live with him because of his temper. Al was stunned with disbelief. He had never struck his wife, never threatened her in any way, had never felt anything but affection for her. But he was so bewildered by her action that he decided to let a few days go by before he went over to her family's house to talk to her.

It was unfortunate that the next night he ran into trouble on his shift. His car answered a call in Harlem, a report of a deadly assault. As usual Neri jumped out of the patrol car while it was still rolling to a stop. It was after midnight and he was carrying his huge flashlight. It was easy spotting the trouble. There was a crowd gathered outside a tenement doorway. One Negro woman said to Neri, 'There's a man in there cutting a little girl.'

Neri went into the hallway. There was an open door at the far end with light streaming out and he could hear moaning. Still handling the flashlight, he went down the hall and through the open doorway.

He almost fell over two bodies stretched out on the floor. One was a Negro woman of about twenty-five. The other was a Negro girl of no more than twelve. Both were bloody from razor cuts on their faces and bodies. In the living room Neri saw the man who was responsible. He knew him well.

The man was Wax Baines, a notorious pimp, dope pusher, and strong-arm artist. His eyes were popping from drugs now, the bloody knife he held in his hand wavered. Neri had arrested him two weeks before for severely assaulting one of his whores in the street. Baines had told him, 'Hey, man, this none of your business.' And Neri's partner had also said something about letting the niggers cut each other up if they wanted to, but Neri had hauled Baines into the station house. Baines was bailed out the very next day.

Neri had never much liked Negroes, and working in Harlem had made him like them even less. They all were on drugs or booze while they let their women work or peddle ass. He didn't have any use for any of the bastards. So Baines' brazen breaking of the law infuriated him. And the sight of the little

girl all cut up with the razor sickened him. Quite coolly, in his own mind, he decided not to bring Baines in.

But witnesses were already crowding into the apartment behind him, some people who lived in the building and his partner from the patrol car.

Neri ordered Baines, 'Drop your knife, you're under arrest.'

Baines laughed. 'Man, you gotta use your gun to arrest me.' He held his knife up. 'Or maybe you want this.'

Neri moved very quickly, so his partner would not have time to draw a gun. The Negro stabbed with his knife, but Neri's extraordinary reflexes enabled him to catch the thrust with his left palm. With his right hand he swung the flashlight in a short vicious arc. The blow caught Baines on the side of the head and made his knees buckle comically like a drunk's. The knife dropped from his hand. He was quite helpless. So Neri's second blow was inexcusable, as the police departmental hearing and his criminal trial later proved with the help of the testimony of witnesses and his fellow policeman. Neri brought the flashlight down on the top of Baines' skull in an incredibly powerful blow which shattered the glass of the flashlight; the enamel shield and the bulb itself popping out and flying across the room. The heavy aluminium barrel of the flashlight tube bent and only the batteries inside prevented it from doubling on itself. One awed onlooker, a Negro man who lived in the tenement and later testified against Neri, said, 'Man, that's a hard-headed nigger.'

But Baines' head was not quite hard enough. The blow caved in his skull. He died two hours later in the Harlem Hospital.

Albert Neri was the only one surprised when he was brought up on departmental charges for using excessive force. He was suspended and criminal charges were brought against him. He was indicted for manslaughter, convicted, and sentenced to from one to ten years in prison. By this time he was so filled with a baffled rage and hatred of all society that he didn't give a damn. That they dared to judge him a criminal! That they dared to send him to prison for killing an animal like that pimp-nigger! That they didn't give a damn for the woman and little girl who had been carved up, disfigured for life, and still in the hospital.

He did not fear prison. He felt that because of his having been a policeman and especially because of the nature of his offence, he would be well taken care of. Several of his buddy officers had already assured him they would speak to friends. Only his wife's father, a shrewd old-style Italian who owned a fish market in the Bronx, realized that a man like Albert Neri had little chance of surviving a year in prison. One of his fellow inmates might kill him; if not, he was almost certain to kill one of them. Out of guilt that his daughter had deserted a fine husband for some womanly foolishness, Neri's father-in-law used his contacts with the Corleone Family (he paid protection money to one of its representatives and supplied the Corleone Family itself with the finest fish available, as a gift), he petitioned for their intercession.

The Corleone Family knew about Albert Neri. He was something of a legend as a legitimately tough cop; he had made a certain reputation as a man not to be held lightly, as a man who could inspire fear out of his own person regardless of the uniform and the sanctioned gun he wore. The Corleone Family was always interested in such men. The fact that he was a policeman did not mean too much. Many young men started down a false path to their true destiny. Time and fortune usually set them aright.

It was Pete Clemenza, with his fine nose for good personnel, who brought the Neri affair to Tom Hagen's attention. Hagen studied the copy of the official police dossier and listened to Clemenza. He said, 'Maybe we have another Luca Brasi here.'

Clemenza nodded his head vigorously. Though he was very fat, his face had none of the usual stout man's benignity. 'My thinking exactly. Mike should look into this himself.'

And so it was that before Albert Neri was transferred from the temporary jail to what would have been his permanent residence upstate, he was informed that the judge had reconsidered his case on the basis of new information and affidavits submitted by high police officials. His sentence was suspended and he was released.

Albert Neri was no fool and his father-in-law no shrinking violet. Neri learned what had happened and paid his debt to the father-in-law by agreeing to get a divorce from Rita. Then

he made a trip out to Long Beach to thank his benefactor. Arrangements had been made beforehand, of course. Michael received him in his library.

Neri stated his thanks in formal tones and was surprised and gratified by the warmth with which Michael received his thanks.

'Hell, I couldn't let them do that to a fellow Sicilian,' Michael said. 'They should have given you a goddamn medal. But those damn politicians don't give a shit about anything except pressure groups. Listen, I would never have stepped into the picture if I hadn't checked everything out and saw what a raw deal you got. One of my people talked to your sister and she told us how you were always worried about her and her kid, how you straightened the kid out, kept him from going bad. Your father-in-law says you're the finest fellow in the world. That's rare.' Tactfully Michael did not mention anything about Neri's wife having left him.

They chatted for a while. Neri had always been a taciturn man, but he found himself opening up to Michael Corleone. Michael was only about five years his senior, but Neri spoke to him as if he were much older, old enough to be his father.

Finally Michael said, 'There's no sense getting you out of jail and then just leaving you high and dry. I can arrange some work for you. I have interests out in Las Vegas, with your experience you could be a hotel security man. Or if there's some little business you'd like to go into, I can put a word in with the banks to advance you a loan for capital.'

Neri was overcome with grateful embarrassment. He proudly refused and then added, 'I have to stay under the jurisdiction of the court anyway with the suspended sentence.'

Michael said briskly, 'That's all crap detail, I can fix that. Forget about that supervision and just so the banks won't get choosy I'll have your yellow sheet pulled.'

The yellow sheet was a police record of criminal offences committed by any individual. It was usually submitted to a judge when he was considering what sentence to give a convicted criminal. Neri had been long enough on the police force to know that many hoodlums going up for sentencing had been treated leniently by the judge because a clean yellow

426

sheet had been submitted by the bribed Police Records Department. So he was not too surprised that Michael Corleone could do such a thing; he was, however, surprised that such trouble would be taken on his account.

'If I need help, I'll get in touch,' Neri said.

'Good, good,' Michael said. He looked at his watch and Neri took this for his dismissal. He rose to go. Again he was surprised.

'Lunchtime,' Michael said. 'Come on and eat with me and my family. My father said he'd like to meet you. We'll walk over to his house. My mother should have some fried peppers and eggs and sausages. Real Sicilian style.'

That afternoon was the most agreeable Albert Neri had spent since he was a small boy, since the days before his parents had died when he was only fifteen. Don Corleone was at his most amiable and was delighted when he discovered that Neri's parents had originally come from a small village only a few minutes from his own. The talk was good, the food was delicious, the wine robustly red. Neri was struck by the thought that he was finally with his own true people. He understood that he was only a casual guest but he knew he could find a permanent place and be happy in such a world.

Michael and the Don walked him out to his car. The Don shook his hand and said, 'You're a fine fellow. My son Michael here, I've been teaching him the olive oil business, I'm getting old, I want to retire. And he comes to me and he says he wants to interfere in your little affair. I tell him to just learn about the olive oil. But he won't leave me alone. He says, here is this fine fellow, a Sicilian, and they are doing this dirty trick to him. He kept on, he gave me no peace until I interested myself in it. I tell you this to tell you that he was right. Now that I've met you, I'm glad we took the trouble. So if we can do anything further for you, just ask the favour. Understand? We're at your service.' (Remembering the Don's kindness, Neri wished the great man was still alive to see the service that would be done this day.)

It took Neri less than three days to make up his mind. He understood he was being courted but understood more. That the Corleone Family approved that act of his which society

condemned and had punished him for. The Corleone Family valued him, society did not. He understood that he would be happier in the world the Corleones had created than in the world outside. And he understood that the Corleone Family was the more powerful, within its narrower limits.

He visited Michael again and put his cards on the table. He did not want to work in Vegas but he would take a job with the Family in New York. He made his loyalty clear. Michael was touched, Neri could see that. It was arranged. But Michael insisted that Neri take a vacation first, down in Miami at the Family hotel there, all expenses paid and a month's salary in advance so he could have the necessary cash to enjoy himself properly.

That vacation was Neri's first taste of luxury. People at the hotel took special care of him, saying, 'Ah, you're a friend of Michael Corleone.' The word had been passed along. He was given one of the plush suites, not the grudging small room a poor relation might be fobbed off with. The man running the nightclub in the hotel fixed him up with some beautiful girls. When Neri got back to New York he had a slightly different view on life in general.

He was put in the Clemenza *regime* and tested carefully by that masterful personnel man. Certain precautions had to be taken. He had, after all, once been a policeman. But Neri's natural ferocity overcame whatever scruples he might have had at being on the other side of the fence. In less than a year he had 'made his bones'. He could never turn back.

Clemenza sang his praises. Neri was a wonder, the new Luca Brasi. He would be better than Luca, Clemenza bragged. After all, Neri was his discovery. Physically the man was a marvel. His reflexes and coordination such that he could have been another Joe DiMaggio. Clemenza also knew that Neri was not a man to be controlled by someone like himself. Neri was made directly responsible to Michael Corleone, with Tom Hagen as the necessary buffer. He was a 'special' and as such commanded a high salary but did not have his own living, a bookmaking or strong-arm operation. It was obvious that his respect for Michael Corleone was enormous and one day Hagen said jokingly to Michael, 'Well now you've got your Luca.'

Michael nodded. He had brought it off. Albert Neri was his man to the death. And of course it was a trick learned from the Don himself. While learning the business, undergoing the long days of tutelage by his father, Michael had one time asked, 'How come you used a guy like Luca Brasi? An animal like that?'

The Don had proceeded to instruct him. 'There are men in this world,' he said, 'who go about demanding to be killed. You must have noticed them. They quarrel in gambling games, they jump out of their automobiles in a rage if someone so much as scratches their fender, they humiliate and bully people whose capabilities they do not know. I have seen a man, a fool, deliberately infuriate a group of dangerous men, and he himself without any resources. These are people who wander through the world shouting, "Kill me. Kill me." And there is always somebody ready to oblige them. We read about it in the newspapers every day. Such people of course do a great deal of harm to others also.

'Luca Brasi was such a man. But he was such an extraordinary man that for a long time nobody could kill him. Most of these people are of no concern to ourselves but a Brasi is a powerful weapon to be used. The trick is that since he does not fear death and indeed looks for it, then the trick is to make yourself the only person in the world that he truly desires *not* to kill him. He has only that one fear, not of death, but that *you* may be the one to kill him. He is yours then.'

It was one of the most valuable lessons given by the Don before he died, and Michael had used it to make Neri his Luca Brasi.

And now, finally, Albert Neri, alone in his Bronx apartment, was going to put on his police uniform again. He brushed it carefully. Polishing the holster would be next. And his policeman's cap too, the visor had to be cleaned, the stout black shoes shined. Neri worked with a will. He had found his place in the world, Michael Corleone had placed his absolute trust in him, and today he would not fail that trust.

CHAPTER THIRTY-ONE

On that same day two limousines parked on the Long Beach mall. One of the big cars waited to take Connie Corleone, her mother, her husband, and her two children, to the airport. The Carlo Rizzi Family was to take a vacation in Las Vegas in preparation for their permanent move to that city. Michael had given Carlo the order, over Connie's protests. Michael had not bothered to explain that he wanted everyone out of the mall before the Corleone–Barzini Families' meeting. Indeed the meeting itself was top secret. The only ones who knew about it were the *capos* of the Family.

The other limousine was for Kay and her children, who were being driven up to New Hampshire for a visit with her parents. Michael would have to stay in the mall; he had affairs too pressing to leave.

The night before Michael had also sent word to Carlo Rizzi that he would require his presence on the mall for a few days, that he could join his wife and children later that week. Connie had been furious. She had tried to get Michael on the phone, but he had gone into the city. Now her eyes were searching the mall for him, but he was closeted with Tom Hagen and not to be disturbed. Connie kissed Carlo goodbye when he put her in the limousine. 'If you don't come out there in two days, I'll come back to get you,' she threatened him.

He gave her a polite husbandly smile of sexual complicity. 'I'll be there,' he said.

She hung out the window. 'What do you think Michael wants you for?' she asked. Her worried frown made her look old and unattractive.

Carlo shrugged. 'He's been promising me a big deal. Maybe that's what he wants to talk about. That's what he hinted anyway.' Carlo did not know of the meeting scheduled with the Barzini Family for that night.

Connie said eagerly, 'Really, Carlo?'

Carlo nodded at her reassuringly. The limousine moved off through the gates of the mall.

It was only after the first limousine had left that Michael appeared to say goodbye to Kay and his own two children. Carlo also came over and wished Kay a good trip and a good vacation. Finally the second limousine pulled away and went through the gate.

Michael said, 'I'm sorry I had to keep you here, Carlo. It won't be more than a couple of days.'

Carlo said quickly, 'I don't mind at all.'

'Good,' Michael said. 'Just stay by your phone and I'll call you when I'm ready for you. I have to get some other dope before. OK?'

'Sure, Mike, sure,' Carlo said. He went into his own house, made a phone call to the mistress he was discreetly keeping in Westbury, promising he would try to get to her late that night. Then he got set with a bottle of rye and waited. He waited a long time. Cars started coming through the gate shortly after noontime. He saw Clemenza get out of one, and then a little later Tessio came out of another. Both of them were admitted to Michael's house by one of the bodyguards. Clemenza left after a few hours, but Tessio did not reappear.

Carlo took a breath of fresh air around the mall, not more then ten minutes. He was familiar with all the guards who pulled duty on the mall, was even friendly with some of them. He thought he might gossip a bit to pass the time. But to his surprise none of the guards today were men he knew. They were all strangers to him. Even more surprising, the man in charge at the gate was Rocco Lampone, and Carlo knew that Rocco was of too high a rank in the Family to be pulling such menial duty unless something extraordinary was afoot.

Rocco gave him a friendly smile and hello. Carlo was wary. Rocco said, 'Hey, I thought you were going on vacation with the Don?'

Carlo shrugged. 'Mike wanted me to stick around for a couple of days. He has something for me to do.'

'Yeah,' Rocco Lampone said. 'Me too. Then he tells me to keep a check on the gate. Well, what the hell, he's the boss.'

His tone implied that Michael was not the man his father was a bit derogatory.

Carlo ignored the tone. 'Mike knows what he's doing,' he said. Rocco accepted the rebuke in silence. Carlo said so long and walked back to the house. Something was up, but Rocco didn't know what it was.

Michael stood in the window of his living room and watched Carlo strolling around the mall. Hagen brought him a drink, strong brandy. Michael sipped at it gratefully. Behind him, Hagen said, gently, 'Mike, you have to start moving. It's time.'

Michael sighed. 'I wish it weren't so soon. I wish the old man had lasted a little longer.'

'Nothing will go wrong,' Hagen said. 'If I didn't tumble, then nobody did. You set it up real good.'

Michael turned away from the window. 'The old man planned a lot of it. I never realized how smart he was. But I guess you know.'

'Nobody like him,' Hagen said. 'But this is beautiful. This is the best. So you can't be too bad either.'

'Let's see what happens,' Michael said. 'Are Tessio and Clemenza on the mall?'

Hagen nodded. Michael finished the brandy in his glass. 'Send Clemenza in to me. I'll instruct him personally. I don't want to see Tessio at all. Just tell him I'll be ready to go to the Barzini meeting with him in about a half hour. Clemenza's people will take care of him after that.'

Hagen said in a noncommittal voice, 'There's no way to let Tessio off the hook?'

'No way,' Michael said.

Upstate in the city of Buffalo, a small pizza parlour on a side street was doing a rush trade. As the lunch hours passed, business finally slackened off and the counterman took his round tin tray with its few leftover slices out of the window and put it on the shelf of the huge brick oven. He peeked into the oven at a pie baking there. The cheese had not yet started to bubble. When he turned back to the counter that enabled him to serve

432

people in the street, there was a young, tough-looking man standing there. The man said, 'Gimme a slice.'

The pizza counterman took his wooden shovel and scooped one of the cold slices into the oven to warm it up. The customer, instead of waiting outside, decided to come through the door and be served. The store was empty now. The counterman opened the oven and took out the hot slice and served it on a paper plate. But the customer, instead of giving the money for it, was staring at him intently.

'I hear you got a great tattoo on your chest,' the customer said. 'I can see the top of it over your shirt, how about letting me see the rest of it?'

The counterman froze. He seemed to be paralysed.

'Open your shirt,' the customer said.

The counterman shook his head. 'I got no tattoo,' he said in heavily accented English. 'That's the man who works at night.'

The customer laughed. It was an unpleasant laugh, harsh, strained. 'Come on, unbutton your shirt, let me see.'

The counterman started backing towards the rear of the store, aiming to edge around the huge oven. But the customer raised his hand above the counter. There was a gun in it. He fired. The bullet caught the counterman in the chest and hurled him against the oven. The customer fired into his body again and the counterman slumped to the floor. The customer came around the serving shelf, reached down and ripped the buttons off the shirt. The chest was covered with blood, but the tattoo was visible, the intertwined lovers and the knife transfixing them. The counterman raised one of his arms feebly as if to protect himself. The gunman said, 'Fabrizzio, Michael Corleone sends you his regards.' He extended the gun so that it was only a few inches from the counterman's skull and pulled the trigger. Then he walked out of the store. At the kerb a car was waiting for him with its door open. He jumped in and the car sped off.

Rocco Lampone answered the phone installed on one of the iron pillars of the gate. He heard someone saying, 'Your package is ready,' and the click as the caller hung up. Rocco got into his car and drove out of the mall. He crossed the Jones

Beach Causeway, the same causeway on which Sonny Corleone had been killed, and drove out to the railroad station of Wantagh. He parked his car there. Another car was waiting for him with two men in it. They drove to a motel ten minutes further out on Sunrise Highway and turned into its courtyard. Rocco Lampone, leaving his two men in the car, went to one of the little chalet-type bungalows. One kick sent its door flying off its hinges and Rocco sprang into the room.

Phillip Tattaglia, seventy years old and naked as a baby, stood over a bed on which lay a young girl. Phillip Tattaglia's thick head of hair was jet black, but the plumage of his crotch was steel grey. His body had the soft plumpness of a bird. Rocco pumped four bullets into him, all in the belly. Then he turned and ran back to the car. The two men dropped him off in the Wantagh station. He picked up his car and drove back to the mall. He went in to see Michael Corleone for a moment and then came out and took up his position at the gate.

Albert Neri, alone in his apartment, finished getting his uniform ready. Slowly he put it on, trousers, shirt, tie, and jacket, holster, and gunbelt. He had turned in his gun when he was suspended from the force, but, through some administrative oversight they had not made him give up his shield. Clemenza had supplied him with a new .38 Police Special that could not be traced. Neri broke it down, oiled it, checked the hammer, put it together again, clicked the trigger. He loaded the cylinders and was set to go.

He put the policeman's cap in a heavy paper bag and then put a civilian overcoat on to cover his uniform. He checked his watch. Fifteen minutes before the car would be waiting for him downstairs. He spent the fifteen minutes checking himself in the mirror. There was no question. He looked like a real cop.

The car was waiting with two of Rocco Lampone's men in front. Neri got into the back seat. As the car started downtown, after they had left the neighbourhood of his apartment, he shrugged off the civilian overcoat and left it on the floor of the car. He ripped open the paper bag and put the police officer's cap on his head.

At 55th Street and Fifth Avenue the car pulled over to the kerb and Neri got out. He started walking down the avenue. He had a queer feeling being back in uniform, patrolling the streets as he had done so many times. There were crowds of people. He walked downtown until he was in front of Rockefeller Centre, across the way from St Patrick's Cathedral. On his side of Fifth Avenue he spotted the limousine he was looking for. It was parked, nakedly alone between a whole string of red NO PARKING and NO STANDING signs. Neri slowed his pace. He was too early. He stopped to write something in his summons book and then kept walking. He was abreast of the limousine. He tapped its fender with his nightstick. The driver looked up in surprise. Neri pointed to the NO STANDING sign with his stick and motioned the driver to move his car. The driver turned his head away.

Neri walked out into the street so that he was standing by the driver's open window. The driver was a tough-looking hood, just the kind he loved to break up. Neri said with deliberate insultingness, 'OK, wise guy, you want me to stick a summons up your ass or do you wanta get moving?'

The driver said impassively, 'You better check with your precinct. Just give me the ticket if it'll make you feel happy.'

'Get the hell out of here,' Neri said, 'or I'll drag you out of that car and break your ass.'

The driver made a ten-dollar bill appear by some sort of magic, folded it into a little square using just one hand, and tried to shove it inside Neri's blouse. Neri moved back on to the sidewalk and crooked his finger at the driver. The driver came out of the car.

'Let me see your licence and registration,' Neri said. He had been hoping to get the driver to go around the block but there was no hope for that now. Out of the corner of his eye, Neri saw three short, heavyset men coming down the steps of the Plaza building, coming down towards the street. It was Barzini himself and his two bodyguards, on their way to meet Michael Corleone. Even as he saw this, one of the bodyguards peeled off to come ahead and see what was wrong with Barzini's car.

This man asked the driver, 'What's up?'

435

The driver said curtly, 'I'm getting a ticket, no sweat. This guy must be new in the precinct.'

At that moment Barzini came up with his other bodyguard. He growled, 'What the hell is wrong now?'

Neri finished writing in his summons book and gave the driver back his registration and licence. Then he put his summons book back in his hip pocket and with the forward motion of his hand drew the .38 Special.

He put three bullets in Barzini's barrel chest before the other three men unfroze enough to dive for cover. By that time Neri had darted into the crowd and around the corner where the car was waiting for him. The car sped up to Ninth Avenue and turned downtown. Near Chelsea Park, Neri, who had discarded the cap and put on the overcoat and changed clothing, transferred to another car that was waiting for him. He had left the gun and the police uniform in the other car. It would be got rid of. An hour later he was safely in the mall on Long Beach and talking to Michael Corleone.

Tessio was waiting in the kitchen of the old Don's house and was sipping at a cup of coffee when Tom Hagen came for him. 'Mike is ready for you now,' Hagen said. 'You better make your call to Barzini and tell him to start on his way.'

Tessio rose and went to the wall phone. He dialled Barzini's office in New York and said curtly, 'We're on our way to Brooklyn.' He hung up and smiled at Hagen. 'I hope Mike can get us a good deal tonight.'

Hagen said gravely, 'I'm sure he will.' He escorted Tessio out of the kitchen and on to the mall. They walked towards Michael's house. At the door they were stopped by one of the bodyguards. 'The boss says he'll come in a separate car. He says for you two to go on ahead.'

Tessio frowned and turned to Hagen. 'Hell, he can't do that; that screws up all my arrangements.'

At that moment three more bodyguards materialized around them. Hagen said gently, 'I can't go with you either, Tessio.'

The ferret-faced *caporegime* understood everything in a flash of a second. And accepted it. There was a moment of physical

weakness, and then he recovered. He said to Hagen, 'Tell Mike it was business, I always liked him.'

Hagen nodded. 'He understands that.'

Tessio paused for a moment and then said softly, 'Tom, can you get me off the hook? For old times' sake?'

Hagen shook his head. 'I can't,' he said.

He watched Tessio being surrounded by bodyguards and led into a waiting car. He felt a little sick. Tessio had been the best soldier in the Corleone Family; the old Don had relied on him more than any other man with the exception of Luca Brasi. It was too bad that so intelligent a man had made such a fatal error in judgement so late in life.

Carlo Rizzi, still waiting for his interview with Michael, became jittery with all the arrivals and departures. Obviously something big was going on and it looked as if he were going to be left out. Impatiently he called Michael on the phone. One of the house bodyguards answered, went to get Michael, and came back with the message that Michael wanted him to sit tight, that he would get to him soon.

Carlo called up his mistress again and told her he was sure he would be able to take her to a late supper and spend the night. Michael had said he would call him soon, whatever he had planned couldn't take more than an hour or two. Then it would take him about forty minutes to drive to Westbury. It could be done. He promised her he would do it and sweet-talked her into not being sore. When he hung up he decided to get properly dressed so as to save time afterwards. He had just slipped into a fresh shirt when there was a knock on the door. He reasoned quickly that Mike had tried to get him on the phone and had kept getting a busy signal so had simply sent a messenger to call him. Carlo went to the door and opened it. He felt his whole body go weak with a terrible sickening fear. Standing in the doorway was Michael Corleone, his face the face of that death Carlo Rizzi saw often in his dreams.

Behind Michael Corleone were Hagen and Rocco Lampone. They looked grave, like people who had come with the utmost reluctance to give a friend bad news. The three of them entered the house and Carlo Rizzi led them into the living room.

Recovered from his first shock, he thought that he had suffered an attack of nerves. Michael's words made him really sick, physically nauseous.

'You have to answer for Santino,' Michael said.

Carlo didn't answer, pretended not to understand. Hagen and Lampone had split away to opposite walls of the room. He and Michael faced each other.

'You fingered Sonny for the Barzini people,' Michael said, his voice flat. 'That little farce you played out with my sister, did Barzini kid you that would fool a Corleone?'

Carlo Rizzi spoke out of his terrible fear, without dignity, without any kind of pride. 'I swear I'm innocent. I swear on the head of my children I'm innocent. Mike, don't do this to me, please, Mike, don't do this to me.'

Michael said quietly, 'Barzini is dead. So is Phillip Tattaglia. I want to square all the Family accounts tonight. So don't tell me you're innocent. It would be better for you to admit what you did.'

Hagen and Lampone stared at Michael with astonishment. They were thinking that Michael was not yet the man his father was. Why try to get this traitor to admit guilt? That guilt was already proven as much as such a thing could be proven. The answer was obvious. Michael still was not that confident of his right, still feared being unjust, still worried about that fraction of an uncertainty that only a confession by Carlo Rizzi could erase.

There was still no answer. Michael said almost kindly, 'Don't be so frightened. Do you think I'd make my sister a widow? Do you think I'd make my nephews fatherless? After all I'm Godfather to one of your kids. No, your punishment will be that you won't be allowed any work with the Family. I'm putting you on a plane to Vegas to join your wife and kids and then I want you to stay there. I'll send Connie an allowance. That's all. But don't keep saying you're innocent, don't insult my intelligence and make me angry. Who approached you, Tattaglia or Barzini?'

Carlo Rizzi in his anguished hope for life, in the sweet flooding relief that he was not going to be killed, murmured, 'Barzini.'

'Good, good,' Michael said softly. He beckoned with his right hand. 'I want you to leave now. There's a car waiting to take you to the airport.'

Carlo went out the door first, the other three men very close to him. It was night now, but the mall as usual was bright with floodlights. A car pulled up. Carlo saw it was his own car. He didn't recognize the driver. There was someone sitting in the back but on the far side. Lampone opened the front door and motioned to Carlo to get in. Michael said, 'I'll call your wife and tell her you're on your way down.' Carlo got into the car. His silk shirt was soaked with sweat.

The car pulled away, moving swiftly towards the gate. Carlo started to turn his head to see if he knew the man sitting behind him. At that moment, Clemenza, as cunningly and daintily as a little girl slipping a ribbon over the head of a kitten, threw his garrotte around Carlo Rizzi's neck. The smooth rope cut into the skin with Clemenza's powerful yanking throttle, Carlo Rizzi's body went leaping into the air like a fish on a line, but Clemenza held him fast, tightening the garrotte until the body went slack. Suddenly there was a foul odour in the air of the car. Carlo's body, sphincter released by approaching death, had voided itself. Clemenza kept the garrotte tight for another few minutes to make sure, then released the rope and put it back in his pocket. He relaxed himself against the seat cushions as Carlo's body slumped against the door. After a few moments Clemenza rolled the window down to let out the stink.

The victory of the Corleone Family was complete. During that same twenty-four-hour period Clemenza and Lampone turned loose their *regimes* and punished the infiltrators of the Corleone domains. Neri was sent to take command of the Tessio *regime*. Barzini bookmakers were put out of business; two of the highest-ranking Barzini enforcers were shot to death as they were peaceably picking their teeth over dinner in an Italian restaurant on Mulberry Street. A notorious fixer of trotting races was also killed as he returned home from a winning night at the track. Two of the biggest shylocks on the waterfront disappeared, to be found months later in the New Jersey swamps.

With this one savage attack, Michael Corleone made his reputation and restored the Corleone Family to its primary place in the New York Families. He was respected not only for his tactical brilliance but because some of the most important *caporegimes* in both the Barzini and Tattaglia Families immediately went over to his side.

It would have been a perfect triumph for Michael Corleone except for an exhibition of hysteria by his sister Connie.

Connie had flown home with her mother, the children left in Vegas. She had restrained her widow's grief until the limousine pulled into the mall. Then, before she could be restrained by her mother, she ran across the cobbled street to Michael Corleone's house. She burst through the door and found Michael and Kay in the living room. Kay started to go to her, to comfort her and take her in her arms in a sisterly embrace but stopped short when Connie started screaming at her brother, screaming curses and reproaches. 'You lousy bastard,' she shrieked. 'You killed my husband. You waited until our father died and nobody could stop you and you killed him. You killed him. You blamed him about Sonny, you always did, everybody did. But you never thought about me. You never gave a damn about me. What am I going to do now, what am I going to do?' She was wailing. Two of Michael's bodyguards had come up behind her and were waiting for orders from him. But he just stood there impassively and waited for his sister to finish.

Kay said in a shocked voice, 'Connie, you're upset, don't say such things.'

Connie had recovered from her hysteria. Her voice held a deadly venom. 'Why do you think he was always so cold to me? Why do you think he kept Carlo here on the mall? All the time he knew he was going to kill my husband. But he didn't dare while my father was alive. My father would have stopped him. He knew that. He was just waiting. And then he stood Godfather to our child just to throw us off the track. The cold-hearted bastard. You think you know your husband? Do you know how many men he had killed with my Carlo? Just read the papers. Barzini and Tattaglia and the others. My brother had them killed.'

She had worked herself into hysteria again. She tried to spit in Michael's face but she had no saliva.

'Get her home and get her a doctor,' Michael said. The two guards immediately grabbed Connie's arms and pulled her out of the house.

Kay was still shocked, still horrified. She said to her husband, 'What made her say all those things, Michael, what makes her believe that?'

Michael shrugged. 'She's hysterical.'

Kay looked into his eyes. 'Michael, it's not true, please say it's not true.'

Michael shook his head wearily. 'Of course it's not. Just believe me, this one time I'm letting you ask about my affairs, and I'm giving you an answer. It is not true.' He had never been more convincing. He looked directly into her eyes. He was using all the mutual trust they had built up in their married life to make her believe him. And she could not doubt any longer. She smiled at him ruefully and came into his arms for a kiss.

'We both need a drink,' she said. She went into the kitchen for ice and while there heard the front door open. She went out of the kitchen and saw Clemenza, Neri, and Rocco Lampone come in with the bodyguards. Michael had his back to her, but she moved so that she could see him in profile. At that moment Clemenza addressed her husband, greeting him formally.

'Don Michael,' Clemenza said.

Kay could see how Michael stood to receive their homage. He reminded her of statues in Rome, statues of those Roman emperors of antiquity, who, by divine right, held the power of life and death over their fellow men. One hand was on his hip, the profile of his face showed a cold proud power, his body was carelessly, arrogantly at ease, weight resting on one foot slightly behind the other. The *caporegimes* stood before him. In that moment Kay knew that everything Connie had accused Michael of was true. She went back into the kitchen and wept.

Book IX

CHAPTER THIRTY-TWO

THE BLOODY victory of the Corleone Family was not complete until a year of delicate political manoeuvring established Michael Corleone as the most powerful Family chief in the United States. For twelve months, Michael divided his time equally between his headquarters at the Long Beach mall and his new home in Las Vegas. But at the end of that year he decided to close out the New York operation and sell the houses and the mall property. For that purpose he brought his whole family East on a last visit. They would stay a month, wind up business, Kay would do the personal family's packing and shipping of household goods. There were a million other minor details.

Now the Corleone Family was unchallengeable, and Clemenza had his own Family. Rocco Lampone was the Corleone *caporegime*. In Nevada, Albert Neri was head of all security for the Family-controlled hotels. Hagen, too, was part of Michael's Western Family.

Time helped heal the old wounds. Connie Corleone was reconciled to her brother Michael. Indeed not more than a week after her terrible accusations she apologized to Michael for what she had said and assured Kay that there had been no truth in her words, that it had been only a young widow's hysteria.

Connie Corleone easily found a new husband; in fact, she did not wait the year of respect before filling her bed again with a fine young fellow who had come to work for the Corleone Family as a male secretary. A boy from a reliable Italian family but graduated from the top business college in America. Naturally his marriage to the sister of the Don made his future assured.

Kay Adams Corleone had delighted her in-laws by taking

instruction in the Catholic religion and joining that faith. Her two boys were also, naturally, being brought up in that church, as was required. Michael himself had not been too pleased by this development. He would have preferred the children to be Protestant, it was more American.

To her surprise, Kay came to love living in Nevada. She loved the scenery, the hills and canyons of garishly red rock, the burning deserts, the unexpected and blessedly refreshing lakes, even the heat. Her two boys rode their own ponies. She had real servants, not bodyguards. And Michael lived a more normal life. He owned a construction business; he joined the businessmen's clubs and civic committees; he had a healthy interest in local politics without interfering publicly. It was a good life. Kay was happy that they were closing down their New York house and that Las Vegas would be truly their permanent home. She hated coming back to New York. And so on this last trip she had arranged all the packing and shipping of goods with the utmost efficiency and speed, and now on the final day she felt that same urgency to leave that long-time patients feel when it is time to be discharged from the hospital.

On that final day, Kay Adams Corleone woke at dawn. She could hear the roar of the truck motors outside on the mall. The trucks that would empty all the houses of furniture. The Corleone Family would be flying back to Las Vegas in the afternoon, including Mama Corleone.

When Kay came out of the bathroom, Michael was propped up on his pillow smoking a cigarette. 'Why the hell do you have to go to church *every* morning?' he said. 'I don't mind Sundays, but why the hell during the week? You're as bad as my mother.' He reached over in the darkness and switched on the tablelight.

Kay sat at the edge of the bed to pull up her stockings. 'You know how converted Catholics are,' she said. 'They take it more seriously.'

Michael reached over to touch her thigh, on the warm skin where the top of her nylon hose ended. 'Don't,' she said. 'I'm taking Communion this morning.'

He didn't try to hold her when she got up from the bed. He

said, smiling slightly, 'If you're such a strict Catholic, how come you let the kids duck going to church so much?'

She felt uncomfortable and she was wary. He was studying her with what she thought of privately as his 'Don's' eye. 'They have plenty of time,' she said. 'When we get back home, I'll make them attend more.'

She kissed him goodbye before she left. Outside the house the air was already getting warm. The summer sun rising in the east was red. Kay walked to where her car was parked near the gates of the mall. Mama Corleone, dressed in her widow black, was already sitting it it, waiting for her. It had become a set routine, early Mass, every morning, together.

Kay kissed the old woman's wrinkled cheek, then got behind the wheel. Mama Corleone asked suspiciously, 'You eata breakfast?'

'No,' Kay said.

The old woman nodded her head approvingly. Kay had once forgotten that it was forbidden to take food from midnight on before receiving Holy Communion. That had been a long time ago, but Mama Corleone never trusted her after that and always checked. 'You feel all right?' the old woman asked.

'Yes,' said Kay.

The church was small and desolate in the early morning sunlight. Its stained-glass windows shielded the interior from heat, it would be cool there, a place to rest. Kay helped her mother-in-law up the white stone steps and then let her go before her. The old woman preferred a pew up front, close to the altar. Kay waited on the steps for an extra minute. She was always reluctant at this last moment, always a little fearful.

Finally she entered the cool darkness. She took the holy water on her fingertips and made the sign of the cross, fleetingly touched her wet fingertips to her parched lips. Candles flickered redly before the saints, the Christ on his cross. Kay genuflected before entering her row and then knelt on the hard wooden rail of the pew to wait for her call to Communion. She bowed her head as if she were praying, but she was not quite ready for that.

It was only here in these dim, vaulted churches that she

allowed herself to think about her husband's other life. About that terrible night a year ago when he had deliberately used all their trust and love in each other to make her believe his lie that he had not killed his sister's husband.

She had left him because of that lie, not because of the deed. The next morning she had taken the children away with her to her parents' house in New Hampshire. Without a word to anyone, without really knowing what action she meant to take. Michael had immediately understood. He had called her the first day and then left her alone. It was a week before the limousine from New York pulled up in front of her house with Tom Hagen.

She had spent a long terrible afternoon with Tom Hagen, the most terrible afternoon of her life. They had gone·for a walk in the woods outside her little town and Hagen had not been gentle.

Kay had made the mistake of trying to be cruelly flippant, a role to which she was not suited. 'Did Mike send you up here to threaten me?' she asked. 'I expected to see some of the "boys" get out of the car with their machine guns to make me go back.'

For the first time since she had known him, she saw Hagen angry. He said harshly, 'That's the worst kind of juvenile crap I've ever heard. I never expected that from a woman like you. Come on, Kay.'

'All right,' she said.

They walked along the green country road. Hagen asked quietly, 'Why did you run away?'

Kay said, 'Because Michael lied to me. Because he made a fool of me when he stood Godfather to Connie's boy. He betrayed me. I can't love a man like that. I can't live with it. I can't let him be father to my children.'

'I don't know what you're talking about,' Hagen said.

She turned on him with now-justified rage. 'I mean that he killed his sister's husband. Do you understand that?' She paused for a moment. 'And he lied to me.'

They walked on for a long time in silence. Finally Hagen said, 'You have no way of really knowing that's all true. But just for the sake of argument let's assume that it's true. I'm

not saying it is, remember. But what if I gave you what might be some justification for what he did. Or rather some possible justifications?'

Kay looked at him scornfully. 'That's the first time I've seen the lawyer side of you, Tom. It's not your best side.'

Hagen grinned. 'OK. Just hear me out. What if Carlo had put Sonny on the spot, fingered him. What if Carlo beating up Connie that time was a deliberate plot to get Sonny out in the open, that they knew he would take the route over the Jones Beach Causeway? What if Carlo had been paid to help get Sonny killed? Then what?'

Kay didn't answer. Hagen went on. 'And what if the Don, a great man, couldn't bring himself to do what he had to do, avenge his son's death by killing his daughter's husband? What if that, finally, was too much for him, and he made Michael his successor, knowing that Michael would take that load off his shoulders, would take that guilt?'

'It was all over with,' Kay said, tears springing into her eyes. 'Everybody was happy. Why couldn't Carlo be forgiven? Why couldn't everything go on and everybody forget?'

She had led across a meadow to a tree-shaded brook. Hagen sank down on the grass and sighed. He looked around, sighed again and said, 'In this world you could do it.'

Kay said, 'He's not the man I married.'

Hagen laughed shortly. 'If he were, he'd be dead now. You'd be a widow now. You'd have no problem.'

Kay blazed out at him. 'What the hell does that mean? Come on, Tom, speak out straight once in your life. I know Michael can't, but you're not Sicilian, you can tell a woman the truth, you can treat her like an equal, a fellow human being.'

There was another long silence. Hagen shook his head. 'You've got Mike wrong. You're mad because he lied to you. Well, he warned you never to ask him about business. You're mad because he was Godfather to Carlo's boy. But you made him do that. Actually it was the right move for him to make if he was going to take action against Carlo. The classical tactical move to win the victim's trust.' Hagen gave her a grim smile. 'Is that straight enough talk for you?' But Kay had bowed her head.

446

Hagen went on. 'I'll give you some more straight talk. After the Don died, Mike was set up to be killed. Do you know who set him up? Tessio. So Tessio had to be killed. Carlo had to be killed. Because treachery can't be forgiven. Michael could have forgiven it, but people never forgive themselves and so they would always be dangerous. Michael really liked Tessio. He loves his sister. But he would be shirking his duty to you and his children, to his whole family, to me and my family, if he let Tessio and Carlo go free. They would have been a danger to us all, all our lives.'

Kay had been listening to this with tears running down her face. 'Is that what Michael sent you up here to tell me?'

Hagen looked at her in genuine surprise. 'No,' he said. 'He told me to tell you you could have everything you want and do everything you want as long as you take good care of the kids.' Hagen smiled. 'He said to tell you that you're his Don. That's just a joke.'

Kay put her hand on Hagen's arm. 'He didn't order you to tell me all the other things?'

Hagen hesitated a moment as if debating whether to tell her a final truth. 'You still don't understand,' he said. 'If you told Michael what I've told you today, I'm a dead man.' He paused again. 'You and the children are the only people on this earth he couldn't harm.'

It was a long five minutes after that Kay rose from the grass and they started walking back to the house. When they were almost there, Kay said to Hagen, 'After supper, can you drive me and the kids to New York in your car?'

'That's what I came for,' Hagen said.

A week after she returned to Michael she went to a priest for instruction to become a Catholic.

From the innermost recess of the church the bell tolled for repentance. As she had been taught to do, Kay struck her breast lightly with her clenched hand, the stroke of repentance. The bell tolled again and there was the shuffling of feet as the communicants left their seats to go to the altar rail. Kay rose to join them. She knelt at the altar and from the depths of the church the bell tolled again. With her closed hand she struck

her heart once more. The priest was before her. She tilted back her head and opened her mouth to receive the papery thin wafer. This was the most terrible moment of all. Until it melted away and she could swallow and she could do what she came to do.

Washed clean of sin, a favoured supplicant, she bowed her head and folded her hands over the altar rail. She shifted her body to make her weight less punishing to her knees.

She emptied her mind of all thought of herself, of her children, of all anger, of all rebellion, of all questions. Then with a profound and deeply willed desire to believe, to be heard, as she had done every day since the murder of Carlo Rizzi, she said the necessary prayers for the soul of Michael Corleone.